MADRID & TOLEDO

How to use this book

The main text provides a survey of two cities' cultural history, Toledo from its adoption as the Visigoth capital in 554 and Madrid, the new capital selected by Philip II in 1561, both till the present day. It is illustrated with paintings, sculpture, architecture and general views.

The maps (pp. 252-55) show the principal monuments, museums and historic buildings, using symbols and colours for quick reference.

To find a museum or gallery turn to Appendix I, which lists them alphabetically, with their address, opening times and a note on their scope and contents. The larger collections are sub-divided into departments. Page numbers indicate where these are mentioned or illustrated in the text.

To find a historic building or church turn to Appendix II, which gives a similar alphabetical list of important buildings, landmarks, monuments, fountains, squares, etc. Grid-references enable the most important places to be easily located on the maps (e.g. Plaza Mayor, XY, means horizontal reference X, vertical reference Y).

For information on artists—painters, sculptors, architects, goldsmiths, engravers, etc. — turn to Appendix III. Here are listed those who contributed to the cultural greatness of Madrid and Toledo and whose works are now to be seen there. Each entry consists of biographical notes, details of where the artist's works are located, and references to the main text where they are mentioned or illustrated.

World Cultural Guides

MADRID & TOLEDO

Fernando Chueca Goitia

154 illustrations
in colour and black and white

special photography
by Mario Carrieri

Thames and Hudson · London

The lines, though airy gossamer and lace
Dethroned the peak with their pre-answered prayer;
For what the stars concede to us of space
And what the clouds abandon of the air
Is all pure architecture.

Roy Campbell
On the Architect's Designs for the Escorial
From Collected Poems Volume II 1968
by permission of The Bodley Head

The text translated by Monica Threlfall
The appendices translated by Suzanne Sale.

The World Cultural Guides
have been devised and produced by
Park and Roche Establishment, Schaan

ISBN 0 500 64006 8

Printed and bound in Italy by Amilcare Pizzi S.p.A.

Contents

Aerial photographs pp. 10, 94, 146, 164, 214,
226 by Silvela, Madrid.

End-paper illustration: Plaza Mayor de Madrid
c. 1780, Anon. Museo Municipal, Madrid.

Jacket illustration: Convento de San Juan de
los Reyes, Toledo. Photo: MAS.

Significant dates
in the history of Madrid and Toledo

BC 219 Hannibal attacks Saguntum.

193 Toletum taken by the Romans.

AD 409 Peninsula overrun by Vandals, Alani and Suevi.

416 Visigoth king Valia arrives to fight invaders.

c. 500 Beginning of Spanish Visigothic kingdom.

672-80 Visigoth king Wamba rebuilds walls of Toledo.

712 Moslem leader Tarik reaches Toledo.

797 Uprising in Toledo against Al-Haquem I.

852-886 Madrid founded during emirate of Mohammed I.

932 Toledo surrenders to Abd Al-Rahman III.

999 Building of Bab-el-Mardón Mosque (Cristo de la Luz).

1085 Alfonso VI, king of Castile and León,
conquers Toledo.

1118 Alcalá de Henares becomes subsidiary town
of Toledo.

c. 1140 Toledo School of Translators founded. Classical,
Arab and Jewish works reach West.

1158-1202 Madrid becomes free city of 10 parishes.

1221 Mudéjar church of San Román consecrated in Toledo.

1227-1493 Building of Toledo Cathedral.

1366 Sinagoga del Tránsito founded in Toledo.

1369 Pedro the Cruel assassinated by Enrique Trastamar.

1469 Isabella of Castile marries Ferdinand of Aragon.

1476 Convento de San Juan de los Reyes
founded in Toledo.

1492 Conquest of Granada. Ending of Arab power in
Spain. Jews expelled from Castile and Aragon.
Columbus discovers America.

1494 Hospital de Santa Cruz founded in Toledo.

1495 Alexander VI (Borgia) Spanish Pope, confers title
of Catholic Monarchs on Ferdinand and Isabella.

1498 University of Alcalá de Henares founded.

1516-17 Regency of Cardinal Cisneros.

1519 Charles I of Spain elected Holy Roman Emperor
with title Charles V.

1520-21 Revolt of the Comuneros.

1524-34 Hospital de San Juan Bautista founded in Toledo.

1534 Ignatius Loyola founds the Society of Jesus.

1547	Cervantes born in Alcalá de Henares.
1560	Convento de las Descalzas Reales founded in Madrid.
1561	Philip II establishes Madrid as empire's capital.
1562	Lope de Vega born in Madrid.
1563	Escorial begun by Juan Bautista de Toledo.
1571	Naval victory at Lepanto.
1576	El Greco settles in Toledo.
1588	Defeat of the 'Invincible Armada'.
1609	Expulsion of the Moors from Spain.
1617-19	Plaza Mayor, Madrid, built by Juan Gómez de Mora.
1622	Velázquez becomes court painter to Philip IV.
1701-14	War of Spanish Succession.
1713	Treaty of Utrecht. Philip V, a Bourbon, recognized king of Spain.
1718-37	Pedro de Ribera builds main works in Madrid.
1721-32	*Transparente* constructed in Toledo Cathedral, by Tomé.
1734	Destruction by fire of old Alcázar, Madrid.
1738	Palacio Real, Madrid, begun by Sacchetti.
1752	Ferdinand VI founds Academia de Bellas Artes de San Fernando.
1760	Charles III, king, to whom Madrid owes most.
1755	Beatification of Paseo del Prado by Hermosilla. and Ventura Rodriguez.
1778	Puerta del Alcalá built by Sabatini.
1789	Goya becomes court painter to Charles IV.
1808	Joseph Bonaparte, king of Spain.
1814-32	Ferdinand VII restored to throne.
1818	Founding of Prado Museum.
1833-39	First Carlist War.
1868	Abdication of Isabella II. Liberal revolution.
1873-74	First Spanish Republic.
1874	Alfonso XII, Bourbon, restored to throne.
1923-30	Dictatorship of General Primo de Rivera.
1931	Fall of Alfonso XIII and 2nd Republic proclaimed.
1936-39	Spanish Civil War.
1947	Spain declared monarchy under leadership of General Franco.

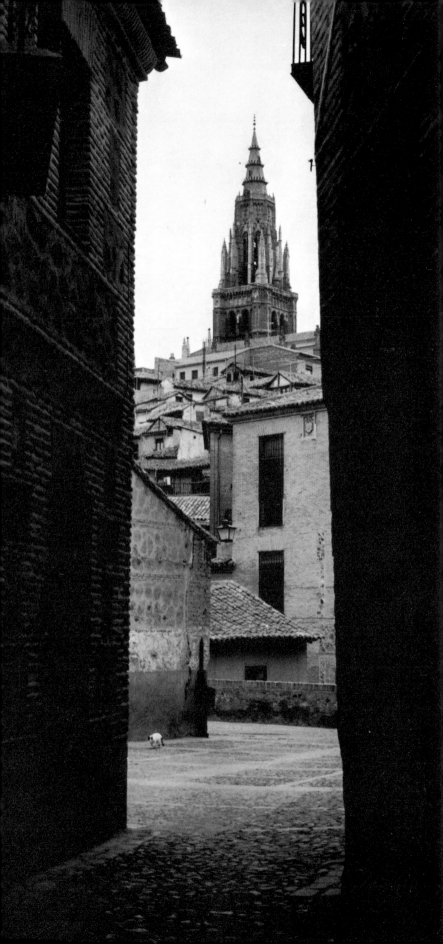

Toledo in history

Toledo, Granada and Seville are Spain's three universal cities. Their names mean something to everyone, not just to the educated or to those who have actually been there, but to others as well who might go there some day and cherish the hope that they will. These are the three cities that have mainly been celebrated in literature, especially during the romantic period of the early nineteenth century when there grew up in the eyes of the world an image of Spain as wild and picturesque, veiled in an aura of legend, which was eagerly cultivated by writers and travellers alike.

One must first of all remember that these three cities have a great Moslem past. They all possess exceptional monuments of Islamic art and have preserved a particular atmosphere, very much their own, which one could never find in any other city with a more homogeneous cultural character. The crossing of two worlds—Islamic east with Christian west—was the only thing that could have given rise to a setting so full of suggestion, so stimulating to western man's sensibilities, so strange in its effect and so rich in variety. Consequently his attention has been drawn time and again to these cities with a mixed culture. Admittedly, Madrid and Barcelona are better known, and visitors flood in to see them on account of their importance in the modern world and because they are great cities in themselves. Naturally too the enthusiastic traveller will also be interested in towns of a more unified western character like Santiago de Compostela, Salamanca, Burgos, Avila or Segovia for their lovely buildings and the structure of each city as a whole. But all things considered no other city can vie with Toledo, Granada and Seville in complexity, universal appeal and undying beauty.

They are very different from each other in spite of their common Moslem heritage. Two of them, Seville and Granada, are in Andalusia, the land of Figaro and Carmen, and consequently any foreigner sees them in a special light, whereas Toledo is in Castile, almost in the centre of the high, broad plateau which spreads over two-thirds of the Iberian peninsula. At the foot of the town flows the peninsula's central river, the Tagus. It runs down between two mountain ranges, the Sierra de Guadarrama and Sierra de Gredos to the north, and the Toledo Mountains to the south. But for reasons which are hard to explain, reasons which have more to do with its history than with its

◁
Toledo. Calle de San Lorenzo.
with the cathedral tower in the background.

9

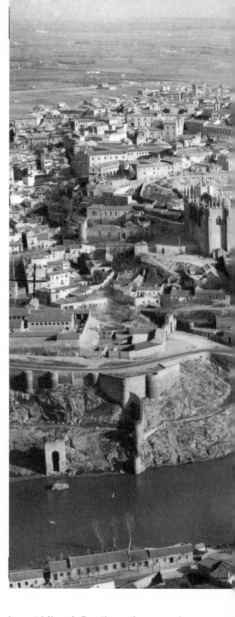

*Toledo, aerial view;
in the foreground, the Tagus
and the Puente de San Martín;
above, the Convento
de San Juan de los Reyes;
in the distance, the cathedral
and the Alcázar.*

geography, Toledo is an island in the middle of Castile and cannot be considered very representative of the Castilian character. For the truth is that Castile is the region which lies to the north of the Tagus, Old Castile with its centre in Burgos, *caput castellae*, between the Sierras de Gredos and Guadarrama, and the Cantabrian Mountains. In a rather silly attempt at symmetry the southern part of the plateau came to be known, to distinguish it from the other, as Castilla la Nueva, New Castile, a rather uninspiring, misleading name. It ought to be called the Kingdom of Toledo or simply Toledo. During Arab rule there actually was a kingdom of Toledo and the extensive diocese of Toledo later comprised a good deal of what we now call New Castile.

Furthermore the city's unusual history, its Moorish past, the way that the three racial groups that made up the tolerant Spanish Middle Ages—Christians, Moslems and Jews—lived together within its walls, the three of them combining to form the Spanish way of life as the historian and encyclopedist Amerigo Castro puts it—all this has given Toledo a character and an original appearance which mark it out from all other Castilian cities. With a past like this, to quote from a book

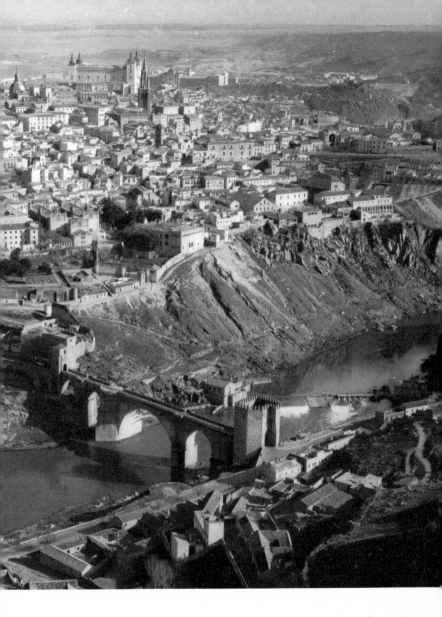

on Toledo by a well-known modern Spanish essayist, Dr Gregorio Marañón, 'Toledo could no longer ever be a pure Castilian town like Avila or Segovia; it is an eastern city which pushed its way into the west, hoping to reach the mysterious Atlantic, ultimate ambition of the age—and developed into a settlement on the rough banks of the Tagus, remaining frozen there in the semi-oriental existence which constitutes its greatest charm.'

The first thing about Toledo is that it is geographically almost an island in the Spanish landscape. The city is perched on a rocky promontory formed by the granite foothills of the Toledo Mountains, a position which earned it the description, in the language of Cervantes, of 'wilderness of rocks, glory of Spain and light of all her cities.' The promontory is surrounded on three sides by the deep gorge that the Tagus has dug out in its arduous course over the rocks. In fact even before the city had begun to spring up there the site must have had all the air of a natural fortress, easily defensible on account of the river gorge, so it was really predestined to become an important settlement and to play a significant part in future history. Apart from its

good strategic position, an essential factor in the development of any urban centre, the site had, among other useful advantages that helped its progress, a magnificent river whose basin drains the whole central area of the peninsula from east to west and therefore serves at the same time as an admirable channel for communications. In Toledo this ravine, running from east to west, meets the roads coming down from the north and crossing the central range on their way to the plains of La Mancha. For a cross-roads like this the narrow ravine of the Tagus and the steep cliffs of the rocky promontory were an advantage— bridges could be solidly built and well defended. And lastly there was rich, flat farmland to give the city the economic backing that was as vital to its life as its strong defences were to its security. Toledo stands on the dividing line between two different landscapes and agricultural zones, with the wheat fields and arable land of the Tagus to the north and pastoral slopes and wooded hills to the south.

On the road from Madrid to Toledo one crosses a monotonous plateau, passing through a few dirty, dejected-looking villages. Illescas is the only one which stands out, by reason of its pretty tower in the Moorish style and the El Greco paintings in its famous hospital. Then one emerges on to the Sagra, once really the granary of old Toledo and today still the most fertile area of what is mainly an arid province. The soil is mostly sand and loam, fairly smooth and flat; if it has rained plentifully in winter and spring, which is far from always being the case, it yields good wheat, barley, dwarf peas, wine and even some olive oil. (Some say the name Sagra comes from the Arabic word *chacra* meaning red, others believe it is from *shara,* meaning land).

Very shortly before one reaches the town itself the landscape suddenly changes as if by magic, becoming more rugged, while the earth takes on a deeper rust-red tone and is carved into dramatic shapes by the erosive action of the water in the Tagus gorge. The rolling hills are more thickly covered with the silvery foliage of the olive trees and the deep green cypresses of the cemetery give the varied scene something of an Italian quality. Then suddenly one comes upon a green carpet of flat meadowland with the city above it like a dream castle, lovely but mysterious, bristling with towers, spires and pinnacles, framed by the semi-circle of hills and mountains surrounding it on the far side of the Tagus. The city's main gates, facing towards Madrid, are called Puerta Vieja and Puerta Nueva de Bisagra, the Old and New Bisagra Gates, odd names which people often wrongly interpret as referring to *bisagra,* the Spanish word for hinge, whereas in fact they are derived from the Arabic *bab-shara,* meaning 'gateway to the fields' or 'to the Sagra', which takes the form *bib-shara* in the plural, hence 'Bisagra'.

In Toledo one cannot consider the city apart from its setting, for one is as beautiful as the other, as varied and as handsome. The town stands on the dividing line between two different kinds of landscape. Here one really could talk of the Bisagra Gate as a hinged door shutting off one view while opening up another, letting through a glimpse of both for only one fascinating second. The reddish hills and gullies, the soft, wide-spreading meadows with the King's Kitchen Garden close by and Galiana Castle to the east, the flat plain where the Roman amphitheatre once stood, stretching on past the ordnance factory and the market gardens as far as the orchards of San Bernardo to the west, all make up one side of the panorama. The Tagus cuts right across, its waters almost always turbulent when cramped between the rocks, but smooth and calm as they are released from constriction and meander along, irrigating the fields.

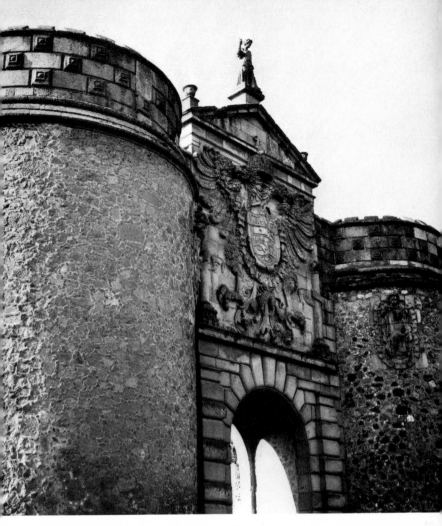

Toledo. Puerta Nueva de Bisagra, a 16th-century Renaissance gateway,
designed by Alonso de Covarrubias,
a brilliant architect in the reign of Charles V.

On the other side of the river the landscape is very rugged, for here
are the first foothills of the nearby mountains. Here, on a stony
granitic soil stretch out the famous *'Cigarrales'*, the Toledo fruit gardens
which the Spanish dramatist Tirso de Molina immortalized in one of
his best known works. They are small fenced patches of cultivated
ground with unassuming little white-washed houses surrounded by
various kinds of fruit trees such as almond, apricot and cherry. These
fruit gardens usually nestle alongside small water courses in the more
protected and kindlier spots, while in the uncultivated surrounding
landscape of rocks and crags, green with the moisture of winter,
ancient holm oaks and twisted olive trees, wild rosemary and broom,
dig in their roots.

The spectacle of the lofty city seen from the crown of mountains sur-
rounding it is an unforgettable experience. At sunset the city seems
to take fire and crackle like a flame, the window-panes catch the last
rays of the sun and throw them back like burning sparks, while the
bells of the innumerable convents toll the angelus. In this moment

of communion with the city and its mystery one seems to be a mute witness of a magic moment in history.

As with all cities of great antiquity, the story of Toledo's origin, being remote and obscure, is a mixture of fact and fiction, generously helped out with myth and folk-lore and supplemented by old wives' tales. This is largely the result of the efforts of ancient chroniclers, who were satisfied with nothing less than the most picturesque genealogy possible and gave credit in their writings to any tale they discovered. Thus Toledo had to have Hercules, son of Jupiter and Alcmena, as legendary founder, the myth being substantiated by the existence of a so-called Grotto of Hercules in the very centre of the town in Calle San Ginés underneath the house at No. 2. Actually it probably served as a crypt and burial place to the parish church of San Ginés which stood on the site of the house but has now disappeared. According to the best authorities, this awesome historic spot is really no more than a Roman water tank, perhaps one of the reservoirs of the city's water supply, which also included a very fine aqueduct. But it would not be surprising if in the far distant past the cult of Hercules was practised here, as it often was in heavily fortified cities, and that there was a sanctuary dedicated to his worship. Perhaps as an offshoot of the Herculean legend others credited Tubal or Tubal Cain, the reputed grandson of Noah, with being founder of the city, and since according to Hebrew tradition he too was a man of mighty strength and valour, a warrior as well as a blacksmith, such an illustrious ancestor would seem eminently appropriate in the eyes of the blacksmiths and sword-makers of Toledo.

Etymology competes with legend and for those who believe the Greeks founded the city it was first called Ptolietron, whereas for those who maintain it was the work of the Jews, Tolodoht was the name, meaning 'city of generation', because it was settled by the people of ten tribes of Israel. And there are others who claim, by an ingenious feat of philological juggling, that the name comes from the city's founders, the Roman consuls Tolemon and Bruto (the Spanish form of Brutus). Just throw together the first two syllables of the former and the last syllable of the latter and hey presto you have it—Toleto! However, this amounts to saying that the city did not exist before the Romans, whereas history has already proved that it did.

The only definite historical information that we possess is gleaned from two short passages of Livy's writings, which state briefly that the settlement of Toletum, small though well defended on account of its favourable position, was taken by force by the proconsul Marius Fabrius in 193 BC in a battle against a league of the tribes from the interior. The following year the Vettones tried to recapture it, but in vain, and from then onwards it remained incorporated into the Roman system as capital of the region of the Carpetani, though dependent juridically on Cartagena. Some historians think it even attained the rank of a Roman Colonia, though this is improbable; judging from the occasional historical mentions and the numerous monuments of the period of which remains survive or to which references have been found, Toledo was merely an important Municipium.

▷

Toledo. Capilla de Santa Catalina, 15th century, with the church of San Marcos and the spire of the cathedral in the background.

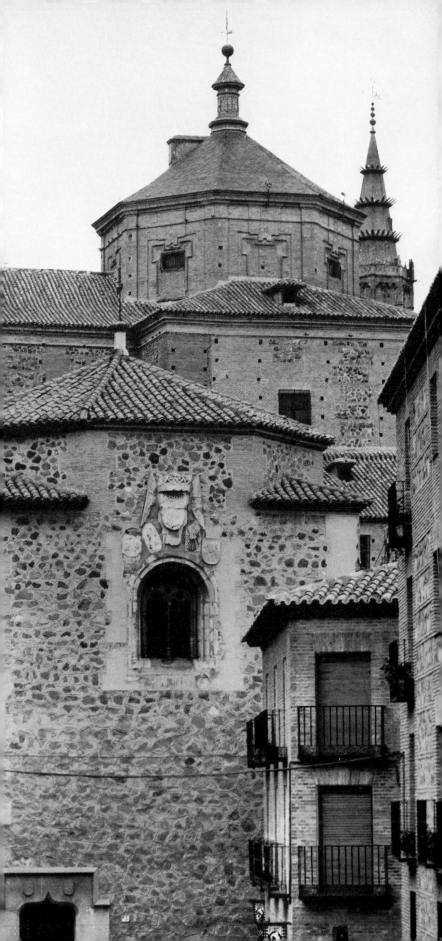

Very little is known about the early Christian era in Toledo in spite of the important rôle that the city was destined to play in the religious history of Spain. But that the seedling put down deep and vigorous roots is beyond doubt, for it was in Toledo that the praetor Dacianus established an important anti-Christian tribunal during the period of ruthless persecution in the fourth century. But not long afterwards, in AD 400, Toledo witnessed the celebration of the first council of newly Christianized Spain, one which opened the series of ecclesiastical conventions which brought such fame to the city. The councils gained greatly in importance with the consolidation of the power of the Visigoths and especially after the conversion of Reccared during the third council in AD 589. Seventeen of these councils took place in all, and they became one of the basic instruments for managing the Visigoth state. The duty of convening the councils fell to the king, and he was present in person at the opening, surrounded by dignitaries of the court. The subjects discussed during the councils included temporal matters as well as spiritual ones, though there was a predominance of the latter and sessions given over entirely to these were attended only by the bishops. But what really counted was the immense moral authority they conferred on the state, while at the same time representing the continuity in high government circles of the Hispano-Roman element and the classical tradition, as opposed to the feudal and war-like power of the Germanic minority. Some historians have seen in the Councils of Toledo the origins of the Spanish Cortes of the Middle Ages. When, after the unhappy years of the first barbarian invasions the power of the Visigoths was well established in the peninsula, Toletum was already the ecclesiastical capital of the old Hispanic region, and it was in this city that Leovigild set up the headquarters of his realm. This produced a certain amount of friction between the Arian rulers and the Catholic prelates, but all was settled by the time of Reccared's conversion.

During this period, certainly one of the most brilliant in the city's history, there lived a remarkable man who became the most famous of the saints of Toledo, Bishop Alfonso or Ildefonsus. He was still no more than a boy when he left home and defied the anger of his powerful father by seeking refuge in the monastery of St Cosmas and St Damian of Agali, the most venerable religious establishment in Toledo in the time of the Visigoths. It had been enriched some years before by one who had first been a well-known figure at court and later a model monk, St Eladio, and Ildefonsus had the consolation of being ordained priest by old Eladio himself. When the most outstanding figure of the Visigothic period, St Isidore of Seville, author of *Etimologias,* arrived in Toledo, he found in Ildefonsus a faithful and devoted companion as well as an attentive disciple who often accompanied him on his travels. The famous prelate of Toledo wrote a defence of the Virgin Mary (*'de perpetua virginitate beatae Mariae'*) and pious tradition had it that his work was rewarded by the descent of the Virgin herself to deck him in a magnificent vestment. This event has been repeatedly illustrated in all representative

▷

The pointed tower of Toledo Cathedral seen over the roof-tops of the old town.

P. 18/19
Toledo rising from the deep gorge of the Tagus which surrounds it.
The cathedral can be seen in the centre and the Alcázar is on the right.

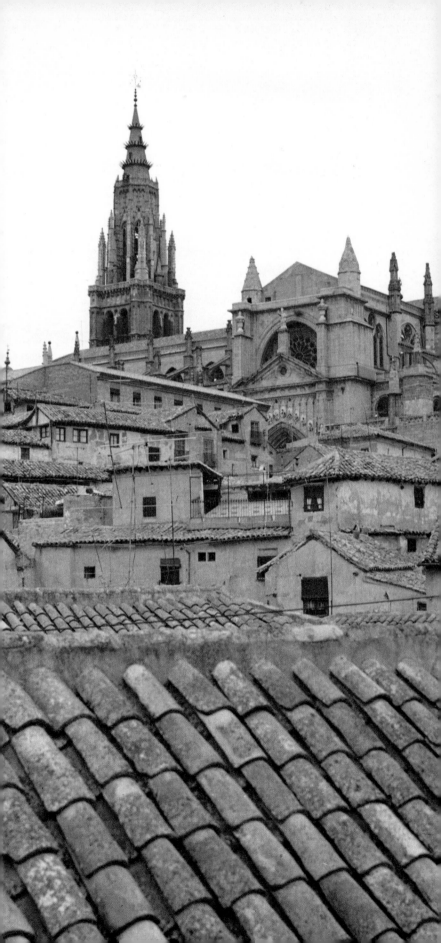

art of Toledo, from the tympanum of the central portal of the ca-
thedral to the decoration on the most insignificant religious objects.
The scene is also represented in the cathedral's coat of arms—St Ilde-
fonsus being clothed in the vestment. We can recall here that one
of El Greco's most impressive paintings shows St Ildefonsus dressed
as a sixteenth-centry priest sitting at his work-table writing the praises
of the Virgin, whose statue dominates the whole room. The painting
hangs in the Caridad Hospital at Illescas.

In all Visigothic Spain nothing could have compared with the city on
the Tagus, nothing could match the glory of its palaces and royal court
nor compete with the magnificence of its cathedral and monasteries, such
as Agali where Eladio flourished, together with Justo, Eugenio the
astronomer, Eugenio the poet and Ildefonsus, all of them archbishops
and leading lights of the Councils. But for all its splendour and for
all its venerable history, how much of Visigothic Toledo can we
still see in the form of monuments or even archaeological remains?

View and Plan of Toledo, c. *1609,*
by El Greco, Museo del Greco, Toledo.

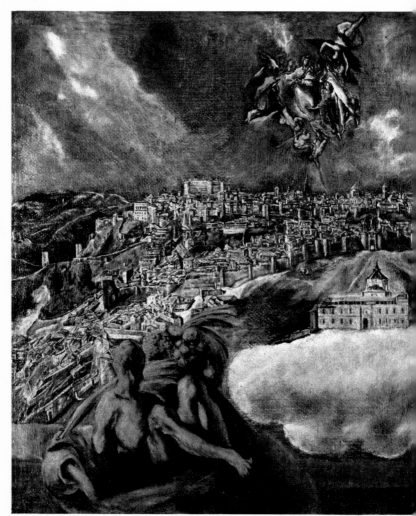

Hardly anything, and still less anything complete. The most striking are a few capitals of columns mixed up with Roman ones in some small Toledo churches in the Moorish style, built over other earlier ones from which they took these features. The Iglesia del Salvador, which used to be a mosque and which contains intact a row of arches from the Moslem shrine, still has some of these capitals and an extremely interesting pilaster with decorative motifs which must come from a Visigothic chancel. There is also a good group of Visigothic capitals in one of the courtyards of the Hospital de Santa Cruz, and since it is in this beautiful building that the archaeological museum is housed, several other relics of that golden age, such as gravestones, can be seen there. Lastly, in one of the walls in Calle San Ginés one can see Visigothic stones embedded in the wall and used as facing stones, some of them intricately carved. Doubtless they come from the vanished church which was mentioned earlier in connection with the Grotto of Hercules.

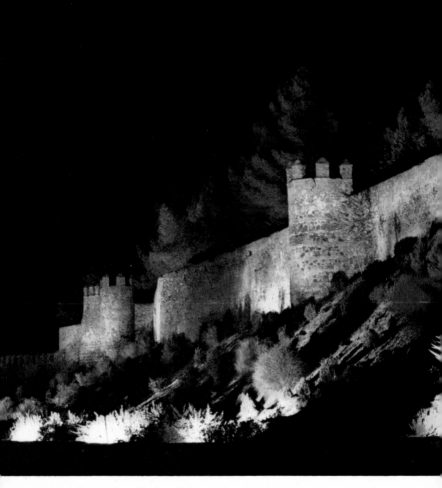

Toledo, the north wall which follows the 7th-century fortifications built by Wamba, the Visigoth king, and rebuilt in Moslem and Christian times.

Wamba, one of the most important Visigothic monarchs, who reigned from 672 to 680, rebuilt the old city walls of Toledo, the almost forgotten Roman enclosure, and erected what must have been a strong and comprehensive defensive system. The best preserved part is the eastern curtain wall beneath the Alcázar, running from the Puerta de Alcántara opposite the bridge of the same name to the Puerta de Doce Cantos, the 'Gate of Twelve Songs'. But the Alcántara gate has been greatly altered from its original Visigothic form both by the Arabs and in subsequent modifications.

The protective work and military consolidation carried out by Wamba was interrupted when his successor to the throne, Ervigio, usurped his place by devious means. Ervigio gave the king a poisoned drink which left him unconscious and completely at his mercy. He then

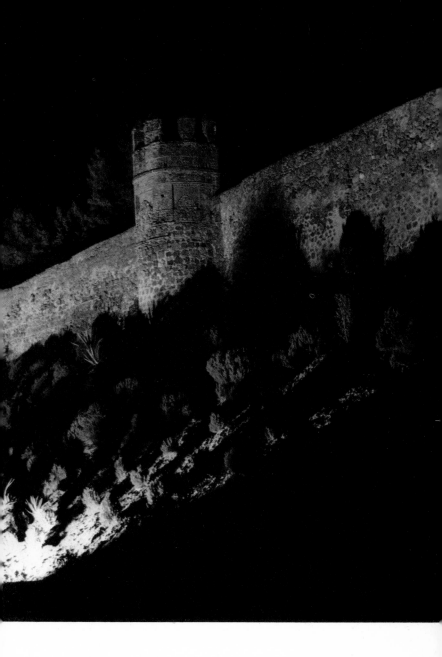

tonsured him and forced him into the Order of Penitence, which disqualified him from reigning, after which he was given no option but to retire to the monastery of Pampliega. In devising this cunning plot Ervigio had been able to count on the support of the Church and of Archbishop Julian, who obtained from the new king the supremacy in Spain of the archbishopric of Toledo.

The anarchy and instability of the Visigothic state continued to spread. Already as early as Wamba's reign the Arabs had conquered Tangier and were a growing menace, always ready to take advantage of the dissensions in the Germanic ruling class. In 710 Vitiza was dethroned by Don Rodrigo and faction increased. Don Rodrigo, eminent but unfortunate, had to come to the help of the south to hold back the Moslem invasion and later disappeared in circumstances which

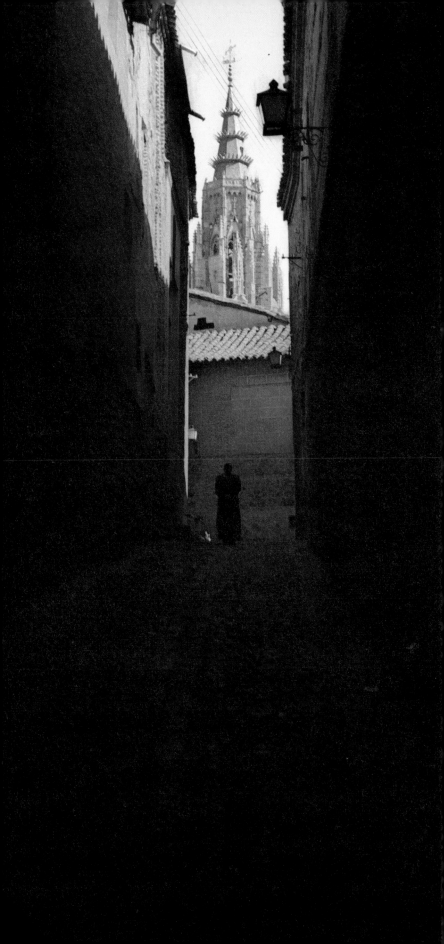

have never been cleared up. But on the occasion when history is silent, legend takes over; and in Toledo legend has always found a climate where its inventions could flourish. According to one such fanciful story, the Moslem invasion, which was in reality doubtless inevitable, originated in an act of treason on the part of Count Julian, Governor of Ceuta, who was anxious to take revenge on his sovereign for the seduction of his daughter Florinda, better known in Toledo as 'Florinda de la Cava'. Still connected with this legend is a fortified tower known as Baño de la Cava, which can be seen a few yards downstream from the Puente San Martín. Actually this tower was erected at the head of a bridge of boats long since disappeared, to defend it, and cannot be anything but of Mudéjar construction, almost certainly of the thirteenth century, with a few Arab details such as the shafts of the columns of the door, which are covered with faint inscriptions. It is certainly far removed in time from the era of such romantic tales of gallantry. All the same many people are convinced— and who knows, perhaps they are right—that this is where the beautiful Florinda bathed and was glimpsed by the over-bold king, and where his ghost still seeks her in the stilly watches of the night.

With the Moslem invasion Toledo, like most of the rest of the peninsula, entered a new stage in its history. It was early in 712 that Tarik reached the foot of the walls; and the ancient Visigoth capital, once the throne of a whole empire which was never again to be united, fell without resistance, as a faded and fragile rose falls to a harsh gust of wind or a house of cards to a breath of air—it vanished like a dream.

The history of the Moslem Toledo or Tolaitola is one of uninterrupted rebellions and sieges. Actually the city and its surrounding territory enjoyed a fair degree of independence from the Moorish kings in Córdoba. This had a good deal to do with the unusual composition of the population of Toledo, where the preponderant group was the Mozárabs, who were Christians who lived under Moslem rule without forsaking their land, and enjoyed certain privileges such as the freedom of worship with their own priests and bishops. On occasion these rebellions by the population gave rise to events of revolting cruelty, like the notorious *Jornada del Foso,* the Day of the Ditch. What happened was that when Al-Hakem I came to the throne in Córdoba he entrusted his lieutenant Amru-ben-Yusuf with the task of re-establishing his authority over the rebel city. Having achieved this, Al-Hakem appointed as governor of the city Amru-ben-Yusuf's son, a dissolute, cowardly and cruel young man who quickly alienated the sympathy of the Toledo population to such an extent that they overthrew him in a new popular uprising. With his paternal pride considerably hurt, Amru-ben-Yusuf persuaded the king to entrust the government of the town to him, and under the treacherous pretence that he was ready to pardon them he invited the most prominent of the notable figures of the city to a banquet which ended in a horrible massacre. The cruelty of this event lingers on in popular legend, and even now when a Spaniard wants to express the idea of a night of bad omen he speaks of a 'Toledo night'. There seem to have been as many as four hundred victims and their heads were exposed in public while their bodies were thrown into a ditch that had been dug in readiness.

◁
Toledo. Callejón de Santa Ursula,
affording a glimpse of the cathedral's tower.

A prey to continuous rebellion, 'Tolaitola' surrendered in the year 932 to the first Caliph of Córdoba, Abd-al-Rahman III, after which followed a period of relative tranquillity under the rule of the second Caliph, Al-Hakem II. But with the fall of Almanzor, unrest began again and continued until the formation of the independent Moslem kingdom of Toledo, whose first monarch was its former governor, Ismail-Abd-al-Rahman. He was succeeded by his son Yahya, nicknamed Al-Nammun, 'the celebrated', whose reign from 1043 to 1077 was one of the most brilliant periods Toledo experienced in Moslem times. Alfonso VI, banished from Castile, came to his court and sought refuge with the magnificent prince of the city by the Tagus. But Yahya's successors were not so fortunate and were unable to maintain either the prestige or the conquests of their predecessor. They repeatedly fell into the traps that Alfonso cunningly laid for them, and after complicated negotiations he entered the city victoriously on 25 May 1085.

The year 1085 also proved to be a decisive one for Madrid, whose history at the time of the Arabs was closely linked with that of Toledo, of which town it was no more than a military outpost, a strong point contributing to the defence of the kingdom by serving as a look-out in the Manzanares valley, which was a convenient breach for the incursions of the Christians coming from the Sierra de Guadarrama. Madrid too fell round about the year 1085, though it is not known whether this was a step towards the fall of Toledo or a consequence of it; the exact date has not come down to us. Probably because of the lesser importance of the smaller town it was overshadowed by the bloodless conquest of Toledo, which had so much more significance for the Christians. For what this really meant was that with the capture of Toledo the first major Islamic city in Andalusia fell into the hands of the vigorous but much more primitive Christian princes, who thus regained nothing less than the capital of the Visigothic kingdom, indeed of the whole of the Hispanic domain destroyed by the Moslems, which the leaders of the reconquest were aspiring to rebuild.

The 373 years of Moslem rule were so decisive in the shaping of Toledo that no appreciation of its history or art can be made without taking them closely into account. And even among the other Moslem cities in the peninsula it has always been distinguished by its individual characteristics. For instance, the unusually mixed population was made up of Moslems, Christians (organized in their own church communities) and Jews. It was a reign of tolerance, and the arts and sciences flourished. The city boasted a great number of monuments and was one of the foremost focal points of western civilization.

But remarkable buildings are not the only legacy of the Moorish era; more important still are the city itself, its urban structure, the layout of the streets, the physiognomy of its houses, the design of its buildings and so on. All these bestow on Toledo an individual position among the world's centres of art and history. An air of mystery, heavy with the accumulated memories of the past, envelops this city where each street has its own history and echoes of the past ring out from every corner. To stroll through Toledo and to feel its enchantment are one and the same thing. The city seems to have a voice which speaks out across the centuries, above all to poets like Gustavo Adolfo Becquer, who found in Toledo the inspiration for some of his best poems such as: 'La Ajorca de Oro', 'El Beso', 'El Cristo de la Calavera', 'La Rosa de Pasión' and 'Tres Fechas'.

When Alfonso VI came to power the city experienced a sudden and radical transformation. The population for the most part continued living there and kept its habits, customs and other modes of living. The position of the Moslem and Jewish inhabitants was untouched—indeed their freedom of worship was guaranteed by treaty. Alfonso VI, who considered himself head of all three faiths, was at first a benign sovereign compared with the queen, Constance of Burgundy, or the French archbishop, Bernard de Sedirac, who, according to tradition recorded by Rodrigo Jiménez de Rada, secured the consent of the queen to break the agreement with the Moslems and deprive them of their principal mosque.

The queen's intolerance, combined with the fervour of the archbishop, a monk of Cluny, had the effect of gravely offending the Moslem community and, more oddly, the original Christian inhabitants as well, the so-called 'Mozárabs'. Queen and priest, champions of a united Europe and of the universality of the Church, could not but feel vexed by the confusing hotch-potch that was Toledo, where the eastern spirit made itself felt so strongly. They started by persecuting the Mozárabic church with its apostolic rites in the tradition of St Isidore which the Mozárabs had so lovingly preserved at the cost of considerable sacrifice from the time of the Visigoths through nearly four centuries of Moslem rule. The struggle between the old

Toledo. Puerta de Valmardón,
the ancient Arab gate of Bab-el-Mardón.

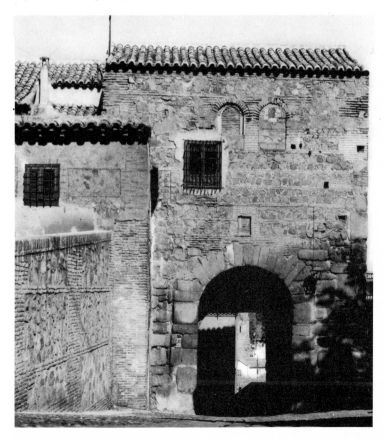

Toledo. The walls of
Antequeruela with Arab
and Mudéjar remains (above).

▷
A house in the Cisneros style,
c. 1520. San Lorenzo
tower in the background.

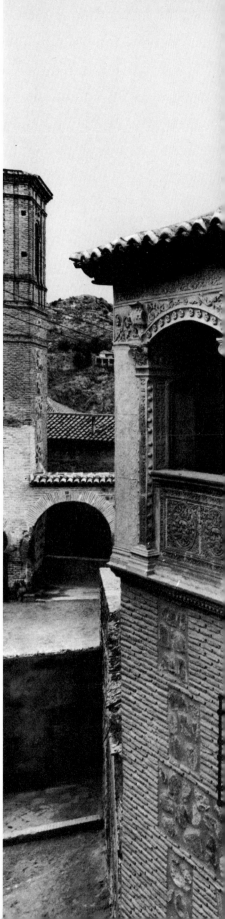

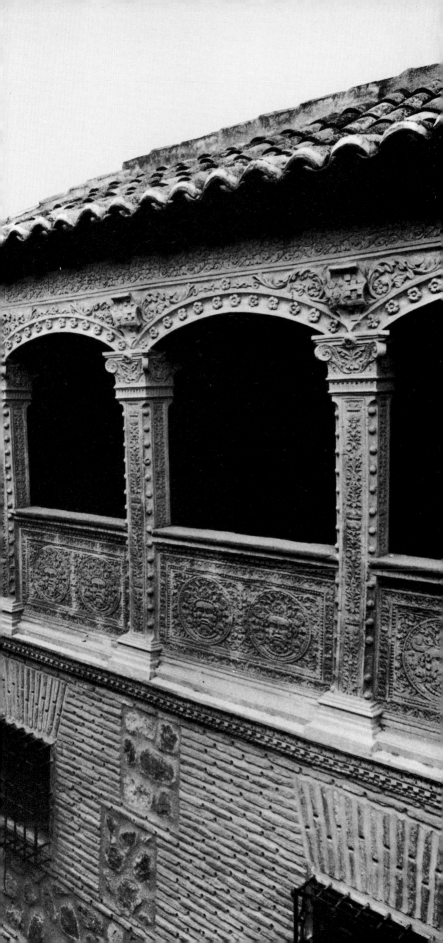

Mozárabs and the partisans of Gregorian reform and Roman rites was violent.

Various stories, all belonging more or less to the realm of fiction have it that at one moment the dispute was to be settled by recourse to arms. So two champions were chosen to represent the opposing parties, and the Mozárab defeated his adversary in battle. But, not satisfied with the outcome, the authorities decided to refer the case to the judgment of God and threw the Roman and the Gothic breviaries into the fire—and the latter remained undamaged by the flames. Of course one must remember that it is popular feeling that gives rise to these legends and that in this case the people were on the side of the Mozárabs. But under pressure from the pope, the queen and the archbishop, Alfonso finished by imposing the Gregorian rite, a despotic act which gave rise to the popular saying, 'The law provides what the king decides'.

The Mozárabs, resigned to the loss of their rights, nevertheless managed to preserve their parishes, of which there were six at first; but with time the number dwindled. All the same it is remarkable to think that there are still two left: the parish of San Marcos and that of SS. Justo and Rufina. Two hundred or so families congregate there, all descended from the Mozárabs, those Spanish Christians who lived in Toledo and kept their faith intact in the midst of the Arabs from the eighth to the eleventh centuries. The apostolic rites were really a historical survival, one of whose main preservers was the great Cardinal Cisneros who was so eager to maintain such traditions that he founded the Capilla Mozárabe in the cathedral so that the rites should not be forgotten. Mass is celebrated there daily according to the old Toledan liturgy.

During the reigns of Doña Urraca, Alfonso VII (the Emperor), Sancho III (the Beloved), Alfonso VIII (hero of the battle of las Navas de Tolosa), Ferdinand (the Saint), Alfonso X (the Wise), Sancho IV (the Brave), Fernando IV (Summoned before the Lord), Alfonso XI (hero of the battle of the Salado) and Pedro the Cruel, Toledo was the undisputed capital of Castile and all the memorable events of the kingdom took place within its walls or had their repercussions there. It was here that Alfonso VIII, while still a boy, was proclaimed king in 1166 by Don Esteban Illán, a nobleman of Toledo, and so came to enjoy his hereditary rights. Ferdinand III laid the foundation stone of the cathedral on 14 August 1227, while Alfonso X, who was born in Toledo, chose the city for his congresses of scholars, giving a welcome to the translators and men of science who used the manuscripts left by the Arabs to communicate to the western world much of the knowledge and philosophy of the classical era. Here too he laid the foundations of the greatest achievement of Spanish jurisprudence called 'Las Siete Partidas', a corpus of laws compiled in seven parts. Another king who showed a great predilection for the city was Alfonso XI who had at his side during the battle of the Salado the great Archbishop of Toledo, Don Gil Camillo de Albornoz. The death of Alfonso XI, which took place at Gibraltar in 1350, marks the beginning of a turbulent period for Toledo as well as for the rest of Spain, a period of upheavals beginning with the ill-fated reign of Don Pedro the Cruel and continuing with the Trastamar kings (Henry II, 1369-79; John I, 1379-90; Henry III, 1390-1406; John II, 1406-54; Henry IV, 1454-74) up to the accession to the throne of Isabella la Católica, the daughter of John II and sister of Henry IV.

In Toledo Pedro the Cruel had the support of the Jewish community,

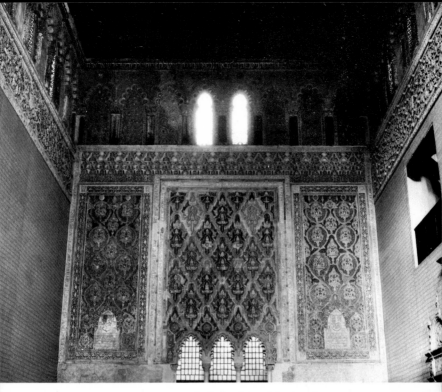

Toledo. Sinagoga del Tránsito, built for Samuel Levi, 14th century.

whose most eminent member was their treasurer, Samuel Levi, founder of the 'Sinagoga del Tránsito', an edifice which to this day does honour to its founder and to that age. But Levi fell into disgrace, all his possessions were confiscated and he was executed in Seville, so that the king lost one of his most effective partisans. With the death of Samuel Levi the great period of Jewish influence in Toledo was over; under the Trastamar rulers they were persecuted and cruelly cut down in numbers. And with this, one can say, Toledo lost its real medieval character, which had been gradually giving way to a new concept of society and of the state. To quote the historian Amerigo Castro, it was the coexistence of Christians, Moors and Jews which created the genuine character of Spanish life at that time.

The purest expression of the spiritual atmosphere of medieval Toledo is found in Moorish art and architecture. During the twelfth, thirteenth and fourteenth centuries Toledo was a wholly Moorish city with the single exception of the cathedral. This means that nothing was produced that in any way broke with the artistic traditions of the past. The architects who had previously built mosques and synagogues now turned to churches, decorating them with the same ornamental work and using the very same materials as were commonly used during the Islamic period. Brickwork, plaster wrought into innumerable filigree designs, wooden ceilings and panelling of incomparable beauty and technical skill, delightful inlay work with colourful tiles—these are the features which continue to embellish churches, palaces and public buildings. In its culture Toledo remained a Hispano-Moslem city. Much has been written about the 'Mudéjar' or Hispano-Moorish style and its characteristics. Some consider it a minor secondary art, a hybrid lacking in imagination and original inspiration, a mere product of Christian structure and forms dressed up with Moslem embellishments. Others feel the opposite; here is an art with a strong personality and of the greatest individuality, especially if one assesses it in terms

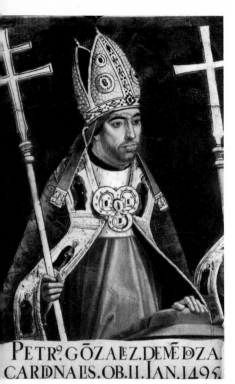

PETR? GŌZAŁEZ.DEMĒĐZA.
CARĐNAŁS.OB.II.IAN.1495

Portrait of Cardinal Mendoza
in the chapter house
of Toledo Cathedral.
He founded the Hospital
de Santa Cruz, the courtyard
of which is seen below.

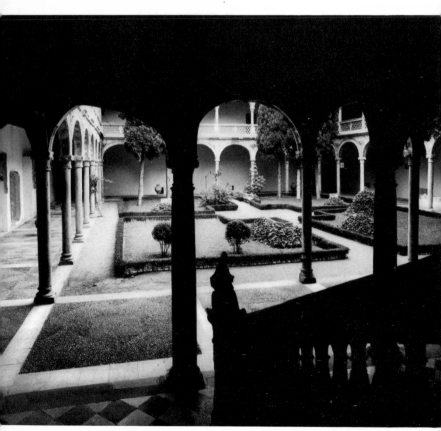

of the context of the country that produced it, for Spain, naturally much influenced by other cultures of greater universal genius, displays in Hispano-Moorish art a sovereign achievement of its own. It is an art which grew up on its own without borrowing from elsewhere, based on its own traditions and a history which is virtually unique (with certain exceptions in the south of Italy and especially in Sicily) in being a mixture of two peoples, two religions and two cultures, resulting, as in chemistry, in a compound which is a different substance altogether and not just a simple aggregation of its components. Where architecture is concerned—and Mudéjar art is essentially architectural—things are not as simple, and to condemn Hispano-Moorish architecture as no more than the result of decorating a Christian church with a few Arab motifs is a vast over-simplification. Different expressions of Mudéjar art are to be found scattered more or less evenly throughout the country—in Old and New Castile, in Aragón, and in Andalusia—but Toledo probably best exemplifies its brilliance and splendour. The style which dominates in Toledo in its churches, towers, palaces, convents, fortifications and gateways, is Hispano-Moorish, Mudéjar, an artistic tradition which the Moslems kept alive even after they were conquered and which they handed down from one generation to another of masons and craftsmen of every kind—plasterers, tilemakers, carpenters and weavers. For even when they had long ceased to be Moslems by religion they remained Moorish in their culture and artistic traditions.

Of course, remarkable examples of the Gothic style do exist in Toledo but even some of these, like San Juan de los Reyes, a typical example of a building of the period of the Catholic Monarchs, are oddly mixed up with Mudéjar features. Naturally the Renaissance and the brilliant period of the Emperor Charles V (Charles I of Spain) have left their mark of courtly magnificence upon the city, but even the effect of all this together is insufficient to dilute the vigorous Hispano-Moorish current which runs through it, ubiquitous and all-pervading. The great Gothic and Renaissance structures stand out conspicuously in the general picture of the city rather like elegant and perhaps somewhat outlandishly-attired foreign visitors; but the man in the street, the genuine and typical local product—that is what the Mudéjar style represents in Toledo.

The main lay-out of the town, in the Moorish style, has changed very little since medieval times. It is just as well, for otherwise the original appearance would have been disfigured and we would have lost an urban relic of the greatest interest, namely a virtually unspoilt Hispano-Moslem and Mudéjar city. The great Renaissance edifices fit into it uneasily, yet hardly mar its characteristic texture. In a word, Renaissance buildings do exist, some of them highly impressive, but no Renaissance city as such, with the traditional symmetrical streets, straight lines and right angles and the unencumbered open squares. Even Philip II's plan to convert the Plaza del Zocodover into a rigorously geometric Plaza Mayor like that in Valladolid or like those in Madrid and Salamanca was to prove fruitless, and it still retains the same quaint irregularity it had in the past.

The Renaissance period in Toledo is dominated by a series of archbishops who were the real princes and permanent overlords of the city, patrons who provided their religious capital with the equivalent of the brilliant Italian courts of the same era, those of the Medicis in Florence, the Sforzas in Milan, the Dorias in Genoa, the Malatestas in Rimini, the Estes of Ferrara, and the Montefeltros of Urbino.

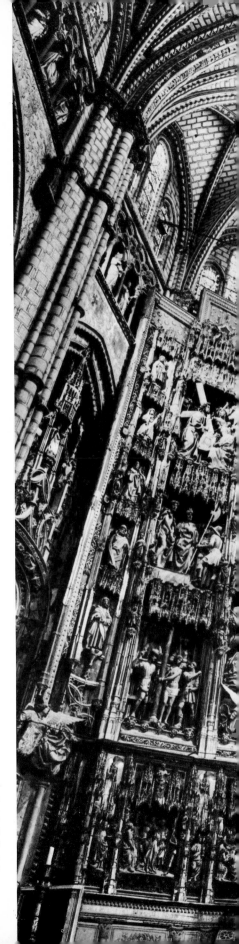

Toledo Cathedral, the high altar,
with magnificent decorations,
designed by Felipe Vigarny
and executed in the
Flamboyant Gothic style
by Spanish and Flemish artists,
early 16th century.

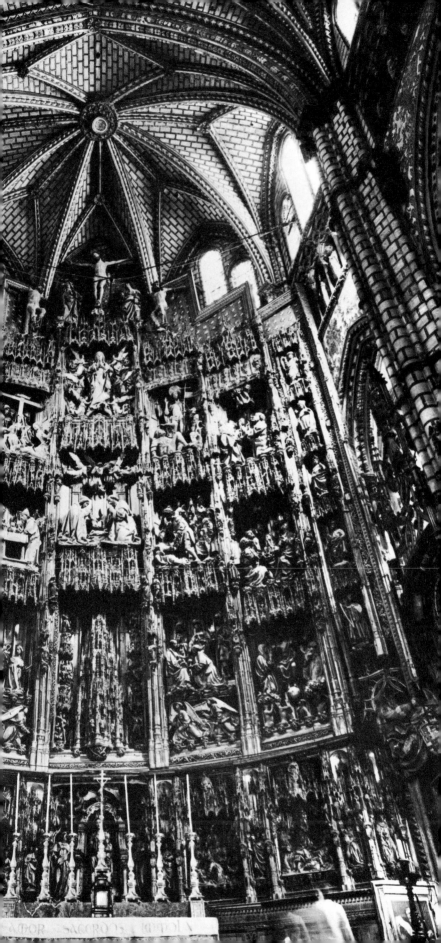

The first of these great archbishops and benefactors was Cardinal Mendoza (1403-95) who sprang from one of the noblest Castilian families and played a pre-eminent part both in the politics and warfare of his period. Known as the Third King of Spain after his sovereigns, the Catholic Monarchs, he took part with Ferdinand and Isabella in the conquest of Granada and was present at the surrender negotiations and handing over of the city. In his primatial cathedral he completed the vaulting and had a magnificent sepulchre made for himself in the main choir near the high altar, almost as if he were a king. To him Toledo owes the foundation of the Hospital de Santa Cruz, one of the city's proudest monuments. Today Santa Cruz has been converted into an attractive museum housing a collection mainly devoted to the art of the period of the Emperor Charles V, though a splendid group of paintings by El Greco is its greatest asset.

Mendoza was succeeded as archbishop of Toledo by Francisco Jiménez de Cisneros (1495-1517), a figure unique in the history of Spain as well as in that of his diocese. Originally Queen Isabella's confessor,

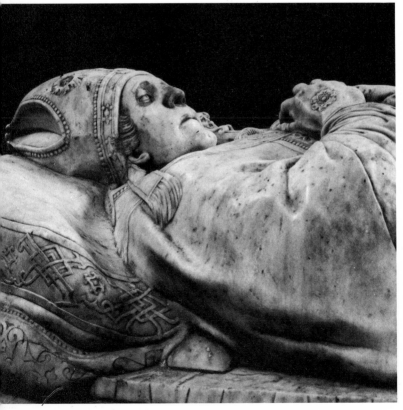

Toledo. Tomb of Cardinal Tavera, detail, by Berruguete, in the Hospital Tavera.

▷
Toledo. Museo de Santa Cruz which contains several fine El Grecos.

he later became one of her most trusted advisers and on her death sustained the power of the monarchy at a period of crisis by making an alliance with King Ferdinand. Together with him he planned and carried out the conquest of Oran, but his achievement was never completely consolidated owing to the lack of a genuine understanding with his sovereign. In spite of their disagreements, King Ferdinand on his deathbed gave the archbishop responsibility for the regency until the coming of age of his grandson Charles of Ghent and while his daughter Juana remained afflicted by complete insanity, confined in Tordesillas. He safeguarded Charles's rights to the throne with unparalleled tenacity, but he died at Roa in 1517 without ever being able to meet the man who was to control the destiny of Spain for nearly forty years.

Cisneros was the founder of the University of Alcalá de Henares (see p. 143) and undertook the publication of the *Biblia Poliglotta Complutensis*. Both these undertakings in the cultural field have won him much renown, while Toledo also owes much to his munificence, for though he was modest and ascetic in his personal life, he always saw

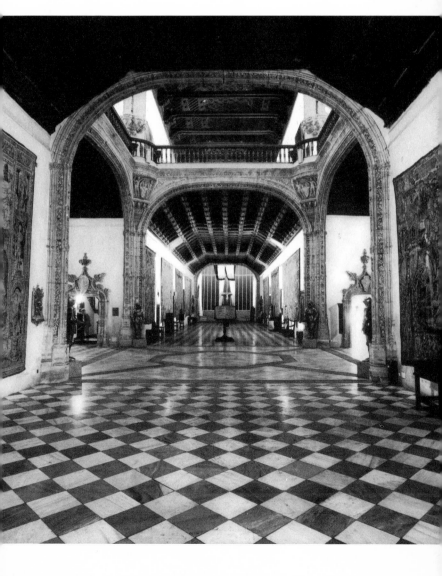

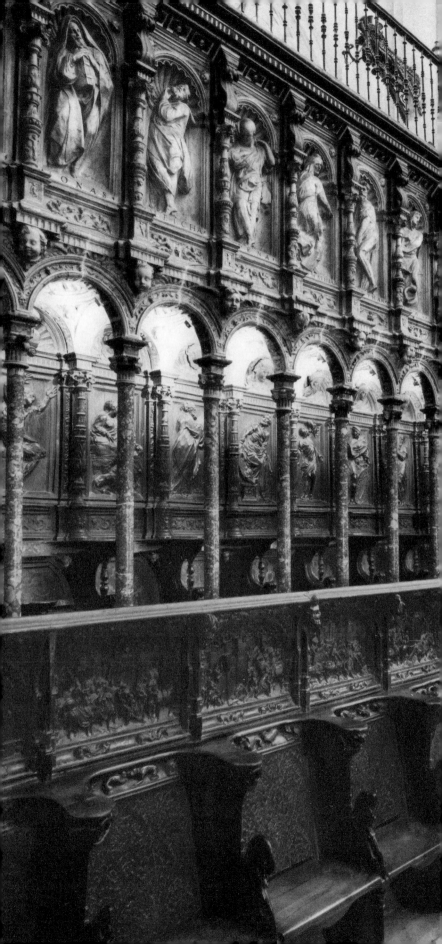

to it that the dignity of the institutions he represented was given its proper lustre. He is responsible for the Mozárabic chapel and the chapter house in Toledo Cathedral, while in the city itself he founded and endowed in 1514 the monastery of San Juan de la Penitencia in some of the houses belonging to the ancient Pantoja family. This monastery was one of the many marvels among the religious institutions of Toledo, but unfortunately it was destroyed during the Civil War in 1936. From 1518 to 1521 a Flemish noble, Guillaume de Croy, nephew of the Lord of Chievres, the favourite of Charles V, held the title of Archbishop of Toledo, but he died at the age of twenty-three without having ever set foot in Spain. The first steps of the new king and future emperor of Germany were guided, with evident disdain for his subjects, by his Flemish advisers, who were guilty of numerous such cases of exaggerated nepotism.

Later Alfonso II of Fonseca (1524-34) became archbishop. He too belonged to a family of enlightened patrons who left impressive monuments in Santiago and Salamanca, but although there are some things in Toledo to remember him by, they are not nearly as remarkable as those for which his family is renowned in other parts of the country.

Don Juan Tavera's period in office (1534-45) coincides with the most brilliant period of the Renaissance in Toledo. He was both the counsellor and intimate friend of the emperor, and he can with justice be entitled Archbishop of the Imperial City, a distinction acquired by Toledo, ancient court of the Visigoths, as centre of the Spanish Empire and seat of the Holy Roman Emperor. Cardinal Tavera enriched his cathedral with such sumptuous works of art as the Vigarny and Berruguete Choir, the interior façade of the Puerta de los Leones with its organ, and the doorway of the San Juan Chapel where he once intended to build his own tomb, which is now the treasury.

But the most important monument the cardinal left Toledo is the Convento de San Juan Bautista, well worthy of being compared with the Hospital de Santa Cruz which has already been mentioned. There in the centre of its church beneath the marble tomb carved by Berruguete—in fact one of his greatest achievements—lie the remains of the cardinal himself.

Cardinal Siliceo (1546-57), former tutor to Philip II, succeeded Tavera. Though an austere and inflexible man of a harsh disposition, he was one of the great artistic benefactors of Toledo. In the cathedral we owe to him the great screens of the high altar in the choir as well as the beautiful pulpits by Villalpando and many other richly decorated features. He founded the Colegio de Infantes with its portal by Villalpando and the Colegio de Doncellas Nobles, where he is buried. This distinguished series of great prelates who contributed so much to Toledo's elevation to the position of capital of an empire was at last interrupted when Bartholomeo de Carranza (1568-76) was tried by the Inquisition in the same year as he took office, and spent the next sixteen years in its prisons. He died in Rome and was buried in the convent of S. Maria sopra Minerva.

During the emperor's reign a great many magnificent works were executed, among them the restoration and renovation of the Alcázar and the Triumphal Gate, or Puerta Nueva de Bisagra, to both of which the brilliant architect and sculptor Alonso de Covarrubias

◁
Toledo Cathedral, choir stalls,
carved by Berruguete, c. 1540.

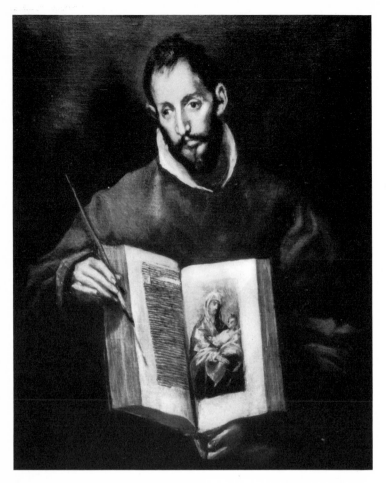

St Luke the Apostle, c. *1590, by El Greco,*
in the sacristy of Toledo Cathedral.

▷
St Joseph with the Christ Child, c. *1597,*
by El Greco, Museo de Santa Cruz, Toledo.

contributed. With all this the rank of Imperial City, which was and remains such a source of pride to the city of Toledo, was confirmed in monumental form. But even though constant change is no more than men can expect, fate seems to have mocked Toledo, in that reaching the summit and beginning to decline followed each other so closely. The city had hardly begun to enjoy the privileges of high rank when it found itself suddenly stripped of everything and summarily demoted from the status of capital of the nation, the title transferred to the neighbouring town of Madrid on the orders of Philip II.

In this most crucial of moments in the life of Toledo, when the city still enjoyed great splendour but was suffering the cruel disdain of its master Philip, a strange character came to knock at its gates. He was a painter recently arrived from Italy, but born in distant Crete. El Greco must have reached Toledo in 1576 and from then onwards was so closely identified with the city that El Greco cannot be understood without Toledo, nor Toledo without El Greco. Why and in what

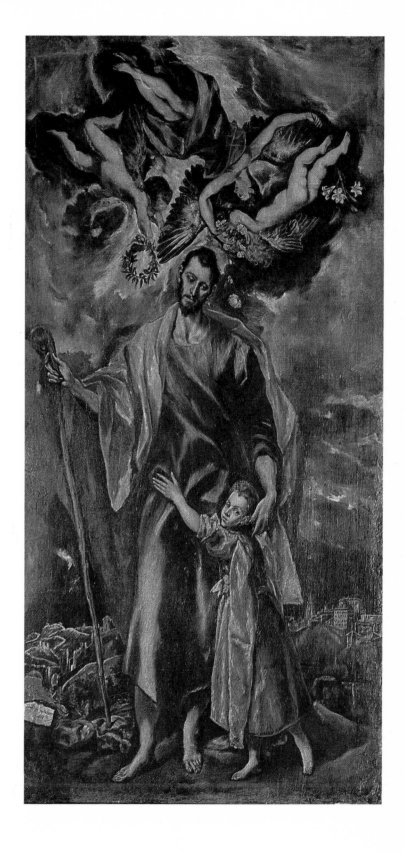

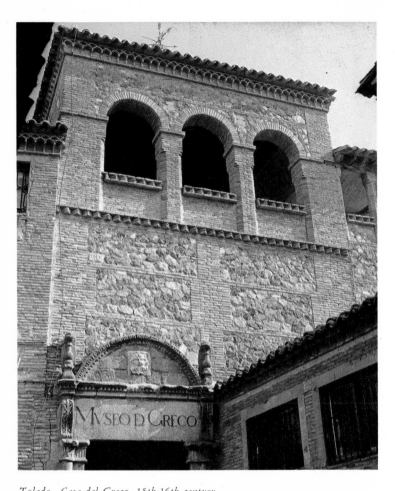

Toledo. Casa del Greco, 15th-16th century.

▷

Toledo. The Convento de Santo Tomé, with a Mudéjar tower.

circumstances the painter arrived at the Imperial City has always been and still is a mystery. Probably the young Cretan came because he was attracted by the possible commissions that might be offered on the vast project of the Escorial. It is a fairly commonly held opinion that the painter and Philip II were not in sympathy with each other, though some people, like the art historian Francisco Javier Sánchez Cantón for instance, maintain that no such disagreement or coldness existed. There is little doubt however that even if the king did not actually reject him, he certainly showed no great enthusiasm for him. All the same an interesting commission seems to have cropped up, namely painting eight canvases for the monastery of San Domingo el Antiguo in Toledo. The contract documents bear the dates of 8 and 9 August 1577, but they seem to suggest that the painter had visited the city previously. The fact is that he settled permanently in Toledo and lived there till the end of his days, married, and had a son who followed in his footsteps. From 1585 until his death on 7 April 1614 he lived in one of the houses belonging to the Marquis of Villena, next to what is now called 'Casa del Greco', one of the most popular places to visit in the town, sacred ground for lovers of art. And in spite of having been tragically

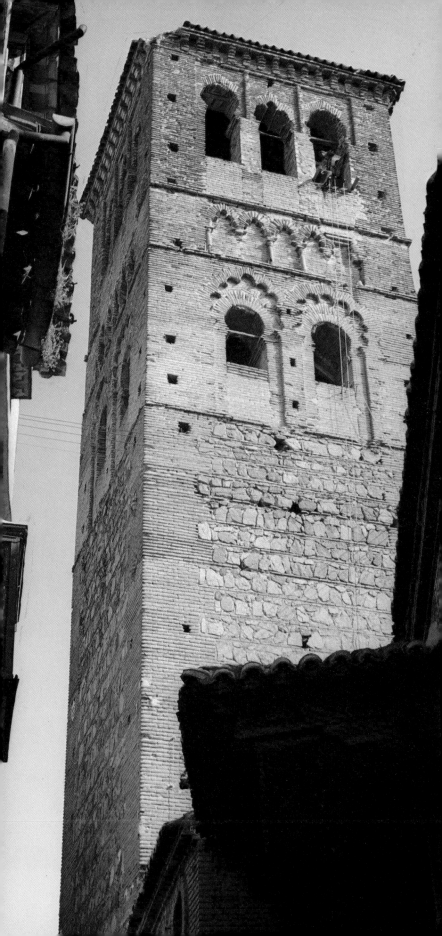

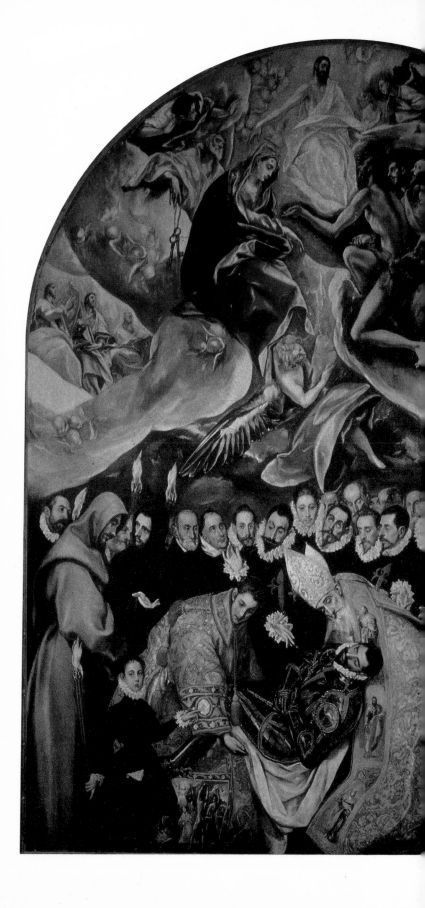

El Greco
Burial of the Count of Orgaz, *1586,*
depicting the legend of Gonzalo
Ruiz de Toledo's interment with
his patron saints, Augustine and
Stephen, bearing the body.
Convento de Santo Tomé, Toledo.

plundered, Toledo is still an unparalleled museum of his works. The best paintings are to be found in the Convento de Santo Tomé (*Burial of the Count of Orgaz*) in the cathedral, in San Domingo el Antiguo, in the chapel of S. José, in the Museo de Santa Cruz and in the Casa del Greco.

Toledo from the Cigarreles. *In the centre, the cathedral's spire, the towers of the Alcázar and the cupola of San Juan Bautista can be seen.*

During the painter's lifetime the city was entering upon a period of melancholy and decay, having lost the brilliance of the court and the bustle of activity that accompanies public affairs, while it was gradually retreating into the passive silence of the fatalist—again rather an eastern characteristic. Those noblemen of lean and haggard countenance,

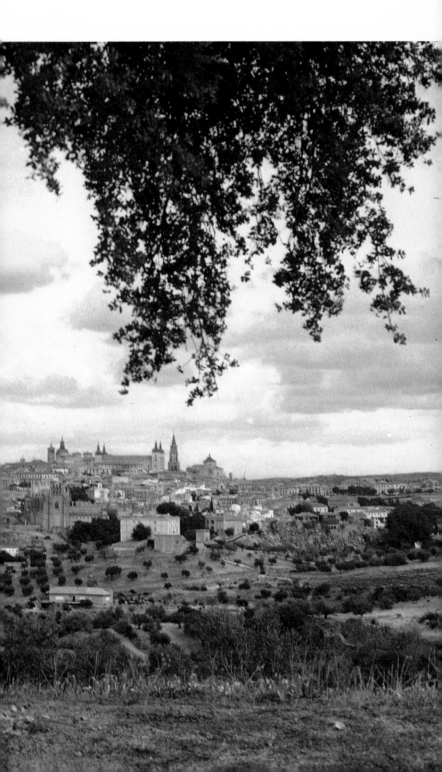

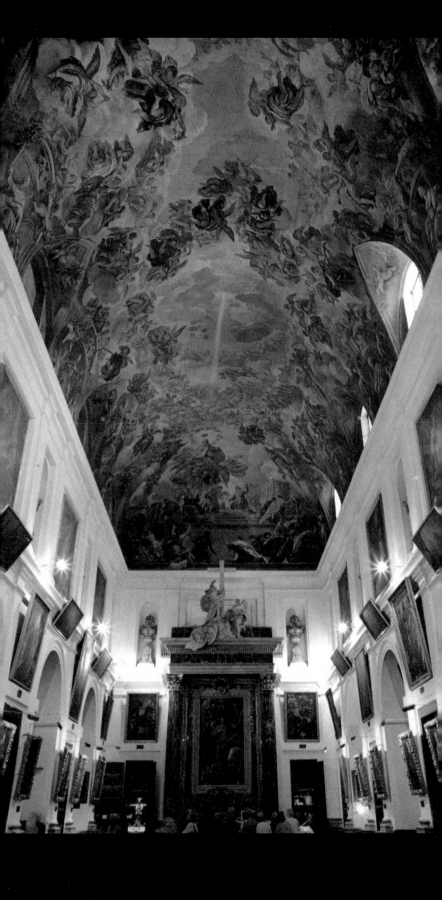

whose liquid imploring eyes gaze into space beyond the bounds of this earth, must surely have lived an uneventful and introverted life which little by little ate away at their very existence as they watched the gradual disintegration of their society. For El Greco these were his best models, and for us his canvases are the best picture of that society. Everything seemed to be dying in Toledo, just as it was in the souls of those disenchanted beings. Odd though it be, it is in a sense logical that the city which Philip II had abandoned found itself again in the person of the painter who had after all also been rejected and had failed to get any important official commissions. A common destiny was to unite them.

Why did Philip II give up a capital which seemed only to be gaining steadily in status during his father's reign? There are and always will be many versions of this event that was to have such decisive consequences, not least for the two cities concerned, so closely related in their origin and so close to each other in their situation that their histories have been constantly intermingled. For many centuries Madrid was but a modest appendage of Toledo; now their positions are reversed but they are both dependent on each other. It is often said that the excessive power of the archbishop in Toledo hindered the smooth functioning of the civil organization, which had been virtually taken over by the clergy. Cardinal Cisneros himself gives us a clue to this in his strange split personality. While in office as archbishop and primate of the Spanish church his seat was in Toledo, yet when, as regent, he was involved in dealings of a political nature his own town seemed to inhibit and restrict him and he sought out the less restrictive atmosphere of Madrid. One of the chaplains of the Capilla de los Reyes Nuevos in Toledo Cathedral wrote in 1674, when the city's decline was already inevitable, that Emperor Charles V, not wishing to cast his own shadow over the primate and city council, dutifully transferred himself to Madrid, like Constantine when he left Rome in favour of Constantinople. But there is no doubt that the one who came to feel most strongly the pressure of the religious atmosphere in Toledo was Philip II, a king who conceived of the monarchy as an almost sacred institution and saw the state as a theocracy in which he held the position of supreme priest. Hence he was not inclined to put up with the close presence of an ecclesiastical hierarchy and preferred to govern independently from Madrid, nourishing his utopian dreams of being a *Rex Sacerdos* in the rocky landscape of the Escorial (see p. 220).

There are abundant other reasons of a more practical nature to justify the transfer of the capital; the complicated and cramping street-plan of Toledo, the difficulty of suburbs growing up on the cliff site, the impossibility of any extension on the steep headland and the absence of any further space for the new buildings needed by the bureaucratic apparatus of a modern capital. Then there was the enormous problem of providing an adequate water supply, since the Roman aqueducts and the water-pipes had been destroyed and only a partial solution had been found through an ingenious device, a hydraulic machine for carrying water up from the Tagus to the Alcázar, cleverly constructed by the famous watchmaker to the emperor, Juanelo Turriano. Each house of any standing in Toledo had its own large underground

◁
Toledo Cathedral, the sacristy, 1600-20.
The ceiling is by Luca Giordano.
In the background, El Greco's Espolio (Christ Despoiled).

water tanks for collecting rainwater, but the water shortage must still have been serious, whereas Madrid had the advantage of natural reservoirs of underground water which were ample and convenient for the needs of those ways. All this and the royal hunting grounds surrounding Madrid, the Casa de Campo and the Monte del Pardo, increasingly attracted the kings from Toledo to the still modest small town on the Manzanares river, which almost without warning found itself transformed into the capital of the world's greatest empire at that time.

The higher Madrid rose, the lower Toledo sank, as if the young town, leech-like, was sapping its life-blood and energy. The long and lamentable period of Toledo's decadence ran parallel with the disintegration of the empire and seems all the more regrettable for being destined never to know the period of revival that occurred in the eighteenth century and other more recent periods of renewed prosperity. It is only today that the stricken city has recovered, thanks to tourism, improved communications with Madrid, and the growing desire of townspeople to escape from city life and look for peace and quiet. Admittedly Toledo still bears the unhealed scars of wounds inflicted by despair and centuries of neglect; there are still men and women in Toledo who dream idle dreams, as the writer Juan Benet puts it, in the midst of a hive of industrial activity and amongst blocks of low-cost housing. Let us hope that Toledo may one day return to the richer, fuller life of past times without losing the legacy of history which makes the city such a centre of attraction to the artistic and cultured world.

From the middle of the seventeenth century onwards Toledo's history

Toledo. Plaza de San Domingo el Real, atrium of the church, 16th-century Renaissance, and belfry of the Convento de los Carmelitas, 15th-century Mudéjar.

is a sad tale of protracted decay. Only the vigorous Jesuit Order showed the spirit to accomplish work of any boldness, which they did in building the monastery of San Ildefonso with its monumental Baroque church. After the beginning of the eighteenth century the bishops of Toledo began again to feel the urge to express themselves and give their names to impressive buildings or public works. One of these was Don Diego Astorga y Céspedes who was responsible for the famous *Transparente* in the cathedral, a work of art which earns Toledo an undisputable place in the history of Baroque art (see p. 142); another was Don Francisco Lorenzana, a characteristic example of the enlightened mind of the last days of the eighteenth century. To his zeal we owe the building of the university on the site formerly occupied by the House of the Inquisition—the idea of enlightenment obliterating obscurantism must have warmed the good prelate's heart—and the insane asylum, the old Hospital del Nuncio where El Greco may have found the models for some of his apostles. He also built the Puerta Llana in the cathedral and a number of other works combining useful-ness with elegance. Cardinal Lorenzana's architect was a pupil of Sabatini, the great architect of Charles III who did so much for Madrid, by name Ignacio Haan. He left to Toledo a few touches of the neo-classical style which, though excellent in themselves, clash rather sharply with the medieval and essentially Hispano-Moorish character of the city. Consequently Lorenzana, though he earned a place in religious and cultural history (his great library is still preserved in To-ledo), has not gained unanimous praise among critics of architecture. During the Romantic Period Toledo simply dozed, inactive and

◁
The remains of an Arab palace in the Plazuela del Seco, 10th-11th century.

51

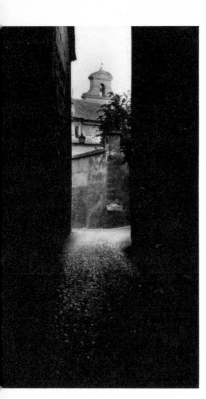

Toledo. The roof of San Domingo
el Real and the belfry of the
Convento de los Carmelitas.

▷
Callejón de Santa Isabel with
the belfry of the convent
in the distance.

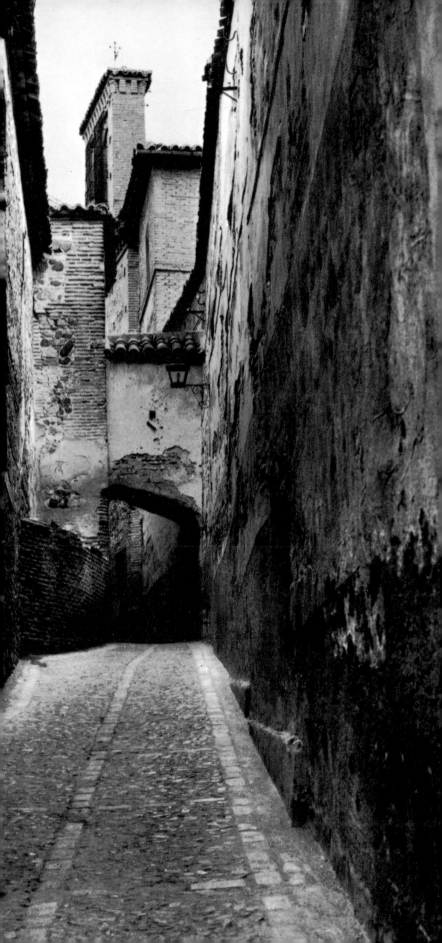

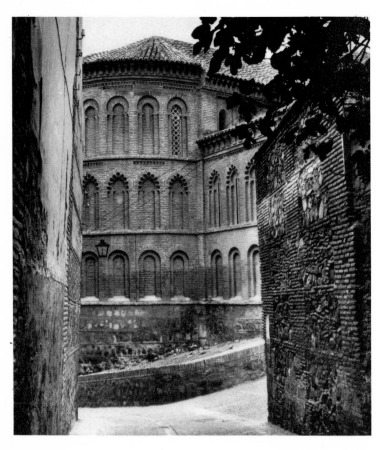

Toledo. The church of San Bartolomé, the 13th-century apse with the blind arcades, of red brick, a typical feature of the period.

The Zocodover, ancient market-place or Soukh, now the main square in Toledo. It was renovated in the 16th century.

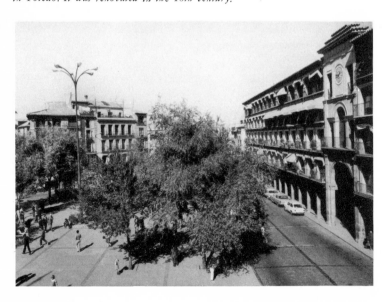

enfeebled, a moribund wreck of an imperial past, warming its old bones on its rocky site which by now had really become its funeral pyre. But poets, painters and engravers made their pilgrimage to the city and its relics with growing enthusiasm. Duque de Rivas, Zorilla and Becquer all set some of their most charming tales in Toledo. The square before San Domingo el Real is still suffused with the atmosphere typical of Becquer, and there is a stone inscription which is dedicated to his memory. A visit to the square at night is warmly recommended; one passes through covered passageways and winding alleys faintly lit by the flickering light of a lamp illuminating some holy image, and it is one of the most romantic settings one can find. The great painter and engraver of the Spanish romantic period, Jenaro Pérez Villamil, has also left us a picture of nineteenth-century Toledo through his many paintings, engravings and lithographs. Historians and archaeologists too have been active; to name but a few, José and Rodrigo Amador de los Ríos, Sixto Ramón Parro, Ramírez de Arellano and others have all contributed to the study of the city's past. Benito Pérez Galdós, the great nineteenth-century novelist, is another of those eminent men who have felt the call of Toledo. Navarro Ledesma, Ortega Munilla, Manuel Bartolomé Cossío, the best critic and biographer of El Greco, Felix Urabayen, Dr Marañón and the film director Luis Buñuel have all shown how Toledo has never ceased to stimulate the interest of Spain's intellectuals and artists.

Moslem Toledo

In the brief history of Toledo we have mentioned the city's Roman and Visigothic past but indicated that the scanty remains of those distant periods mean more to the archaeologist or specialist than to the casual visitor or amateur art lover on the lookout for aesthetic experiences. The first monuments with the added interest of being works of art rather than just historical relics are those of the Moslem period, but it must be emphasized first of all that over and above the individual monuments the most typically Moslem thing remaining in Toledo is the town itself.

Of all Spanish cities Toledo is perhaps the one that has best kept the original Moslem lay-out, one of the reasons being that the complex nature of its topography made any change or any attempt at regularization extremely difficult. As the archaeologist Leopoldo Torres Balbás put it 'the sharp relief of the terrain in Toledo and the deep foundations and cellars of many of its buildings made it necessary for the streets to follow the same pattern throughout the centuries even more consistently than in other places.'

Normally Hispano-Moorish cities were made up of a central nucleus almost always surrounded by a wall and called the *madina*, or in Spanish *medina*. The *medina* in Toledo coincides with the perimeter of the rock or hill which rises above the extensive lowlands, surrounded on almost three sides by the Tagus. Within the *medina* stood the Great Mosque, the main market square where the principal trade was carried on, the various corn exchanges serving both as granaries and inns for the merchants, the baths and several smaller markets. Thus the *medina* was the focal point of the religious and commercial life of the town, the part where there was the most bustle and movement. The Great Mosque occupied the site where the cathedral now stands and around it must have spread the main commercial area, for obviously merchants would look for the most frequented spots to set out their merchandise.

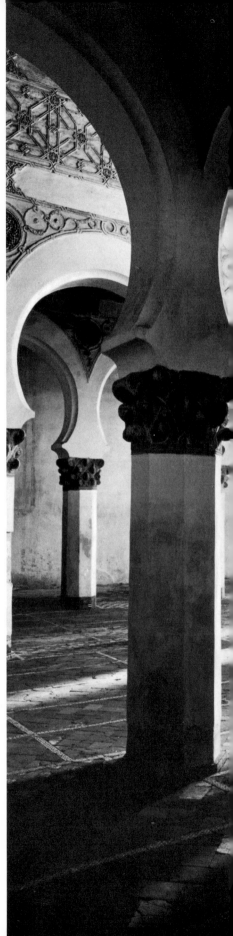

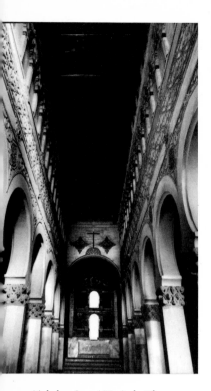

Toledo. Santa María la Blanca,
the nave, and (right) the interior
with characteristic Mudéjar arches.

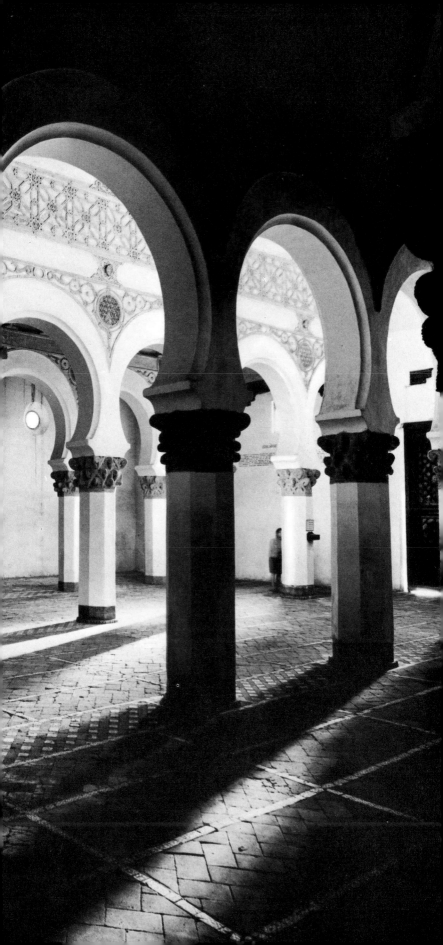

It is still the same today—the streets leading to the cathedral are the busiest shopping area. Behind the cathedral still exists the old Plaza Mayor, the main square, though reduced in size, since some of it was taken up by the Teatro de Rojas and the modern market.

The room for movement and the open spaces that were lacking inside the walled enclosures of these Hispano-Moorish towns were often provided by the paved courtyards of the mosques, especially during the hours between services. So the old main square was probably not very big—through being away from the centre of the town the so-called Plaza del Zocodover was probably more extensive.

Zocodover is an Arab name derived from the word meaning cattle market, and it was obviously sensible to locate this near one of the entry gates so that the animals did not have to be brought into the town centre. The gate named Arco de la Sangre or Arch of Blood leads from the *medina* to the low-lying Alficén or Al-Hisén quarter, which it was intended to defend, and which overlooked the Puente de Alcántara. Today, Plaza del Zocodover is the centre of life in Toledo, the meeting place of the little provincial capital, where in fine weather the crowded cafe terraces spread out their tables in the open air, catering for a lively gathering of local people and numerous tourists. But the situation of this square near the periphery of the city reveals its original function.

The lack of any ample open spaces in these Hispano-Moorish towns is compensated for by a multitude of little openings and angles formed by the bend of a street or the meeting of two or three of them. Toledo is a perfect example of this and one of the things which makes strolling through the town so rewarding is the way one comes across these picturesque and charming little corners where streets unexpectedly widen into a small square or cross-roads.

Apart from the *medina* or centre, a series of suburbs called *arrabales*, a Spanish name coming from the Arab *rabad*, attached themselves to the cities as they developed. These satellite developments grew up outside the city walls but depended on the central enclosure and often clung to its gates. Thus in Toledo there exists the Santiago quarter and beyond it the Antequeruela quarter, spread out over the low-lying area north of the old built-up promontory on the only side where there was a smooth and easy access to it. Once they had grown up these suburbs were in turn fortified by walls which were incorporated into those of the main city. The Hispano-Moorish cities and their suburbs were a veritable mosaic of small separate quarters, some of them so small they consisted only of a single street, in which lived the natives of a certain region, the members of a group of families or the craftsmen of one trade. On top of this—given the complicated ethnological composition of such cities—came the grouping of the population by race or religion, according to whether they were Jews, Mozárabs (Moslemized Christians), Franks and so on.

In Toledo, where there was an enormous mixture of races all living together, there were no clear separations and no ghettoes as in other cities—they all lived cheek by jowl with each other. Nevertheless the main Jewish quarter lay in the western part of the city, centring on the present Calle Santo Tomé and Calle del Angel. The two famous synagogues, the one called 'del Tránsito', next to the Casa del Greco,

▷

Toledo. The church of San Román, with a Mudéjar tower, 12th-13th century.

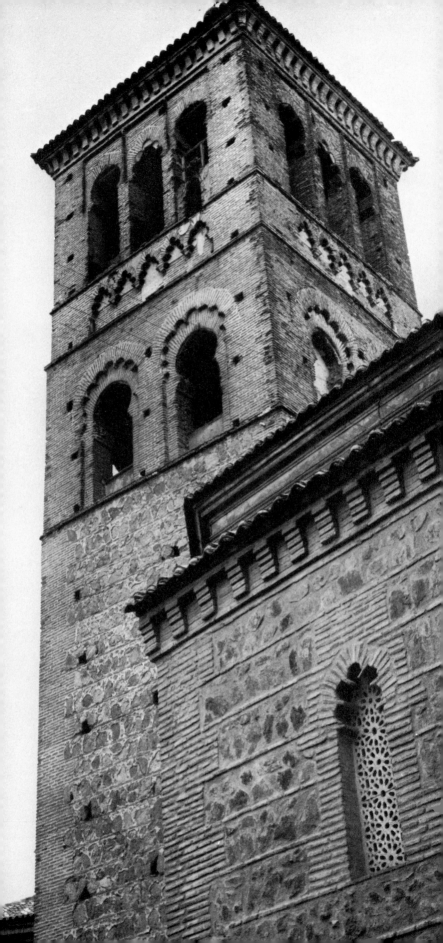

and the Santa Maria la Blanca, were situated in this quarter, which still contains streets named 'Calle de la Judería' and 'Travesía del Judío'.

The Calle de las Tornerías in the commercial centre of the town used to be called Calle de Francos, the best evidence that in the Middle Ages a group of merchants coming, as was often the case, from beyond the Pyrenees had settled there. The Mozárab population was so numerous that it spread all over the city, as shown by its ancient parish churches —San Lucas, San Sebastián, San Torcuato (disappeared), Santa Eulalia, San Marcos and SS. Justa y Rufina.

The strange way the streets run in Toledo gives an odd character to the city; they doubtless follow the same course as in the old Arab street plan. Some of them are more important than others because they link two or more principal points in the town or lead to the busiest gates of the city, but they are no wider than the rest in spite of it; and even these busy streets are just as winding and full of sharp corners as the minor ones. Many of them even turn on their own course and run parallel with themselves. The result is that no line of sight extends for more than a few yards, and the city seems concentrated and self-centred. At these sharp corners one often finds doors located to give a good view, with small windows or gazebos above them from which one can observe the street without being seen.

From these streets secondary ones, if possible narrower and still more winding, lead off and in turn many tiny blind alleys lead off from them. These are called 'darb' and some of them were closed at night by a door as protection and to ensure the tranquillity of the little community. One can still see traces of the hinges of some of these doors. These little cul-de-sacs lead into the very heart of the blocks of houses to give access to the dwellings, forming a veritable labyrinth like the veins in the human body.

Another feature often found in Arab cities, and Toledo is no exception, is the way many of its alleys are covered over, thus turning the streets into virtual tunnels. This is for the most part due to the irregular lay-out of privately-owned ground and the lack of space among the crowded buildings. In some cases it is just a matter of a gangway joining the upper parts of the houses, but in other cases one finds whole rooms straddling the street. After the reconquest the height of these passages was raised and the regulations in Toledo stipulated that builders constructing edifices over the streets, which are called 'covered passages', should do so at a height sufficient to allow an armed and mounted horseman to pass beneath them unhindered. There are quite a few of these left in Toledo and at night they create a mysterious secretive atmosphere. On the way down through Calle de Santa Clara, then turning left down Calle San Domingo leading into the little square with the convent of the same name, one walks through several of these covered passages.

In short, the city continues to preserve intact the oriental feeling which stems from a structure virtually unaltered by the passing of time. An intriguing example is the way the enclosed wooden balconies, which existed all over the town during the nineteenth century and could therefore be called a modern feature, developed from the tradition of the Moorish windows with latticed wooden shutters enabling one

▷

Toledo. Cuesta de San Justo; in the distance, the church of San Justo which has an old Mudéjar tower with 18th-century Baroque alterations.

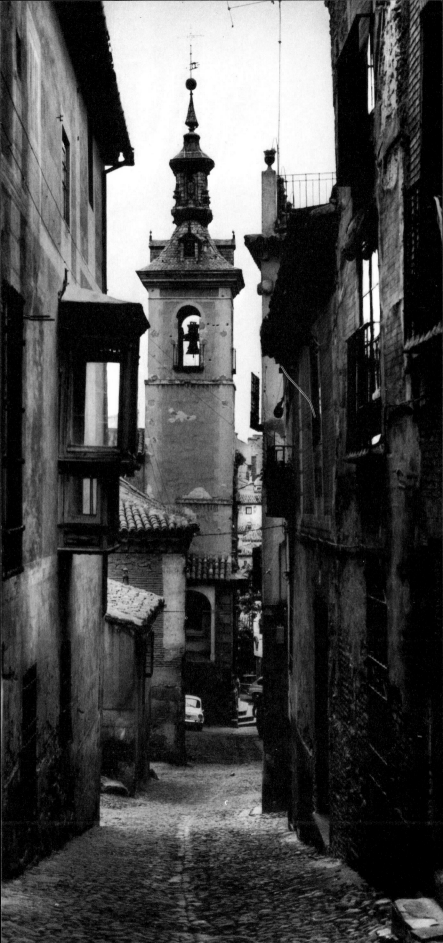

to peer discreetly into the street without being seen, which are still found in eastern cities, though in Cairo they are steadily disappearing.

The system of fortifications in Toledo is extremely complex, both in its topography and its chronology, and through the series of successive enclosures round the *medina* and the *arrabales*. It includes some of the major works of the Moslem period. Roman and Visigoth antecedents and the wall attributed to King Wamba have already been mentioned, so too has the oldest remaining stretch between the Puerta de Doce Cantos and the Puerta de Alcántara. In the description of the fortifications from the Puerta de Alcántara onwards, which now follows, it will perhaps be clearer if comments on the Moorish sections are immediately followed by references to later additions made during the Mudéjar and Renaissance periods.

A few yards from the Puerta de Alcántara the fortifications end abruptly, and there lies a rebuilt extension of the Paseo del Miradero, like a large balcony overlooking the lowlands. Further to the west they appear again in the shape of a handsome curtain wall following the line of the Calle de Carretas, called Muro del Azor. Here there are two gate-towers and one of the old entrance gates to the *medina*. The first tower, moving from east to west, is called Torre de Alarcón, while the second is the famous Puerta del Sol, one of the best examples of military art in Toledo. It is an advanced bastion which stands in a prominent position, perpendicular to the city wall, and an opening in its lower part enables traffic to pass through. It may originally have been built as a square tower, and had a further round tower added on at a later date, with an arch over the passage between them. The lower half probably dates from the twelfth century, though some historians think that it could have been started during the last years of the Moslem period when invasion by the Christians was becoming an increasingly disturbing threat. The lower body of the tower consists of carved stone and masonry with both horseshoe and pointed arches, while over this rises another lighter section which is a masterpiece of elegant brickwork in the Mudéjar style. It is crowned with battlements and projecting machicolation and probably dates from the fourteenth century, the apogee of Mudéjar art. The builders were the religious warriors of the Hospital, the Knights of the Order of St John of Jerusalem, who received from Alfonso VIII the ancient hermitage of Cristo de la Luz situated near the Puerta del Sol.

A little further along the city wall one comes across another gate whose history is really more interesting than its architectural features. It is the one commonly called Puerta de Valmardón from the Arabic *Bab-el-Mardon*, meaning Gate of Mardon. The Puerta de Valmardón leads from the outer enclosure to the *medina*. According to legend, when Alfonso VI conquered Toledo he entered the first enclosure by the Puerta Vieja de Bisagra and then came through this Valmardón Gate into the second, where he attended the first thanksgiving mass in what was then a mosque but is now the Convento de Cristo de la Luz. Accompanying the king were the hero El Cid and the Abbot of Sahagún, the French monk Bernard de Sedirac, who later became first archbishop of reconquered Toledo.

From the Puerta de Valmardón towards the west the city wall loses much of its impressiveness, hidden by convent gardens and desecrated

▷

Toledo. Puerta de Alcántara, with the characteristic Moslem doorway.

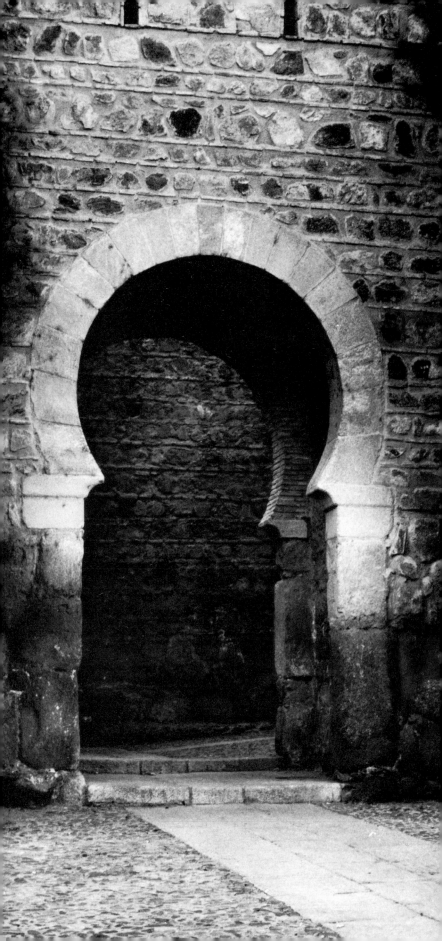

by modern buildings. But the fortifications continue to the Hospital de Dementes, known as El Nuncio, where they join the outer city walls and continue as one. Another long stretch can be seen and followed easily past several towers though various low shacks partly hide it, until it comes to an end with the Puerta del Cambrón.

The Puerta del Cambrón, although it does not look it, especially with the pretty but deceptive appearance it acquired in the reconstruction of 1576 during the reign of Philip II, actually dates back to the Visigoth period, and must have existed at least since the reign of Wamba, who has always enjoyed a grateful and respected memory in Toledo. Gutiérrez Tello, the mayor at the time of Philip II, engraved here and on the Puerta Nueva de Bisagra an inscription in honour of the Visigoth king bearing the words: EREXIT FACTORE DEO, REX INCLITUS, URBEM WAMBA. José Amador de los Ríos in his book *Toledo Pintoresca* complained bitterly and with some justification of Gutiérrez Tello's vandalism in destroying the Arabic inscriptions on the gates and bridges of Toledo which were of such historical value, and substituting Christian ones which contributed nothing to knowledge of the past. Nevertheless by some chance one can still see on the Puerta del Cambrón and on the shaft of one of the columns supporting the outer arch the following very faint inscriptions: 'God is great: I acknowledge that there is no other God but God: I acknowledge that Mohammed is the apostle of God: God is our helper.'

The original Visigothic gate must have been greatly altered by the Moors and the form they gave it must have lasted till the reign of Philip II. From the Arab period, as well as a few fragments such as the columns already mentioned, must come its design in the shape of double gates with a central courtyard. Philip II's reconstruction superimposed on this original structure the present edifice, which takes the form of a small castellated building with four towers and modest roofs in the style of the period.

On this side of the wall there must have been extensive thickets of thorns and brambles (*cambroneras*) which gave the gate its popular name. From there onwards the ramparts continue, with the exception of a few breaks, round the San Martín quarter until they merge with the bridge of the same name. At the point where it turns to descend to the river it forms an angle with an enclosed area which is protected by round watch towers built to guard the access to the river. Tradition has it that it already existed in the eleventh century. Close to this spot, at the very edge of the water, stands the ruined tower known by the romantic name of Baño de la Cava, since it was the bathing place of the lovely Florinda de la Cava, mistress of Don Rodrigo, the last king of Gothic times.

This Mudéjar tower with two Arab columns incorporated into one of its arches is nothing but the fortified head of an old bridge which once existed here, having possibly started life as a bridge of boats, and was destroyed by the floods of 1203. Between the Puente de San Martín on the west and the Puerta de Doce Cantos to the east, the gorge of the Tagus is a far better natural defence than any that man could have devised and constructed. But walls were built here all the same, though they were never on the same scale as elsewhere, and some fragments still remain. One can still see some ruined towers and a few stretches of ramparts that have not been covered up by the embankments, the most clearly defined being next to the church of San Sebastián.

So much for the main enclosure; now for the ramparts running around the suburbs. Contrary to what might be expected, these are just as

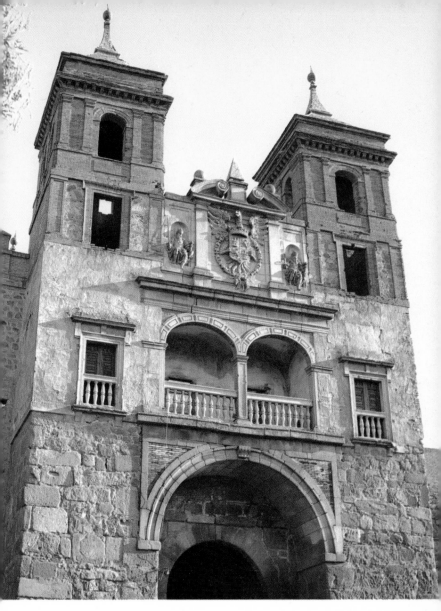

Toledo. Puerta del Cambrón, façade, which was rebuilt in the time of Philip II.

important as the former—and for the most part better preserved. At the point where the eighteenth-century Nuncio building stands, the second rampart begins and runs parallel with the first for a long stretch. It has been recently cleared and can be seen from the Paseo de Recadero and its gardens. There are several curves in the rampart along this stretch, encircling the suburb of Santiago, and in one of these stands a gate which is nowadays considered one of the most noteworthy of its period through having maintained its Arab appearance virtually intact, which is rarely the case with other gates. This is the Puerta Vieja de Bisagra, which is of Moorish origin with a few features borrowed from an earlier style. Like all the gates in Toledo, the oldest as well as the later ones, it has a straight narrow entrance, something which distinguishes the from other Arab gates, particularly those of the Almohade and Nazarí periods, which have bends and double bends to make them easier to defend. The straight Toledo gates are double, being composed of an inner and an outer door, and are set under arches which are

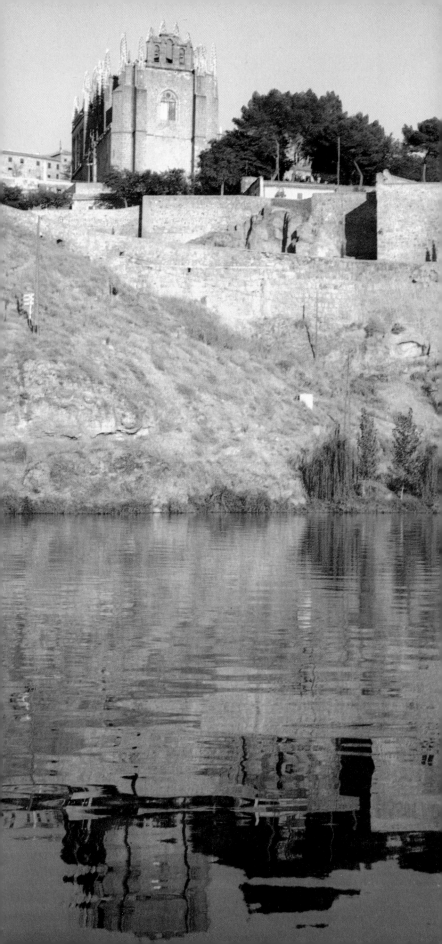

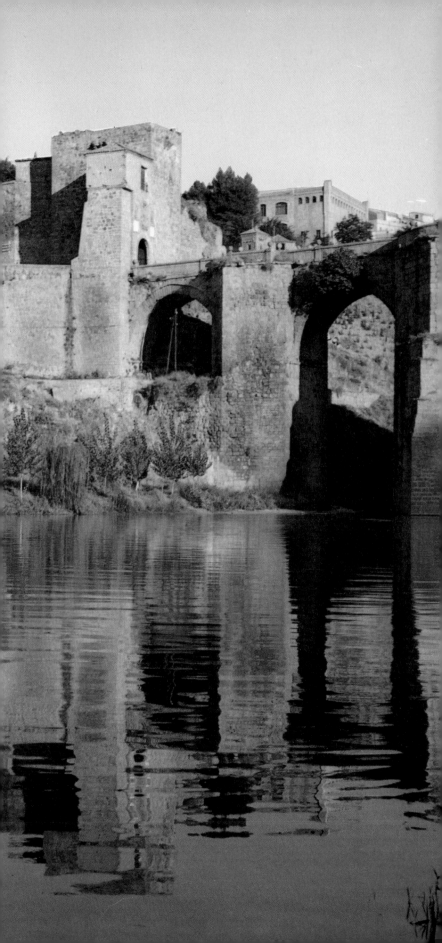

P. 66/67
Toledo. Puente de San Martín,
and the Convento de
San Juan de los Reyes.

▷

Puente de Alcantára,
the oldest bridge in Toledo.
Originally Roman, it was
destroyed by Mohammed I in
854 and has since been several
times rebuilt. On the right, with
the castle of San Servando,
and on pp. 70-71.

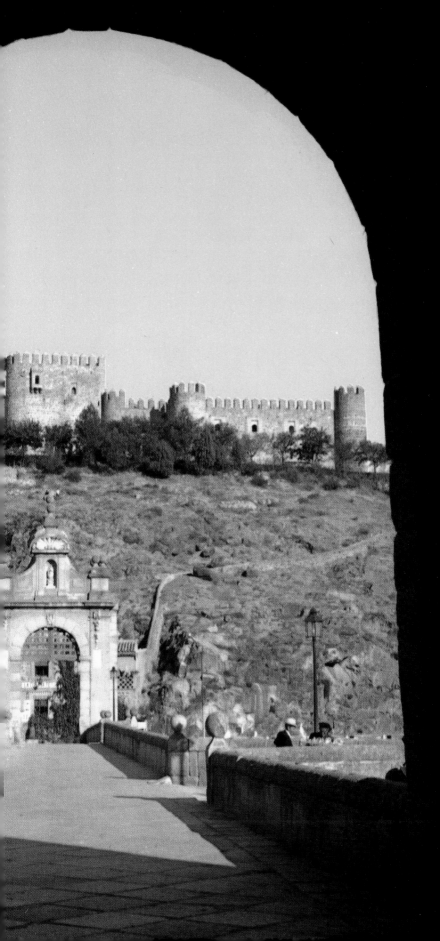

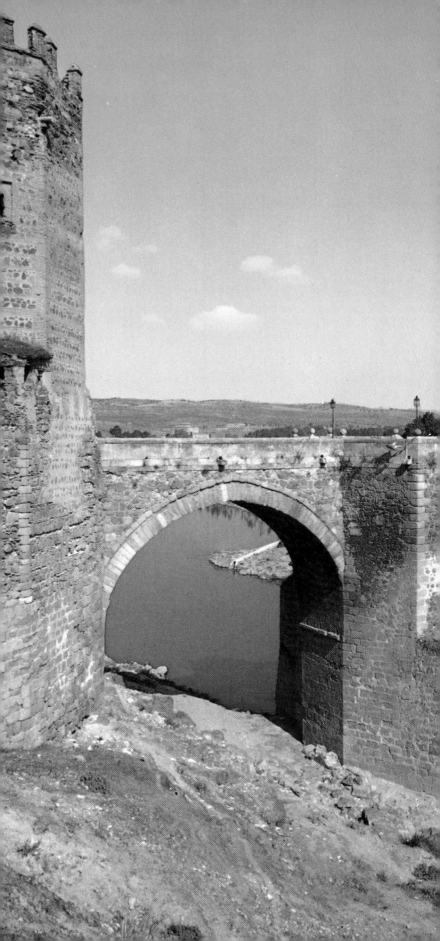

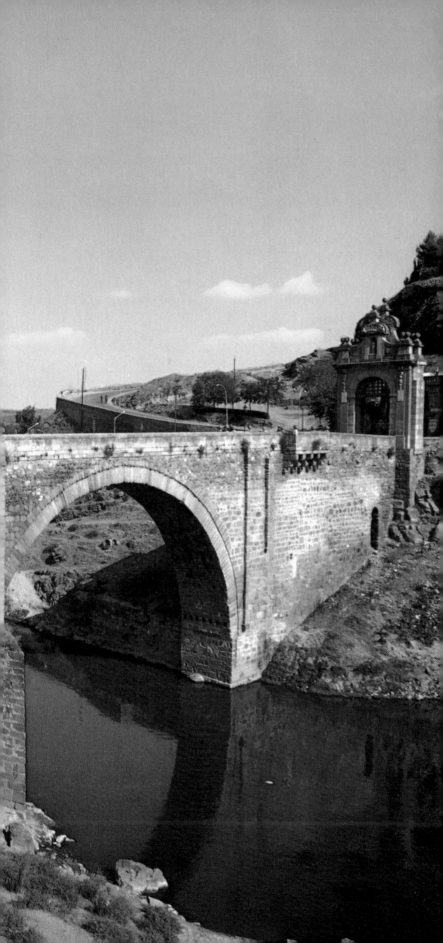

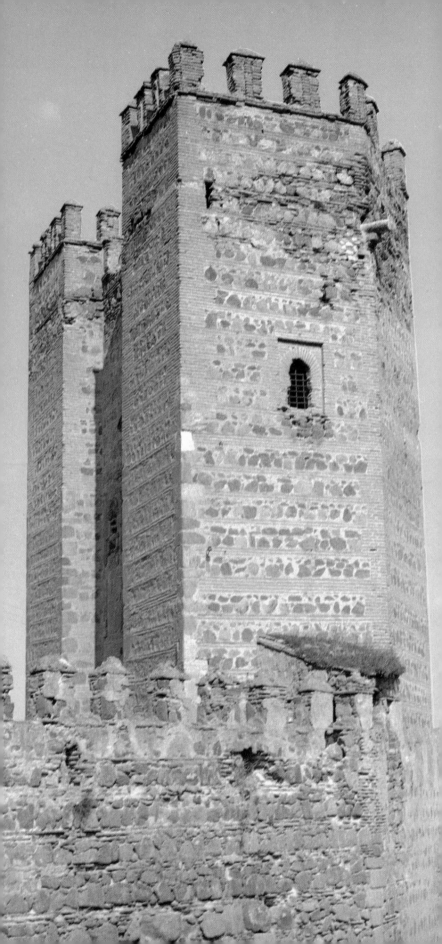

constructed so as to accommodate the span of the gates when they are open. Between the two gates is the portcullis which, when lowered between the to neighbouring arches, fits into the ground and forms a formidable obstacle to attack.

The lower part consists of a great horseshoe arch placed between two blind pointed arches, a composition that has a distinctly oriental flavour about it. Behind the central arch opens the minor arch of the first door, also horseshoe-shaped, with a stone lintel which is set in at the level of the springers of the arch. The clasp of the arch above the lintel is now missing. This combination of arch and lintel is a characteristic feature of the mosque in Córdoba and of the works executed during the period of the Caliphate. The upper part of the construction with its small square windows and its crown of battlements is of the Hispano-Moorish period. Continuing along the fortifications, one comes to-the Puerta Nueva de Bisagra, which was the main entrance to the city in the Renaissance and still is. Its origins however go back much further, for it has been identified with the *Bib-Athifafelin* or Puerta de los Grederos. The oldest part, that facing inwards to the city, still bears traces of the Moorish period, for instance on the lower half of the towers and in some of the horseshoe arches. In the Middle Ages it was greatly altered and it was again renovated and enriched in 1550. From that period the little turrets crowning the interior façade were covered with pointed spires made of glazed tiles. On the outer side the great Renaissance architect Alonso de Covarrubias built a beautiful triumphal arch placed between two round towers in honour of Charles V. The strictly classical gate, inspired by the work of Serlio, bears a monumental coat of arms of the emperor, the two-headed eagle with its great wings spread out.

From the Puerta Nueva de Bisagra to the east lies a long stretch of wall with several rectangular and semicircular towers surrounding the suburb of Antequeruela. Right at the end of this stretch stands the projecting Almofala Tower, which also had a gate like the Puerta del Sol whose architecture it resembles to a certain extent, though on a simpler scale. Looking towards the east one sees the so-called Puerta Nueva which is of no interest. The wall then joins with that of the main enclosure at a point below the Paseo del Miradero, level with where the Capilla de los Desamparados stands.

The two great fortified bridges and the castle of San Servando complete the elaborate and interesting system of fortifications of Toledo. The Puerta de Alcántara is the older and is situated at the point where the gorge of the Tagus begins to narrow on the eastern side. It is fairly probable that the existing bridge is the successor of an old Roman one destroyed in 854 by Mohammed I when he was besieging the rebellious citizens of Toledo. Rasis el Moro, the Spanish-Arab historian, devotes some attention to the present bridge in one of his works, describing it as a sumptuously beautiful construction, superior to any other in Spain. It was built in 866 by Halaf, son of Mahoma Alamesí, Mayor of Toledo, and it survived until the great floods of 1257 which forced Alfonso the Wise to have it completely rebuilt. A rather long-winded stone plaque which the king ordered to be put up does justice to the Arab builders and explains why the work was undertaken. This interesting record of the history of the bridge is fortunately preserved on the entrance arch on the city side

◁

Toledo. Watch tower on the Puente de Alcántara, built by Alfonso X in 1258.

of the bridge. After this, as normally happens with such public works, it underwent numerous restorations and reconstructions, all commemorated in corresponding inscriptions, the last alteration being the building of the Baroque gate at the opposite end of the bridge to the city. Unfortunately this gate, built by Philip V in 1721, replaced a fortified tower, one of the two defending the bridge. Today only one of them is left, so that the bridge has in part lost its military aspect. On the other hand the Puente de San Martín to the west still has all its military attachments including a fortified tower at each end. This superb construction consisting of five arches of varied sizes replaces an ancient bridge which stood further downstream and was destroyed in the flood of 1203. It dates back to the early years of the thirteenth century but was extensively restored in the fourteenth century by Archbishop Pedro Tenorio who found it in ruins after the fratricidal struggle between Pedro the Cruel and Henry II.

The same generous prelate, Pedro Tenorio, was responsible for the reconstruction, starting virtually afresh, of the Castillo de San Servando which had always been of immense assistance in the defence of the Puerta de Alcántara. It was originally a Moorish fortification built for this purpose and was later repaired by Alfonso VI who founded the Convento de San Servando near by. The present construction (recently restored) is typical of the Hispano-Moorish style prevalent at the time of Tenorio. It has a rectangular plan with round towers, one of which is much larger than the others and has machicolations and presents an imposing silhouette from a distance.

Contrary to what might be expected, there are only a few Arab monuments in Toledo in spite of the predominantly Moorish character of the town as one sees it and of the wealth of evidence that has just been described in dealing with the fortifications. For a time, historians or archaeologists failed to distinguish clearly in an admittedly rather unclear field between strictly Moorish buildings and those which were Mudéjar or Hispano-Moorish. Toledo was conquered very early, namely in 1085, at a time when a good part of Spain

Toledo. The hermitage of Cristo de la Luz, originally the mosque of Bab-el-Mardón, built 999, one of the earliest examples of Moorish architecture in Spain. Below, the exterior, and right, the interior, with columns incorporating some old Visigothic capitals.

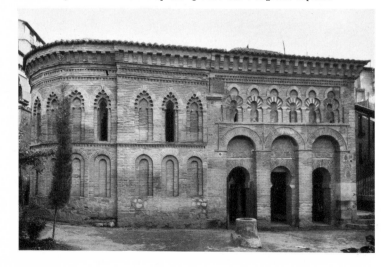

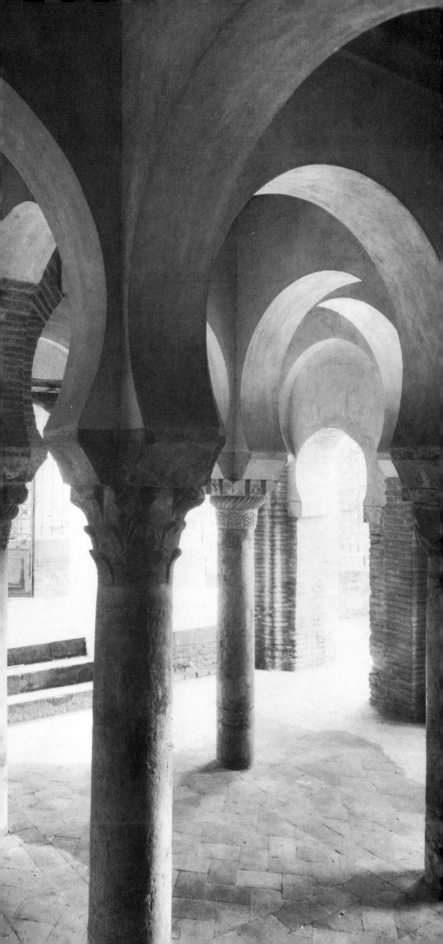

remained in the hands of the Mohammedans, thus creating a situation where the same art flourished in Christian as well as in Moslem Spain, wrought by the same hands, using the same techniques and born of the same culture. Hence the Mudéjar art of Toledo can be considered just as much a mixture of Spanish and Moorish as that which was being created before the conquest; but there are historical reasons that make a strong case for grouping them separately.

The gem of Spanish Moslem architecture in Toledo is without any doubt the hermitage of Cristo de la Luz, the ancient mosque of Bab-el-Mardón situated near the city gate of the same name which opens, as we have seen already, into the city's main enclosure. It is a diminutive shrine but architecturally very rich. This once puzzled some archaeologists, who thought it must be the remains of a larger mosque which had vanished. However, the is no evidence to support this theory nor is there anything unusual in this being its original size. Anyone who has visited Islamic cities in North Africa or in the East will know from experience that countless numbers of small shrines abound in all the little alleys of the *medinas* and that some of them, for various reasons, are much more elaborate than others. Perhaps the existence of a chapel of the Visigothic period on this same site and the proximity of an important city gate gave distinction and prestige to this shrine in spite of its minute size. An inscription in Kufic characters, skilfully carved in the brickwork on the west façade, gives the date of its completion as 999 under Musa-ben-Alí. Thus it is the oldest of all the buildings still standing in Toledo today. Its architecture is rather Byzantine in style and bears a certain resemblance to the basilica-plan churches of the Comneni. The rectangular area is divided into nine compartments by means of a network of horseshoe arches which rest either on free-standing columns or on the outer walls. It differs from Byzantine churches in that the latter usually use pillars rather than columns, but in this case the traditions of Córdoba were too strong; in addition it was common in Toledo to put Roman and Visigothic column shafts to good use. The whole architectural treatment of the interior is influenced by the mosque of Córdoba and the nine little cupolas are imitations in miniature of the cupolas of Al-Hakem. Consequently it must needs be of a later date than the last enlargement of the mosque of Córdoba (961-76), which fits in very well with its ascribed date of 999. The exterior is equally unusual and for this a new factor in Andalusian art is responsible, namely the brickwork.

The motifs of the decorative brickwork found in the Cristo de la Luz hermitage were destined to be used in Hispano-Moorish art in Toledo with hardly any variation for innumerable years to come. In short Mudéjar art in Toledo was both born and immortalized in this timeless building.

Only two of the four sides of the mosque are decorated—that is, treated as façades. The other two must have been hidden and are no more than ordinary party walls. The surrounding buildings, of course, have changed considerably, so that what was once a mass of crowded dwellings is open space today. The northern and western façades, at an angle to each other, are the decorated ones, though curiously enough they are completely different, as if they were meant to be viewed separately. It looks as though the westerly façade faced onto the street, though it may have been shut in, whereas the northerly one overlooked the courtyard or *Sahn* of the Mosque, which would be defined by fences or walls. The street façade has several

interlacing arches in brickwork and a panel above them in the shape of a frieze with commemorative inscription. The courtyard façade has one principal row of arches and a minor one of smaller horseshoe arches. It bears resemblance to the military architecture of the Puerta Vieja de Bisagra and there are grounds for thinking that decorative brickwork resulted from the use of bricks in fortifications. On the lower half of the building there is a graceful row of arches, most of

Toledo. Puerta Vieja de Bisagra, the Moorish gate through which the victorious Alfonso VI rode when he captured Toledo from the Moslems in 1085.

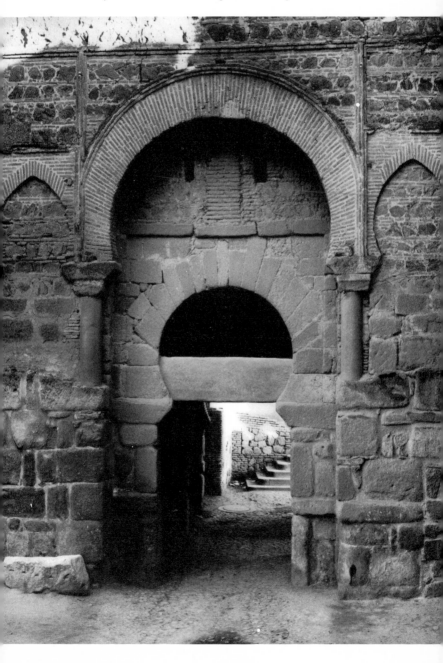

*Toledo. Entrance to the church of
San Román, Formerly the
site of a Visigothic Temple,
and later a mosque.
This building dates from 1221.*

them blind, all horseshoe arches very like those in Córdoba, bordered by more trefoil-shaped arches of brick. The whole square structure of the mosque is crowned by a projecting cornice resting on brickwork brackets, a favourite device of Hispano-Moorish buildings.

In the thirteenth century a Hispano-Moorish apse was added to this unusual building in order to accommodate Christian services, since it was here that Alfonso VI heard his first mass after entering Toledo. It remained a Christian shrine under the jurisdiction of the archbishop until 1186, when it came under the control of the Knights Hospitaller of St John, and it was they who built the apse. This is renowned for its paintings, the non-representational ones being Moslem in character and the figurative ones Romanesque. It is a tragedy that they should be in such an appalling state of preservation.

Following the completion of Cristo de la Luz the mosque called Mesquita de las Tornerías was built in the twelfth century. In 1159 the Hispano-Moorish people of Toledo lost a few of their mosques and perhaps they were allowed to build this one provided it was unobtrusively placed. Hence its situation inside a house in Calle de las Tornerías and on the first floor to boot. For a time this street was called Calle de Francos because several families of French merchants had set up business there. The ground plan of the mosque is identical to that of Cristo de la Luz—a rectangular plan with nine sections formed by four free-standing columns in the middle. The central part alone has a ribbed vault in the style of Córdoba, the others being plain.

The only thing that is left of the many mosques with parallel naves which must have existed in Toledo is a row of arches, discovered in the Iglesia del Salvador. It consists of eight graceful arches to support which the builders had made use of surviving Roman and Visigothic columns. The shaft of one of these is a Visigothic pilaster carved with biblical themes which must have belonged to the chancel of a Visigothic church previously standing on this spot. The mosque conceivably had five aisles and survived in this form until the year 1159, when it was probably converted to Christian worship.

Precious little else is left of the Moslem religious architecture and virtually nothing of their civil building. By some rare chance there remains in the former convent of the Comendadoras de Santiago, which now belongs to the Ursuline Order, a chapel called 'Capilla de Belem' with an octagonal plan and a cupola of intercrossed arches. It was most probably the shrine or private mosque of one of the palaces which existed there, where the kings of Toledo had their residence. The fifteenth-century mural paintings decorating the chapel are interesting, so too is the tomb of the Master of Santiago, Juan Pérez (d. 1280), decorated with plasterwork and motifs called 'mocarabes'. In the old parish church of San Lorenzo, destroyed during the Civil War, there still stands, though badly damaged, an Arab building of some kind hard to define. The church tower was built on top of it and no one knows whether it was the *mihrab* or prayer niche of the mosque that once stood there, or another part of it. It has a square base and a few blind trefoil arches on small columns can still be seen decorating the walls.

Very near the ruins of San Lorenzo, below the Colegio de Infantes, are the remains of some badly damaged Arab baths, hard to date on account of the lack of decorative details. Some more baths in even worse condition are to be found in the old Jewish quarter (Callejón del Angel no. 11). Unlike other Spanish towns, particularly Granada, Toledo has no noteworthy examples of this typical Arab feature.

Next to the church of San Miguel el Alto in the Plazuela del Seco there used to be two splendid palaces, belonging no doubt to high-ranking Moslem citizens, which passed after the conquest into the hands of the Knights Templar and were still being referred to as Casa de los Templarios in such old guide books as that of Sixto Ramón Parro. Now they are a crowded mass of slum dwellings, and it would need an exceptionally detailed examination to discover any traces of their former splendour. The most tangible is an archway decorated with plasterwork at the end of a courtyard as one enters from the Plazuela del Seco. The archway, the entrance to one of the main rooms, is perfectly half-round in shape and decorated exquisitely by worked plaster voussoirs alternately ornamented and plain. To judge by the style, which resembles the subtle art of the Almorávide period, this arch must date from the last years before the conquest.

In the stretch of lowland by Toledo called Huerta del Rey, a former

Toledo. The tower of the church of San Miguel (13th century), situated in the highest part of the city, next to the Alcázar.

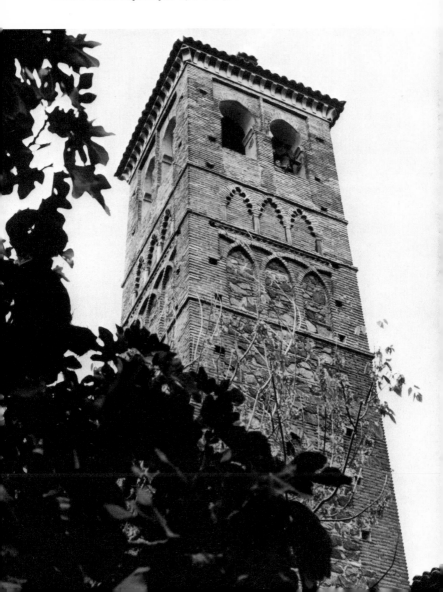

estate of the Moslem monarchs of the city, there still stands a puzzling, enigmatic building, half castle and half country house. The oldest part could well date from the eleventh century from the period of Yahia-al-Mamun and can be identified with the building known in Spanish as 'Palacio de la Noria'. It was later rebuilt and last decorated in the fourteenth century with Mudéjar plasterwork. It is now known as Castillo de Galiana and, though privately owned, can be visited on request.

During the period of Arab rule there were many Christians who co-existed with the invaders yet preserved their religion, and churches and parishes remaining from that period have already been mentioned. But this should not lead one to think that these churches contain nothing but the purest Mozárabic architecture, so typically Spanish, of the kind that has been the object of so penetrating a study by Manuel Gómez Moreno. Nearly all the churches were either rebuilt in the Hispano-Moorish period or totally altered at a later stage. Some writers think that the churches of San Sebastián, Santa Eulalia and San Lucas have a certain Mozárabic character but this is no more than conjecture, for the truth is they are predominently Hispano-Moorish, as we shall see when we come to deal with them.

There is only one authentic and complete Mozárabic church in Toledo, and that is not even in the town but twenty-two miles to the east, near the village of San Martín de Montalbán and the castle of the same name, in a remote uninhabited spot. It is called Santa María de Melque and must have been the chapel of an old Mozárabic monastery, that is, Christian monks living under Arab rule. Excavations are now under way all round the church, which has a cruciform plan and a very similar layout to the Visigothic church of Santa Comba de Bande (672), the massive walls of a fortress and only elementary decoration. Apparently Roman as well as Visigothic remains are to be found here. According to Gómez Moreno it was built between 862 and 930, when Toledo had an independent government dominated by Mozárabs.

Hispano-Moorish Toledo

The strength and spontaneity of Hispano-Moorish or Mudéjar culture is not hard to explain. The conquest had far reaching effects and radically altered the political, religious and cultural life of the city but it was unable to stamp out the traditions of a past marked by a mysterious mixture of Hispanic, Hispano-Gothic and Moslem influences. The races which had always lived together in Toledo, including the Jews and Moslems, continued to do so, though there is evidence that the Moslem families of rank, the upper classes, emigrated, their part as leaders being taken by rather unsophisticated Castilians, stubborn and solid, while the popular element, the common man, the simple artisans and workers, sought to adapt themselves to their new masters. In other words, though the surface of the waters was ruffled by a rough wind of political intrigues and quarrels, the depths remained undisturbed. It proved impossible to change overnight the customs and way of life, let alone the religion, which the staunch old Mozárab maintained against the arrogant French and Castilian prelates. Social habits and behaviour, etiquette, pastimes, music and festivals, language, dress, interior furnishing whether in a palace or a family house, and the thousand details that give life its particular physiognomy— none of these could be changed. Though subjugated in one sense,

Toledo. Calle de la Plata, a Gothic-Mudéjar doorway, 15th century.

in another the people were actually the conquerors, imposing their tastes on the Christians, who were sensitive to the attractions of the new atmosphere and allowed themselves to succumb to its influence, a phenomenon that can be observed throughout the whole of the Middle Ages. The same applies in the royal tombs of the Christian kings and princes, where one finds their clothes of oriental material and design, and in their palaces and noble houses, where the walls are adorned with plasterwork and tiles, and the ceilings are decorated with the superb work of Moorish craftsmen. All this is evidence of a substantial dissemination of culture.

If this idea be true with reference to so many aspects of civilization and the arts, it is even truer of architecture, where the evidence is overwhelming. Building in Toledo continued after the conquest as if nothing had happened, one reason amongst others being that the same hands were at work. The masons, the masters of many crafts, such as the carpenters whose skill has never been equalled, the tile-makers with their carefully guarded secrets of colouring and glazes, the plasterers artfully shaping their decorations, all of them were Moslems who took refuge and adopted the name of Mudéjar, applied to Moslems who had submitted to Christian rule. Whether one can really speak of submission is doubtful, for what were they but the heirs of a Spanish racial history which had been through Roman, Visigoth and Islamic periods?

In Toledo just as in so many other parts of Spain the Hispano-Moslems bore the fluctuations of history with indifference, faithful only to themselves, sustaining only a kind of internal continuity based on unchanging national characteristics. This accounts for the fact that no Romanesque or Gothic churches were built during the Middle Ages, at a time during the twelfth century when most Castilian Romanesque architecture was being created and when Toledo was already

Toledo. The doorway of
San Pedro Mártir, late 16th century,
with the Mudéjar tower
of San Román adjacent.

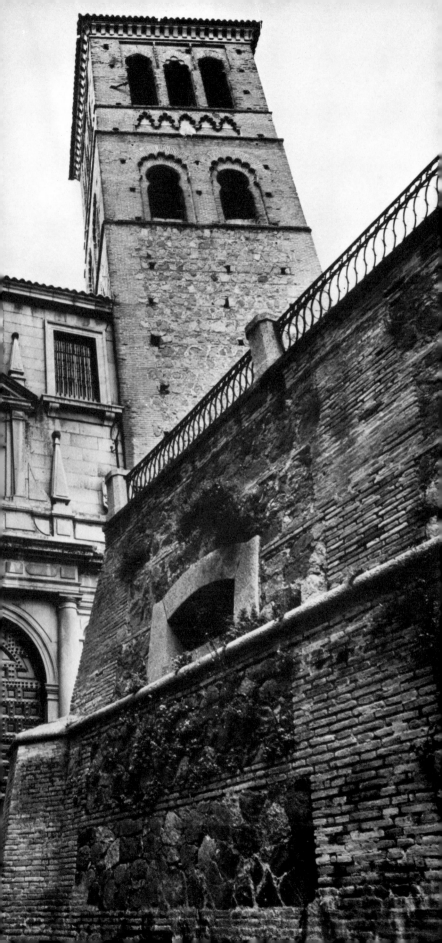

Christian. This may sound a little startling when one considers that Toledo boasts a Gothic cathedral which can claim to be the first in Spain in point of size and richness. But just as the exception serves to prove the rule, the disconcerting appearance of the cathedral, insisted on by the Catholic hierarchy, emphasizes how exceptional it is in the townscape of Toledo. For instance Rodrigo Jiménez de Rada, the archbishop who laid the foundation stone of the cathedral in 1226, had a few years earlier, in 1221, consecrated the church of San Román, the best and the most eastern in feeling of the Mudéjar churches of Toledo. Up to the reign of the Catholic Monarchs, which marked the end of the Middle Ages, no more Gothic churches were built other than the cathedral in the city which was the religious capital of Christian Spain. Without exception all the medieval churches in Toledo are Hispano-Moorish, and thanks to this the city can boast of an endless collection of this type of architecture, which would be even greater if so many had not been destroyed.

The oldest churches follow the traditional structure of the basilica, usually employing as supports columns taken over from Roman or Visigothic buildings. This custom of using older buildings was widespread amongst the Arabs, as can be seen in the case of even such an important building as the mosque of Córdoba. Hence many Roman and Visigothic columns and capitals must have passed from one building to another, until they came to rest in the Hispano-Moorish ones. The Mozárabic churches existing during the Moslem domination must also have been small basilicas of this type, though the attributions of the experts on some churches in Toledo vary between Mozárabic and Mudéjar. Furthermore some churches continue to be thought of as Mozárab, not because of their style but because during the Arab occupation they were open to Christian worship. But in fact both the old Mozárabic and the new Latin ones are really Hispano-Moorish in style, the former because they were rebuilt and the latter because of the date when they were first constructed.

The small church of San Sebastian, standing on the south side of the path running above the Tagus, has this basilical plan with columns. Various writers believe it was once a mosque whose character was changed when its religion was changed. It must have been extensively restored in the thirteenth century, acquiring thereby the distinctly Mudéjar appearance it now has.

Then there is the little church of San Lucas, diminutive but charming, whose history is doubtful. It ranks as a Mozárabic parish church, which would suggest that it is of considerable age, but the facts available to support any theories about it are extremely scarce. Here too we have a small basilical ground-plan though the original stone columns that were used for it have been replaced by constructed pillars of less distinction. These brickwork pillars, square with chamfered corners, have in all likelihood been influenced by those in the synagogue of Santa María la Blanca, which was built at the end of the twelfth century. More interesting is the structure of the recently restored church of Santa Eulalia. In this basilica simple columns (re-used old ones) alternate with compound ones (one pier and two columns back to back) in such a way that the horseshoe arches of the gallery are grouped two by two in a graceful pattern and provide a marked Moslem flavour to the beautiful interior.

The initial step taken in Santa Eulalia is confirmed in the structure of the church of San Román. Here the free-standing column has disappeared and been replaced by the compound pier with columns

clustered round it. This is a sensible solution, since it strengthens the pier to carry wider arches, at the same time maintaining the grandeur and dignity created by the columns. The origins of San Román, like those of so many other churches in Toledo, must go back a long way. It was possibly a Visigothic temple and was indubitably a mosque, as testified by the stones and tombs which the governor Gutiérrez Tello ordered to be removed, under instructions given him by Philip II. The religious purge carried out by Tello was highly regrettable, causing irreparable loss to the city.

The old church of San Román must first have been restored at the expense of the powerful Esteban de Illán, who may have built the

Toledo. Santiago del Arrabal, a fine example of Mudéjar architecture.
The interior has a typical ornamental wooden ceiling.

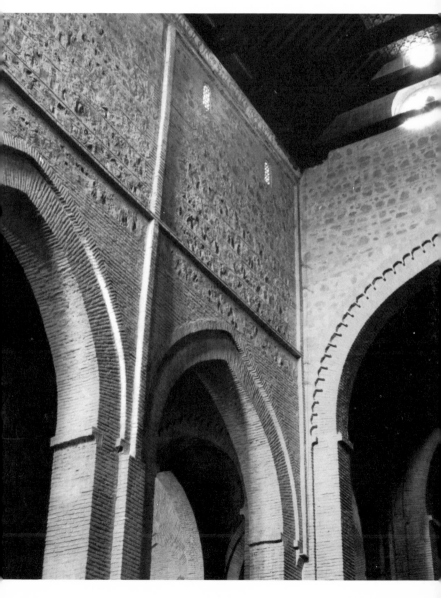

strong tower, one of the best Hispano-Moorish towers in Toledo, from which Alfonso VIII was proclaimed king in 1166. The tower may well have been still under construction at the time, for judging by its style it dates from a little later than the middle of the twelfth century. One can see from the position of the central apse that the church first consisted of a single aisle, which number was increased to three. The date of its consecration in 1221 is known with certainty, so its present layout probably dates from this period. The arches separating the aisles are very beautiful and extremely elaborate. Above them, giving the central nave greater height, rise other smaller arches set in the same way as those seen in some mosques, such as in Damascus. This church enjoys the exceptional good fortune of having kept a good many of its thirteenth-century paintings, in which Christian and Moorish elements are admirably combined. The figures are in late Romanesque style, while the geometrical motifs drawn from plant-life, combining both inscriptions and representations, are undoubtedly Moslem in origin. All these elements make the church of San Román the most important of the Mudéjar churches in Toledo and give it the interior which has the strongest eastern flavour about it.

In the first half of the sixteenth century the great architect Alonso de Covarrubias decorated the chancel of San Román with a beautiful Plateresque chapel, elegantly designed and with delicate tracery, serving as a frame to an altarpiece of the same period.

A little later in the development of Hispano-Moorish architecture comes the church of Santiago or del Arrabal which is situated in the quarter next to the Puerta Nueva de Bisagra. The earliest mention of this church was in 1179 and the tower possibly dates back to that year, being one of the oldest in Toledo as well as one of the simplest and barest in style. According to Sixto Ramón Parro, Sancho II, king of Portugal, who died in Toledo and was buried in the cathedral, may have had a hand in its reconstruction. The oldest commemorative stone in the existing building dates from 1287. Everything about it leads one to think that its present appearance dates from the end of the thirteenth century.

The transept, in contrast to the basilical plan of the naves, has a vaulted roof reinforced with brickwork tracery and shows an effort to approximate the Gothic style. The height of the interior and its vertical emphasis show the same tendency. On the other hand the three apses, with their decorative blind arches both on the outside and the inside, continue the older tradition. Like most of the other Mudéjar churches, Santiago lost its pictorial decoration and has now been restored with the brickwork of the walls left free. The effect, though not the one intended by its builders, is still impressive. The church of San Vicente has been restored in the same manner and its single apse has great beauty.

Toledo possesses a handsome collection of Mudéjar towers, as elegant as minarets, which add great life to the silhouette of its buildings. Apart from those which have already been mentioned in dealing with the main churches, there are others which are worthy of note such as Santo Tomé, sister tower of San Román and the pride of that famous

▷

A Mudéjar tower in Illescas, 14th century, with elaborate decorations.

P. 90/91
Toledo. The cloister of the Convento de San Juan de los Reyes,

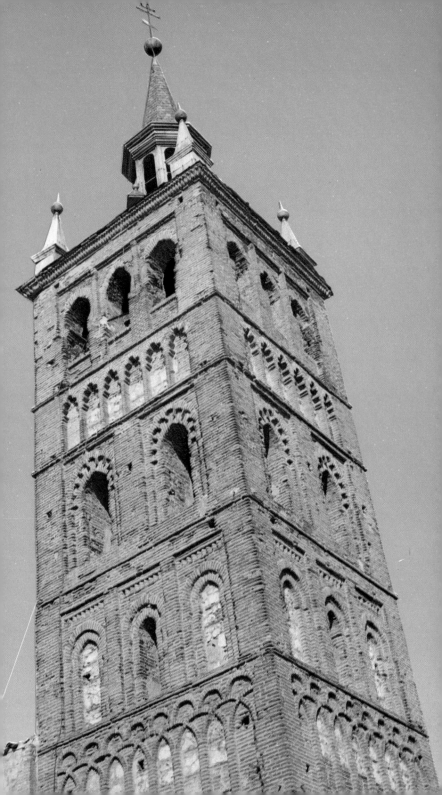

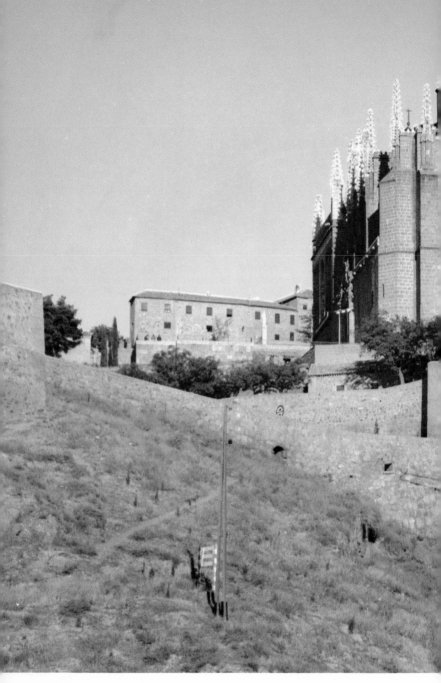

Toledo. Convento de San Juan de los Reyes, typical example of architecture of the time of the Catholic Monarchs, with Mudéjar features

parish church where the whole world admires El Greco's *Burial of the Count of Orgaz*: that of the church of Santa Leocadia, which is virtually undamaged and forms a whole with the apses and a good piece of façade; or that of San Miguel el Alto, tall and graceful. Then there is the tower of La Magdalena Church and those of San Pedro Mártir and San Bartolomé of the same family; but more elaborately decorated than the Toledo towers, is the pretty tower

of Illescas. San Bartolomé also has a beautiful apse, and so has the
Convento de Santa Isabel, the church of Cristo de la Vega, which is
the old basilica of Santa Leocadia, and the Convento Santa Fe. The

P. 94/95
*Toledo, aerial picture: in the centre a remarkable
view of the cathedral showing its structure in detail.*

93

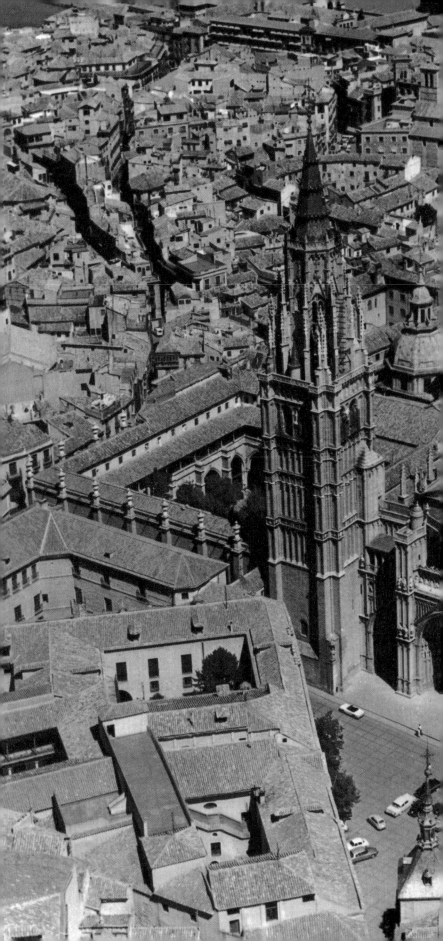

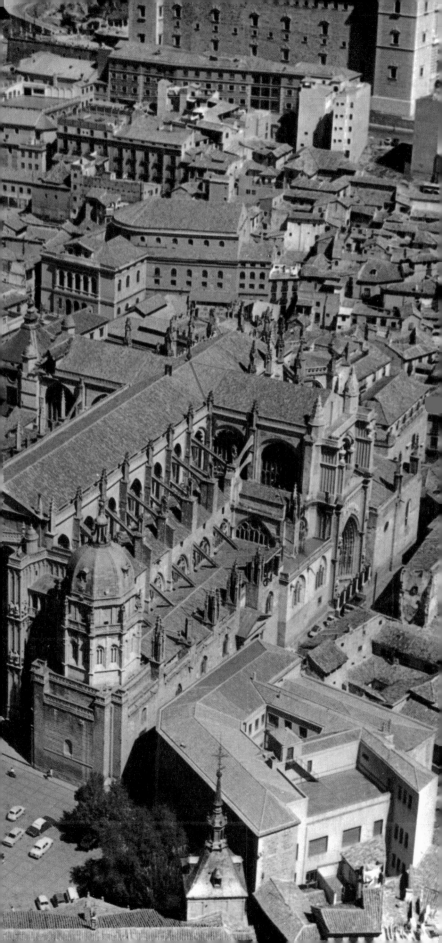

Toledo.
The garden of the Casa del Greco.

last-named, approached through the convent courtyard, belongs to the church, built during the time when the convent was in the hands of the Knights of Calatrava, and is the only Gothic apse in Toledo. It has a polygonal plan and buttresses, and is skilfully adorned with brick-work representing interlaced pointed arches.

The church of San Andrés deserves to be mentioned apart, for it consists of a curious amalgamation of parts from different periods. On the north side remain a few Arab columns and blind arches; the naves and aisles are Hispano-Moorish in style with the arches resting not on the original columns but on new ones put in during the seventeenth century. In the lateral walks before the now vanished apses there are some extremely interesting vaults made with 'mocárabes' which must date from the fourteenth century. The original sanctuary was destroyed and replaced by a sumptuous one in the Gothic style, which Francisco de Rojas, ambassador of the Catholic Monarchs, had built in 1500 as a tomb for himself and his family. The remarkable painted altarpieces are by Juan de Borgoña and his assistant Antonio de Comontes.

Finally the Corpus Christi Chapel in the church of SS. Justo y Pastor is worthy of note, with ornamental plasterwork, socles of decorative tiles and carved woodwork ceilings which seem like an

interior from the Alhambra. It probably dates from the beginning of the fourteenth century when the church was rebuilt by Gonzalo Ruiz de Toledo, lord of Orgaz, who later became known as Count of Orgaz, the name immortalized by El Greco. Gonzalo, a very pious man, had many of the city's churches rebuilt. The apse also dates from this time. The tower was decorated with Baroque features and the interior disfigured by some renovations in the classical style.

Until now only the Christian churches of the Hispano-Moorish period have been mentioned, but the two remaining synagogues must not be forgotten—what is separated by religion can sometimes be brought together under the heading of art. Though of different periods they are both examples of that Mudéjar art which dominated the whole epoch unopposed and enjoyed the allegiance of all the estates of the realm and all religions in the tolerant Middle Ages. They both testify to the great importance of the Jews in Toledo's history. Fanaticism can sometimes be vanquished by sheer beauty and the synagogues were saved by their magnificence. Immediately following the expulsion of the Jews in 1492, they were converted into churches.

Toledo's largest synagogue was converted into the church of Santa María la Blanca at the beginning of the fifteenth century. It is one of the most striking and original buildings in the whole city. Hebrew chronicles seem to put forward evidence that it was built at the end of the twelfth century by Ibrahim, son of Aljafex and favourite of Alfonso VIII, but its style, according to Gómez Moreno, belongs rather to the first half of the thirteenth century. Its fine naves are indeed a beautiful sight and when looked at diagonally they are reminiscent of an Almohade mosque. Its octagonal pillars with their very original capitals are Corinthian in derivation but are proof of the adaptive skill of Moslem craftsmen; they had a great influence on Toledan architecture where one finds numerous courtyards with columns of this kind, though usually much plainer.

The Sinagoga del Tránsito, as it is called today, stands a short distance from the other, also in the old Jewish quarter. Opulent and elaborate, it was built at the expense of Samuel Levi, the famous treasurer of Pedro the Cruel. Begun in 1366 it must have adjoined his mansion, serving as it were as its chapel. The plan in the shape of a large room with a high gallery has the air of a private religious building. Both the exquisite plaster decorations—one of the best examples of Mudéjar ornamental work in Toledo—and the magnificent ceiling are remarkable examples of the Arab-influenced art that was developing in Toledo parallel with that of Granada. It has now been converted into a Sephardic museum with the intention of bringing together all possible relics of the glories of the Hebrew presence in Spain.

The richness of the palaces and great houses was quite on a par with that of the religious buildings, but unfortunately only a few of them are still standing, and none of these in the original state. However two exceptionally precious fragments of these palaces still remain, having accidentally escaped the destructive sweep of time.

One of them, which is called 'Taller del Moro' (The Moor's Workshop), is an ancient remainder of the palace of the Ayala family, one of the most powerful in the city. A large rectangular salon with two additional rooms more or less in the shape of alcoves were reception rooms of a palace whose layout was in the Moorish style. These reception rooms would give onto an inner courtyard through a row of arches just as in the courtyards of the Alhambra. The well-preserved decoration of the interior, with a number of Arabic

inscriptions, is reminiscent of the Granada palace in its elegance and distinction, and the carved ceilings are magnificent.

Throughout its history it must have undergone many changes, being first a convent, then later a workshop where the marbles of the cathedral were cut and polished. As it was in the street called Calle del Moro it took the same name. It has recently been restored and a small Ceramics Museum has been installed in it, containing some noteworthy examples of this once famous art of Toledo.

The Casa de Mesa, thus named after the surname of the family which lived there in the nineteenth century, was once the palace of the family of Esteban Illán. The only notable feature remaining is the large and splendid salon. It must date back to the end of the fourteenth century and the plaster decoration is typical of the Mudéjar work of Toledo. Over a base of very intricate plasterwork, a larger design in the Gothic style is applied, consisting of carved stems, tendrils and clusters. The panelled ceiling in the shape of a polygonal vault with ornamental scroll-work forming star-shaped polygons is a marvel and it reminds one of the Sala de Comares in the Alhambra.

Scattered fragments are also to be found in the ruined Corral de Don Diego; in the house called after Conde Esteban at No. 5 Plaza del Consistorio (next to the Ayuntamiento); in the Convento de Santa Isabel de los Reyes which still has a few interesting rooms and court-yards in the inner recess which unfortunately cannot be visited because monastic regulations forbid it; and also in other convents.

However, the Palacio de Fuensalida next to the Taller del Moro deserves a special mention. These two seemed to have formed part of the same palace belonging to the powerful Ayala family. Pedro López de Ayala, first Count of Fuensalida, had it built towards the middle of the fifteenth century. Its highly regular layout around a large courtyard constitutes a variation on the ancient Moorish mansions, something of a forerunner of the Renaissance. None the less all the architectural and decorative features are in the purest Mudéjar style and hence very typical of Toledo. A sad event which took place here, the death of the Empress Isabella, wife of Charles V, shows that this palace must have been an important building.

Toledo also possesses a large number of great houses, not quite grand enough to be called palaces, belonging to the patricians and the wealthy class, which were notable for their entrance doors, beautiful courtyards, plasterwork and carved ceilings. Some of them survive but usually in a terrible state of disrepair, having lost their former distinction through the gradual deterioration of social condi-tions in Toledo, due to the emigration of the aristocracy and the more cultured classes to the increasingly attractive capital of Madrid. But it is still fascinating to be able to peep into the courtyards of these old crumbling houses, picturesque and full of life in spite of their decrepitude. The usually have stone columns on the ground floor and airy wooden galleries on the higher ones.

Should the visitor wish to see what these richly furnished houses looked like he should go to one which is mainly attractive for another reason, namely the Casa del Greco. Where there is now a pleasant garden next to the Paseo del Tránsito, there used to be in the Middle Ages several imposing palaces, allegedly built by Samuel Levi. En-rique de Villena, Marquis of Villena, lived there, a controversial, enig-matic character, with the reputation of being a sorcerer and alchemist. It is recorded that, from 1585 until his death in 1614, Domenico Theotocópuli lived in the principal dwelling of the Marquis de Villena.

Toledo, Taller del Moro, the octagonal roof-frame of the former 14th-century mosque which is now a museum of ceramic and industrial art.

These disappeared but at the beginning of the century there were still some others left nearby, called Casas de la Duquesa Vieja. When they were about to disappear they were acquired in 1905 by Benigno Varela, Marquis de la Vega Inclán, first Royal Commissioner for Tourism in the reign of Alfonso XIII, under a very praiseworthy scheme which was to have far-reaching consequences. He restored them beautifully and with exquisite taste, and reconstructed them into what might have been El Greco's last residence. This well-meant piece of historical inaccuracy is compensated for by the skill and good judgment with which the whole enterprise was accomplished. For even if he did not actually live in this house, it must have been in one of those next door in an atmosphere hardly different from that which has been recreated.

Thanks to the Marquis de la Vega Inclán it is possible to see what a wealthy sixteenth-century house looked like, predominantly in the Mudéjar style even though Renaissance details are to be found here and there, with charming gardens on various ground levels, sometimes spreading over vaults or caves, the tiny courtyards with their graceful

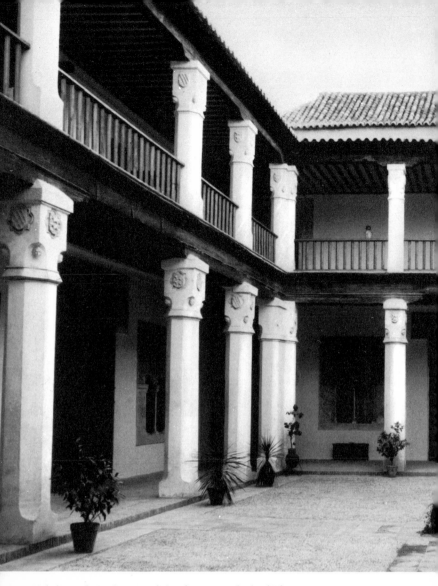

Toledo. Palacio de Fuensalida, the courtyard of which was commissioned by Pedro Lopez de Ayala, in the 15th century.

wooden galleries, the porticos and terraces, the innumerable unexpected little corners suitable for each different hour of the day or season, the cool airy rooms of the ground floor and the warmer ones of the upper levels. The architecture is simple but full of originality and the decoration shows all the variety and richness of Toledo craftsmanship—walls and friezes of Moorish plasterwork, handsome doors of inlaid wood, socles of glazed tiles and decorated ceilings with carved beams, all of them adding their touch of colour to the monastic whiteness of the walls, the heavy dark tones of the woodwork ceilings or the vibrant brightness of the tiles. With this there mingles charmingly a restrained amount of greenery; there are pots of geraniums everyhere, rosebushes, honeysuckle, ivy and vines climbing the walls, swordlike lilies and the compact foliage of oleanders.

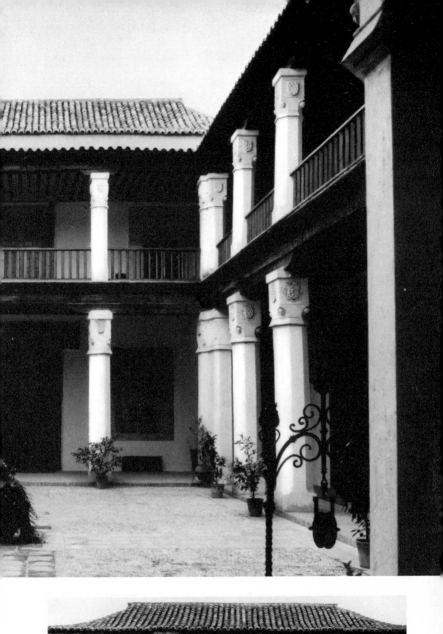

The Casa del Greco was furnished with great pains and attention to historical detail, dispersing among the rooms some of the painter's works and some family portraits. Then, next door to this house, a museum of paintings was installed where, apart from El Greco, there are works by Tristán, Zurbarán, Juan Bautista del Mazo and others. Among the paintings by El Greco himself the outstanding ones are the view of Toledo, a wonderful *San Bernardino* from the old college of the same name, the portraits of Antonio and Diego de Covarrubias, the theologians and humanists, who were sons of the architect Alonso de Covarrubias and friends of the artist, and an excellent *Twelve Apostles* of his last period.

Among the civil buildings of Toledo the Cárcel de la Santa Hermandad should be mentioned. It stands in the Calle de la Tripería behind the apse of the cathedral, half hidden by the new and discordant provision market.

The Hermandad or Brotherhood was a kind of militia formed for the purpose of protecting men who had to go out into remote areas and often fell into the hands of highwaymen and brigands, who in those days were called *golfines*. This institution came into being during the reign of Alfonso VIII and since it found favour with the kings, it had gained great standing by the time of the Catholic Monarchs. This house must have been built during this period. Its most remarkable feature is the Gothic-Mudéjar façade which is protected by an overhanging roof and is adorned with the fine sculptured coat-of-arms and heraldic emblems of the Catholic Monarchs. The interior has been restored and now houses a small museum of the city's history. Another façade which is just as individual is the one commonly called 'Palacio del Rey Don Pedro.' The projecting roof protecting it is in this case wider and rather reminiscent of the Nazarí-period roofs of Granada. The door resembles that of the Fuensalida palace and the wolves passant and castles on the coats-of-arms prove that these houses, like so many in Toledo, belonged to the powerful Ayala family. It is most difficult to judge today what their original appearance was, for only damaged and disfigured fragments remain. This building is probably the one which was later the palace of the counts of Cedillo, later still the Universidad de Santa Catarina, and today the Seminario Menor. From the old palace of the Cedillos only a simple but very elegant little courtyard remains with a double row of arches and marble columns, as well as a pretty flight of steps with beautiful Gothic balustrade, one room with a splendid carved wooden ceiling and a few pieces of decorative plasterwork which were discovered when the white walls were stripped and show how luxurious these dwellings really were.

Toledo Cathedral

Perched on the famous crags of Toledo like a plume which man has added to the natural scene, a spire and a finial of the rock itself, stands the cathedral of Toledo. It is a gigantic and beautiful paradox in stone, a paradox because it came into being in totally alien surroundings where it seems foreign, even extravagantly strange. Its stubbornly nordic and Gothic character is a contradiction which would hardly have

▷

*Toledo. Palacio de Fuensalida, where the Empress
Isabella, wife of Charles V, died.*

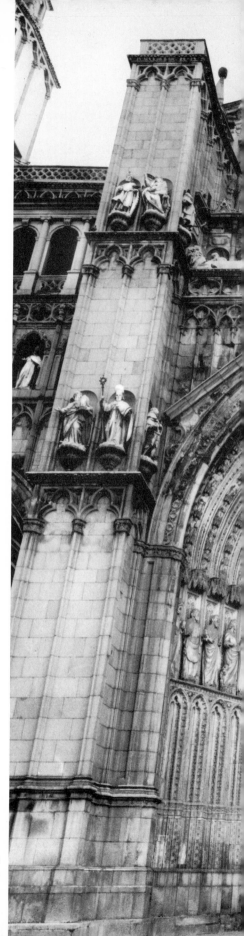

Toledo Cathedral, the Puerta del Perdón, 14th-15th century.

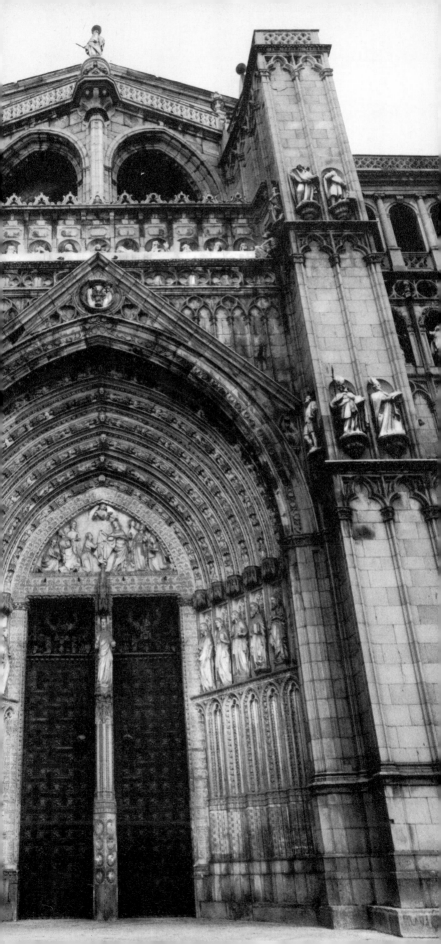

fitted smoothly into the ancient Moslem *medina* if it had not been for certain specific concessions made to time and circumstance with the passage of the years. For instance, instead of the two towers that were planned, only one was built, and thanks to this it could pass as the single minaret of the great mosque that it once was. But Toledo, already the crucible of national life in the Middle Ages, wanted to create in its midst a visible spiritual symbol of the conquest and here seemed to be the perfect pedestal for erecting a major work of Christian faith. The site used to be occupied by the main mosque of the Moslems, and Toledo's conqueror, Alfonso VI, solemnly promised to respect it; but during one of his absences from the town Queen Constance and Archbishop Bernard de Sedirac, both of them French, seized it unexpectedly and treacherously threw out the Moors, erected an altar and installed a bell in the minaret to summon the Christians. According to Father Mariana, this coup was very nearly the ruin of the city. The king's anger and rage were so great that neither the queen nor the archbishop was able to placate him, and in the end it was the Moslems who succeeded in doing so, by making a gesture of tolerance and accepting the usurpation as legitimate. In the chancel of the cathedral one can still see a figure representing the prudent Alfaquí Abu-Walid, who was the negotiator who brought a peaceful end to the explosive dispute.

In much the same way as occurred in other cities conquered by the Christians, in Toledo the main mosque served for many years as a cathedral; in fact right until the great reign of Ferdinand III when Castile reached the peak of its fame. Toledo's chapter of Canons was wealthy and governed by the illustrious prelate Rodrigo Jiménez de Rada. He was a spirited and cultured man who had studied theology in Paris and had enjoyed in France the astounding spectacle of the first Gothic cathedrals. Consequently he was well prepared to undertake the vast project of building into the middle of Moslem Toledo a grandiose cathedral in the manner of the French ones; a cathedral that would symbolize the ecclesiastical aristocracy of the thirteenth century, its scholarly culture and the policy of unification adopted by the European high clergy.

The cathedral is designed in the purest style and accords with the most exacting norms of the art of the thirteenth century, bearing some relation to the French cathedrals of Bourges and Le Mans. Its immense scale makes it one of the largest in Spain. It is divided into five aisles, and a nave and four aisles continue behind the chancel so as to form the most beautiful open ambulatory that a Gothic cathedral could have. The vaulted ceiling of this ambulatory is remarkable in its design which consists of alternating triangular and rectangular panels.

The foundation stone was laid on 14 August 1227. Its first architect was a certain Master Martín, who apparently came from France, and was succeeded by one Petrus Petri, possibly really named Pedro Pérez. The sanctuary must have been finished in about 1238, but work on the cathedral continued for many years with fluctuating success and at varying speeds until the last part of the vaulting was completed in 1493. It was enriched steadily with the passage of years, so that one can justly claim that no other Christian shrine

▷

Toledo Cathedral, the magnificent nave with Gothic arches and 14th century ambulatory in the background. Behind, the Transparente, *18th century.*

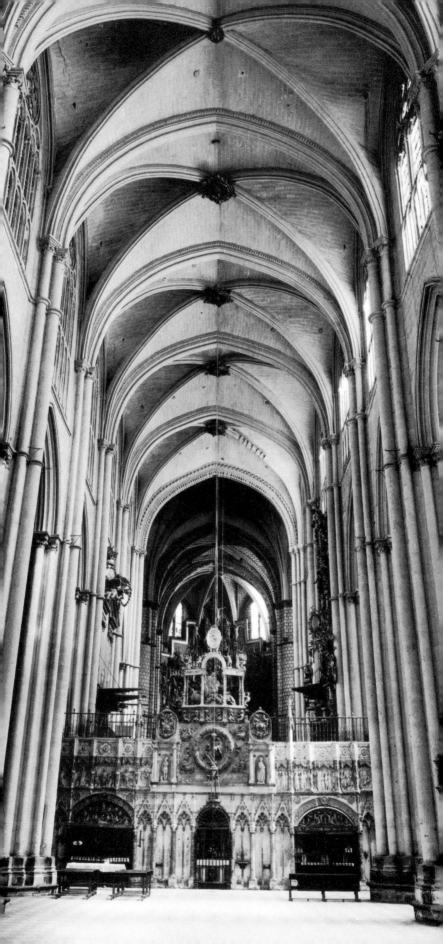

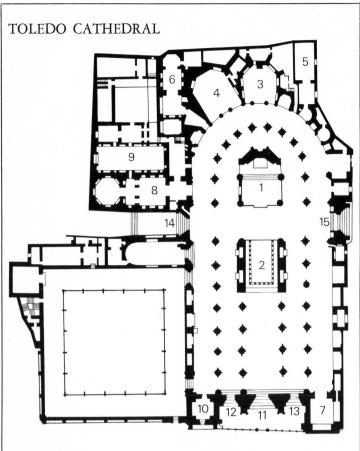

TOLEDO CATHEDRAL

1 CAPILLA MAYOR

2 CORO

3 CAPILLA DE
S. ILDEFONSO

4 CAPILLA DE SANTIAGO

5 SALA CAPITULAR

6 CAPILLA DE LOS REYES
NUEVOS

7 CAPILLA MOZARABE

8 CAPILLA DE LA VIRGEN
DEL SAGRARIO

9 SACRISTIA

10 TESORO

11 PUERTA DEL PERDON

12 PUERTA DEL INFIERNO

13 PUERTA DEL JUICIO

14 PUERTA DEL RELOJ

15 PUERTA DE LOS
APOSTOLES

Toledo Cathedral. Ground plan. (Right) the nave and lateral wall of the choir. Lithograph by Pérez Villamil. Author's collection.

▷

P. 110/111

The main façade of the cathedral with the Puerta del Perdón. On the left, the tower (1380-1440) of which the open last storey contains the bells. On the right, the Mozárabic chapel is surmounted by an octagonal dome which ends in a lantern, the work of Jorge Manuel Theotocópoli, son of El Greco.

can vie with it in splendour. It certainly deserved the title of *Dives Toletana.*

The cathedral was first conceived as an orthodox replica of a French cathedral but it has turned out to be something quite different, owing to the transformations wrought over the years, to the accumulation of works of art inside it and to the presence of the town surrounding it. Consequently the French archaeologist Elie Lambert was able to say of the Cathedral with considerable truth that it was a world in which the centuries had accumulated works of art of such variety that its fabulous wealth and unlimited diversity strike one with awe at first sight. Inside, this immeasurable richness spreads across all the aisles and reaches as far as the most obscure corner; but nowhere is it so flamboyant as in the main chapel, with its gigantic altarpiece gleaming in its gilded beauty.

It was carved by Copín de Holanda, Petit Juan, Vigarny, Sebastián de Almonacid and a legion of gilders, painters and workers in relief. Then there is the superb Renaissance grille by Villalpando, the royal tombs of Alfonso VII, Sancho III, and Sancho IV of Castile, the tomb of Cardinal Mendoza in the manner of Sansovino, and the innumerable statues which fill the impressive interior. Maurice Barrès, the French writer

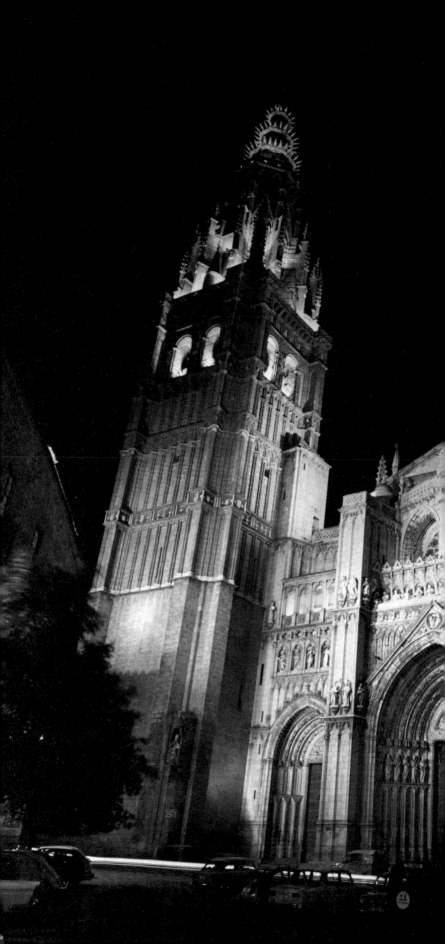

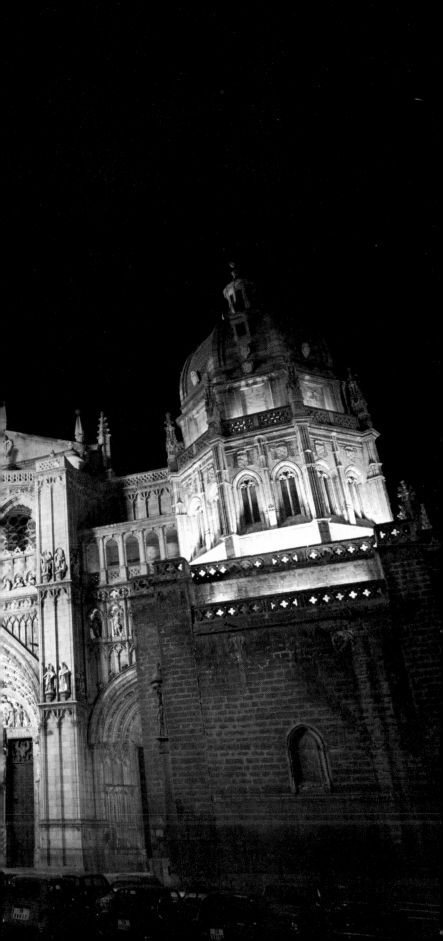

who was so enamoured of El Greco and Toledo, declared that nowhere in the world had he ever seen a place so sumptuously decorated.

As as the custom in Spanish cathedrals, the choir stands in front of the chancel, on the western side of the transept. It is a typically Spanish arrangement which disturbs the interior perspective of the church but which a sense of tradition, as in this case, preserve from alteration. The altar, the place of sacrifice, and the choir, the place of praisegiving, are joined by the *Via Sacra*. The choir of Toledo Cathedral has a superb set of stalls, the work of three different masters. The lower tier is by Rodrigo Alemán, the upper tier on the north (epistle) side is by Felipe Vigarny and that on the south (gospel) side by Alonso Berruguete. Berruguete's work is considered to be some of the finest and most inspired produced by the Castilian school of sculpture.

Toledo Cathedral, chapter house carved and panelled ceiling, with frescoes by Juan de Borgoña.

P. 114/115
The Transparente, *by Narciso Tomé, completed 1732, in Toledo Cathedral. A sacramental chapel without walls, made into an elaborate exercise in Baroque illusionism, combining the arts of architecture, sculpture and painting.*

The munificence of its bishops and the desire for posthumous fame among the important men of its congregation were responsible for the addition to the original cathedral structure of great and striking chapels. The largest of these is the Santiago Chapel built entirely by Alvaro de Luna, favourite of John II, who was later beheaded in Valladolid in the year 1453.

The chapel called Capilla de los Reyes Nuevos was built to give a worthy burial place for the kings of the House of Trastamar. Henry II, John I, and Henry III rest here in beautiful Plateresque tombs, though John II, the father of Isabella la Catolica, is not there; he was since buried in the Cartuja de Miraflores at Burgos. But his statue is in the cathedral of Toledo, so that he should be remembered in its prayers.

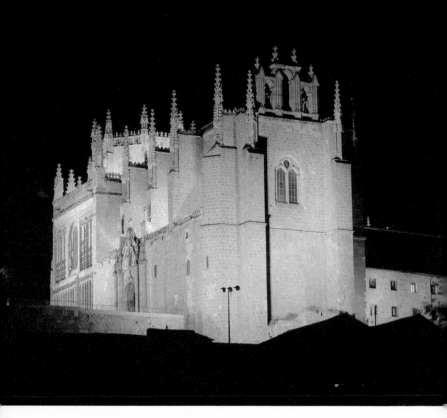

*Toledo. Convento de San Juan de los Reyes, commissioned
by Ferdinand and Isabella, and built by Juan Guas in 1480-90.*

It was Cardinal Cisneros who built the elaborate series of rooms
which make up the chapter house and its annexes. They have the
prettiest Moorish-Plateresque decoration and their walls are covered
with frescoes by Juan de Borgoña. Below there is a long series of
portraits of all the archbishops who occupied the throne of Toledo.
More severe in style, influenced by that of Juan de Herrera, architect
of the Escorial, is the Capilla del Sagrario and the Reliquiary adjoin-
ing it. The building of the sacristy, a vast and severe room which
is today a veritable museum of paintings, is of the same period. El Gre-
co's *Christ Despoiled* and *St Luke the Apostle*, are among his greatest
masterpieces. *The Captive*, one of Goya's most impressive paintings,
shines forth from an altar, while between the sacristy and the vestry
hang paintings by Juan de Borgoña, Morales, Tristán, Pantoja, Caravag-
gio, Bassano, Zurbarán, Orriente, Velázquez, Rizi, Titian, Guercino,
Reni, Seghers, Mengs and others. In the adjoining rooms there are or-
naments, garments and other precious objects, particularily the Bible
of St Louis, king of France, a priceless manuscript with miniatures of
the thirteenth century.
Finally there is the last part of this museum-like cathedral, namely
the chapel commonly called 'El Tesoro,' the Treasury. It is situated
just beneath the great tower of the Cathedral. In it is housed the
Custodia, a reliquary by Enrique de Arfe, Christianity's most precious
gem and a glory of the Germanic genius. It is surrounded by a mass

of other splendid pieces of gold and silver work and beautiful jewelry of immense value.

One should not leave the cathedral without casting at least a glance at the famous *Transparente* behind the high altar, in the middle of the ambulatory round the chancel. It is a remarkable creation in the most uninhibited Baroque style, and the use of light to heighten the effect of shape and colour is very dramatic. It is by Narciso Tomé, and whether one likes it or not one must take notice of it and admit that it is a work of genius.

If, on coming out dazed by so many splendours, the visitor seeks to observe the cathedral from the outside, he will find himself perplexed, confused and maybe annoyed. The gigantic cathedral seems to hide. There is no way of taking it in at a glance, for the city swallows it up, imprisons it as if to punish it for its disquieting architecture.

On one side of it a vast cloister leans against its walls. Inside the cloister is a teeming human anthill. Sacristans, choirboys, bellringers, vergers and perhaps an old canon, clerics and laymen crowd together and one can hear the muffled noise of the children in the sidewalks outside where mothers hang out their washing in the sun. From here there is a bridge joining the cathedral to the archbishop's palace. Next to this bridge the great tower rises in majesty, a magnificent monument of granite strength crowned by an octagonal structure, light and gleaming, a work inspired by Hannequin of Brussels.

Arriving at the Plaza de la Catedral one finally comes to the front of the church, but alas, the old Gothic façade has been hidden in part by a piece of eighteenth-century renovation. Of the original façade only three doors remain. The central one is called Puerta del Perdón, the left hand one Puerta del Infierno and the right-hand one Puerta del Juicio, the doors of Forgiveness, Hell and Judgment respectively. They were made at the beginning of the fifteeth century.

The Puerta del Reloj is the oldest of the cathedral doors and opens to the north arm of the transept. A narrow lane full of atmosphere leads to this door. But there is no doubt that the most beautiful of all the doors is the latest one. It is called the Puerta de los Apóstoles or de los Icones, in the south aisle of the transept. It is the masterpiece of Hannequin of Brussels and his team of sculptors and stonemasons, and is a striking example of northern Gothic style of Spain. On this side the cathedral is less hidden, but soon the streets start to envelop it, leaving only glimpses of odd fragments of buildings. It is indeed a strange sight to see this Gothic cathedral apparently hiding its exterior just like those Arab dwellings which hardly give a hint on the outside of the magical splendour to be found within. The city has wrapped itself round the cathedral so as not to show what should only be discovered in the secret intimacy of the interior.

Renaissance Toledo

Having already lived through so many glorious periods, so many and such different civilizations, each of them writing its story in turn in works of art on the soil of Toledo, as on a palimpsest, the arrival of the Renaissance brought Toledo into a new period of unaccustomed splendour. The main factors in this process were first of all the Catholic Monarchs, then later, and more decisively, the Emperor Charles V; and again the great archbishops who successively took over the primacy of Toledo.

To quote the Conde de Cedillo, 'Toledo was at this point the very

heart of the Spanish monarchy, and even the real centre of worldwide politics and diplomacy. Like the planets revolving around the sun the widowed queens of Portugal and Aragón, Doña Leonora and Doña Germana, formed a court worthy of such a sovereign, together with princes of royal blood like the Dukes of Bourbon and Calabria or the Duchess of Alençon, and Don Enrique de Labrit, son of the deposed king of Navarre; personalities such as the Grand Master of Ceremonies, the Viceroy of Naples, Carlos de Lannoy and Cardinal Salviati, envoy of Clement VII; the cream of Spanish nobility and a wide range of foreign nobility as well; high dignitaries of the church and finally the ambassadors representing all the sovereigns and the republics of Europe and even some Asian and African kings.' This indeed seemed like a renaissance, a rebirth after the long dark night of the revolt of the Comuneros (1520-21), for, as is well known, the centre of this movement was Toledo, a town which has always shown itself very jealous of its privileges and very punctilious in matters of honour and status. The grave political blunders that marked the early stages of the reign of Charles V had profoundly aggrieved the city, for it was forced to see the archbishop's throne which had once been held by Mendoza occupied by a young lad of twenty years of age, and

Toledo. San Juan de los Reyes, detail of apse with statues of macebearers, symbols of royalty.

◁
The apse and the base of the cupola.

a foreigner, Guillaume de Croy, a nephew of the Lord of Chievres. The great leader of the Comuneros was the Toledo nobleman Juan de Padilla, and even after he had been beheaded at Villalon on 24 Aprile 1521, his cause was maintained by his widow, Doña Maria de Pacheco, and there was an other uprising in 1522. Possibly because Toledo had at first been the greatest enemy of the young king, it later became his favourite city, and the one on which he lavished most favours. Even though the movement had been suppressed, its spirit triumphed and Charles had to change his policy completely.

The truth of the matter is that in Renaissance Toledo, in the Toledo of Charles V, it was the foreign nobility and the grandees of other houses who shone, rather than the city's own noble families. Even though the Silvas, the Ayalas, the Rojas and the Toledos reached high positions and merited the trust of their king, they were surpassed by others and so, as had frequently happened during the course of its history, the city kept itself at a distance, haughty and unapproachable, in the midst of the vanity fair and auction of favours that was the court. Toledo might have changed all of a sudden, might have divested itself of its century-old Hispano-Moorish roots as of an archaic and obsolete burden, but this did not happen. The city continued to be

faithful to itself, in fact reaffirming its personality in its new way of living. The great Renaissance buildings were incorporated into the town and melted into it without detracting from it, its original look and way of life were preserved, and the newly constructed palaces, castles and hospitals all lived together like new offspring in the bosom of an old family. Many of these new buildings, in spite of their unquestionable newness, paid homage to the past and were in fact affected by it, in the sense that even in Renaissance architecture, when one is least expecting it, one comes across traces of the old Mudéjar style which have rubbed off from the surroundings,—something as difficult to eradicate as the ancestral customs of a primitive tribe.

One must also remember that in the sixteenth century Toledo was still a great centre of craftsmanship, bursting with life and energy, where hundreds of skilful and industrious hands produced a constant stream of works of art of the finest quality and workmanship. Carpenters, wrought-iron workers, ceramic artists, plasterers, weavers, embroiderers, niello workers and armourers made up an army of all the crafts, an essential source of vitality and richness for all the projects with which great noblemen wished to embellish their buildings, to maintain the luxury of their houses and to enhance even more their regal and sumptuous mode of life. In these luxury crafts lay the link between past and present, for they were themselves the most genuine representatives of the traditions of the past, which they maintained in creative life and thus kept from extinction.

First of the series of great foundations that followed closely upon each other was the monastery belonging to the Order of St Francis, universally known as the Convento de San Juan de los Reyes. This splendid building was the consequence of a vow made by the Catholic Monarchs before the decisive battle of Toro, in which Ferdinand and Isabella were defending their claim to the throne against Doña Juana la Beltraneja, who had the support of the king of Portugal. Their resounding victory consolidated their cause and opened up the way to the unification of Spain, which this church really represents, symbolically and in its architecture, since its style, Gothic in conception and Hispano-Moorish in many details, embodies the new spirit of luxury and refinement inseparable from the Renaissance.

Ferdinand and Isabella wanted this monument to their piety and their power converted into a collegiate foundation blessed with an ample income, where the standard of the ceremonies would attain a magnificence comparable only with that of the cathedral; and they wanted it to be a mausoleum where their ashes would be laid to rest. The first project was never fulfilled because the cathedral chapter placed as many obstacles as possible in the way of establishing a rival chapter that might overshadow it, and the second failed because of the capture of Granada and the natural preference that Queen Isabella felt for the city that she had won by her own endeavours. For a few years Toledo, the old favourite, suffered the indifference of her monarchs, who devoted more time and attention to Granada. But the coolness was only slight and was soon compensated by the young emperor, Isabella's grandson.

Even though San Juan de los Reyes never achieved its high destiny and the burial chapel (which is all that the church really is) remained empty, it nevertheless succeeded in becoming one of the best-endowed

▷

Toledo. San Juan de los Reyes, the nave with its beautiful vaulting.

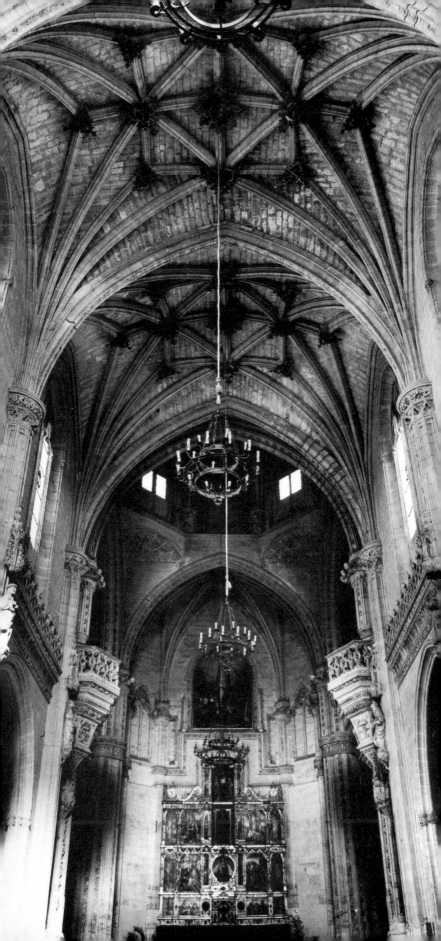

Toledo. Hospital de Santa Cruz.
The rich and elegant portal.
in early Plateresque style,
designed by Alonso de Covarrubias.
In the tympanum,
Cardinal Mendoza,
founder of the hospital,
is adoring the cross.

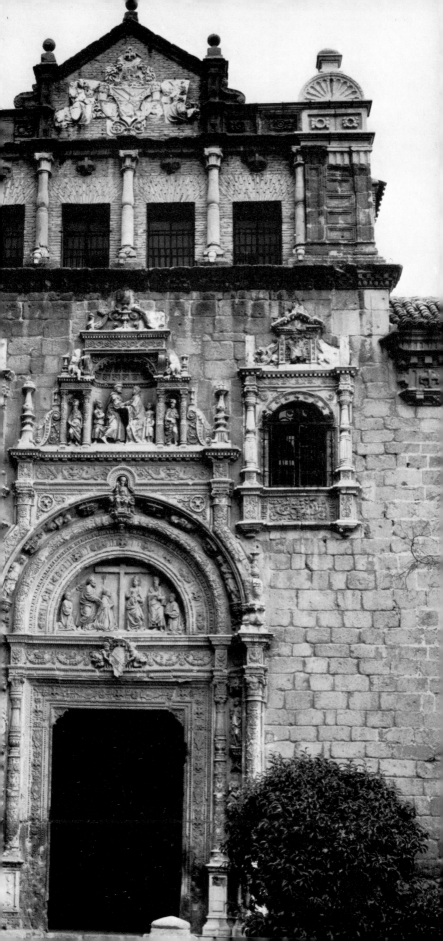

and richest foundations in Spain, possessing vast art treasures and a library whose collection of codices and rare manuscripts is beyond price. But the inconceivably ruthless pillaging of the French soldiery and the chaos of the War of Independence combined to sweep most of it away. For many years San Juan de los Reyes stood in pathetic though poetic ruins and only very gradually was the skeleton of the old building reconstructed. All Spain of the Romantic Period fell under the spell of the ruins of San Juan de los Reyes; the poet Gustavo Adolfo Bequer, for instance, published a study of the building in 1857, though it is more of a dirge dedicated to its old, evocative stones, imbued with a combination of enthusiasm for past glories and bitter melancholy arising from the spectacle of disintegration and decay. Today the ruins have been transformed by a reconstruction that was certainly painstaking but perhaps rather cold and heavy-handed.

The most interesting of the preserved parts of the old monastery are the church and the cloisters, the latter in particular being entirely restored. The church is of the monastic type so frequently found at the time of Ferdinand and Isabella, consisting of a single nave with chapels in between the buttresses, a raised choir and a transept which formed a unit with the chancel. It is really made up of two very separate parts, the transept and the Capilla Mayor or chancel, conceived together as a monumental burial chapel and the nave. All the lavish and elaborate decoration is reserved for the sanctuary, for the royal sepulchre, while the nave and the choir are plain and simple appendages necessary for the monastic services. The two parts of the interior used to be separated by a screen which no longer exists. From the outside a glance at the building shows the difference between the two parts—one of them profusely decorated with Gothic tracery, fretwork windows, filigree-like pinnacles, heraldic figures, lanceolate battlements with their lively, eye-catching outline, the other smooth, sober and monastic. The creator of this place of worship of unusual, if sometimes rather forced, originality was one of the most fascinating architects of the period of Ferdinand and Isabella and one of the most effective exponents of the impetuous, flamboyant style of his time. Juan Guas, a native of Lyons, had come to Spain probably with the group of Flemish artists under the leadership of Hannequin of Egas, known as Hannequin of Brussels, who was responsible for the spread of the Hispano-Flemish Gothic style throughout the city. Furthermore Juan Guas was of an adaptable turn of mind and so was able to absorb the spirit of the vigorous Mudéjar art of his adoptive country and introduce it into his work, marrying it in a most individual way with the Gothic style of the north. Thus inside San Juan de los Reyes one finds friezes consisting of designs, influenced by Mudéjar art and particularly by its extensive use of woodwork. Even the method of composing the decoration which completely fills immense surfaces without, as it were, pausing for breath or leaving gaps, is nothing if not typically oriental. It seems that Juan Guas considered San Juan de los Reyes the crowning peak of his achievements for so he had it recorded, *'fizo a Sant Juan de los Reyes'* in the chapel in the church of San Justo where he is buried.

The battle of Toro took place in 1476, and the convent must have been already under construction at that time but without the splendour which later came to it as the result of the royal vow. Building took place during the war for Granada, and the chains one can see hanging from the walls once held Christian captives who were

*Toledo. San Juan de los Reyes, the transept with the escutcheons
of the Catholic Monarchs. Lithograph by Pérez Villamil. Author's collection.*

liberated at the fall of Málaga, Almería, Baeza, Alhama and other
places in the kingdom of Granada. The shields decorating the walls
of the transept do not include a symbolic pomegranate (*granada*)
among their coats of arms, conclusive proof that they were made before
1492; inscription running all the way round the transept at the
height of the capitals commemorates the expulsion of the Jews and
the capture of Granada. The building of the beautiful cloister in the
Hispano-Flemish style must have taken place at a slightly later date,
for all along the lower gallery runs an inscription which mentions,
among other things, the death of Queen Isabella in 1504. Enrique
Egas must have taken over the work on this cloister from Juan Guas;
he succeeded him also as superintendent of the main work of the cathe-
dral. The architecture of the cloisters shows the intricate, decorative
style of Egas, more restrained than that of his flamboyant predecessor.
Cardinal Mendoza, trusted counsellor of the Catholic Monarchs from
when he took part in the battle of Toro onwards, managed in a

Toledo. Hospital de Santa Cruz, Renaissance courtyard and (right) exterior.

short space of time to extend his influence to the point where he gained his nickname, 'Third King of Spain'. Scion of the one of the most distinguished land-owning families of Spain, that of Santillana-Infantado, he was a patron of the arts like all other members of his family, while his literary education made him a humanist. With the rest of his family he helped the Italian Renaissance to spread and take root in Spain, as in shown by the foundation of the Colegio Mayor de Santa Cruz in Valladolid, which is the first Castilian civil building to show clear signs of the influence of the classical era. The culmination of a brilliant ecclesiastical career was his accession in 1482 to the archbishopric of Toledo, twelve years before he was to die. He played a decisive part in the finishing of the cathedral, building the last remaining part of the vaulting, so as to enjoy the sight that had been laboriously achieved over the centuries. He had his own tomb built in the presbytery, and Queen Isabella, who was the executrix of his will, gave it her personal care. It is a magnificent cenotaph in the style of Andrea Sansovino, apparently based on an Italian design. His greatest enterprise was the Hospital de Santa Cruz which stands on the most easterly side of the city near the Plaza del Zocodover, on a spot which used to be occupied by the very ancient palaces of the Visigothic and Moslem Kings. Pedro González de Mendoza obtained permission by papal bull from Pope Alexander VI in 1494 to construct the monastery, but he died shortly afterwards, entrusting the building to the care of the queen and the royal dukes.

A site having been chosen, no easy task, work began in 1504 according

to plans drawn up by Enrique Egas, who was the cathedral's chief master-of-works at that time. The first part to be built must have been the central cruciform part, the typical ground-plan of the hospitals built by the Catholic Monarchs, conceived as a vast cross with arms of equal length on two floors. In this way the wings of the infirmary were at the same time the nave of the church, and since the altar is placed at the centre of the cross, the patients were able to participate in the services from their beds. This gigantic cruciform edifice is one of Toledo's most imposing architectural features, and rather difficult to define from the point of view of style. It is in the main Mudéjar and Gothic with a few Renaissance touches pushing their way timidly in, like new shoots through the mass of a tree's old foliage. The great panelled ceilings, some of the best of Mudéjar carpentry, give the interior the unmistakable flavour typical of Toledo.

Many years later the courtyards surrounding the main building were gradually completed, and so were the vertical planes of the façade and lastly the elaborate doorway. By this time the great architect of the sixteenth century, Alonso de Covarrubias, was already working on the building. He was born in 1488 in Torrijos, a town near Toledo, and started life as a sculptor. It was he who carved the tombs of Tello de Buendía and the Archdeacon of Calatrava in Toledo Cathedral. During his youth he was employed on various buildings in Sigüenza and Guadalajara, though whenever he was needed he used to go back to Toledo to draw plans or give advice. He settled in Toledo when he was commissioned to build the Capilla de los Reyes Nuevos in the cathedral, which is really a whole church in miniature in the plateresque style of exuberant surface ornamentation typical of the Spanish Renaissance. In 1527-34 he built the doorway of the church of

the Convento de San Clemente in Toledo which, with its supple rhythms, richness and variety can be considered a model of early Renaissance art in Castile. It was at this stage that he must have turned his attention to the work on the Hospital de Santa Cruz, designing the main courtyard and the superb stairway, which became a prototype for many others later, including some by Covarrubias himself, such as that in the archbishop's palace at Alcalá de Henares, now disappeared.

The great doorway of the Santa Cruz Hospital is extremely original and even slightly disconcerting. The arrangement of a succession of archivolts in such a way, one after the other, as to create a sort of sculptured tympanum in the middle shows a Gothic influence that had not yet disappeared. Some details border on caprice and fantasy, like the half columns which are carved to follow the line of the archivolts. Everything about this door is fanciful to the point of licence and it marks the high point of its author's feeling for the Plateresque style. The effect as a whole and the diversity of artistic inspiration manifested in this hospital make it a breathtaking building to look at; its naves are grandiose, it breathes serenity in the symmetrical harmony of its courtyards and the refinement and beauty of its decoration. A series of museums and cultural bodies are now very appropriately grouped together in these buildings. There is first of all the Museo de Santa Cruz which recreates the atmosphere of the imperial Toledo of Charles V, and houses magnificent tapestries, period furniture, silver, bronzes, manuscripts and so on, apart from painting and sculptures. At the end of the main nave hang the banners and standards from Don John's flagship at Lepanto.

The El Greco paintings, of which there are eighteen exhibited in this museum, deserve a special mention, for the collection includes such

El Greco
The Coronation of the Virgin,
c. *1590, Museo de Santa Cruz,*
Toledo.

exceptional works as the *Assumption* which belonged to the church of San Vicente. It was only finished in 1613, just a few months before the painter's death. It is universally thought to be the painter's most remarkable creation during the last period of his work. The museum also contains canvases by Antonio Moro, Pantoja, Tristán, Ribera and Goya. Recently it has acquired an altarpiece by Alonso Berruguete moved from its former place in the Ursuline convent.

The same building also houses the Museo Arqueológico Provincial. In the main its collection consists of Roman mosaics, architectural fragments from the Visigothic period, some noteworthy stones with epigraphic designs and pieces of Arab and Mudéjar pottery, as well as some other works of art of various origins. Lastly there is the Casa de la Cultura, which has a well-stocked library formed by Cardinal Lorenzana.

The second of the great hospices of Toledo, was established by Cardinal Juan Tavera, Archbishop of Toledo, President of the Supreme Council of Castile and Governor of the Kingdom during some of the absences of the Emperor Charles V. In a letter to the cardinal from Spira the emperor wrote on 5 February 1541: 'Diego de Guzman told me about the Hospice that you wish to build and endow near the Bisagra Gate in Toledo. It gives me great pleasure that you should want to do such a noble thing which will be of such service to our Lord. The site seems to me a good one and so with all blessings you may start work.' Work was indeed started immediately according, it is said, to the plans of Bartolomé Bustamante, private secretary to the cardinal, but under the direction of Alonso de Covarrubias, who held an undisputed postion as Toledo's greatest architect at that time. In 1545 Juan de Tavera died, so progress on the building was slowed down though not actually interrupted. In the year 1549 Bustamante entered the Society of Jesus and so Covarrubias and other well-known masters of a younger generation, such as Hernán González de Lara and the two Vergaras, father and son, carried on with the work. The church was begun in 1562, according to the plans of González de Lará, and was not finished until 1624. The architecture of the Hospital Tavera illustrates very well the transition to a more sober, less ornamented style which was to find a major exponent in the architect Juan de Herrera and in his patron Philip II when he was chosen for the building of the monastery of the Escorial.

In the main façade, which unfortunately remained unfinished, Covarrubias has replaced the decorated surfaces of Plateresque style by a more restrained treatment, covering them only with a pattern of relief work in the Mannerist style. The double courtyard is divided by a colonnade leading to the church and is a masterpiece of grace and harmony, soberly executed yet with a light Renaissance touch. The church, begun later when Covarrubias was already old and tired and about to retire, is an excellent example of the plain and unencumbered architecture of the end of the sixteenth century. The most original and successful elements in it are its external features, which are hard and clear-cut, dominated by a cupola of octagonal form placed between four obelisks. A year after beginning work on the church of the Hospice, the foundations of the monastery were laid.

The cardinal's tomb, which is a renowned work by Berruguete and

◁

Toledo. Hospital Tavera, named after its founder,
who was counsellor to Emperor Charles V, was founded in 1541.

one of his last and most dramatic achievements, was placed in the centre of the church. The plan was that El Greco should design and paint the central altarpiece and its wings, but this never came to fruition for the painter died in 1614 and quite a few of his canvases were dispersed; the only one remaining in the Hospital Tavera is the one representing the *Baptism of Christ.*

Recently a few of the rooms of the hospital have been restored by the Dukes of Lerma, patrons of the foundation, who have converted them into a veritable museum. On view there: portrait of the cardinal by El Greco, painted after the sitter's death, probably with the use of a death mask obtained by Berruguete, another El Greco, the *Holy Family*; and an extraordinary Ribera depicting a woman with a beard, which odd fate apparently afflicted a certain Calabrian woman.

It is tragic to think that great collections of paintings executed by El Greco, which would today excite universal admiration and constitute one of the city's most precious treasures have been lost either through the upheavals of time or, what is worse, through sheer cultural ignorance or sordid desire for gain. Since the project for the great composition of the altarpiece of the church of the Hospital de San Bautista miscarried, there remain in Toledo only the series from the Convento de San Domingo el Antiguo and the Capilla de San José. The remarkable church of San Domingo was begun in 1576 with a legacy from Doña María de Silva, a Portuguese noblewoman who had come to Spain with Empress Isabella and had died a nun in this convent. The architecture is by Nicolás de Vergara and the altarpieces were the first work undertaken by El Greco in Spain between 1577 and 1579. The only portions remaining are the *Two Saint Johns* of the central part, and the *Adoration of the Shepherds* and the *Resurrection* from the wings, and the grandiose general effect, where earthly trappings begin to be tinged with mysticism, has been lost.

The same could be said of the Capilla de San José, founded by the knight Martín Ramírez with the intention of dedicating a convent to St Teresa who lived in one of his houses on the site where the chapel now stands. The architecture of the shrine, which was consecrated in 1594, is very simple but is lavishly and tastefully decorated. The central altarpiece still displays two paintings by El Greco, one of *St Joseph with the Child* and one of the *Coronation of the Virgin*, but the side pieces representing a marvellous figure of *St Martin on Horseback*, and the *Virgin between St Inés and St Tecla* have been removed and are now on view in the National Gallery of Art in Washington.

Cardinal Siliceo was no different from his predecessors where the patronage of the arts in Toledo was concerned. To him we owe the grilles of the main altar and the choir in the cathedral, the beautiful pulpits by Villalpando and many other splendid decorations. He was the founder of the Colegio de Infantes, still standing, in which one can admire one of the most exquisite and cunningly conceived portals of the Spanish Renaissance. It is the work of Villalpando and seems to be a reproduction of the design of a title page of a book of the day. The cardinal also created the Colegio de Doncellas Nobles where he is buried, a handsome building but from the artistic point of view not a particularly distinguished one.

Outstanding among so many impressive constructions erected in Toledo in the sixteenth century is the Alcázar, both because it was the royal

▷

Hospital Tavera, Renaissance courtyard, designed by Alonso de Covarrubias.

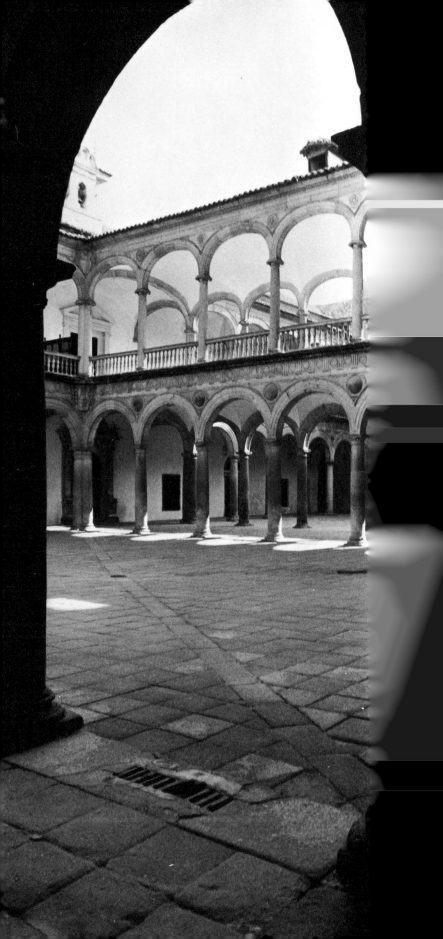

residence and also because of its imposing proportions and importance. True we are not dealing here with a building actually begun in the sixteenth century, for its origins date back much further, but it was so fundamentally altered and enriched in the sixteenth century, that in the form in which it has come down to us it can be considered to belong to that period.

It is generally believed that Alfonso VI had a fortress built on the site after he had relieved Toledo, though it is more probable that he enlarged, improved and altered some other buildings of a military character that must have existed there since Roman, Visigothic and Moslem times. Alfonso VIII, Ferdinand III, John II and the Catholic Monarchs improved and embellished the old fortress according to their tastes, and a little of the medieval building can still be seen on the projecting façade which might date from the time of Alfonso X though it has been extensively reconstructed.

This is the state in which the Alcázar was to be found at the beginning of the sixteenth century, a heterogeneous mass of various periods and styles lacking in unity and harmony, until Charles V, who had always held Toledo in affection, decided to convert it into the best and most luxurious residence in his kingdom. He entrusted the alterations, equivalent in fact to rebuilding the whole thing, making use of just a few of the old walls and vaults, to Alonso de Covarrubias, and the general conception of the Alcázar-cum-palace was his creation. He planned a structure of the utmost symmetry, using a large Renaissance courtyard as a base with corridors all round, leading to the very compact block with corners marked by projecting towers following the traditional pattern of military architecture. The main façade facing to the north and the courtyard are Covarrubias's most characteristic designs. Few other façades could possibly have better illustrated the imperial concept—all is grace, nobility and rhythmic regularity. The imposing proportions, powerful towers, the solemn deliberate spacing, the daring and individual battlements are the typical elements. And the ashlar stone relief work, instead of emphasizing the lower storey as it does in Florentine palacees, reaches up to the upper gallery, continuing a feature of the Isabelline style already exemplified in the Palacio del Infantado in Guadalajara, the work of Juan Guas. The handsome doorway is itself a patent of nobility, with the emperor's coat-of-arms presented between two macebearers with their wide sleeved tunics covered in heraldic designs. In a word, it is a Renaissance façade which reflects Italian ideas in a few details but remains intrinsically Spanish in its basic concept.

The courtyard is also a superb archetype of the Spanish version of aristocratic Renaissance architecture, resembling the Hospital Tavera in general lines but with a stronger presence owing to its grander dimensions. Throughout the series of courtyards with porticoes which he built, Covarrubias had been gradually refining his architectural expression; in the Hospital de Santa Cruz it is still rather Plateresque in manner, Italian 'quattrocento'; then there is the well-designed courtyard of the convent of San Pedro Mártir, also in Toledo, which has a more popular character with its mixture of curved and straight arches; and there are the courtyards of the bishop's palace at Alcalá de Henares and the Convento de Lupiana in Guadalajara, the latter of particularly vigorous inspiration.

Finally there are the Tavera and Alcázar courtyards, where the upper story of the latter displays the influence of the architect's followers, disciples and apprentices in whose work an austere geometrical style

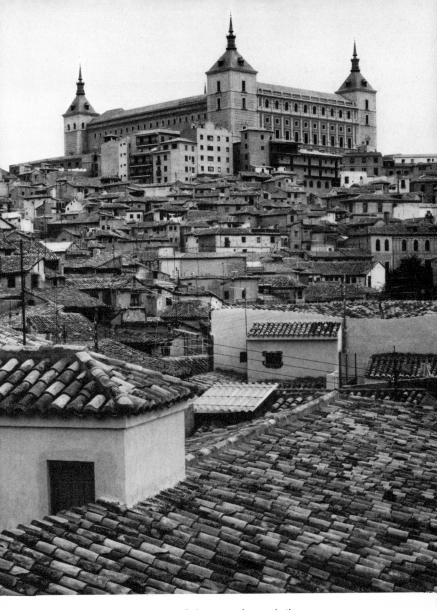

*Toledo, the Alcázar, a Moorish fortress palace, rebuilt
in the 16th century by Alonso de Covarrubias and other architects.*

was emerging, result of the more advanced ideas originating from the
teaching of Serlio and Juan Bautista de Toledo.
The great enterprise of renovating the Alcázar was begun on the main
façade in 1537. The doorway was started in 1546, at the same time
as the work on the front of the Puerta Nueva de Bisagra, another
of Covarrubias's works showing the same exalted love of heraldry.
At this stage one floor of the courtyard had already been completed.
In 1550 the designing of the gallery of the upper floor was awarded to
Hernán González de Lara who failed to fulfil the conditions to the
letter and so had to give way to Francisco Villalpando and Gaspar de
la Vega, who finished it in 1554. Villalpando, the great designer in
ironwork, also translated the third and fourth books of Serlio, published
in Toledo in 1563, which from then onwards were held in great
esteem by all Spanish architects.
A great controversy has always reigned over the main staircase of the

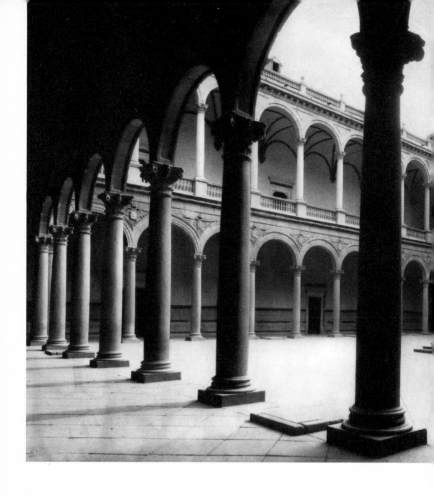

Alcázar. The designs Covarrubias had drawn up must have been set aside in favour of one by Villalpando, almost certainly at the instigation of Philip II who wanted it to be very grand, taking up the whole of the southern face of the courtyard. It was started in 1552 but work must have progressed very slowly, for Villalpando died in 1561 and only the first flight had been built. Construction must have continued under Juan de Herrera, whose work so closely imitated Serlio's, that it is hard to distinguish between master and disciple. There was only the southern façade to be completed, the one which involved the staircase. Juan de Herrera drew up the plans for this after the death of old Covarrubias. Herrera enjoyed the unreserved patronage of Philip II and was consequently the artistic dictator of his period. In 1558 it was finally ready. Herrera had created one of his most Italianate works, inspired both by Serlio and Vignola. Its height is reminiscent of the façade of the Villa Farnese at Caprarola, and stone and brickwork are used together to harmonious effect. The only Hispanic detail about it, which seems to be a discreet homage to Covarrubias, is the arcade of the uppermost storey.

The Alcázar of Toledo is one of the most unfortunate and ill-fated buildings in the history of Spain. What had been a superb palace, without rival at the time of Charles V, the Holy Roman Emperor, and Philip II, was destroyed and reduced to utter ruin during the war of the Spanish succession. In 1710 the troops of Archduke Charles of Austria occupied it and then set fire to it when they had to abandon it on 28 November of the same year. With great energy and patriotic feeling it was rebuilt by Cardinal Lorenzana, who asked Charles III

Toledo. Renaissance courtyard in the Alcázar, completed 1554.

of Spain to grant it to him in order to have it converted into a Royal Charitable Institution. This in turn was destroyed by the military in 1810, just a hundred years later. It lay in ruins again for a long time, until 1854, when it was once more rebuilt for the purpose of serving as a College of Infantry. This was completed in 1857, but it was yet again destroyed by an accidental fire, which meant it had to be rebuilt for a third time. This brings us to the present century, to the year 1936, during the Spanish Civil War, when the Alcázar was the scene of a famous and heroic exploit, the ten-weeks' siege by the Loyalists and its subsequent relief. A sad and almost unbelievable history this martyred building has had! Today its outline once more stands out sharply against the sky of Toledo but its architecture has ended by being cold and harsh, lacking the nobility of the original and the patina of centuries.

One of the most elegant achievements of civic architecture in Toledo is the pretty Ayuntamiento building. There is no doubt that the original plans for it had been conceived by Juan de Herrera, and it seems to have been started around 1575. The ground floor in the form of a terrace and the first floor arcade of Doric arches could not be more typical of Herrera's work, purer or better designed. It is noticeable that he had not forgotten the lessons of Juan Bautista de Toledo. The upper part in the Ionic order is rather puny, and has been attributed to Jorge Manuel Theotocópuli, El Greco's son. The towers were supposed to be extended at a later stage, to judge by the elaborate notes on his sketch.

The capitals, which turned out very much in the style of Madrid, were copied in the last and the penultimate rebuilding of the Alcázar.

Inside it is worth noting the coloured tiles in the summer chapter house in the ground floor.

Echoes of the reigning Herrera style of the late sixteenth century, mentioned in connection with the cathedral, are the various buildings started by Cardinal Sandoval y Rojas, uncle of the powerful Duke of Lerma, protegé of Philip II and one the last art-patron archbishops of Toledo to be known for splendid building enterprises. The chapel of the Virgen del Sagrario, the Ochavo, the sacristy and the courtyard and adjacent annexes form a complex which Tormo once called an Escorial in miniature. The artists working on it were Nicolás de Vergara the Younger (d. 1606), Juan Bautista Monegro (1546-1621), and Jorge Manuel Theotocópuli (d. 1631), who all had different artistic backgrounds and only accidentally became architects.

Toledo in decline

After having been abandoned by the court one day in the year 1561, when it moved to Aranjuez, never to return, Toledo society began to realize, unconsciously at first, but slowly more and more acutely, that its historical destiny had changed once and for all. At first it would have seemed a matter of chance or accident that the little town of Madrid should enjoy the favour of Philip II, who preferred to administer his vast dominions from there. However the move, which was never officially announced but day by day confirmed and corroborated, must have been accepted gradually. Toledo had ceased to be the capital of Spain and slowly a new destiny was beginning to take shape, one that would lead it to inevitable decline. Industry in Toledo was still functioning very prosperously and thousands of families lived from the manufacture of silk, wool, velvets and from embroidery, ceramic work, swordmaking and ironwork, but Toledo was soon to suffer a terrible blow to her economy when the Moors were expelled in 1609. This brought with it an increasing depopulation of the town, the nobility leaving in order to move closer to the seat of the court, clerks and attorneys departing to follow the administration and the Councils, and tradesmen on finding their business ruined and themselves unemployed; and the artists going because they lacked commissions. The ecclesiastical class survived, clustered around the archbishopric, whose radiance could not be dimmed. It supported, along with the church dignitaries, a host of theologians and scholars of aesthetics, canon law and and humanities. With the help of talented laymen they kept alight the torch of literature in Toledo, which had shone so brightly at the time of Covarrubias, Salmerón, Rivadeneyra, Garcilaso, Medinilla and Mariana and which had always been helped by the flourishing local printing industry.

Thus José Maria Quadrado was able to say: 'When the light of her greatness began to wane it caught such brilliant golden reflections and coloured the sky with such a variegated cloud-scape, blew with such a perfumed breeze and spread such a serene peaceful feeling of calm, that her hour of decadence took on the air of strength, so that the evening seemed to shine more brightly than noontide.'

When Toledo was thus laid low, a strong new religious order, the Society of Jesus which had already spread throughout Europe and whose impressive establishments bore witness to its power and the glory of Baroque art, boldly undertook the construction of its great convent in the highest part of Toledo, next to the church of San

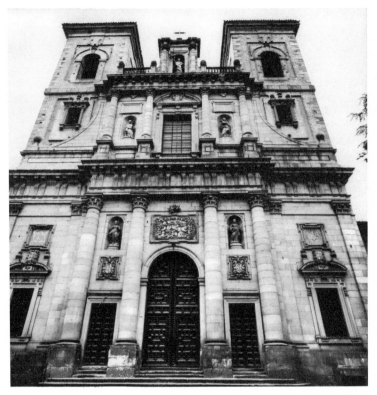

Toledo. Façade of San Juan Bautista, 17th century, formerly a Jesuit church.

Román, in one of the houses belonging to the Toledo family. Tradition has it that it was here that St Ildefonsus was born and for this reason the new convent was called after him. Along with the splendid house was constructed a superb church, the work of Francisco Bautista, lay brother of the Society, the same man who worked on the Colegio Imperial in Madrid and who was very active in the mid-seventeenth century. The Jesuit church, which was converted into a parish church under the name of San Juan Bautista after the expulsion of the Order, is one of the best examples existing in all Spain of the Vignola style which the Jesuits adopted after the construction of Il Gesù, the parent church of the Society in Rome. It is built with a single nave and chapels, a large transept and a dome above the crossing. The façade is worthy of special consideration, for Francisco Bautista admirably solved the problem of incorporating two towers into the design for the façade of a small shrine, producing a neat and attractive new version of a traditional combination.

But Cardinal Siliceo professed great enmity towards them and it was only when be died and Bartolomé Carranza acceded to the archbishopric after him that tthe disciples of St Ignatius were able to put down roots in Toledo. But they were delayed in obtaining a house of their own and wandered through various places and colleges. This perhaps turned out for the best where Toledo is concerned, for it thus acquired an addition to its catalogue of monuments in the shape of a great Baroque church; had it not been built, this style would hardly have been represented in the town.

Actually Toledo does possess a very singular example of the last

phase of Baroque art, though it is not really a building but only an altar in the middle of the cathedral. The world-famous *Transparente* is considered by some to be the result of the delirium of an unstable mind, and by others—and this is the more modern view—to be the climax of the Baroque genius, a sumptuous creation where architecture, sculpture and painting, enhanced by theatrical effects of light, combine to form one of the most imaginative examples in the field of plastic art. The *Transparente* was commissioned by Archbishop Diego de Astorga y Céspedes, and made between 1721 and 1732 by one of the most interesting masters of Spanish Baroque, Narciso Tomé.

But apart from this monument Toledo has very little to show in the way of Baroque art. Of this the main examples are the following: the Baroque churches of the Capuchinas de la Inmaculada Concepcion and of the Benitas Recoletas, the former by Bartolomé Zumbigo; the portal and decoration of the tower of the church of San Justo y Pastor; the eighteenth-century residence of the working canons of the cathedral, now an old peoples' home, in the Calle del Locum; the pretty house at No. 18 in Calle de la Silleria and a few other gateways here and there.

In curious contrast to the otherwise eminently medieval, picturesque character of the city, Toledo can boast a few very noteworthy examples of neoclassical art, something rare indeed on the architectural map of Spain. This is due to the fact that Cardinal Francisco Antonio Lorenzana arrived from the archbishopric of Mexico to take over Toledo with such a decided will to reform and regenerate everything under his authority, that the work he accomplished is to be seen all over the town; and not only in the concrete but in the spiritual field as well, for his charity, paternal government and love of letters have also gained him a safe niche in history.

Having been trained in the principles of the Enlightenment, he followed, where art was concerned, the academic doctrine that sought to restore to it the purity of the classical rules. On arrival in Toledo he rebuilt the Alcázar into a Real Casa de Caridad, employing the famous architect Ventura Rodríguez to execute the work. Afterwards he turned his attention to his own archbishop's palace, which he wanted to rebuild from its foundations though he never succeeded in doing more than half of it. The side facing east,, overlooking the Calle del Arco del Palacio, is the work of Lorenzana from plans most likely by Ventura Rodríguez, his principal architect. When the latter died in 1785, an excellent young pupil of Sabatini's called Ignacio Haan must have been recommended to the archbishop when he decided to build the Hospital de Dementes, called 'El Nuncio', afresh and on a better site. It is a simple but impressive building, rigorously symmetrical and intelligently planned, started in 1790 and finished in 1793. A little later the young architect was faced with a more exciting challenge when he was entrusted with the plans for a new university—the present Instituto de Segunda Enseñanza—on which work was started in 1795, also at the expense of the generous archbishop. It is a superb building ranking as the best of its style in all Spain after the Museo del Prado in Madrid.

The last important work of Ignacio Haan that we know of is the Puerta Lana on the southern front of the cathedral. It was finished in 1800, the very year that Don Luis María of Bourbon, a royal prince of Spain, became archbishop of Toledo. Lorenzana, the last archbishop to be a great patron of the arts, had left Toledo in 1798 due to quarrels with Godoy, the powerful favourite of Charles IV, and sought refuge

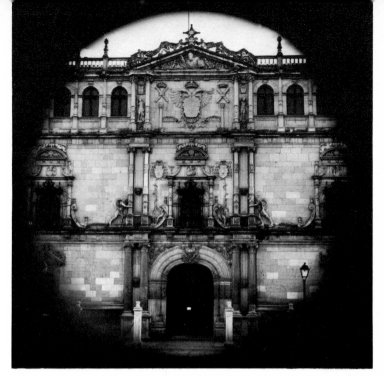

Alcalá de Henares, the Plateresque façade of the university by Rodrigo de Hontanon, 1541-53.

in Rome, where he died in 1804 without having had to witness the misfortunes that were to befall his native country.

Whether or not it was the style most befitting the character of Toledo, neoclassical is the closing chapter in the architectural history of Toledo, for since 1800 no building worthy of mention in an architectural history has been erected on the city's rocky soil.

Alcala de Henares

The town of Alcalá de Henares is a successor to the Roman Complutum, which was situated to the west of the present city and was of considerable importance. It was here during the Roman occupation that the martyrdom of the child-saints Justo and Pastor took place. When the ancient Complutum was devastated by the Vandals, the ashes of the martyrs remained buried until they were found by St Asturio, Bishop of Toledo, who founded a sanctuary to commemorate the discovery approximately on the spot now occupied by the Iglesia Magistral, in the crypt of which the relics lie. During Arab rule the position of the town was once more changed and it was rebuilt on a hill overlooking the river Henares from which it acquired the name Al-Kal'a Nahr (Castle on the Henares). The remains of the former settlement are today known as Alcalá la Vieja.

When Toledo was conquered by Alfonso VI, Archbishop Bernard de Sedirac seized Alcalá in 1118 and from then onwards it was a subsidiary of Toledo and particularly of its archbishopric. At the time of Rodrigo Jiménez de Rada the town was christened 'the archbishop's court', and for many years the archbishops of Toledo had a palace there which they were constantly enlarging and enriching. Alcalá became, if not by law at least in practice, a fief of the archbishops, and consequently its history and art run parallel to those of the city of Toledo.

Once Cisneros had been raised to the primacy of Toledo, he conceived the idea of creating a college and faculties for the teaching of the liberal arts, theology and canon law in the same way as they were studied in Valladolid, Salamanca and other universities. The Colegio Mayor was the first part of the project and its first stone was laid by the cardinal on 14 March 1498. From then on Alcalá was, after Salamanca, the most important university city in Spain until the university was transferred to Madrid during the nineteenth-century period of reforms and centralization. But the University of Madrid is still known as Universidad de Madrid-Alcalá and also as the University Complutum. Cisneros, desirous of bringing fame to the new university and arming the world against the threat of heresy, prepared the publication of the famous *Biblia Poliglotta Complutensis* on which the greatest scholars of the Hebrew, Greek and Latin languages had worked. He was lucky enough to see his prodigious undertaking run its course to the very end, for the Bible took fifteen years to produce and the printing was finished in 1517, the very year the cardinal died at Roa in Burgos while on his way to meet the future Emperor Charles V.

Cisneros, whose love and predilection for Alcalá de Henares were the origins of its prosperity, stipulated in his will that he should be buried in the chapel of the Colegio de San Ildefonso, which is the university college which he had himself founded. Hence he is one of the few archbishops of Toledo not to have been buried in the cathedral, nor in the city whose primacy he held. His tomb was carved by the distinguished sculptor from Burgos who had been trained in Italy, Bartolomé Ordóñez. It was badly damaged during the Civil War in 1936.

But even if the shade of Cisneros did not succeed in conferring greatness on Alcalá de Henares, it was nevertheless here that the greatest Spanish genius, Miguel de Cervantes Saavedra, was born. He was baptized in the church of Santa María la Mayor on October 9, 1547 in the chapel that is today the only part of the original church still standing. Recently a house has been rebuilt that is supposed to recall the atmosphere of the birthplace of the author of *Don Quiote*.

Alcalá de Henares used to be full of impressive buildings but during the period of its decadence, and especially during the Civil War, it suffered very badly. In the war the old archbishop's palace with its lovely courtyard by Covarrubias was almost completely destroyed and the Iglesia Magistral suffered severe damage. There are still a few interesting religious houses left, particularly one rather impressive one belonging to the Jesuits, and a few handsome brick buildings which used to form part of the university.

During the time when it was a university town the main building always was the Colegio Mayor de San Ildefonso founded by Cisneros. The oldest preserved part is the chapel, begun in the cardinal's time and beautifully decorated in Gothic-Mudéjar plasterwork. The main front of the exterior is very plain, crowned by a belfry in the Herrera style. The college hall, built between 1518 and 1519, is a handsome rectangular room surrounded by Plateresque galleries with intricate plaster decoration in a style typical of Cisneros. The Moorish carved ceiling is an amazing piece of woodwork, looking like a great starry canopy.

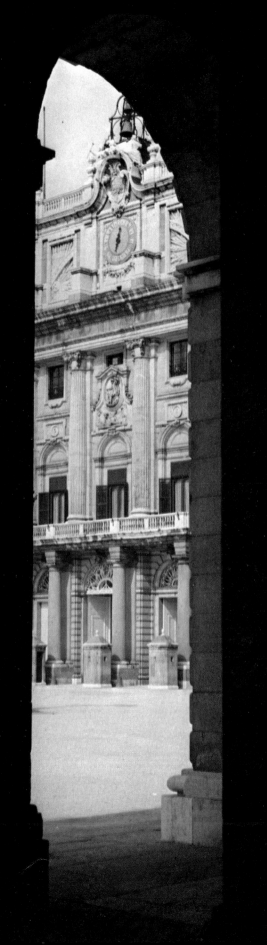

The present great stone façade of the university is the work of the architect Rodrigo Gil de Hontañón, who began it in 1543. Its distinction, its skilful composition and beautiful rhythms, and its well-chosen and appropriate ornamentation make it the Plateresque façade which best illustrates the glorious period of the Emperor Charles V, whose coat-of-arms hangs in the middle of it. The first courtyard is in the classical style, sober and elegant, rather later than the façade (1662). The magnificent triple courtyard was built in 1557, by Pedro de la Cotera.

Madrid, aerial view. In the foreground, the Nuestra Señora de Almudena, and the gardens of the Campo del Moro; Plaza de Oriente on the right.

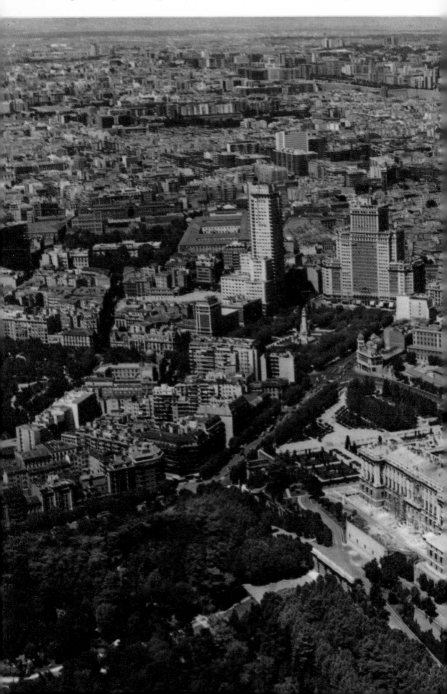

Madrid in history

The name is said to be derived from the Arabic *Magerit* or *Macherit* but the etymology is obscure and doubtful. For the Arabs it served as a kind of outpost or stronghold defending Toledo and secured the vital communication link between Toledo and the Alcarria, the road that ran along the Henares under the lee of the Sierra de Guadarrama and opened the way towards the lands of Aragón. Madrid was 'the famous castle that dispels the fear of the Moorish king' to quote the well-

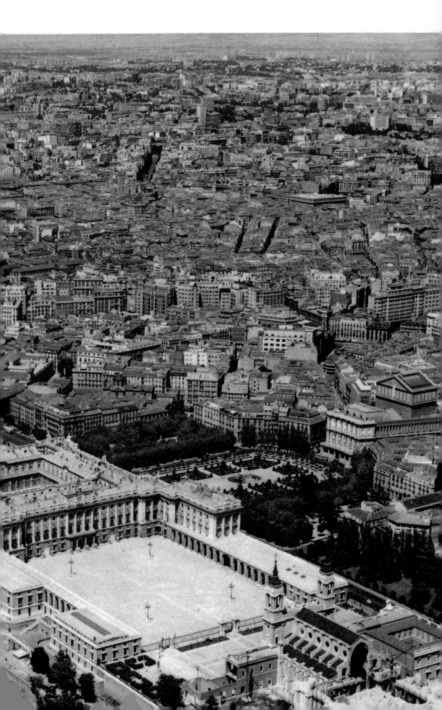

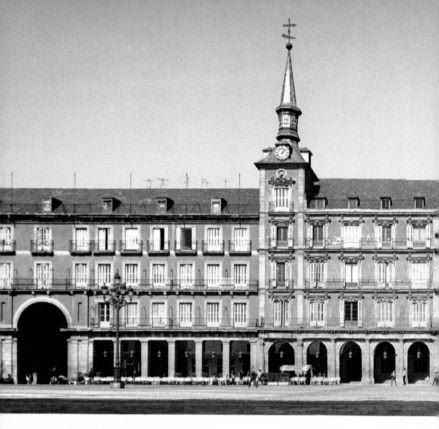

Madrid. The Casa de Panadería, 1617-20, in the Plaza Mayor.

known ballad by Nicolás Fernández Moratín. And when the Moorish king lost all, Madrid was the first to fall. After Alfonso VI conquered Toledo in 1085, Madrid became linked to the Christian kingdom. At this point therefore Madrid's strategic role changed, but under other auspices it continued to gravitate around the larger planet with no apparent likelihood of any change.

The importance of Madrid had always lain in its fortress, well placed, at a good height, overlooking the narrow Manzanares running at its feet. The population, insignificant in size, huddled against the protective walls of the Alcázar whose fortifications formed a double row of ramparts. The first surrounded a small citadel or *almudaina* consisting of administrative buildings and the main mosque which later became the church of Nuestra Señora de Almudena, and the second, larger one enclosed and protected the dwellings of the majority, that is, the proper town which developed from the Arab *medina*.

Before and after the conquest there lived in Madrid a heterogeneous population made up of Arabs, Christians and Jews, much as in Toledo, who experienced similar historical vicissitudes. Sometimes the Moors and the Jews, who practised usury and thereby provoked hatred and conflicts, demanded the intervention of the royal authority as mediator, as in the case of Sancho IV in 1293. In 1391 or 1392 a serious and bloody attack on the Jews of Madrid occurred, which evoked prompt and retaliatory action, though in the late Middle Ages, in 1481, Moors and Jews were invited to enliven the feast of Corpus Christi with their dancing and games.

There can be no doubt, therefore, that in the Middle Ages Madrid was a typical Mudéjar city very like all others of similar history. The governing and landowning classes changed from time to time but the lower echelons, tradesmen and labourers, continued in much the same

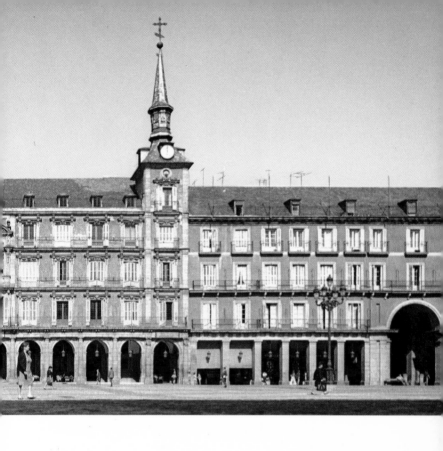

way. Only the alcázars and palaces changed proprietors; mosques were converted into churches, the bustle and movement around the corn exchange and the raw silk exchange continued with the same merchants and the same indefatigable craftsmen. Activity in the building trade was maintained by Moorish architects, who had inherited the talent and the functions of their forebears. They built new churches with towers that looked like tall, thin minarets, so much so that the two remaining from medieval Madrid, that of San Nicolás and San Pedro, have erroneously been considered to be such.

In the thirteenth century Madrid was made up of ten parishes. It was a free town attached to Castile, with its own judicial powers from the time of Alfonso VIII onwards. Its economy, relying essentially on livestock, was based mainly on the pastureland of the southern slopes of the Sierra and particularly on the Real de Manzanares. Many a dispute with Segovia arose over its possession, for much was at stake. The Council of Madrid in a petition to Alfonso XI in 1312, maintained that without these mountains, these pastures for the cattle, and the wood and other materials needed for domestic use, Madrid could not survive longer than a year. From some orders given by the Council in 1380, for the guarding and policing of the fruit and other produce of the land, we know that vines and various fruit trees such as fig, almond, cherry, apple, plum and pear grew around Madrid; that there were fine gardens with all sorts of vegetables, rose arbours and olive groves, all of which must have made the environs of Madrid very much greener and more agreeable than they later became as a result of human neglect; the dryness and aridity of the land are due to the harshness and ingratitude of men's minds. The orchards, the gardens and kitchen-gardens are clear indications of a Moslem past which persisted, along with many other things, in the Mudéjar city. Only an administrative

Madrid. The church of San Jerónimo el Real,
late Gothic in style and extensively restored in the 19th century.

capital, more interested in the progress of the court than in the benefits
and advantages provided by nature, could thus destroy the formerly
smiling Madrid countryside and transform it into a sight as dreadful
as that depicted in the view by Texeira in the middle of the seventeenth
century. The royal hunting grounds alone remained, reaching to the
gates of the city and still today, though shrunk in size, surrounding a
large sector of the northeast of Madrid.

These hunting grounds lay at the root of the preference the kings
always felt for this area. Henry III and Henry IV showed attachment to
the oak forests of Madrid which were full of bears and wild boar.
Henry IV made a great contribution to the enlargement of Madrid, in
whose Alcázar he enjoyed residing. As a gesture of gratitude for the

loyalty the people of Madrid showed him, he bestowed the titles 'Most Noble' and 'Most Loyal' on the town, titles it proudly continues to use in its writs and decrees. He granted it the right to hold a market and other royal privileges which his successors the Catholic Monarchs continued to dispense.

A certain Fernández de Oviedo, a native of Madrid who later became a distinguished historian of the Indies, recounts that towards the end of the Middle Ages, Madrid could count 3,000 inhabitants and its surrounding country as many again, and speaks admiringly of the plentiful water supply, the healthy climate, the orchards and the gardens. Hardly anything remains of medieval Madrid, of that Hispano-Moslem, later Mudéjar, town, fortified, with narrow winding streets and a

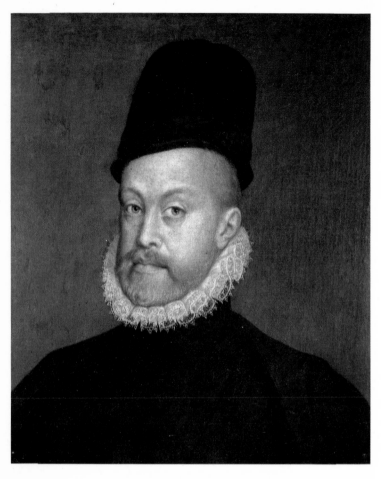

Philip II c. *1575, by Sánchez Coello, 1531-32 - Museo del Prado, Madrid.*

picturesque outline, surrounded by vegetable gardens and woods. This is the price cities pay when they become great and rich—like human beings who do the same, they lose their past.

So all there is left of that past in Madrid is a couple of Mudéjar towers, scattered stretches of fortified city walls and the odd late Gothic building such as the Casa de Luján in the Plaza de la Villa and the house adjacent to it, belonging to the same family. The city's best monument, the Alcázar, which was constantly being altered and improved by the kings, disappeared completely in the great fire of 1734. Only after the most detailed search can one find any trace of the old medieval town, for instance if, instead of looking at the houses, one concentrates one's attention on the streetplan of the little alleys and passageways lying within a radius of 330-450 yards around the Plaza de la Villa.

The square, which has an aura of the past about it, as well as plenty of obvious present day activity, is one of the few cases of the survival of tradition and a sense of permanence Madrid can boast of. For Madrid has always been a city contemptuous of its past, more interested in modernization than in conservation, eager to destroy the visible stages of her progress, lacking in a spirit of continuity and in tranquillity, all characteristics that have made it what it is today, a capital

city of few and scattered monuments which hardly ever form a coherent whole, of ill-defined urban units which, if they ever did exist, were quickly wiped out in its burning desire for constant renewal. To all this the Plaza de la Villa provides a pleasurable contrast, for it was here that the chimes of the now vanished church of San Salvador used to call the town council to meetings in the porch. And even today, centuries later, it continues to assemble at very nearly the same spot, though in its own hall. It used to be called Plaza de San Salvador in the Middle Ages and was Madrid's main square, just as Plaza del Arrabal was to be later, after it had been converted by Philip II and Philip III into the Plaza Mayor, and later still the famous Puerta del Sol in its turn lost its role without, alas, finding a successor to fulfil its functions.

The house and tower of the Luján, a Madrid family of Aragonese origin, is the outstanding building in the square, more on account of its historical reputation than its architectural or archaeological value. The tower and house used to belong to Gonzalo de Ocaña, the city governor, and his wife Doña Teresa de Alarcón, a relative of Captain Hernando de Alarcón who brought Francis I to Madrid as a prisoner. Popular tradition and various historians maintain that he put up the captive French king at his family house before he was transferred to the Alcázar though others hold that he was taken there directly. Since opinion is so equally divided, let us not destroy the legend which Lope de Vega himself used to boast of when talking of his birthplace: 'I was born in the Plateria at the very place where the Emperor Charles V laid France at his feet'.

The house has kept its portal in the late Gothic style, a sweeping arch with three shields of heraldic designs which must date from the end of the fifteenth century. The tower, recently restored, consists of nothing more than bare walls with a touch of Toledo about them. It was through a small, older door, with a pointed horseshoe arch giving on to the Calle del Codo, that the king of France is supposed to have entered. Today the Casa de los Luján houses the Academía de Ciencias Morales y Políticas and the Sociedad Económica de Amigos del País. The neighbouring houses belonging to the same family are occupied by the Hemeroteca Municipal, where the stairway from the old Hospital de la Latina has been placed, a building dating from the time of the Catholic Monarchs, whose door has been transferred to the school of architecture in the university city.

Another noteworthy building in the same square is the Casa de Cisneros, built in the sixteenth century. It used to form part of the family estate of Benito Jiménez de Cisneros, nephew of the cardinal and son of his brother Juan. It is in the Plateresque style of Toledo, as can be seen easily on the side facing the Calle Sacramento which is the only old façade. The rest has been rebuilt in this century. Now it houses various municipal departments and the Mayor of Madrid's office. The cardinal never lived in this house, which was finished after his death, but he was frequently a guest in the city, staying at the house of the Lasso de Castilla family in the Plaza de la Paja, next to the church of San Andrés and the Capilla del Obispo. Today the site of the Lasso house is occupied by some buildings later restored in the Plateresque style of Toledo. While the energetic cardinal was regent of the kingdom before the accession of the throne of Charles I in 1517 (elected Holy Roman Emperor Charles V in 1519), he made Madrid the seat of government, so as to make a clearer definition of his functions which in Toledo were those of archbishop. Once, when

he was in the Lasso house with a delegation of Castilian noblemen who were questioning his authority, he went to the window and pointing to a few pieces of artillery standing in the square, made his famous remark to the turbulent noblemen: 'Those are my authority.' For Cisneros Toledo was the ecclesiastical capital, Alcalá de Henares the academic one and Madrid by force of circumstance the political one. Thus its destiny began to take shape.

Once Charles I was safely on the throne and the revolt of the Comuneros in which Toledo had played such an important part had been overcome, the young prince of the house of Hapsburg wished to make amends for his first mistakes and regain the favour of the old city by enlarging it and giving it marks of distinction above all his kingdom. The last and most brilliant period of Toledo's history in modern times coincided with his reign. It seemed as if nothing could cast a shadow on the good fortune in which the city basked.

Nevertheless Madrid was growing, taking shape and developing the characteristics that were to distinguish it in the future. The town which was eventually to assume the functions of a capital was already becoming a potential one. But before it reached that definite point its population and prestige were growing and the number of its houses, foundations and monuments increasing. It was already a locality of some importance consisting of about three thousand buildings. To the north the town spread as far as the Red de San Luis, to the east as far as Plaza de Antón Martín, and to the south as far as the so called 'Cerillo del Rastro'. To the west it could not spread further than the banks of the Manzanares. Its population, probably over 20,000, was considerable for a town in Spain at that time.

The Convento de San Jerónimo el Real, which was established in Madrid in about 1503, dates from the end of the reign of the Catholic Monarchs, but its construction continued for much longer, though apparently the nave of its chapel was already finished in 1505. It could well have been built very quickly, to judge by the materials used, namely brick and mortar for the walls, brick and plaster for the vaulted ceilings, following the Mudéjar tradition that was widespread throughout the region—for one must not forget that Madrid belonged and still belongs to the old kingdom of Toledo.

The church, of impressive dimensions, belonged to the type of convent church built at the time of Ferdinand and Isabella, having one large single nave, transept and apse, vaulted niche chapels and a raised choir. This convent was always a great favourite with the monarchy which used to retire to it at times of mourning and during Lent. It was here that the princes of Asturias took their vow, or rather, were proclaimed heirs to the throne, since the tradition began with the vow of Prince Philip, later Philip II.

Unfortunately there is nothing left of the old Convento de San Jerónimo apart from the church and the arcading of the seventeenth-century cloister, and even the church was rebuilt and altered in the reign of Isabella II, the decoration and furnishing of the interior being finished in 1887.

Another example of architecture of the late Gothic period in a town otherwise severely lacking in medieval buildings is the Capilla del Obispo erected by Don Gutierre de Carvajal y Vargas, bishop of Plasencia. The Vargas family was one of the most distinguished families in Madrid and St Isidore, the farm-hand, patron saint of Madrid, was in their service. With the construction of this magnificent building, more to be a church than a mere chapel, they

Madrid. Doorway of the Convento de las Descalzas Reales, 16th century. Doña Juana of Austria, daughter of Emperor Charles V, was born here.

cherished the hope that San Isidro would be buried there, a hope that was temporarily fulfilled, for he lay there from 1535 to 1555. The chapel stands beside the parish church of San Andrés and used to be linked by a communicating door.

When in 1535 the work in the characteristic Spanish Gothic style which lasted throughout the reign of Charles V was finished, the church consisted of a nave, two aisles and a polygonal apse with a beautiful vaulted roof decorated with star-shaped motives.

Though its basic architecture is late Gothic the altarpieces, tombs and other features are distinctly Plateresque, in the best style of the mid-sixteenth century. The altarpiece is an outstanding work in low relief not just by the standards of Madrid, where there is little of this kind of art, but for the country as a whole. Juan de Villoldo the Younger was engaged for the whole project and actually executed the colouring and the ornamentation, but for some of the sculpture he seemingly contracted the services of Francisco Giralte of Palencia, one of Alonso Berruguete's best pupils.

The bishop had a splendid tomb built for himself in the wall of the epistle side, which bears his figure praying in the presence of his family and friends, as well as various allegorical figures and graceful

motifs of little importance. The intricate closely-knit modelling is full and detailed, soft and supple and brings out the smooth quality of the alabaster. Of the same material and high standard, though plainer, are the tombs of the founder's parents, carved, it is presumed, by the same Francisco Giralte, though information on all three of the tombs is scarce. Equally remarkable are the wings of the main door which nowadays opens on to a sad little courtyard, and which Torno attributes to Francisco de Villalpando of Toledo.

Recently the doors of the most interesting convent in Madrid, previously always closed to lovers of art and history, have been thrown open to the public, which is now free to dream and marvel at it, for it would be hard to find many other buildings so full of history and beautiful works of art, and permeated by such a magical atmosphere. The convent owes its existence to the personal endowment of Juana of Austria, the youngest daughter of Charles V and mother of the unfortunate Sebastián of Portugal. Many famous women of the House of Austria have taken their vows or lived under her shadow since 1560 when the nuns were first installed here under the rules of the Franciscan Order. For this reason it was known as Convento de las Descalzas Reales (Convent of the Barefooted Princesses). Doña Juana, a most interesting character, died at the age of thirty-seven in 1573 after such an eventful life that it is difficult to imagine how it can all have been packed into so short a period.

She had hardly been married a year when her husband, Prince John of Portugal, died, leaving her not only a widow but an expectant mother as well at the age of only nineteen. Instead of staying at the court of Portugal and caring for her son, she returned to the Spanish court in response to the affectionate call of her brother, whose realm she governed during some of his absences. She was a woman born to rule and would have gladly ascended the throne of France had the matrimonial negotiations with Charles IX not resulted in the choice of her niece, Isabel, daughter of her sister María, Empress of Germany, also closely connected with the convent's history.

Like all the women of that dynasty, she maintained very close relations with the new religious order, the Society of Jesus, and especially with St Francis Borgia, general of the Company, her adviser when the Convent was founded. The saint's sister, the great-niece of Pope Alexander VI, was appointed the first—and highly forceful—abbess of the Convent.

Doña Juana was born in one of the noble houses situated in the San Martín quarter, one of the suburbs outside the enclosure of the old city walls. She had received the houses as dowry from her father the emperor, and never hesitated in converting them into a convent. The façade can still be seen on the Plaza de las Descalzas. The walls are made of the usual Toledan mixture of materials and the granite portal with semi-circular tympanum is very similar to many others in the Imperial city. Of the interior, both the courtyard and staircase have been preserved, though in somewhat altered form, especially the latter, adorned with brightly coloured frescoes dating from about 1661 and attributed by Tormo to the Bolognese painter Agostino Metelli.

The church was built against the wall of the old palace but to this day its history has been poorly documented. The façade has been attributed to Juan Bautista de Toledo, architect of the Escorial, and it would not be strange to find that the king should have lent his finest artist to a sister who was both his friend and his adviser. It is a very schematic façade, difficult to compare with anything Spanish. It

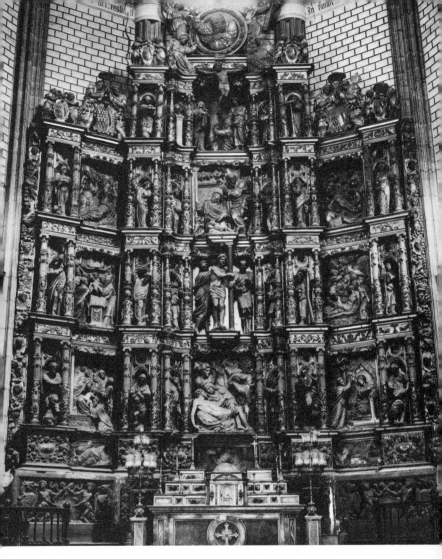

Madrid. Capilla del Obispo, the magnificent Plateresque altarpiece, executed by Giralte and Villoldo, mid-16th century.

expresses certain ideas of Serlio's and of the Toledan school of Villalpando. Since it lost its old altarpiece by Gaspar Becerra, which was burnt in 1812, the interior is rather lacking in interest. The only part of it that has any individual character is the funeral chapel of Doña Juana, to the right of the presbytery, with a beautiful statue in an attitude of prayer, the work of Pompeo Leoni.

In the choir, a solemn-looking tomb contains the remains of Empress María, elder sister of the founder. At the end of a long reign she too came to seek refuge in this religious house so full of memories, and here she died in 1603.

In the formerly impenetrable retreat of Las Descalzas, one can today visit and admire a little chapel called 'del Milagro', which is the prettiest thing imaginable, painted throughout by Jiménez Donoso, Rizi, and Carreño de Miranda. Built in 1678, it is, according to Tormo, a precious landmark in the history of the Baroque decorative arts in Spain. Many are the works of art stored up in this remarkable convent, such as paintings by Brueghel the Elder, Sánchez Coello, Pantoja, sculptures

by Pedro de Mena and so on, but the most outstanding are the tapestries by Rubens, woven in Brussels and donated by the Infanta Doña Isabel Clara Eugenia, governor of the Low Countries. They depict the history of the church and are hung up in the cloisters during the Holy Week celebrations.

This Convento de las Descalzas Reales, with its history so closely linked with the names of Charles V and Philip II, and with its architecture half looking back to old Toledan styles and half looking forwards to new developments along the lines of the Escorial, can be considered both the last monument of the ancient Madrid, Mudéjar and Toledo-influenced, and the first monument of the Madrid of the House of Austria. When it was created, Madrid was just becoming established as the political capital of the monarchy, of a rather nomadic monarchy which Philip II, the bureaucratic king, wanted to settle once and for all. Could this warrant the suggestion that the convent and its founder represented one more of the many links tying the king to Madrid?

Madrid under the Austrian Dynasty

Madrid had two lives, one humble and obscure, as a satellite of Toledo, the other as the unexpectedly chosen court of a monarchy dominating the whole world, but the zenith of whose power dangerously coincides with the beginning of its decline. Madrid was like one of those young favourites of the mighty that rise rapidly to heights of power as lofty as they are unexpected; on being suddenly elevated by Philip II the city had neither the time nor the opportunity nor even the energy to transform itself materially into a big city. The town always kept about it a certain feeling that revealed the accidental and provisional nature of its beginnings. Philip II did make an attempt to enlarge it, but not a very far-reaching one if we consider it in the cold light of day without any illusions. While Madrid was still in the honeymoon period of its promotion in 1561, the king was already becoming obsessed with the choice of a site for erecting the culminating achievement of his reign— the Escorial Monastery. In 1563 he laid the first stone and with that he deprived Madrid of his major constructive effort and left his capital without any impressive building. In fact the city was smoothly and steadily converted into a seat of government offices, an immense corridor of power for dealing with state affairs, a nest of civil servants and job-seekers. And thus we come to 1601, just after Philip III's accession to the throne, the year in which the influence of the Duke of Lerma caused a decree to be passed for the transfer of the court to Valladolid. This did not last long, for in 1606, thanks to their energy and generosity, the people of Madrid managed to have it returned to their own city. The monarchy, powerful though it was, was constantly in financial difficulties and was very alive to any pecuniary advantages available. But Philip III and Philip IV, with their coffers always empty, embroiled in dynastic and religious wars, could do little for Madrid, so that by the time of Charles II, in spite of its size, it was as impoverished and impaired as the sickly monarch who ruled it. This goes a long way towards explaining the astonishment of visitors when they come to perceive the discrepancy between the historical importance of the capital of two hemispheres, the seat of a monarchy that governed in Flanders, Milan, Naples, Mexico, Peru and the Antilles, and the very rare material indications of that grandeur that they can see in the metropolis.

While Europe was building itself a future, Spain was praying and

Madrid. Convento de la Encarnación, the decorative doorway.

founding convents, but religious faith, formerly a life-giving spring, had declined into a formalistic routine, while hope had been reduced to self-deception and illusion. The country seemed to be wandering through an arid wilderness, enslaved and lost to the world, her darkened mind transfixed by frightening flashes of illumination that did no more than reveal her misery. The *via dolorosa* that the Spaniard had to traverse when success had turned its back on him plagued his spirit to the point of making him morbid and unbalanced. Religion pushed its way into every walk of life and threatened to overgrow and asphyxiate the social body like a parasite. Madrid in the seventeenth century was a city overflowing with religious institutions. Jerónimo de la Quintana tells us that in the year 1629 it could count seventy-three religious buildings—parish churches, convents, hospitals and administrative buildings. And one must not forget that the number of religious foundations grew at a faster rate for the rest of the century during the reigns of such pious monarchs as Philip IV and Charles II.

Madrid itself became like a convent. Wandering through the streets one must have had that feeling of melancholy produced by bare, silent walls; at each crossroads some belfry would look down entreatingly on one from the sky, and the bronze voices of the hours would repeat, like the sea, their never ending litany. A sad and rather oppressive atmosphere, but one with a certain fascination, for it was the meeting place of every type of those ecclesiastical habits, tunics and vestments, which turn the human race into a ghost of itself.

But all these churches and convents, as well as the palaces, were half-hearted constructions, hastily improvised by those eager to make their presence known at court—individuals and communities alike.

As Jacques Pirenne said, Spain had the unfortunate experience of seeing the gold and silver from the Indies slipping through her hands like water through a sieve, only to end by filling the pockets of Genoese bankers, Antwerp shipowners and French industrialists.

Madrid at the time of Philip IV was a motley confusion, but full of contrasts and vitality. It was the Madrid of the giant Spanish geniuses, where a brilliant theatre flourished as nowhere else, where the boundary between the real and the imaginary life was blurred and the two intermingled, the Madrid of Lope de Vega, Tirso de Molina, Calderón and Velázquez. Velázquez's triumphal career coincides with the apogee of the Madrid of the House of Austria. In his time, a hundred years after Madrid became the capital, the city had trebled its size, and it was in this period that a city wall was completed beyond which the town did not spread until the middle of the nineteenth century. The wall as well as surrounding all the houses, in which lived some 100,000 people, also included the royal palace of Buen Retiro, the monasteries of San Jerónimo and Atocha to the east and the gardens of the Alcázar to the west.

Just as Philip IV had Velázquez, so too Madrid had its private painter in the form of the geographer Pedro Texeira, who has left us one of the most complete pictures possible of this noble city. Texeira's description not only covers its topography and physical structure, but also depicts its atmosphere and makes one feel able to breathe the very air of the place. Not for nothing was this map engraved in the same year, 1656, as *Las Meninas* was painted.

Much of the Madrid of the almost psychological portrait Texeira drew still exists. The inner ground plan has varied very little, and nothing reveals better than this the hasty growth of the town, the way in which it has developed along roads, paths and short cuts, crossing and recrossing each other in the search for the quickest way. The map shows a converging town with many ramifications, not overcrowded, since houses were very low in those days, but one that completely lacks any planned structural style. Only one square, the Plaza Mayor, was actually conceived and planned as such; all the others developed from crossroads, commons, public spaces, wasteland; all products of chance, not of art. Madrid squandered her energies in fiestas, processions, theatrical performances and fleeting pageants. It seems that the spirit of Madrid was akin to that of Sigismund, Calderón's hero in *La Vida es Sueño*: doubtful of his good fortune and given to dreaming he thinks that 'all human fortune passes like a dream so today I shall make the most of it while it lasts'.

Philip made Madrid the capital (though he never proclaimed it as such, but just let the influence of time make it so) but he showed little affection for the city, nor did he make much effort to improve and modernize it. This eminent patron of architecture failed to leave Madrid with a single building worthy of his name. The Escorial project and his beloved royal seats of Aranjuez, Balsain and El Pardo absorbed him entirely. In Lisbon he made more effort to leave something of himself behind, probably because it was more necessary to flatter his new conquest than to look after his faithful companion. In Madrid he built the Puente de Segovia and slightly rearranged the street of the same name, for he liked to look after the roads leading to his country residence. It is difficult to define his work on the Alcázar with any clarity, for it was rather incidental, and his plans for making the Plaza del Arrabal symmetrical were later absorbed by the total reconstruction of the square undertaken under Philip III.

The Infanta Margarita, *1660, by Velázquez, Museo del Prado, Madrid.*

The first religious building in the new capital to be constructed entirely under the Austrian monarchy was the Convento de la Encarnación, founded by Philip III and his wife, Doña Margarita, in 1611. It was completed by Juan Gómez de Mora in 1616, in the style of Herrera, and the façade of the church at the back of the monastery complex combines distinction and austerity.

The church interior, which must also have been very severe, was completely renovated in 1767 by Ventura Rodríguez, and is one of his most delicate works. Francisco Gutiérrez, Isidro Carnicero and Antonio Primo did the stucco-work; José Castillo, Ginés Aguirre and Francesco Ramos painted the altarpieces, and Juan Muñoz, Manuel Alvarez, Juan Pascual de Mena and Felipe de Castro enriched it with sculptures. The result is a miracle of grace and harmony.

The convent itself, which is now open to the public, has some notable

Madrid. Convento de la Encarnación,
the façade by Juan Gómez de Mora, 1611-16.

▷
Madrid. Plaza Mayor,
designed by Juan de Villanueva in 1791, and completed 1853.

features, including the choir and the extremely beautiful reliquary, which is kept behind the high altar with its *gloria*, as well as a fine collection of religious paintings.

The predecessor of the present Plaza Mayor was a suburban square lying outside the Puerta de Guadalajara which only began to take shape under John II of Castile. Juan de Herrera and Francisco de Mora set about improving and formalizing it but it was only Philip III who thought seriously of endowing the capital with a real square that would be the centre of city life. Between 1617 and 1619, Juan Gómez de Mora designed the present layout and completed the work. A solemn inauguration took place in May 1620 on the occasion of the celebrations of the beatification of St Isidore. It is quite possible that Gómez de Mora took his inspiration from the main square in Valladolid which was rebuilt by Philip II. The one in Madrid is considerably larger, for 3,000 people lived in the houses facing it and it can hold up to 50,000 if necessary during celebrations.

With the years the Plaza Mayor underwent a number of alterations. The Casa de Panadería, the most striking building on it, was rebuilt by José Jiménez Donoso in 1672 after a firé and its façade was decorated with paintings by Claudio Coello. Another terrible fire destroyed the southern and western sides of the square, which

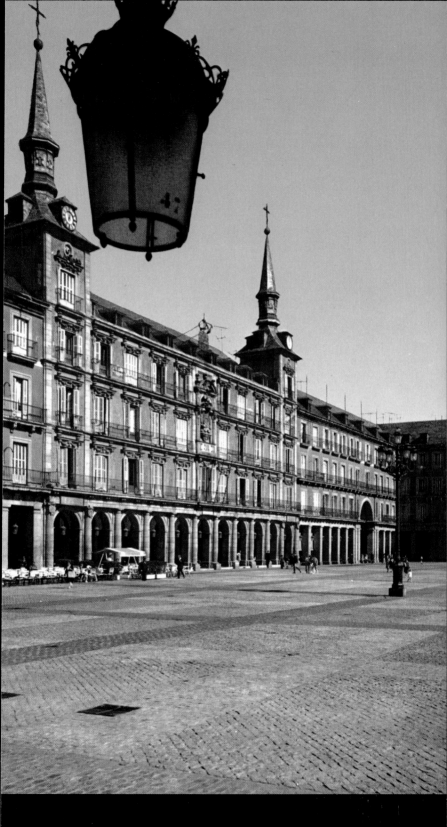

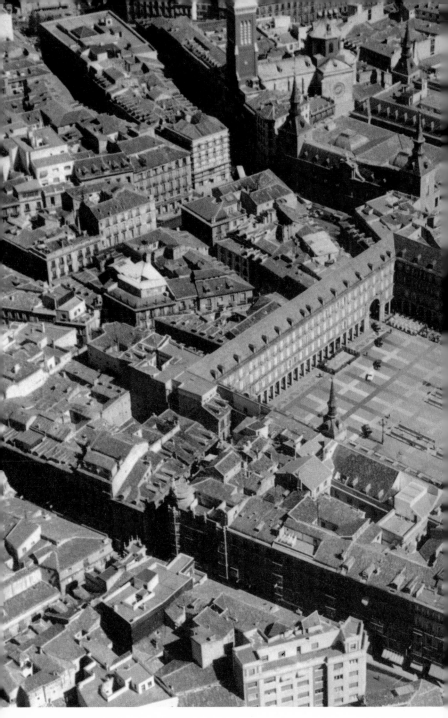

Madrid, aerial view of the Plaza Mayor. In the background, the Cárcel de Corte, and the red brick tower of the church of Santa Cruz.

not only entailed its reconstruction but gave rise to a general rebuilding project which was conceived by Juan de Villanueva in 1791 but not finished until 1853. Villanueva made substantial alterations and is responsible for its present day appearance. The Plaza Mayor is the principal town-planning achievement of the Austrian monarchs and the only complex of a high standard worthy of their capital.

Shortly after the Plaza Mayor was finished, and in its immediate vicinity,

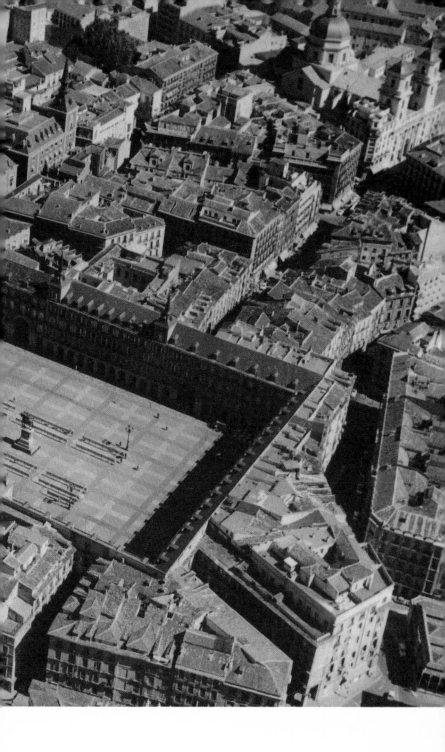

another of the best examples of civil architecture of the time of the Austrians was built, the Cárcel de Corte, which was intended to serve as offices for the *Alcaldes* of the royal household, and the court with a prison for persons of high rank, from which it took its name. In fact, along with the Casas Consistoriales (Town Hall) built a little later, it makes up the pair of public buildings which represents the way the city was governed. This was, as we know, on a dual basis,

Madrid. The church of San Jerónimo el Real, façade with an impressive doorway.

◁
Madrid. The equestrian statue of Philip IV by Pietro Tacca, 1642. Plaza de Oriente.

and in effect the house of Alcaldes de Casa y Corte and the Municipal Council were the two bodies administering the affairs of Madrid.

The old building of the court prison, today converted into the Ministry of Foreign Affairs, has a façade in the style of the Escorial, with baroque elements, airy turrets with spires, and a strongly accented central axis. The interior consists of a double courtyard with a magnificent staircase in the middle, all so delicately carved that it is a delight to look at. It is not difficult to see forerunners of this building in the Hospital Tavera in Toledo and even in the Alcázar of Madrid itself, whose influence can clearly be seen.

It is paradoxical that this most typically Spanish building should have been attributed to an Italian named Juan Bautista Crescenzi, who came to Madrid to decorate the royal mausoleum of the Escorial. Honours and titles were showered on him, for he was the brother of a Roman cardinal, and Philip IV then named him superintendent of his building works. But the truth of the matter is that the building must have been planned by Juan Gómez de Mora or by Alonso Carbonell, the two most distinguished architects at court at that time. The date of the commencement of the work is suggested as being 1629, and completion 'In the reign of His Majesty Philip IV, in the year 1634, with the approval of the Council, this Court Prison was constructed for the comfort and security of the prisoners.'

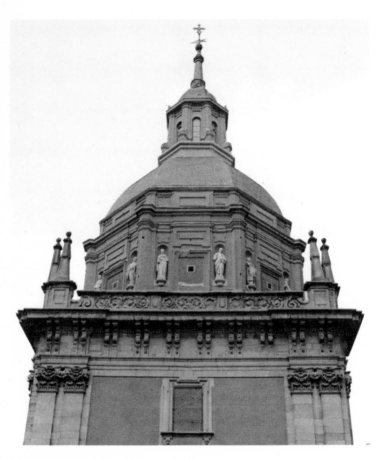

Madrid. Capilla de San Isidro, with lively cupola,
by Brother Bautista, begun 1642.

A little later, the removing of the city council into a similar building
was considered and in 1640 Gómez de Mora presented his plans for
erecting it on land belonging to the council on the same Plaza de San
Salvador (today 'Plaza de la Villa') where it used to have its meetings,
as mentioned earlier. Work started in 1644 but progressed only
slowly. In Texeira's map of 1656 no more than the site is shown.
José de Villareal took over from Gómez de Mora on the latter's
death in 1648, and he in turn was succeeded by Teodoro Ardomans,
who built the present portals (1670) and towers. By 1693 it must
all have been finished. With time the building, which was not lofty
and had calm, classical lines, took on a more Baroque aspect, and
in the eighteenth century Villanueva opened it up with a colonnaded
balcony, so that one could watch the processions making their way
down the Calle Mayor.

Next to the Museo del Ejercito stands the old 'Cason del Buen
Retiro'. It is the old ball-room and pleasure pavilion of the palace,
decorated with a magnificent ceiling, still preserved, by Luca Giordano,
depicting the founding of the Order of the Golden Fleece.

There used to stand on one of the lawns the statue of Philip IV on
horseback, modelled and cast in bronze in Florence by Pietro Tacca,
which the Grand Duke of Tuscany Ferdinand II presented to the king.
It was unveiled in 1642 in what has since then been called the 'Plaza
del Caballo'. In the nineteenth century it was transferred to another

part of the same park, then in 1844 it was decided to move it once again, this time to the Plaza de Oriente, where it was placed on a superb pedestal decorated with fountains and statues, all designed by the architect Juan José Sánchez Pescador.

The most valuable thing remaining from the old Buen Retiro palace is its extensive and leafy park, which was made into the city's municipal park. With time it has become an oasis of greenery in the very centre of the town, rather like Central Park in New York, both of them being surrounded by an urban mass of increasing size and density. The palace was called 'del Buen Retiro' and its garden simply 'Retiro' because it was created as an extension to the quarters that the kings owned in the convent of San Jerónimo, which they used to retreat to in Holy Week or during periods of mourning. With Philip IV's palace destroyed and the old Alcázar completely disappeared, the Madrid of the Hapsburgs had lost the brightest jewels of its architectural crown.

One would also imagine that the capital of such an empire, the seat of a monarchy calling itself Catholic, would be notable for large and splendid churches. But not a bit of it! For a start, Madrid never had a cathedral, but came under the powerful diocese of Toledo, which had always contemplated with great misgivings any attempt to raise the ecclesiastical status of Madrid. The medieval parish churches were extremely modest buildings, as was appropriate to a straggling Hispano-Moorish village. With time they changed of course but acquired little in the way of splendour, so that the most important religious institutions were convents, and the Baroque churches, which are admired and written about today, used to form part of religious communities.

As if this were not enough, radical reforms and the fury of the mob, which for some strange reason vents its feelings on helpless works of art, obliterated countless religious buildings though this is not the place for a necrological catalogue.

In spite of this there is still a remarkable collection of Baroque churches in Madrid, remarkable not so much for the richness of the buildings themselves—for they are generally made of poor materials, brick and stucco with altars of gilded wood—but for the sparks of individual genius they display, and for the harmoniousness and generally high standard of their architecture. Other Spanish Baroque churches in a more elaborate, more uninhibited and extravagant style do exist (and at the present time these more extreme styles seem to enjoy greater appreciation, as a reaction against the anti-Baroque period of the recent past); but it would be difficult to find a better balanced, more variegated collection than in Madrid. This is because they were the product of the highly cultured atmosphere of the court and of circumstances which brought together a group of artists of solid basic training and more refined taste. And yet we are faced with the disconcerting fact that the majority of the artists who designed those churches are unknown—which emphasizes their character as a group or school, the supremacy of the collective over the individual spirit. However, there is no doubt that many versatile artists such as Herrera Barnuevo, Francisco de Herrera the Younger, Jiménez Donoso and so on had a direct or indirect influence over their creation, contributing from their experience in various forms of art, their mastery of draughtsmanship and their skill in decoration.

The work of Brother Francisco Bautista (1594-1679) is the first in the Madrid series. He was a lay Jesuit and a consummate master in the art of building. His most distinguished creation is the present cathedral

of San Isidro, the old church of the Imperial College of the Society of Jesus, built in part with legacies from the Empress María, elder sister of Philip II. The Jesuit Father Pedro Sánchez began the work and directed operations until his death in 1633, when he was succeeded by Brother Bautista. It is one of Madrid's most impressive churches, being modeled on Il Gesù in Rome, with details emanating from the local school. The façade is grandiose and great effect is derived from the skilful use of Corinthian columns.

To Brother Bautista we also owe the small but elegant Capilla del Cristo de los Dolores next to the church of San Francisco el Grande. The great historian of Madrid churches, Elías Tormo, has claimed that this is the city's most typical church, and the most beautiful in its simplicity of all those built in the reign of Philip IV. It was erected between 1662 and 1665 by the masons Marcos and Mateo López, who were possibly father and son.

Another priest, Lorenzo de San Nicolás (1595-1679), famous for his treatise 'The Art and Use of Architecture' of 1633, shares with his contemporary the praise for having introduced Baroque art to the court. His most distinguished work is the church of the convents of Benedictine nuns of San Plácido. It is hardly known, let alone visited, for the front is hidden away up a narrow little alley, but it deserves better, for the sober, well-proportioned interior is an admirable example of the style inspired by the reign of Philip IV, added to which it is richly endowed with excellent works of art—three altarpieces, the largest with paintings by Claudio Coello, four paintings by Francisco de Rizi, some magnificent sculpture by Pereira and an excellent dying Christ by Gregorio Hernández. It is therefore not surprising to discover that Velázquez's picture of Christ, now in the Museo del Prado, was formerly kept here. The church was built between 1641 and 1661.

Clear evidence of the great vogue enjoyed in this period by fresco painting, as practised by such pioneer artists as Donoso, Rizi, Carreño de Miranda, Palomino, Giordano, Coello, is shown by the building of a church such as San Antonio de los Portugueses, which has no architectural ornamentation at all and leaves to painting the task of simulating it. It has an elliptical base and is crowned by a cupola, which was decorated by Juan Carreño de Miranda and Francisco Rizi. The lower part beneath the cornice is covered with a fresco painted by the Italian, Luca Giordano, who lived in Spain during the period 1692 to 1702.

The year 1622 saw the canonization of St Isidore, a man who during his life-time had always been a modest brother. The ceremony took place with full court honours and to the crowning joy of the populace, great efforts were made to give him a burial place that could at the same time be a shrine worthy of his glory. This was to be in the church of San Andrés, of which he was a parishioner, and this is the origin of the Capilla de San Isidro, a monument conceived and elaborated with a splendour unusual in the architecture of Madrid.

Juan Gómez de Mora and Pedro Pedroso drew up the first plans; later those of Pedro de La Torre were preferred, involving building the chapel up against the church of San Andrés, which is how it was carried out. The first stone was laid in 1642, but work progressed at a slow rate until it was given renewed impetus in 1657. Different

▷

Madrid. Convento de San Plácido, interior of the church, designed by Brother Lorenzo de San Nicolás, paintings by Rizi and Claudio Coello, and sculpture by Pereira.

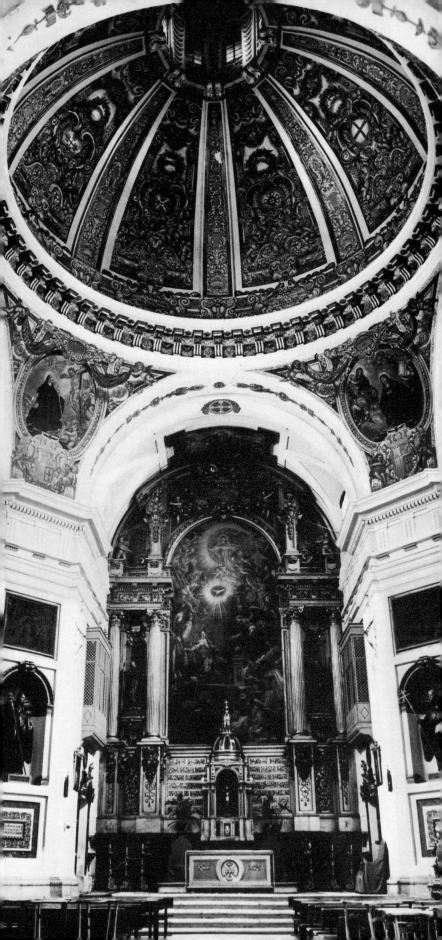

craftsmen continued to be involved in the project, the last of which were the Flemish stucco workers Carlos Blondel and Francisco de la Viña, who gave the opulent interior a semi-Flemish semi-Genoese appearance. It was destroyed in 1936, except for the external shell, whose almost insolent profile still juts into the skies of Madrid.

Other modest, unassuming convent churches cast very much in the Madrid mould but with a few delightful advances in style, are those of the convent of the Order of Mercy of Juan de Alarcón, the Convento de las Góngoras of the same Order and the Augustine convent of Santa Isabel.

This brings us to two other churches which are probably the most typical of Madrid: the church of Las Calatravas and the church of Las Comendadoras de Santiago. The first is noteworthy for the vigour of its contours and bold modelling, the second for the charm of its simple central plan. It was the latter that gave Tormo the idea that its designer might have been one of those Madrid masters who had travelled to Italy, such as Herrera the Younger. It is shaped like a Greek cross with the arms ending in exedras. It was built between 1668 and 1693 and the altarpiece of the high altar signed by Luca Giordano bears the date of 1695. The sacristy is also most interesting—a much later work, built between 1745 and 1754 by Francisco Moradillo who was much influenced by the style of the Italians Juvara and Sacchetti.

Madrid of the Bourbon period

The eighteenth century saw the arrival of a new dynasty on the throne, the Bourbons, but the development of religious architecture in Madrid remained continuous. Not until much later in the century, after the establishment of the academy and the renewal of the intellectual atmosphere, do we witness the development of the local style into restrained Hispano-French Baroque forms, forerunners of future neoclassical art. In the meantime matters follow the traditional course and there is little change to be noted. Hence many eighteenth-century churches are hardly different from their predecessors, even though their excessively rigid structures were softened by the strong personality of Pedro de Ribera.

Ribera produced most of his work with a relatively short period of time, that is approximately between the years 1718 and 1737, during which he produced an uninterrupted succession of impressive works whose shape and colour still enliven Madrid today. It was as if the floodgates of his inspiration had suddenly been opened, and the story of his life as an artist is of an intensity and eventfulness matched by few others.

In his first known work, the Ermita de la Virgen del Puerto, he begins with a flexible, rhythmical ground plan and uses the exedras to mellow the lines of the octagonal basic contours. This minor masterpiece, the personal foundation of his protector, the Marquis of Vadillo, was consecrated in 1718 and, though it was damaged during the Civil War when it lost its altarpieces and accessories, its beautiful framework still stands and has been recently restored. The undulating lines of its ground plan are reproduced in the concave curves of the brilliant spire of the cupola, while the diminutive front proudly exhibits its Herrera-style façade. The contrast is cunning but does not upset the cleverly achieved harmony of the proportions.

More traditional, though, is the structure of the church of Monserrat,

Madrid. Church of Monserrat.
Ribera's tower, c. 1720, is typically idiosyncratic.

belonging to Benedictine monks, which could not be more typical of a Madrid church of the seventeenth century. It is a pity it was never finished, for it was interrupted before the transept was built. One thing, though, that makes the assumption that it was the work of Ribera doubtful is its complete lack of any novelty. But, on the other hand, the doorway and the tower are unmistakably his, the latter in particular being full of imagination and crowned by a bulbous dome, rather reminiscent of European Rococo and executed with great delicacy. The ironwork of the main door of the church dates from 1720 but the tower could have been finished some years later. Ribera also had a hand in the construction of the church of San Cayetano, begun in 1700 and attributed with some likelihood to José Churriguera who was possibly the author of the handsome façade. The fact that its ground-plan is so Italianate has led to the suggestion that it may have come from the country of origin of the Theatine Order, founded by the same St Cajetan, which wanted something new and impressive for its house in Madrid. Ribera's plans, dated 1722 and 1737, are still in existence and show the artist's intention of embellishing his architecture by imbuing his decorative work with a strong Rococo flavour. Moradillo finished the church in 1761 with fewer flights of fancy and more in the classical style. The only part of the Piarist

church of San Antón of any interest is the ground-plan, which is full of movement according to Ribera's taste. The church was spoiled by a nineteenth-century reconstruction, but it does possess a remarkable canvas by Gora, *The last communion of St Joseph of Calasanzas*, one of the most intense and dramatic of his painting of religious subjects. Churches continued to be built during and after Ribera's time which faithfully repeat the main features of Madrid Baroque, which demonstrates its staying power. The church of the old convent of Portacoeli today called San Martín, was started in 1725, and is an unmistakable example of this basic conservatism of style. But of greater beauty is the church of the Convento de Bernardas Recoletas del Sacramento, which was started in 1671 but not finished till 1744. Its façade is Baroque and the interior is notable for its handsome proportions.

The most splendid example of the Madrid Rococo style is the present church of San José, formerly called San Hermenegildo, belonging to the now vanished Convento de las Carmelitas Descalzas. The front, though it can no longer be seen in full because it is squeezed in between two modern blocks, is delightfully gay, pretty and lively. All the architectural features seem to merge into each other and strive upwards in a typically Rococo manner.

After the War of the Spanish Succession, when Philip V, the first Bourbon king, was assured of his throne, Madrid had the good fortune to be administered by an excellent governor, Francisco Antonio Salcedo y Aguirre by name, Marquis of Vadillo, who governed the town from 1715 to 1729. It was natural that after a period of uncertainty and nervousness the capital, long fallen into a kind of lethargy, should undergo renovation and embellishment. Instrumental in these renovations was the brilliant Pedro de Ribera, very much a native of Madrid and Vadillo's right-hand man. The king, though educated at Versailles, did not seek to impose his taste on Madrid, which was left free to follow its own traditional aesthetic course. Thus in the first decades of the eighteenth century the popular spirit expressed in Baroque triumphed in Madrid as never before.

Ribera, apart from being an artist of considerable imaginative power who knew how to take what he had inherited from Churriguera and develop it to its logical final expression in decoration, was a great town-planner, a man capable of visualizing and creating on a grand scale. Madrid had never been a well-planned city. Philip II had done no more than rebuild the access to it by the road and bridge from Segovia and lay the base for the future Plaza Mayor. After that nothing more was done and the city continued to spread higgledy-piggledy, following its roads and rustic paths, with convents and humble dwellings growing up along them.

Once more it was a question of access that was creating a problem for the town-planners, a problem that was masterfully resolved by Ribera with the new Puente de Toledo, planned in 1719 and finished in 1722. It is a really monumental construction, considering the narrow bed of the Manzanares, though the main objective was not so much to build a bridge as to safeguard the watercourse and create an entry worthy of the capital. It is difficult to know what to admire most in this bridge, its architectural qualities or its functional value, for, with its paved causeways, ramps, entries and exits, it is conceived with a town-planner's eye for grandeur.

Ribera also redesigned the Paseo de la Virgen del Puerto, which in his day was a conspicuous jumble of buildings, dominated by the hermitage

Madrid. Puente de Toledo, completed 1732, by Ribera. The two structures on the central arch contain statues of St Isidore and St Maria de la Cabera.

of the same name which has already been mentioned, laying out flower beds, fountains and other amenities which have now disappeared. The plan to embellish Madrid also included the series of new fountains designed by Ribera, which were installed in the Plaza de Antón Martín, Red de San Luis, Puerta del Sol and Calle de San Juan. Only the Antón Martín fountain is left, which has come to rest in the gardens of the Hospice after having wandered from place to place in the town. The constant and almost always ill-advised municipal alterations in Madrid have squandered a legacy of monuments, fountains and gateways which, had they been preserved, would have given the city the architectural distinction it lacks so much today.

Two more buildings of the period by Ribera were of a kind to lend a city character by their size and artistic quality. One is the Cuartel del Conde Duque which housed the bodyguard of Philip V and whose original gateway bears the date 1720. The other is the Hospicio

de San Fernando, the most famous of Ribera's public buildings. The splendid hospice—today a municipal museum and library—was begun in 1728 and finished in 1729. Its doorway is most unusual and totally original, exemplifying with typical Spanish dash the most graceful features of an extremely personalized Rococo.

The work of this remarkable builder does not end here. Ribera also found time and enterprise enough to construct some of the handsomest palaces in the Madrid Baroque style. For the first time in Madrid the nobility began to feel the urge to give their own houses architectural distinction. There were no palaces comparable to those of other cities, but rather large houses with elaborate doorways. All the same they do represent some progress compared with the wretched mansions of the seventeenth century.

Of the remaining palaces and portals, those attributed to Ribera are the Palacio de Miraflores on the Carrera de San Jerónimo, Palacio de Torrecilla, nothing more than a doorway in the building next to the Ministerio de Hacienda, Palacio de Ugena in Calle de las Huertas and the Palacio de Perales in Calle de la Magdalena.

In the last years of his life, the great architect must have sunk into obscurity and melancholy. He had chanced to be alive at the time of one of those sudden changes in history to which it is difficult for a fully formed personality to adapt. New ideas began to dominate the scene, new masters rose to prominence, recently arrived from Italy at the express request of Isabel Farnese, second wife of Philip V. Ribera probably felt supplanted and perplexed, forgotten during his own lifetime, which is by far the saddest fate. Novelty succeeds upon novelty, fashions change, men come and go, and he who had been a pioneer, the real source of the town-planning policy of Charles III, was left by the wayside as if he had been lagging behind.

Europe called to Spain to participate in her intellectual awakening and share in her tastes. Philip V in his early years as king had hardly dared to give any direction to the course of Spanish taste or impart his own opinions, but when he saw the need for a new royal palace to be built, he never doubted for a moment that it would be the symbol of a new enlightened and progressive tendency. He considered the old national Baroque style to be dead and buried, a symbol of backwardness and obscurantism. There is no doubt that the most wise, intelligent Spaniards were eager to follow him along these lines. Spain had to be reborn, regenerated, to rise from the ashes of decadence, and the arts—literature, painting and architecture—were to be the brilliant heralds of this awakening.

On the night of 24 December 1734 a violent fire totally destroyed the Alcázar of the Austrian monarchy, which was a strange survival of the remote past in the midst of a new gallicized society. The chance flame that sparked off the conflagration might have been kindled by the hand of history, as if it were trying to make things easier. Many precious works of art and a valuable store of documents were lost, but no doubt the opportunity was welcome to the first Bourbon king, who was thus rid of a totally alien setting and could replace it by another,

▷
Madrid. Hospicio de San Fernando, 1722-29, its portal conceived as a lush Rococo cornucopia.

P. 178/179

Madrid. Fuente de Cibeles, 1775, designed by Ventura Rodríguez, and executed by Francisco Gutiérrez and Robert Michel.

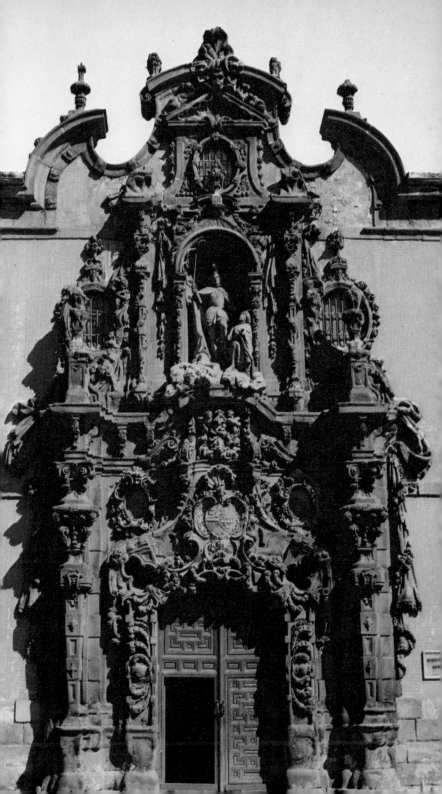

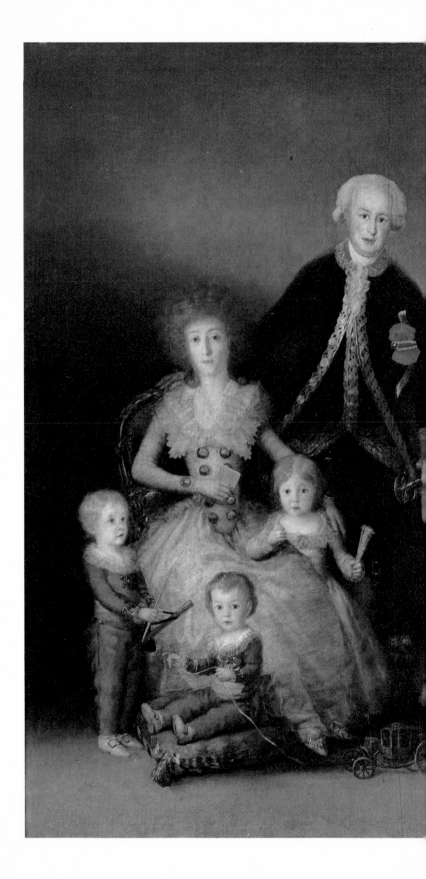

The Duke of Osuña
and his family, c. *1787, by Goya
Museo del Prado, Madrid.*

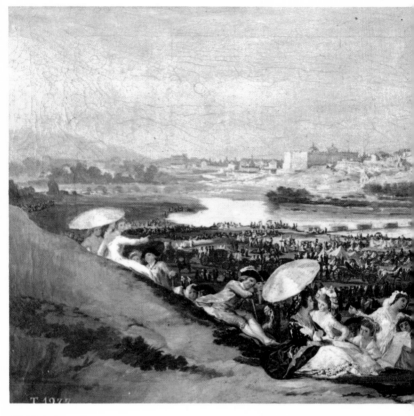

The Meadow of San Isidro, c. *1788, by Goya, Museo del Prado, Madrid.*

more in accord with his own background and ideas. Consequently he immediately set to work, sending a message through his ambassador in Rome to Filippo Juvara, architect to the Piedmontese Court, asking him to come to Madrid to draw up plans for the new building. Juvara did not agree with the site that had been chosen, thinking it too small, and drew up vast plans for another site which in turn did not satisfy the king who wanted the new palace to rise up over the old Alcázar of the Austrians, to maintain historical continuity. The king and the architect fell into disagreement. Then suddenly the distinguished architect, the great exponent of late Italian Baroque, died, victim of a neglected cold brought on by the icy winds of the Guadarrama, on 31 January 1736. The man from Messina had been able to do little more than draw up plans, prepare sketches and teach an exceptional pupil, the young Spaniard, Ventura Rodríguez, his craft. A little later Giovanni Bautista Sacchetti, native of Turin, whom Juvara had designated on his deathbed as his successor, arrived in Madrid. The king made him design new plans that would be adaptable to the old site. The present palace is consequently the work of Sacchetti, though in the disposition of the exterior an echo of Juvara's design remains.

The first stone was laid on 7 April 1738, but although the work was started with greater enthusiasm, it was not ready to be lived in until 1764, in the reign of Charles III. The reduction in size brought about by Sacchetti did not however run parallel with a reduction in cost, for superhuman efforts had to be made in the preparation of the site on the river side, supporting it by means of tiered platforms and vaulted

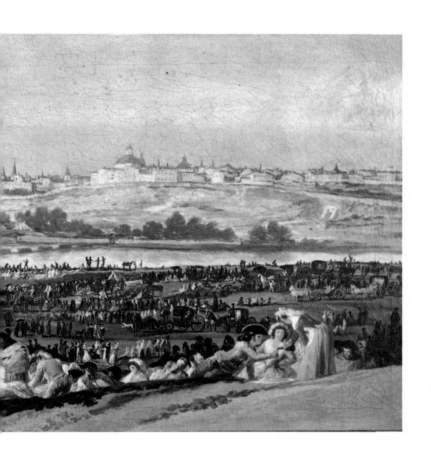

cellars. The palace can be said to be one of the strongest and most solid constructions ever put up by man, a really cyclopean achievement.

The ground-plan used by Sacchetti is faithful to the traditional design of Spanish alcázars—a square shape with a large inner courtyard, and towers at the corners which in this case do not project upward. The front elevations are essentially Italian almost in the style of Bernini, with a similar composition to those of the Odescalchi Palace in Rome —a rusticated base, gigantic pilasters, entablature, and a balustrade crowned with pedestals and statues. After the magnificent collection of statues of the kings of Spain, carved by the best court sculptors, had been erected, Charles III ordered them to be pulled down and thus the composition lost much of its Berniniesque flavour. These statues now adorn the Plaza de Oriente and other gardens, walks and squares, of Madrid and a few of the provincial capitals. All formed part of an allegorical series conceived by the erudite Benedictine Father Samiento. They were so arranged as to constitute a veritable allegorical poem, an idea that is as typically eighteenth-century in character as Linnaeus's *Systema Naturae.*

The whole palace was built of grey Guadarrama granite and limestone from Colmenar, giving a beautiful contrast of tones. For fear of a new outbreak of fire, the use of wood was restricted to doors and windows. The ceilings were vaulted and supported by very thick walls, as much as four and a half yards on the ground floor. Between 1750 and 1757 the building of the chapel, in which Ventura Rodríguez played a distinguished part, was finished. Sacchetti's original very elaborate Rococo

*Madrid. Palacio de Liria, 1773, the main façade designed
by Ventura Rodríguez. (Right) Palacio Real, ground plan.*

main staircase was redesigned by Sabatini under the inspiration of the
staircase at the palace of Caserta which was built by his father-in-law,
Vanvitelli. Sabatini then added a wing in the south east corner, which
disrupted the unity of the whole without succeeding in giving the Plaza
de la Armería the look of a *cour d'honneur* in the French manner, for
he refrained from adding its counterpart on the opposite side.

The methodical arrangement of the Plaza de la Armería was com-
pleted during the reign of Isabella II who also finished the gardens of
the Campo del Moro, decorating them with pretty fountains.

The Palacio Real ranks as Madrid's outstanding building, huge and
majestic and a museum in itself, the most important one in Madrid
after the Prado. After Alfonso XIII left Madrid (in 1931) it was never
again lived in, and possibly never will be, even if the monarchy were to
be restored. It seems likely that it will continue to exist as a museum,
though it may be occasionally used for special celebration or solemn
ceremonies, as indeed it is now.

The palace contains a very important series of fresco-covered ceilings
executed by the best painters of the period. Corrado Giaquinto painted
the one on the ceremonial staircase, as also those in the hall of columns
and on the cupola of the chapel. Giovanni Baptista Tiepolo painted the
vaulted ceilings of the Salón de Alabarderos and the Throne Room,
the most impressive in the palace, where he painted an allegory
representing the greatness of the Spanish monarchy, signing and dating
it in 1764. These ceilings are the most beautiful in the entire building,
perhaps even Tiepolo's best. Anton Raffael Mengs, considered a

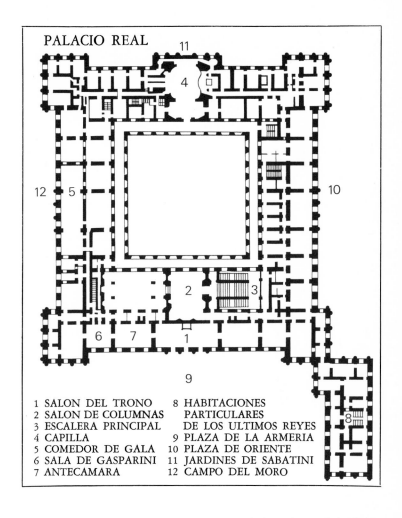

PALACIO REAL

1 SALON DEL TRONO
2 SALON DE COLUMNAS
3 ESCALERA PRINCIPAL
4 CAPILLA
5 COMEDOR DE GALA
6 SALA DE GASPARINI
7 ANTECAMARA
8 HABITACIONES
PARTICULARES
DE LOS ULTIMOS REYES
9 PLAZA DE LA ARMERIA
10 PLAZA DE ORIENTE
11 JARDINES DE SABATINI
12 CAMPO DEL MORO

second Apelles by his contemporaries, painted the ceilings of the Saleta and the Antechamber. There is also some notable work by Domenico Tiepolo, Francisco Bayeu, Vicente López and others of lesser renown. The Gasparini salon, where the stucco decorations in rhythmical Rococo *chinoiseries* by the Neopolitan Matteo Gasparini are preserved intact, the porcelain room of Buen Retiro, hall of mirrors and gala dining-room are of special interest.

Paintings by Goya, Mengs, Lorenzo Tiepolo, and Paret y Alcázar decorate various rooms as an integral part of the decorative ensemble, but in 1962 several rooms were made into a museum and it is here that their best pictures are exhibited. To be noted are a *Portrait of Philip of Burgundy,* attributed to Van der Weyden, panels by Juan de Flandes, *Calvary* by Bosch, Caravaggio's *Salome,* two little Goyas showing powder and cannon balls being made, a *Head of a Woman* by Velázquez, portraits of Philip IV and Isabella of Bourbon by Rubens, a *St Paul* by El Greco, and two delightful Watteaus, *Lesson in Love* and *Rustic Duet.* When the first Bourbon king, wishing to break with the past, attempted to foster development in the arts, the simplest method he could think of was to turn his attention to what was going on abroad and, taking the concept of culture at its most superficial, establish the following premise: if the nations who best embody the ideals of culture and

civilization in the eighteenth century are France and Italy, then it is their art that is most worthy of imitation. From the beginning of Philip V's reign, foreign artists began to appear in Spain. At first they would work side by side with local artists (as we saw in the case of Pedro de Ribera who built a great deal in Madrid in the early eighteenth century) but, little by little, they began to spread their influence until finally they supplanted them. The new currents first began in court circles, and from there spread out in widening ripples. The fact that it was an Italian who built the Palacio Real did much to strengthen the influence of foreign artists, and so did the establishment of the Academia de San Fernando in 1752, with which Italian academic Baroque was officially enthroned in Spain. The first palace on which the new European spirit was to be injected was the palace of La Granja, which we shall come to later.

In 1731 there arrived in Spain from Piacenza a certain Santiago Bonavía, who built the theatre of the Buen Retiro palace in Madrid (since disappeared) and the church of SS. Justo y Pastor (1739-43), one of the city's finest churches and the one which most clearly showed traces of Guarini's Baroque style. Bonavía, who also worked in Aranjuez, was the most important Italian architect to arrive in Madrid before Juvara and Sacchetti.

When Ventura Rodríguez, still little more than a boy, started work as Juvara's draughtsman his fortune was made and the onward course of his career was due to his training with the Italians. He was at that time the only first-class Spanish artist, who stood out amidst the mass of foreigners, and he continued to make good use of what he had learned. In 1749 Ventura Rodríguez began the small but beautiful church of San Marcos in Madrid which reveals his great talent, and the extent to which he had assimilated the lessons of his masters. For the ground-plan of the church he has adopted a model of Juvara's and used it masterfully, whereas the elevations are inspired by Borromini's church, San Carlino in Rome. It is a pity that Rodríguez's rising career was cut short by Sabatini, since this prevented him from leaving posterity with more examples of his achievements, for apart from this church and a few reconstructions in Madrid his best work consists of the Prado fountains.

In the reign of Ferdinand VI, at the wish of his queen, Barbara of Braganza, the Convento de Las Salesas Reales was built. It was intended to educate the daughters of the nobility, under the iron authority of the nuns of the Order of St Francis de Sales. In this case, the designs of a Frenchman were chosen, those of François Carlier, son of Philip V's architect and landscape gardener René Carlier. The first stone was laid on 26 June 1750, and the whole building was finished at the end of 1758.

The church of the convent has all the magnificence of a royal foundation and its architecture strikes a balance between French classicism and Italian pomp. The altars are sumptuous, especially the high altar which consists of four columns in green serpentine marble. All the accessories in the church are conceived as a unity. Paintings by the brothers González, Velázquez (on the cupola) and by Giaquinto, Flipart, Mura, Cignaroli (on the altars) and sculptures by Domingo Olivieri all contribute to form a grandiose orchestrated whole. The

▷

The church of SS. Justo y Pastor, 1739-43, one of the finest religious structures in Madrid, in the Italian Baroque style, with a convex façade.

tomb of Ferdinand VI, based on a design by Sabatini, was erected on the epistle side of the transept. It is a copy of the papal cenotaphs of St Peter's in Rome, and quite lives up to them in the vigour of its moulding. It was carved by Francisco Gutiérrez. The façade, rather too low in relation to its ample width has, however, the advantage of allowing the dome, with its light and elegant profile, to be adequately visible. In any case with its massive regularity, its imposing granite structure and its splendidly exuberant decoration in marble and Colmenar limestone, this building represents a spectacular and convincing architectural feat. After the Salesian community left, when it moved to another more modest convent, the Palace of Justice was installed here after a careful reconstruction, leaving the church to serve as a parish church under the name of Santa Barbara.

Other important buildings in Madrid which date from the period of academicism are the Palacio de Liria (official residence of the Dukes of Alba), with its façades designed by Ventura Rodríguez; the old Casa de Correos by the Puerta del Sol, the work of Jacques Marquet; the Puerta de Recoletos (now destroyed); the Puerta de Hierro; and the Academia de Bellas Artes, originally by Churriguera but transformed in the academic style by Diego de Villanueva. The Palacio de Liria was almost completely destroyed in the Civil War, but its façades remained and the building has been magnificently and tastefully rebuilt. It now houses a collection of masterpieces which can be seen by appointment on certain days. The Academia de Bellas Artes is the most important gallery of paintings in Madrid after the Prado, and is not to be missed by any lover of Zurbarán or Goya.

This brings us up to the reign of Charles III *pater patriae*, who was the Spanish representative of that 'enlightened despotism' whose outstanding figures were Catherine the Great, the Emperor Joseph II of Austria and Frederick of Prussia, the monarchs who were the most admired and extolled by the philosophers who were their friends and attendants. The title despot or tyrant, so unwelcome to the ears of eighteenth-century man, changes meaning when the adjective 'enlightened' is added to it. To quote Paul Hazard, 'enlightenment enhanced the brilliance of their reigns'. The administrative centralization introduced by such rulers restored order where chaos had previously reigned. Order being a reflection of universal reason, the state was to be rationalized. This was the justification for their conduct.

Charles III was as much an ardent centralizer as he was a royalist and a passionate organizer. Whether he was giving a military order, opening a canal or constructing buildings, there was clarity and efficiency in the way he imposed order. Madrid, the capital of his kingdom, the town that had seen his birth, was to benefit the most from his spirit of organization and magnanimity. He speedily set about a substantial reconstruction of Madrid, achieved a great deal, and, if he did not achieve more, it was only because the desired transformation of a neglected country town into a Baroque capital city was more than could be accomplished by one man in one single reign. Nevertheless he deservedly won himself the title of Madrid's best mayor.

The transformation of Madrid wrought by Charles III in his reign mostly affected the periphery: promenades, gardens, monumental gates, approaches, the exterior appearance of the city. Meanwhile the interior was being tidied up and cleaned. But the most spectacular change was accomplished in the Paseo del Prado, where a haphazard public walk that had grown more or less spontaneously along the course of a small stream was transformed into a piece of town planning

Church of San Marcos, built by Ventura Rodríguez.
The painting in the cupola is by Luis Gonzales Velázquez.

Convento des Salesas Reales.
The church, dedicated to St Barbara,
is by François Carlier.

▷
Fuente de Apolo, 1775,
in the Paseo del Prado.

on a grand scale. The importance of the Prado to the town does not lie simply in what it is itself but in the growth around this centre of the most important monumental buildings of that reign, and these were followed by many others during the nineteenth and twentieth centuries. Admittedly the basic idea of Charles III's planning was disrupted and lost its former charm and unity; but, after all, the impulse given then has lasted, with the result that this area continues to be one of the most imposing and handsome open parts of the capital.

The work of reshaping and embellishment began in 1775 under the direction of the engineer José Hermosilla and the architect Ventura Rodríguez. A great promenade, with three decorative fountains, was planned with one in the middle and one at each end, forming the centre pieces of the wide avenues. Though larger and longer than the Piazza Navona in Rome the layout reminds one of it, and the fountains too are in similar positions.

Fortunately the three fountains have been preserved, although the

two outer ones changed their positions many years ago because of the needs of traffic. This has rather spoiled the relation between them. These three fountains are indisputably the most beautiful in Madrid and we owe them to the genius of Ventura Rodríguez who designed them with great skill and elegance down to the last detail, including the sculptures. In this case the sculptors had to do no more than follow the architect's instructions precisely, as is proved by the original plans preserved in the municipal museum.

The most popular of the three fountains is the Fuente de Cibeles at the intersection of the Calle de Alcalá and the Prado. It represents the goddess Cybele in a triumphal chariot drawn by two lions. Francisco Gutiérrez carved the figure of the goddess and Robert Michel the lions. The Neptune Fountain is the counterpart and was executed by Juan Pascual de Mena. The most elaborate of the three is the central one, named after Apollo. The figure of Apollo is by Giraldo Bergaz, while the Four Seasons are by Manuel Alvárez.

The Puerta de Alcalá used to be the triumphal entry arch into the Madrid of Charles III. He himself had entered the city through it

when he came to take possession of his kingdom, hence his desire to replace the old gate of the time of the Hapsburgs by a ceremonial structure more in accord with the taste of his period and his own ideas. His favourite architect Francisco de Sabatini was commissioned to plan and build it, and he finished it in 1778.

Sabatini was a native of Palermo who had trained in Naples, working under his father-in-law Vanvitelli, designer of the Palace of Caserta. He came to Madrid in the entourage of Charles III, and the king bestowed the highest honours on him, making him his chief architect and marshal of his army. Sabatini's arrival shook the positions of all the other architects at court, in particular Ventura Rodríguez, who presented the greatest threat of competition.

For a long time society was unjust to the maestro from Palermo, who could not be forgiven, and understandably so in some cases, for having overshadowed such an outstanding artist as Ventura Rodríguez. But, judging him by his own work and not by the jealousy he aroused by the unfair privileges he enjoyed, one cannot but admit his talent. The Puerta de Alcalá is a superb work, possibly one of the best of its

Madrid. San Francisco el Grande, c. 1780, an 18th-century version of the Pantheon in Rome.

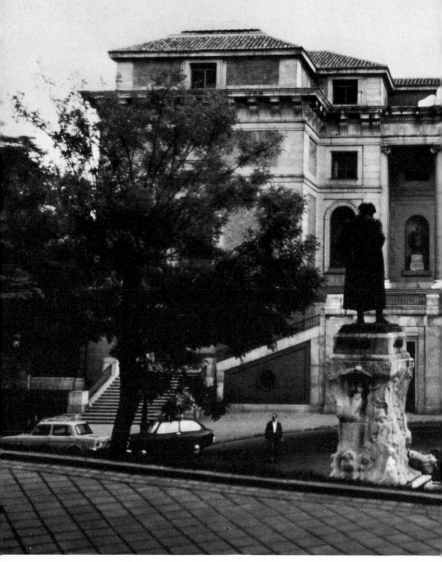

Madrid. Museo del Prado, 1785, north façade, neoclassical style, by Villanueva.

kind in the whole world. Its Roman air reminds one slightly of the Fountain of the Aqua Paulina on the Janiculum, and its vigorous modelling has a touch of Michelangelo, while the decorations embody the delicate taste of the eighteenth century.

Another of Sabatini's great works is the old Casa Real de la Aduana, the royal customs house, in the Calle de Alcalá, today the Ministry of Finance. It is one of the buildings that Charles III had built as an expression of his desire to support and strengthen national institutions as well as to give glory to architecture, the mother of all arts and the mirror of the nation's grandeur. This grandiose building was finished in 1769 and it need fear no comparison with the best Roman palaces, which it resembles. Sabatini succeeded in combining the warm movement of the style with the severity of the Renaissance, the pure lines of a Vignola or Fontana with the opulence of Bernini.

Sabatini also designed the imposing Hospital General at the Puerta de Atocha, which was never finished but still has one courtyard of

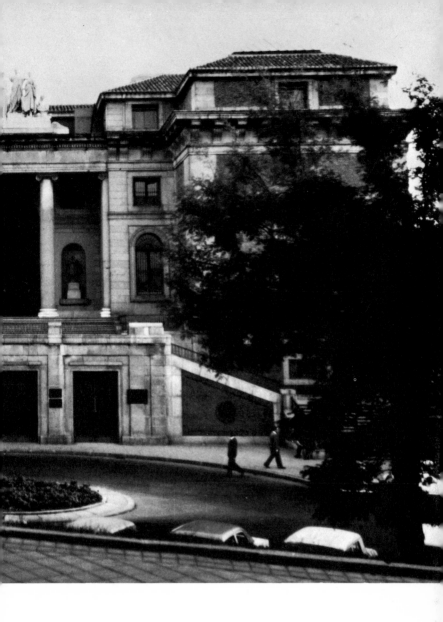

enormous proportions. Another notable building of his is the Palacio del Marqués de Grimaldi near the royal palace, which was later the Ministry of State, then the Ministry of Marine, and today houses the Museo del Pueblo Español. The regular composition of its façade and its original staircase make it well worthy of note.

The church of San Francisco el Grande in its final form, after the rejection of the plans of Ventura Rodríguez and the correction of the mistakes of Fray Francisco de las Cabezas, is also largely the work of Sabatini, who created a rather majestic version of the Roman Pantheon. The decoration of the interior was renewed in the nineteenth century and is in open contradiction to the sober architectural style in which the church was created. There are some eighteenth-century altar paintings including a Goya depicting St Bernardino of Siena preaching to the king of Aragón. It is a youthful work (1781) and, in spite of the vigorous treatment of some of the heads, on the whole a poor painting with academic pretentions.

Museo del Prado, Madrid.
The San Ildefonso group,
(Castor and Pollux?)
showing influence of school of
Praxiteles.

Right, Ariadne, 2nd cent. AD
Roman sculpture of Antonine
Period.

At the end of Charles III's reign another great figure in the history of architecture in Madrid comes to the fore, a man who was to reach the height of his career in the following reign under Charles IV. This was Juan de Villanueva (1739-1811) who, though trained in the new ideas the Academy had brought with it, went beyond them, and became the exponent of neoclassicism in Spain. His period of study in Rome brought him into contact with the archaeological and learned circles of the city and with new trends in the world of art. On returning to Spain he worked on the Escorial for the prince and his family and gradually began to make a name for himself in court circles. In furtherance of his wish to improve the Paseo del Prado, by a decree of 1785 Charles III ordered the building of a museum of natural history, and his minister Floridablanca determined that it should combine impressive size with everything in the way of solidity, usefulness, elegance and beauty. The work must have been quite far advanced by the death

of Charles III in 1788, but it was obviously still far from being com-
pleted and continued throughout the reign of Charles IV until the
tragic year of 1808 when, having only just been finished, it was ruth-
lessly pillaged by the French soldiery, ransacked and the lead strip-
ped from its well-covered roof. What had been intended to be the
museum of natural history was abandoned to the elements through-
out the years of the French domination and the opening of the reign
of Ferdinand VII. Its roof would have crashed to the ground had it
not been restored and a new use sought for the hall. In the last years of
Charles IV's reign some proposals had already been made for the crea-
tion of a great picture museum at court, the idea that came to the fore
again during the brief reign of Joseph Bonaparte, but crystallized only
several years later when Ferdinand VII had already been restored to
the throne of his forefathers. Various sites were considered until a
wise proposal by the Council of Castile suggested as the most suitable

solution that the museum be housed in the building on the Paseo del Prado which was erected at the cost of so much effort by the grandfather and father of the king. The idea satisfied Ferdinand VII, so in the *Gaceta de Madrid* of 3 March 1818 there appeared the decree by which the Museo de Pinturas was created in the building planned and built by Juan de Villanueva. Thus was born the Prado Museum which soon became world-famous. The first rooms were opened to the public on 19 November 1819, in the same year as the first catalogue was published, edited by Luis Eusebi, covering no less than 311 works, including those by Velázquez and the series of battle scenes from the Buen Retiro palace. In 1828 the catalogue covered as many as 755 paintings, and the number steadily grew. On the death of her father Ferdinand VII in 1833, Isabella II inherited the museum, since the collection was considered to be owned personally by her father.

The museum became state property during the revolution of 1868, and in 1872 the collection from the Museo Nacional de la Trinidad was incorporated into it, the latter being made up of paintings acquired through the dissolution of the monasteries in 1835. The basis of the Prado's collection consisted, on the one hand, of the royal collection which constituted the main and most important part, and, on the other hand, of religious painting which had always been so rich and widespread in Spain. To this basic collection were added many other legacies from distinguished patrons of the arts and the continual additions made by the museum foundation, and by the state.

Thus Charles III's ambitions were not frustrated and the great building which he had intended as a haven for the natural history became a shrine for the arts. The Botanical Gardens were laid out next to it and, although in a slightly dishevelled state, they still exist as a scientific institution. Juan de Villanueva himself designed the gates and handsome garden railings as well as the building housing the conservatory and offices, though this was later considerably altered. In the same wave of enlightenment, and with the same desire to bring about progress in the sciences, an observatory was set up not far from the Prado, on a little eminence called San Blas. In order to house it, Villanueva designed in 1790 a pretty building in the style of a Palladian villa with a lovely Corinthian pronaos and an Ionic lantern-dome.

Villanueva, the last great eighteenth-century architect of Madrid, left several other noteworthy buildings in his birthplace, such as the Oratorio del Caballero de Gracia, a little church resembling an ancient basilica, the house of the Royal Academy of History, the columned balcony of the town hall and the plans for the remodelling and reconstruction of the Plaza Mayor—he was the chief architect of Madrid from 1786 until his death, a position he had taken over from Ventura Rodríguez.

Before leaving the eighteenth century we should direct our attention to a simple and humble shrine which would pass unnoticed had it not been brought to life by the brush of a giant in the history of painting. Next to the ancient Puerta de San Vicente there used to be a small hermitage dedicated to St Antony which had to be demolished as part of the building projects of Charles III and Sabatini. The architect built a new one which was in turn demolished to make way for yet another new project. As the cult of St Antony had become very popular, Charles IV sought out a rather remote site lying to the north, and had a third hermitage built, entrusting the plans to a man called Francisco Fontana, a little known architect.

In 1798 the year of its consecration, Charles IV commissioned Goya to

*Madrid. Hermitage of San Antonio de la Florida, the cupola,
with a painting depicting the* Miracle of St Antony.

paint the ceilings and all the free spaces in the transepts. The painter
realized that it was an ideal opportunity for using a single theme
throughout, thus creating a tiny microcosm of the world as Goya saw it.
The central composition is the resurrection in the presence of the
people of Lisbon, of a murdered man whose death was being blamed
on the saint's father, and it occupies the ceiling of the cupola. At the
moment of performing the miracle, St Antony appears, surrounded
by people, whose appearance, movements and expressions are those
of everyday life. Here Goya attains the mastery of great artists
blessed with a gift for recreating life and on this occasion he has
himself performed a miracle. In the spandrels and in the lunettes,
more abstract compositions combining angels and symbols, all handled
with great technical audacity, create an atmosphere that is uniquely
his own.

Since 1919 the remains of the great Aragonese painter, so closely
associated with the Madrid of Charles III and Charles IV, have
been lying in peace in this shrine, which has been deconsecrated as
a chapel but is dedicated to the worship of art.

Madrid in the Nineteenth Century

The impoverished, gloomy days of Madrid in the period after the
war of independence form a tragic contrast with the glorious epoch
of Charles III. Of all periods, this was easily the worst and most
cruelly trying Madrid has experienced in modern times. The state

was disintegrating, the seed of civil discord was sown, and at the hands of opposing factions the nation became, depending on the point of view, the trophy or the spoils of war. There was hardly any energy left for the work of rebuilding and the little that was done was weak and ephemeral.

Juan de Villanueva's pupils were working in the Madrid of Ferdinand VII, but they had no chance of putting into practice the noble ideas their master had instilled into them. Some complained bitterly, like Isidro González Velázquez who spent his life designing projects that were doomed to failure and occupying his time with decorative inanities. One of these projects was to be the major rebuilding of the Plaza de Oriente, which was never realized, for a simple and less ambitious plan was used instead and was completed, as we see it today, in 1841.

Nor was there any spirit left for commemorating patriotic events. Monuments such as the Obelisco del Dos de Mayo, which was not commissioned till 1822, took eighteen years to be finally completed. It is the only work of any quality left in Madrid by Isidro Gonzáles Velázquez, who was otherwise an artist of prolific and subtle inspiration. The obelisk brings together the taste for antiquity and the romantic streak of the period. Less inspired was the Puerta de Toledo, built between 1813 and 1826 to commemorate Ferdinand's return to Madrid. The architect was Antonio López Aguado, a cold and conventional academician who was a follower of Villanueva but had no real creative talent. To him we also owe the planning and building of the Teatro Real, which, unfortunately was much altered later on. It is not until the middle of the nineteenth century that one comes across a positive desire for renewal in Madrid in accordance with the spirit of the period, with the growth of progressive middle-class liberalism, with the aspirations that earned it, not without a certain irony, the description of 'the age of steam and good taste'.

The 'Age of Progress' began with efforts to find solutions to all human and social problems of the city. New cemeteries were created, the Paseo de las Delicias de Isabela II was opened as a prolongation to the north of the Paseo del Prado and the Paseo de Recoletos, which was then called Paseo de la Fuente Castellana and later simply Paseo de la Castellana. Building the city was the dominant preoccupation of those years. The first initiative was taken by Mendizabal and Mesoneros Romanos, but the one who actually achieved constructive results was the Marquis of Salamanca. With his building enterprises, which gave rise to the quarter called after him and also nearly ruined him, Salamanca was one of the most benevolent men of the nineteenth century in Spain. He was a liberal politician, an opponent of General Narváez (Isabella II's powerful minister, spokesman of authoritarian conservatism) and an able financier, both daring and intelligent in his ventures. He promoted the construction of the first railways, and his enterprises also covered the field of the theatre, which was having a second golden age in the cheerful mid-century period. At the height of his fortunes he built himself a mansion in the Paseo de Recoletos, a rich and handsome building which opened the series of luxurious residences for the magnates and the nobility that began to spring up in the Paseo de Recoletos and de la Castellana. His architect, Narciso Pascual y Colomer, was the most distinguished one of the Isabelline period. Fortunately the mansion is still standing though converted into the Banco Hipotecario, whereas so many of these

Tadea Arias de Enríquez, c. *1793-94, by Goya, Museo del Prado, Madrid.*

palaces and town houses have in the last few years fallen victim to the changing needs of life and to land speculation.

One feature in the field of urban reconstruction deserves a special mention and that is the Puerta del Sol, the heart of nineteenth-century Madrid. Before it was rebuilt it was only a small intersection on which converged no less than eight of the town's main roads. The arduous task of reshaping it was accomplished with skill and good judgment between 1857 and 1862, creating an open square, rather large by the standards of the time, whose style showed the heavy bourgeois trend of the middle of the century. The old Post Office building, later the Ministry of the Interior, built in the eighteenth century by the French architect Marquet, became the centre of the square. Opposite this spread out a fan-shaped space with all the streets leading into it on a regular plan.

Until the first year of the twentieth century the Puerta del Sol, brimming over with brilliantly lighted cafés, and shops, was the unchallenged focus of all life in Madrid, and the clock on the actual gate counted the hours in the political life of the nation. The population never ceased to walk the pavements of the Puerta del Sol whatever the hour of day or night. Here the great mingled freely with people from all walks of life in a picturesque medley.

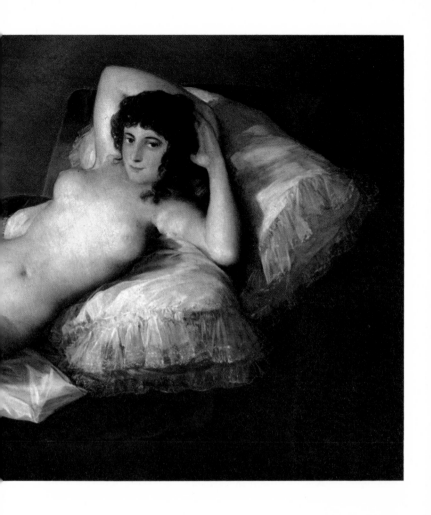

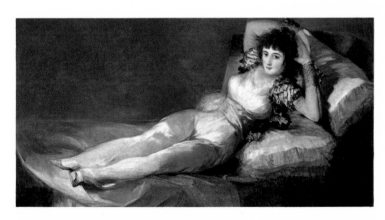

The Naked Maja *and* The Clothed Maja,
by Goya, 1798-1805.
Museo del Prado, Madrid.

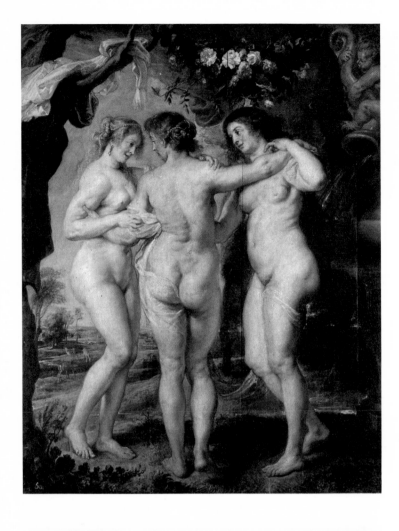

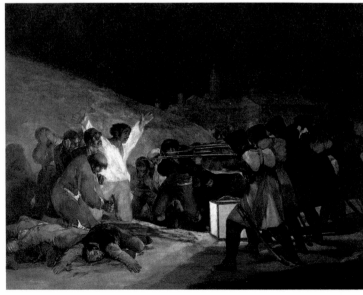

Madrid, Museo del Prado.
Las Meninas, c. *1656, by Velázquez also called* The Royal Family, *generally regarded as the artist's finest work.*

Madrid, Museo del Prado.
The Three Graces, c. *1639, by Rubens (left above)*

Las Tres de Mayo, *1808, by Goya (left), a dramatic rendering of the executions near Madrid, painted* c. *1814.*

their rank and social position nevertheless determined by their dress; for then, unlike today, indifference in matters of clothing was not yet universal. The silk hat of the notable mingled with the Andalusian sombreros or the bowler hat of the man about town, the coarsely woven uniform of the soldier with the sackcloth of the monk, the frayed coat of the common girl with the Paris model of the lady. The square was full of clamour and confusion with the shouts of the pedlars, the curses of the coachmen, the bursts of argument, the hoarse cries of the newspaper sellers, and the dull murmur of the human tide. Nothing more is left of that Puerta del Sol whose praise was sung by Edmundo de Amicis and later by Ramón Gómez de la Serna, except for an empty shell, the physical scene; the spirit has gone.

Hieronymus bosch

The Hay Wain, *by Hieronymus Bosch, central panel from a triptych. Museo del Prado, Madrid.*

Miniature from Beatus of Liebana's Commentary on the Apocalypse.
*Written and illuminated by the monk Facundus for Ferdinand I
of León, 1047. Biblioteca Nacional, Madrid.*

By the middle of the century Madrid had already proved uncontainable and overflowed the old limits which had remained unchanged since the time of Philip IV. They did not consist of a rampart, as in the Middle Ages, but just of a straightforward wall, intersected by several imposing city gates as well as numerous postern gates, whose purpose was mainly fiscal—to facilitate the collection of taxes and municipal dues. All the same it had been a barrier sufficient to contain the growth of the town until it finally burst through. In the reign of Charles IV, before the War of Independence, Madrid had 175,000 inhabitants, and they did not overflow, even though they were a little crowded inside the wall.

In 1857, when the problem of population growth could no longer be overlooked, a royal decree authorized the Ministry of Public Works, with the co-operation of the Town Hall and the Diputación, to formulate a general plan of expansion. The engineer Carlos María de

Castro was put in charge and he completed the plan in 1859. The general lines of it were actually carried out and allowed for the expansion of Madrid until 1930, when the periphery, drawn up under the Castro Plan, was once more stretched beyond its limits.

The dominating feature of the plan was the grid-shaped layout of the streets with rectangular blocks of buildings, a typical example of nineteenth-century town planning theory. The most regular and most imposing zone of the new expansion stretched from the Paseo de la Castellana to the east. It was also the area where the middle class, the increasingly dominant social class, could find the extra space they desired. To the west spread the so-called de Pozas quarter, also a promising area because of its agreeable situation and pretty views over the Casa de Campo, the Palacio de Moncloa Sierra de Guadarrama. The other quarters to the north developed at a slower pace, for they consisted in part of cemeteries and later of reservoirs. The southern areas had a more conventional plan with wide avenues and boulevards radiating from a centre point. They were designed by Charles III with the intention of making the bare treeless suburbs more agreeable, but the contrary happened and the area became impoverished and dilapidated. In addition the railway stations, workshops and warehouses, inevitable adjuncts of a rise in industry, even though only on a small scale, were a disruptive factor in harmonious urban development. Although the industrial belt has by now moved much further out, the area south of the Atocha and Toledo gates is still an unplanned and cheerless factory zone.

Parallel with the creation of these extensions there was a marked advance in the services of a modern city; gas lighting was introduced in 1832, a water supply, thanks to Isabella II's canal, came between 1851 and 1858; public transport in 1871 and finally electric light in 1875. All this was an indication that Madrid was recovering, and that Isabella II's reign provided a calm, constructive interlude, a bourgeois, progressive renaissance in the midst of the vicissitudes of the nineteenth century.

Meanwhile architecture, which we left in the hands of the heirs of Villanueva, was evolving into a search for prototypes more suitable for imitation than those of classical antiquity. Instead of finding inspiration in forums, temples, circuses and basilicas, it turned its attention to the elegant buildings of the Renaissance of the quattrocento, less heroic in scale but more in tune with bourgeois ideals. It was a similar trend, though an earlier one, to Pre-Raphaelite painting. It could almost be called Pre-Bramantism. The best representative of this movement was Narciso Pascual y Colomer, whose style, though still Roman in the Congress of Deputies (1843), becomes frankly Italian Renaissance in the Marquis of Salamanca's palace, his best work. He was followed along this path by Francisco de Cubas, creator of several mansions along the Paseo de Recoletos (some of them demolished) which conferred a certain standing on that distinguished thoroughfare and set the tone for the future Avenida de la Castellana, which until recently was lined with trees and bordered with the palaces, some of them in the French style, of the aristocracy and *haute bourgeoisie* of Madrid. In this way it was a rather exceptional street and one whose buildings and gardens should have been preserved, even though the mode of life they were built for has disappeared. The loss of all the dignity and standing of the Avenida de la Castellana and the replacement of its palaces by new office blocks of offices are among the unfortunate consequences of contemporary urban development.

Francisco de Cubas, who began his career under the auspices of Narciso Pascual y Colomer, later allowed himself to be overshadowed by the powerful personality of Viollet-le-Duc and made himself the exponent of the Gothic Revival in Spain, which he wished to immortalize in the ambitious Catedral de la Almudena, begun in 1883 but still not finished, though it has already been modified so as to harmonize better with the royal palace next to it. In 1885 just after the cathedral was started, the diocese of Madrid-Alcalá was created and it was thought that this would become a fitting cathedral for Madrid-to-be. Before it was completed, however, the title 'Santa Iglesia Catedral' fell to the church of San Isidro, the chapel of the old Imperial College of Jesuits, which title it still bears. Madrid had gained ecclesiastical independence and shaken itself free from the powerful archbishopric of Toledo, but it had done so in a period unpropitious for the building of great representative churches.

In the last years of the century several architecturally very good buildings were put up in the capital. Imposing though they were, they nevertheless lacked the discipline of an established school that gives a style meaning and makes it historically and socially relevant.

For in fact the reigning eclecticism made each architect master of his own school and arbiter of his own tastes. Of these buildings it is worth mentioning the Palacio de Bibliotecas y Museos begun by Jareño and finished by Ruiz de Salces between 1884 and 1892, as well as the Banco de España by Eduardo Adaro, finished in 1891.

The Palacio de Bibliotecas y Museos houses the Biblioteca Nacional, the most important in the country, the Museo Arqueológico and the Museo Nacional de Arte Contemporaneo. The former has a great collection of ancient art and archaeological finds, medieval and Renaissance treasures, and numerous objects of industrial art ranging from gold and silver work to ceramics and porcelain. The Museum of Modern Art, in the process of being reorganized, spans the whole range of nineteenth- and early twentieth-century painting while another museum, this time of contemporary art, is at present being built. When it is open it will exhibit recent trends in Spanish art.

An interesting development appeared in the architecture of Madrid in the late nineteenth and early twentieth century, namely neo-Mudéjar art, headed by Rodríguez-Ayuso (1845-91). This form is based on the re-creation of the Mudéjar style of Toledo, whose presence and

(Left) the golden votive crown of the Visigoth king,
Recceswinth, 649-72.

(Below) the Lady from Elche, Hispano-Roman sculpture, 300 BC
Museo Arqueologico, Madrid.

proximity to Madrid gave inspiration to a few talented architects. Rodríguez-Ayuso built the Plaza de Toros, which has since been demolished, the arena used during the peak of the great bull-fighting era when Lagartijo, Frascuelo and later Joselito and Belmonte kept everyone enthralled. He also built the Aguirre schools and other buildings which no longer exist. The trend found favour in religious architecture and produced a few simple but worthy works such as the church of San Fermín de los Navarros built by Carlos Velasco.

Madrid Today

The great expansion initiated in the nineteenth century continued unhaltingly during the first part of the twentieth century. In 1875 Madrid had 360,000 inhabitants and the figure rose to 529,000 in 1900. By 1945 the city could count 1,167,335 inhabitants. From then onwards there was a steep increase produced by the annexation of the suburban municipalities, continuous immigration, and industrialization encouraged by the centralist government policy of General Franco. In 1950 a figure of 1,618,000 inhabitants was reached. During the decade from 1960 to 1970, the figures rapidly passed from two to three million—all of which gives rise to the problems of planning, building and administration which preoccupy the whole city.

The reign of Alfonso XIII (1902-31) was a period of transition for Madrid—its traditional character and appearance were abandoned in favour of a modern, yet personal and private, cosmopolitanism. The neoclassical tradition was set aside, opening the way to a banal eclecticism of the kind that triumphed, for instance, in the Gran Vía, begun in 1911. The Gran Vía was Alfonso's great internal structural reform, but it was not completed until the period of the Republic. The intention was to open up a road linking east with west, cutting through the old city to relieve the traffic that inevitably had to pass through the Puerta del Sol. The idea was a good one but its execution leaves much to be desired. The pressure of economic interest began to raise the maximum height of buildings and so the first American-style skyscraper, with touches of Spanish Baroque about it, appeared to house the Bell Telephone Company, an American firm that was later nationalized. But since the Gran Vía is crammed with luxury cinemas and theatres of all kinds and has become both in daytime and at night the centre of entertainment in the city, what was designed as a clearway for through traffic has become the most congested and chaotic zone in the town.

Another enterprise which was also given enthusiastic support by the king and produced better results was the construction of the metropolitan underground railway named after him. The first line was opened in 1919 and linked Cuatro Caminos with the Puerta del Sol. The Madrid underground has continued to expand ever since and is today one of the vital instruments in the city's development.

In the cultural field Alfonso XIII encouraged and to a large extent put into effect the ambitious plan for endowing the town with a university city modelled on the American university campus. Madrid University, posthumous child of the venerable University Complutum founded by Cardinal Cisneros in Alcalá de Henares, first occupied and old house in Calle Ancha de San Bernardo, where the students found themselves herded together with no way of expanding because of the crowded houses and with hardly enough air to breathe.

Large open grounds lying to the northeast of Madrid were chosen

Madrid. Biblioteca Nacional, façade, begun by Francisco Jareno in 1866 and completed by Ruiz de Salcez in 1891.

for the new university campus, a site that commanded a view over the Sierra de Guadarrama and had quite a few natural amenities such as the gardens and woods of the Palacio de Moncloa. In the eighteenth century some noble families such as the Dukes of Alba had country houses in this area, while the great painter Francisco Goya and the famous Duchess Cayetana must have passed many a sweet hour of friendship here. The little palace of the Alba family, called Palacio de Moncloa, was destroyed during the Civil War and rebuilt afterwards in a rather different form. Nowadays it is used as a residence for distinguished guests, heads of state and the high dignitaries invited officially by the government.

The new campus was set up in the grounds of the Moncloa estate along a number of main avenues, grouping together in sectors the various teaching faculties—medical science, physics and natural science, literature, law, arts and so on. The architect who was in charge

of the works at the head of a group of distinguished professional men, was Modesto López-Otero. At first a unified line was followed in the design of the buildings, but later a freer and more individualistic policy was followed. In spite of its defects, the university city is an impressive creation and has been carried out with much success. Other university centres to cope with the ever-increasing student population are being built on sites further from the outskirts of Madrid. The monarchy, restored in the person of Alfonso XII, son of Isabella II and father of Alfonso XIII, felt a duty to commemorate its glory and a memorial to Alfonso the Pacifier was built in the Retiro Park which was supposed to symbolize the end of the Carlist Wars that had ravaged the country during the nineteenth century and the feeling of national recovery generated by the Restoration. It is, in more modest form, a nationalist monument like the Victor Emmanuel one in Rome.

It was designed by the architect José Grases Riera, and the main

sculptor was Mariano Benlliure, a native of Valencia and a vastly talented and prolific artist who can be considered to have been one of the best interpreters of the Madrid of the Alfonsos, which he commemorated in many monuments and whose outstanding figures he immortalized in numerous statues. The city has several excellent statues which it owes to his chisel such as Emilio Castelar, General Martínez Campos, the Queen Regent, Alvaro de Bazán, Lieutenant Ruiz, Francisco Goya and others. During Alfonso XIII's reign some ambitious buildings were constructed, mainly banks, since it was here that the national finances were concentrated, as a result of the policy of centralization, much disputed but never abandoned. The Bolsa de Comercio, a classical building by Enrique Repulles y Vargas, the Equitativa block and the Hispano-Americano, Bilbao and Río de la Plata banks all more or less imitate the Banco de España in its monumental style. The period also boasts a noteworthy architect in Antonio Palacios, author of the pompous Palacio de Communicaciones in the Plaza de Cibeles, in which he ably

*Madrid. A fountain
by the Puerta del Sol.*

◁
*Madrid, aerial view of the
Plaza de la Independenzia.
In the foreground,
the Buen Retiro park.*

215

handles themes originating in the national Plateresque style. Palacios was also the author of various banks and commercial buildings.

The brief and troubled period of the Republic was not propitious for any great architectural enterprises, but it did prepare the way for some changes which were to prove their value at a later stage. The Socialist Minister Indalecio Prieto, aided by the distinguished architect Secundino Zuazo Ugalde, drew up a plan for improving the communications network around Madrid, and started by linking up the north and south railway lines by means of a tunnel passing beneath the Paseo de la Castellana, and prepared for this avenue to be extended towards the north. This was destined to be one of the largest areas of Madrid's expansion. In the area opened up by this new avenue Secundino Zuazo planned and began to build a great complex intended to house various ministries, a project that was completed by the Franco government. In his plan Zuazo tried to adapt the austere lines of the Escorial into a modern building.

At the end of the tragic interlude of the war in 1939, Madrid not only woke up and started rebuilding but also became aware of the many problems that the future and its own role were going to bring. The Junta de Reconstrucción was set up in 1939 to create a plan for the development of the city, and this took shape with the passing of the law of 1 March 1946, entrusting these matters to the General Commission for the Urban Organization of Madrid and its Environs, a new body which coordinates on a wide scale and has greater powers than the municipal authorities. This organization is at present responsible for what we now call 'Greater Madrid'.

It is one thing to plan and legislate, but it is quite another to bring everything to realization. Madrid's vegetative growth has generally been several steps ahead of the plans that were supposed to precede and channel it. No sooner was a plan drawn up than it was already out of date because of the very rapid evolution of town planning theory. Furthermore the tremendous housing shortage produced by the Civil War and the population explosion, urgently called for a peremptory solution to the problem. Blocks of houses would spring up chaotically on the outskirts of Madrid without the necessary communication between the two, without main roads or organized transport, without any of the trappings of a city, nor even the basic facilities. It was as if one had to build a house by starting with the roof instead of being able to lay the foundations for a planned structures.

Property speculation is one of the fields into which the national finances have been poured during recent years. This too has produced its own crop of tragedies, owing to the manipulations of interested parties greedy for greater profit margins. It has brought with it grave misuse of land and constant encroachment on the 'green belts' foreseen in the plans but frequently sacrificed to the pressures exerted by influential groups.

Thus when the break-through of the Avenida del Generalísimo was being executed as a prolongation of the old Paseo de la Castellana, the plans were constantly being altered and the density and height of the buildings increased through the rapacity of the property developers. What was intended to be a well-designed modern open sector of Madrid was spoilt by overcrowding.

During the immediate post-war period attempts were made at promoting a national architectural style, based on the doctrines of Herrera, because it was thought that the style of the Austrian period was the

Madrid. Palacio de Communicaciones in the Plaza de Cibeles, 1912. The architect, Antonio Palacios, achieved a design half traditional and half modern.

physical symbol of the Spanish empire whose glories it was desired to rejuvenate. The Air Ministry building in the Argüelles quarter was conceived with these ideas in mind and executed by the architect Luis Gutiérrez Soto. It is the most monumental architectural achievement of the Franco era.

Madrid can boast some good examples of present-day architecture, lively, well entrenched in contemporary fashion and with a personality of their own. One of them is the residential block called Torres Blancas, the work of the architect Francisco Sainz de Oisa, a good illustration of expressionism in architecture with its aggressive structure and open use of concrete. Madrid does not lack young and talented architects who could play their part in the development of the city, but they have not yet achieved the coherent collective expression which is the prerequisite of urban planning. The most talented among them tend to be no more than isolated sharpshooters, leaving the city as a whole at the mercy of the anonymous unseen forces that seem to govern great cities.

Madrid has come to be a great urban monster, and only a profound transformation of it political and socio-economic structures can master this all-devouring dragon, so that the city instead of enslaving man should help him to health, wealth and the pursuit of happiness.

Madrid. Monument to Dr Marañón by Pablo Serrano,
1970, in the university city.

The Monastery of the Escorial

On 10 August 1557, the day on which the church honours St Lawrence,
Philip II's army, commanded by Duke Philibert of Savoy, was engag-
ed in a decisive battle which ultimately resulted in a resounding
victory. The king, being of a temperament that always greatly
respected the mysterious powers that govern events, could hardly
avoid linking the outcome to the martyred saint and felt indebted
to him. This he explicitly admitted in the founding charter of
1561, where he declares his intention of founding a new monastery
'in gratitude for the victory that our Lord was pleased to grant
me on the day of Saint Lawrence in the year of 1557'. Philip II
also decided that the monastery would be devoted to the Order of
St Jerome, which was identified with Spain and hence at the height

P. 218/219
Madrid. The Torres Blancas by Francisco Sainz de Oisa.

220

of its popularity. The choice of a site was a lengthy process, and after consulting the monks and other men of good judgment the king decided on a place on the foothills of the Guadarrama near the insignificant village of El Escorial.

Thus the monastery of El Escorial was born in unpopulated and arid waste land in mountainous country, apparently to the satisfaction of Philip II, to judge by his preference for it to his Gudarrama palace of Balsaín. The king seemed to avoid the old capital of Toledo more and more, without, on the other hand, feeling any great affection for the new one, all of which is rather puzzling. In 1562 the preparation of the ground began while Juan Bautista de Toledo drew up the 'master plan' that was to govern the immense building. Very little is known about Juan Bautista de Toledo who was entrusted with the responsibility of one of the greatest masses of stone that have ever been erected. That he was trained in Italy we do know and some scholars—González Dávila and Juan de Quiñones for instance—assert that he worked on St Peter's in Rome under the wing of Michelangelo. Possibly he did, but that vast project must have occupied a huge number of craftsmen of different skills. The certain fact is that he had established himself in Naples with a considerable fortune when Philip II summoned him to Spain, probably on the advice of the viceroy Pedro de Toledo, for whom Juan Bautista had worked in Naples. On arrival in Spain he was appointed architect to Philip II by an ordinance dated 15 July 1559. Beyond these facts about his life all the rest is conjecture. From 1562 onwards another man had a hand in the plans for the monastery, especially for the church, the architect and military engineer Francesco Paciotto who had also served under the Duke of Parma, Alessandro Farnese and the Duke of Savoy. What seems beyond doubt is that where his new palace was concerned, Philip II wanted to leave the beaten track of Spanish tradition and draw strongly on the springs of Italian culture.

The first stone was laid on 23 April 1565 during a simple ceremony which the king did not even attend. From the beginning of the work Juan Bautista could count on the help of two inestimable assistants, the lay brother Antonio de Villacastrín, a practical man and a capable organizer, and Juan de Herrera, a thoughtful man, both a mathematician and a humanist. The work progressed fast and was therefore quite advanced by the time of Juan Bautista's premature death in 1567. His disappearance would have produced a serious crisis had it not been for the existence of Herrera whose ideas were very close to those of the master and who was able to take over. After twenty-one years of constant effort, to which many men of all levels, architects, draughtsmen, overseers, foremen, pieceworkers, stonemasons and so on, contributed all their talent and enthusiasm, the last stone was finally laid on 13 September 1584. Only in this way can one understand how in such a short space of time such a building could be erected, one which Ortega y Gasset has described as being, after St Peter's in Rome, the heaviest article of faith that rests on the surface of Europe.

The idea of the monastery first took shape in the king's mind as a triumphal monument and a votive offering, then grew both in size and significance till it became first a mausoleum for the kings of Spain and a shrine in which to pray for the salvation of their souls, and later the culmination of divine and human wisdom in the form of a centre of scholarship and a repository for the written legacy

of antiquity. Then lastly it became the symbol of a charismatic conception of royalty based on the reconstruction of the temple of Israel, an idea that obsessed this scond Solomon, as he was called by Góngora. Inside the microcosm of the Escorial Philip II thought of himself as the *Rex-Sacerdos* of a new theocratic state. Symptomatic of this is the fact that the only images on the façade of the church were huge statues of the kings of Judah, Jehoshaphat, Ezekiel, David, Solomon, Jonah and Manasseh, who were prominent in the building and restoration of the temple.

From the aesthetic point of view, the Escorial presents several puzzling traits which have made it difficult to pass a balanced judgment on it, for when a man cannot manage to understand and classify, he tends unconsciously to reject. To quote Louis Bertrand, the palace has no particular age or character. It is impersonal and abstract like the monuments of ancient Egypt, for only by attaining extreme depersonalization could it aspire to the higher level of the super-human symbol.

Even in the choice of his own artists, the king manifested his tendency towards the depersonalized. Both Juan Bautista and Juan de Herrera were capable scholarly men well versed in the humanities and skilled in mechanical arts, but they were not famous artists whose vanity and idiosyncrasies might have contradicted the king's demand. Philip II wanted to be, and in point of fact was, the supreme arbiter of the whole building, in charge of the achievement of the idea he had formed of it, which was turning out to be something approaching his idea of himself. Philip II's real dream was not the painting by El Greco but the monastery that Herrera shaped at his dictation, one of the most remarkable confessions of the human spirit that the world has seen.

The style of the Escorial did not derive from that of any existing school nor indeed was it even the product of the personal talent of one great man. It is a style that evolved *pari passu* with the growth of the building. When the building was finished, a style had been created and Juan de Herrera had become a great artist. This is not a case of a great artist creating a great work but of a work of art making a genius out of the artist. After the Escorial came the Escorial style, which had its influence on Spanish art for over a century. But it did not grow out of anything that was there beforehand; it came into being through circumstances that were unique and could hardly ever be expected to occur again. Nevertheless what has just been said should not be misinterpreted; it does not mean that the Escorial is something quite exotic, born of nothing and conceived out of thin air. History does not allow such things, and anyway excessive originality would have violated the intentions of its founder, dragging him dangerously into the realm of fancy—and the Escorial is everything except that. On the contrary, it tries to capture all that the Renaissance way of thought has of value in its conception of the spirit of objectivity.

The Escorial disdains the heroic ideal of a Michelangelo as too grandiose and too full of pathos; it comes nearer to masters such as Serlio or a Vignola, zealous purifiers of form, essentialists, enemies of superfluous embellishment, rationalists, intellectuals. Its architecture is rooted in reason and protocol, and appealed to a king who was in love, as few have been, with ceremony be it alive or mummified.

The third and fourth books of Serlio's *Architecture* translated into

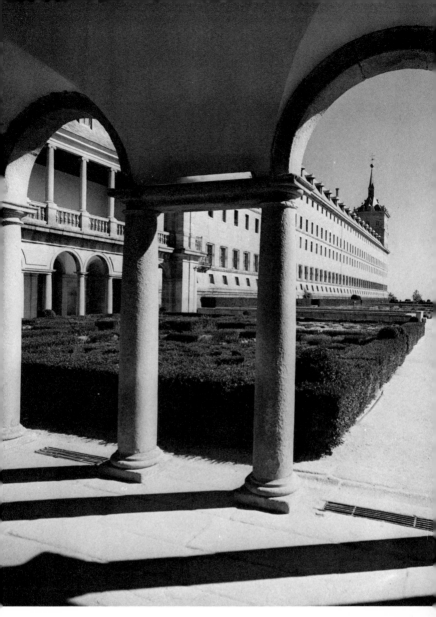

The Escorial, Jardín de los Frailes, and the Galería de Convalecientes.

Spanish by Francisco Villalpando were published in 1552 and dedicated to Philip II. Vignola's short treatise *Regola degli Cinque ordini d'Architettura* was published in Rome in 1562, a year before the first stone of the Escorial was laid. Vignola was consulted by the king about the plan for the monastery, for Philip II always acted with the prudence that was typical of him and sought the advice of the most respected masters.

This is what Padre Sigüenza has to say about this huge building: 'Inside this building one can see showy ramparts, towers and lofty domes, a great and beautiful church, chapels, porches, porticoes, courtyards, arches, pyramids, columns, altars, statues, a great variety of paintings, marble, jasper, metal, ponds, wells, pools, fountains, flower gardens vegetable gardens, aqueducts, a thousand different vases, tables and sacred vestments, all to holy ends and pious uses. One can say that

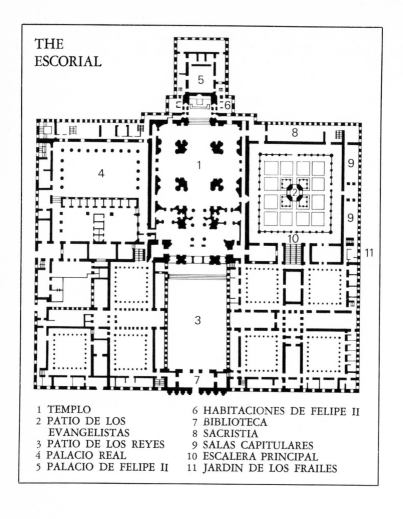

THE
ESCORIAL

1 TEMPLO
2 PATIO DE LOS
 EVANGELISTAS
3 PATIO DE LOS REYES
4 PALACIO REAL
5 PALACIO DE FELIPE II

6 HABITACIONES DE FELIPE II
7 BIBLIOTECA
8 SACRISTIA
9 SALAS CAPITULARES
10 ESCALERA PRINCIPAL
11 JARDIN DE LOS FRAILES

▷

The Escorial. Ground plan and (right) the basilica whose severe and grandiose Doric style expresses the personality of Philip II, imbued with an absolute religious faith.

this is enough, that with all these gifts and offerings, man has purged his guilt; for it seems like God's handiwork created with a sweep of his hand and all for his unvarying purpose.'

'His Majesty's main care in this construction', continues Padre Sigüenza, 'was for the Church, since it was the ultimate goal, the summit so to speak of all that he desired to achieve.' In fact, though the Escorial consists of a monastery, a palace and a college, they are all grouped under the shadow of a gigantic basilica placed in the centre of the rectangular frame formed by the buildings. They do not face the outside, but on to an inner courtyard, a sort of closed atrium. This is called Patio de los Reyes on account of the statues of the kings of Judah adorning the façade. The church, built on a ground plan shaped like a Greek cross and crowned by a dome, is lengthened to form a deep presbytery with a choir on the other side. Above is the choir of the monastery. The Doric architecture is of sovereign sobriety without anything to detract from the elegant lines of the

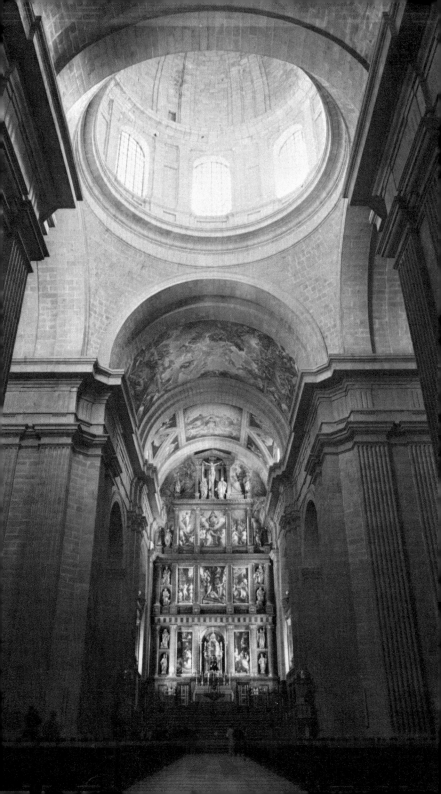

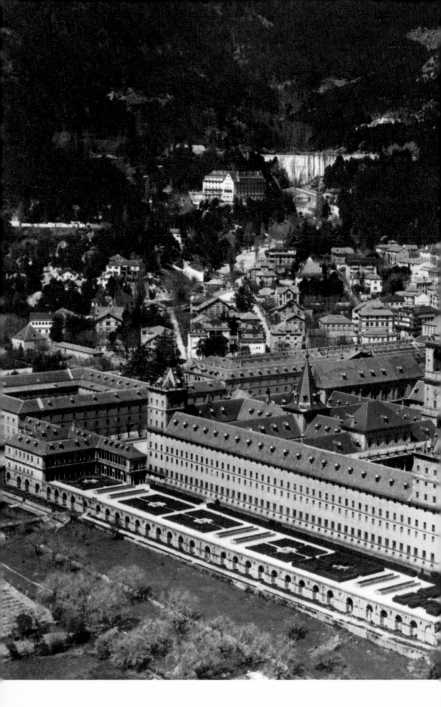

*The Escorial, aerial view. In the foreground,
the Jardín de los Frailes; in the background the pines of Abantos.*

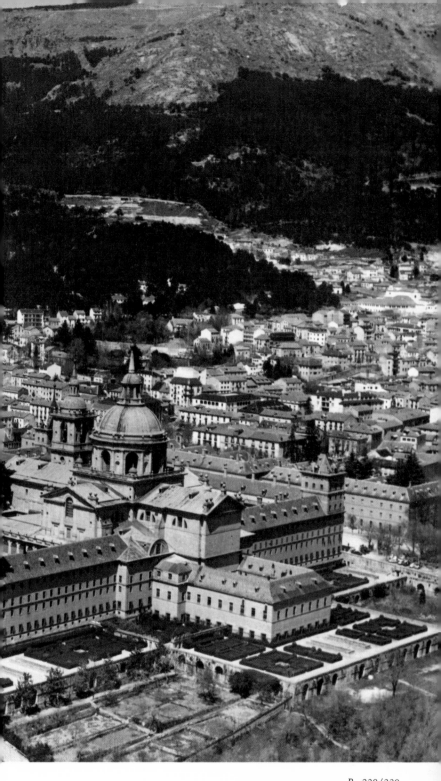

P. 228/229
*Library of the Escorial, decorated with allegorical
and grotesque figures, by Pellegrino Tibaldi and Nicolas Granello.*

P. 230/231
The Escorial from the south.

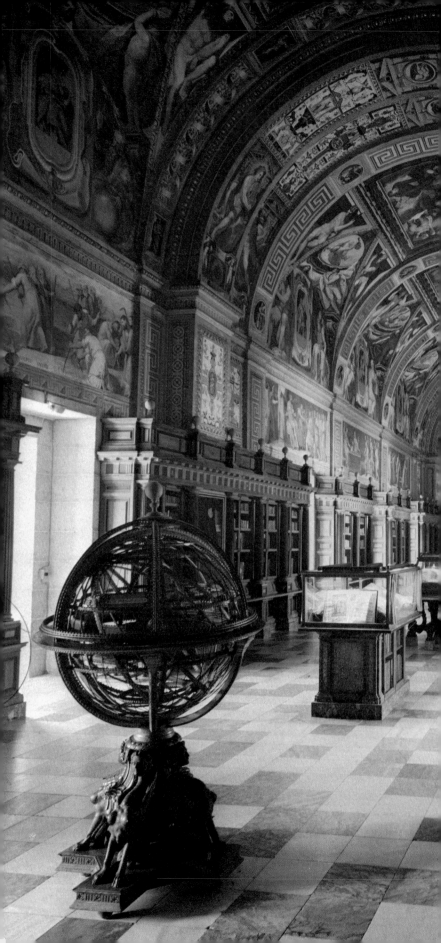

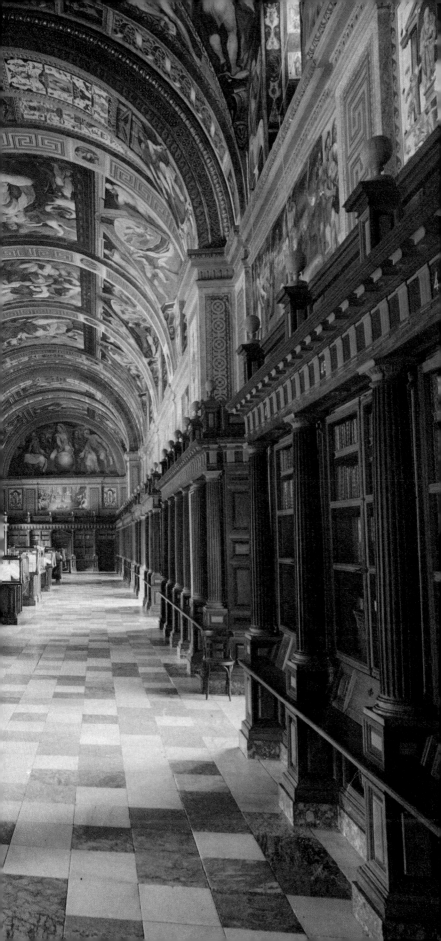

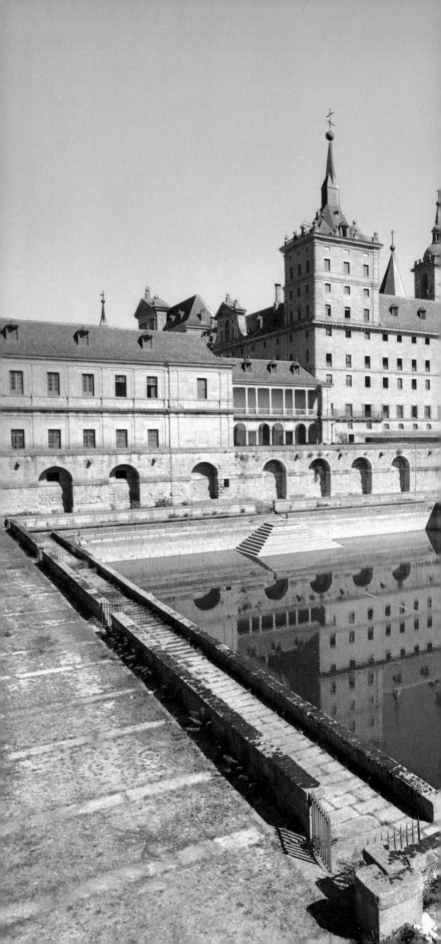

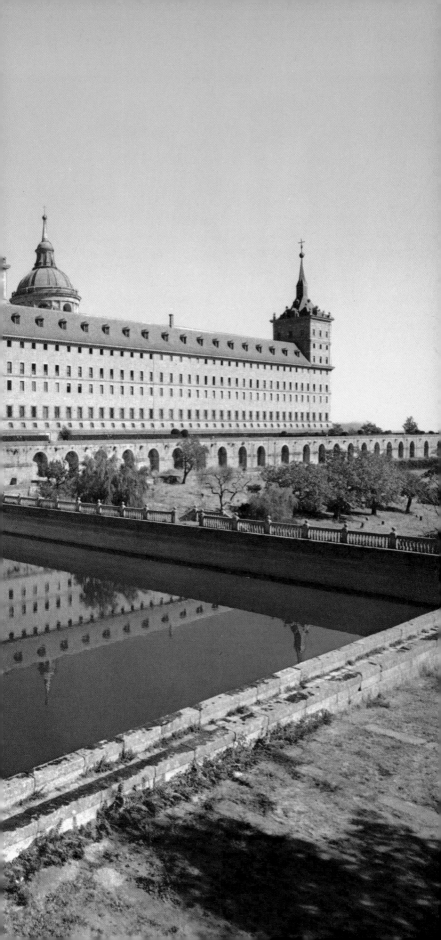

Aranjuez, the Salon de Porcelana, a work in relief by Giuseppe Gricci.

structure and the stone mass of this bare interior makes one feel small and overwhelmed.

The most splendid part of the church is the presbytery, with a superb altarpiece in the Spanish style and the tombs of Charles V and Philip II on either side. The whole forms a kind of gigantic marble and bronze triptych of solemn harmonious colouring. The altarpiece and the tombs are in Juan de Herrera's best classical style and the bronze sculptures of inestimable value are by Leone and Pompeo Leoni. The paintings on the altar, which do not come up to the same standard, are by Federico Zuccaro and Pellegrino Tibaldi.

The vaulted roofs of both the presbytery and the choir were painted, when the church was built by Luca Cambiaso in a cold Mannerist style. Years later Charles II started again with the decoration of the ceilings, availing himself of the prolific talent of Luca Giordano, but still not all the ceilings were covered.

Italian and Spanish painters, with Alonso Sánchez Coello and Juan Fernández de Navarrete, who was dumb, among them painted the forty-three canvases on the minor altars enclosed in stone archways. The monks' choir is a superb piece of architecture and, since it is raised, provides the best view of the interior of the church. Philip II, hidden amongst his monks, used to pray from a seat in the choir stalls carved from designs by Herrera. As well as the vaulting, Luca Cambiaso and Romulo Cincinato decorated the walls with frescoes depicting scenes in the life of St Lawrence. Behind the choir there is a figure of Christ by Benvenuto Cellini, signed 1562, which the Duke of Tuscany gave to Philip II.

The Sacristy is a huge rectangular room with the vaulting painted in the Pompeian style by Nicolas Granello and Fabrizio Castello. There is a reredos which is a Baroque work of the period of Charles II and holds a large composition by Claudio Coello representing the king taking communion surrounded by courtiers. When the painting is removed one can see an inner tabernacle where a very beautiful bronze crucifix by Pietro Tacca is kept.

The royal pantheon is reached from the ante-sacristy down a dark staircase decorated with marble and jasper. The funeral chamber acquired its final form during the reigns of Philip III and Philip IV. It is shaped like an octagon and lies beneath the presbytery in the spot designed for it by Juan de Herrera. The royal sarcophagi lie in the walls, each in a rectangular recess, four on each side of the polygon. The Baroque crucifix on the altar is by Domenico Guidi, and the small but imposing entrance door of this solemn burial chamber is decorated with jasper and gilded bronze and bears the date 1654.

From the ante-sacristy one can pass into the great cloister, which is commonly known as the Patio de los Evangelistas. The cloister, being the centre of monastic life, was one of the first parts of the monastery to be built, for Philip II was, above all, eager to provide quarters for his monks. The architecture is a model of Renaissance harmony with its two orders of arches standing between half columns, the lower ones Doric, the upper ones Ionic. The work of Juan Bautista de Toledo, it reveals this master's sensitivity and erudition. Juan de Herrera later built the fountain in the centre of the courtyard and the little shrine of the Evangelists which, in spite of its beauty, does rather crowd the space.

The gallery in the lower part of the cloister contains frescoes in the

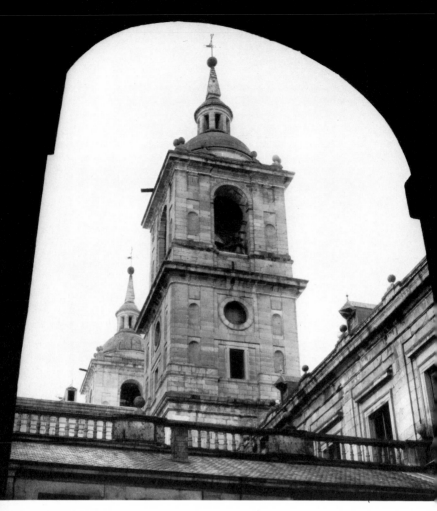

The Escorial, the towers of the basilica.

manner of Raphael by Pellegrino Tibaldi representing scenes from
the New Testament. From the cloister leads the Grand Staircase
doubtfully attributed to Juan Bautista Castello, 'El Bergamasco',
though, judging by its style, it must be by Juan Bautista or Herrera.
On the staircase ceilings Luca Giordano painted a splendid allegory
of 'Glory' and the frieze with conventional scenes from the battle of
St Quentin. Another important part of the convent is the chapter-
house situated by the south wing of the lower cloister. It consists
of three rooms of a structure very similar to that of the Sacristy.
The ceilings were decorated with neoclassical Pompeian paintings
by Cambiaso, Granello and Francisco de Urbino. Up till recently
these rooms contained the most important pieces of the Escorial
picture collection, but these have now been rehoused in a new museum
in the lower rooms of Philip II's palace.

The library is another of the monastery's great rooms. It lies at
the very centre of the main side of the monastery and the fact that
it is in such a prominent position shows the importance Philip II
attributed to it in his total creation. It is beautifully proportioned
with a great vault with lunettes, and the frescoes on allegorical
themes by Pellegrino Tibaldi and Nicolas Granello on the walls and
ceilings, with the elegance of the bookcases, designed by Herrera

and made of the finest woods, give the library an exceptional distinction and a strongly Italian flavour.

The library includes an immense series of books and manuscripts, tenth-century illustrated manuscripts, copies of the eleventh-century Beato de Liebana, the 'Cantigas' of Alfonso X (the Wise), thirteenth century, a Book of Hours written in the Scriptorium of Vrelant for Isabella la Católica, the missals of Charles V and Philip II and so on. The foreign manuscripts include the Virgil of 1407, a Juvenal of the fifteenth century, the eleventh-century *Evangelio Aureo* belonging to the Emperor Conrad II and various oriental works such as the Poems of Hafiz dating from 1584 with beautiful Persian miniatures.

The Escorial Monastery, apart from being a convent, pantheon, college and library also includes a royal palace which Philip II made for himself and which he and the kings succeeding him used for long periods of time. The palace can be divided into two: the king's own private quarters in the eastern wing lying at the head of the church, and the main ceremonial room of the palace situated in the north-east section of the building. The private part is the more interesting, with the simple throne room and the royal apartments which give direct access to the high altar of the church thereby enabling the king to follow the celebration of mass; whilst unwell he could even attend from his bed. The king's apartments were on the epistle side and the queen's on the gospel side, after her death they were occupied by the Infantas Catalina Micaela and Isabel Clara Eugenia.

In the main part of the palace is situated the Hall of Battles with its great vault decorated in the Pompeian style. Its name comes from a fresco representing the battle of Higueruela in the Granada Campaign, which covers its long walls. The other rooms are decorated in the Bourbon style, the most interesting objects being the Flemish and Spanish tapestries, the latter based on cartoons by Goya, Bayeu and Castillo.

In 1963 a collection of the best painting from the Escorial was put together and arranged in a museum prepared for the purpose in the lower rooms, which were the summer quarters of the palace. It is a rather mixed collection with works of a very high standard by Bosch, Gerard David, Van der Weyden, Titian, Veronese, Tintoretto, El Greco and Velázquez, hanging next to works of purely historical or anecdotal value whose only interest lies in their connection with the monastery. There is also an interesting museum showing the history of the building of the Escorial.

All the buildings surrounding the monastery, with courts and walls between them, are simple in style in deference to the main building. Many were designed by Herrera and his pupil Francisco de Mora and others in the eighteenth century by Villanueva, but with equal respect for the architecture of the monastery. On the southern side at the end of the promenade there is a low building built very early on, which served as infirmary for the monks. It has beautiful Renaissance galleries for the convalescents to rest in. They overlook the so-called 'Monk's Garden' lying along the south façade of the monastery which is delightful in its simplicity.

Charles III, who was very attached to the Escorial and made it one of his favourite royal residences, did much to improve the monastery and its surroundings. He built for each of his sons, Charles (later Charles IV) and Gabriel, a little palace like an Italian villa with pretty gardens all around.

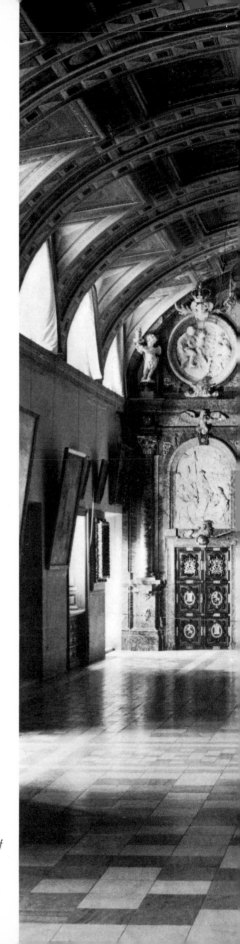

The Escorial, the sacristy, with a Baroque altar by José del Olmo, 1685. The central panel consists of Claudio Coello's great painting, The Communion of Charles II.

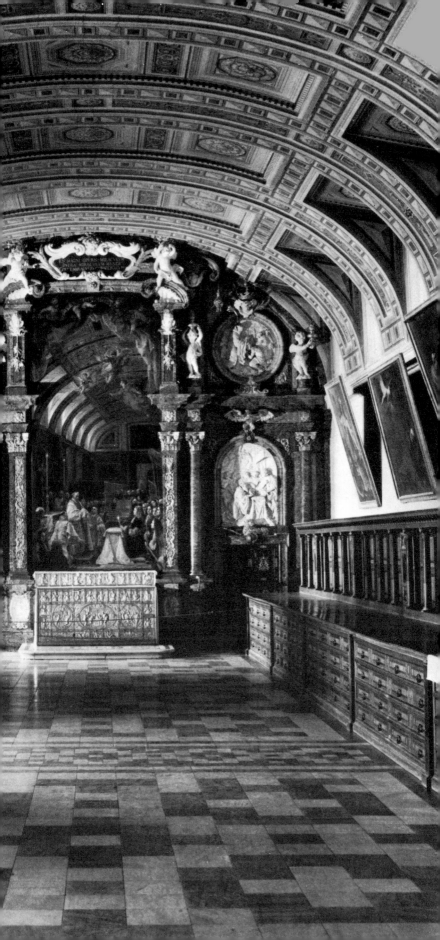

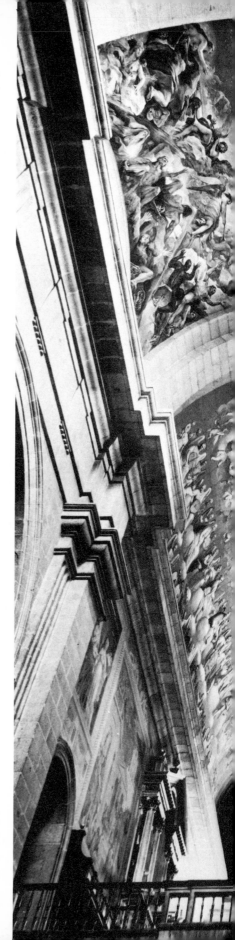

The Escorial
(Right) ceilings of the presbytery;
nearer paiting by Luca Giordano,
the further one by Luca Cambiaso.

Tomb of Charles V
by Pompeo Leoni.

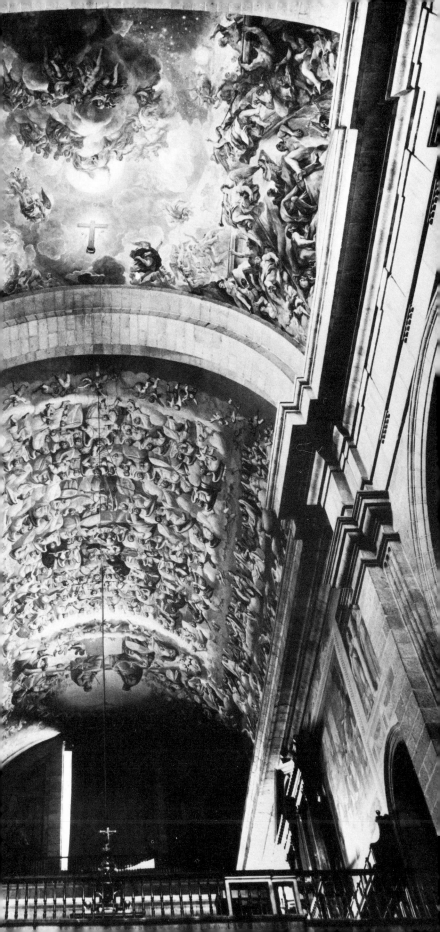

The Royal Residences

Before the Austrian Monarchy, the royal possessions around Madrid were no more than hunting lodges in the open countryside. Nothing else was commonly considered more valuable or attractive than wooded land well populated with wild animals.

But the great cultural progress brought by the Renaissance, the introduction of novel ideas in the art of gracious living, could not fail to bring changes in the purpose and furnishing of the royal residences. Charles V made alterations and had the buildings enlarged, but it was primarily Philip II who devoted most attention to country seats where it was possible to rest and meditate.

Philip II organized his royal seats along the lines of a miniature solar system, the Alcázar in Madrid playing the part of the sun, and with the regularity of planetary movement the court moved from one palace to another.

Each of the royal residences had characteristics of its own and each fulfilled a particular function in the court's rhythmical peregrinations. Some provided an intimate retreat for the monarch and his family, such as the palaces of Pardo, Zarzuela, Balzaín and Aranjuez, while others like the Escorial were for the king to carry out his religious obligations and honour the Supreme Creator, and served as pantheon for the dynasty. Then there were also small 'overnight' residences such as the small palace of Vaciamadrid on the road to Aranjuez, the Casa de Aceca on the way to Toledo, the Casa de la Nieve in Fuenfría in the direction of Balsaín, and similar houses known as Torrelodones, Campillo and Monasterio on the road to the Escorial.

The Bourbons renovated and improved the royal residences. Philip V having abandoned Balsaín of which only a few sad ruins remain, built La Granja not far away, so that he might indulge his hypochondria in a Castilian Versailles. All the Bourbons, especially Charles III and Charles IV, did much to improve Aranjuez, which, from being a private palace, developed into a kind of country city in the manner of the German *Residenzstadt*. At El Pardo Charles III enlarged the old palace of Charles V and Philip II, built by the architect Luis de Vega, to twice its size. The enlargement was carried out by Francesco Sabatini who gave the palace its present appearance with its Baroque silhouette. The most important feature in the El Pardo palace is a series of tapestries, some of the most valuable the country possesses. Charles III also gave the Prince of Asturias another present in the form of a little country palace, also built by Juan de Villanueva, like the one in the Escorial.

In Ríofrío in the province of Segovia, in the middle of a handsome oak forest full of deer and other game, Queen Isabella Farnese had a palace built after the death of Philip V. The Italian Virgilio Ravaglio designed it but it was only completed by Charles III. Its square shape is typically Italian and its Baroque staircase is well worth the visitor's attention. It used to be the scene of royal hunting parties, especially during the reigns of Alfonso XII and XIII, and today it houses an interesting hunting museum.

Of the royal residences still existing, Aranjuez and La Granja deserve special mention.

▷

The Escorial, Patio de los Reyes, basilica, with statues of the kings of Judah.

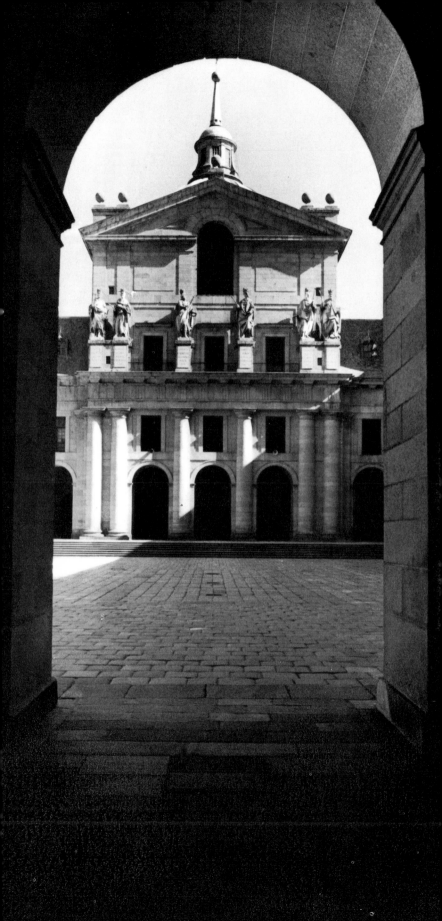

In the Middle Ages, under the name Aranzuel or Aranzueque, it belonged to the Order of St James, but when the jurisdiction of the grand masters of the military orders passed to the Crown by a decision of Ferdinand and Isabella, it became a royal possession, a valuable acquisition, for this oasis of vegetation in the middle of thirsty Castile was well worth having. In the words of one of its zealous admirers, Francisco Nard, there live in admirable union with indigenous species, with no regret for their native soil, the tulip and the Virginian Magnolia, the Monterey pine and the Louisiana ash, the black poplar of Carolina and the Canadian plane tree, the robust Cedar of Lebanon showing itself off just as gallantly as the Chinese thuya, the laurel of Nineveh and the haughtily lofty Byzantium plane tree, the Jerusalem as well as the Arcadian pine.

Charles V used Aranjuez for hunting in and quite frequently lived there, but he had very little built, mostly improvements to the old palace. Philip II began the new palace in 1564 using first Juan Bautista de Toledo and later Juan de Herrera as principal architects. The gardens were laid out around the palace and the beautiful Jardines de la Isla begun. These are perhaps the best gardens of the time of the Austrian monarchs still existing in Spain today. The Bourbon kings greatly changed the palace, making it into a U-shape so as to create a *cour d'honneur* in the French style, and considerably enlarging the small town, which became the official residence of the court during the spring, when the population would increase from 6,000 permanent inhabitants to about 28,000. It was at this time that the handsome Plaza de San Antonio was projected, with the church of the same name at one end, the work of Santiago Bonavía, and the avenues radiating out from the palace was laid out along the lines of a Baroque city.

In 1765 Charles III founded and generously endowed the convent of San Pascual, to follow the creed of St Peter of Alcántara. He commissioned Sabatini to build it and such distinguished painters as Tiepolo, Mengs, Maella and Bayeu to decorate the interior. Unfortunately their work has been lost. The façade of the church is a distinguished work of the great architect of the Puerta de Alcalá, and successfully combines Baroque sentiment with classical strength.

Work in Aranjuez never ceased throughout Charles IV's reign; the grounds were extended with the vast Jardines del Príncipe, with gates designed by Juan de Villanueva and the best fountains by his disciple Isidro Gonzáles Velázquez. The latter also built the Casita del Labrador, a relatively small but incredibly luxurious palace replacing an old workhouse—hence its rather ironical name. It is one of those 'Trianons' or 'Bagatelles' or 'Hermitages' which eighteenth-century royalty was so fond of, a strange compromise between the rustic life and Rococo refinement.

Nothing in Aranjuez can compare with the richness of the interior decoration of the Casita del Labrador, not even the royal palace, even though the latter has something as unusual as the Porcelain Room or the Chinese Room to admire, the walls and ceilings of which are covered all over with sheets of porcelain from the Buen Retiro palace. Everything in the Casita del Labrador is exquisite and refined, silks, tapestries, furniture, all kinds of clocks, lamps and chandeliers, frescoes and paintings, marbles and bronzes, porcelain and glass. The Cabinete del Platino displays an astonishing wealth of materials, fine woods, gilded bronze, enamels, and mirrors, with platinum encrustation; it is memorable too for another no less surprising reason. Napoleon's

Aranjuez, church of the Convento de San Pascual, upper façade.

architects Percier and Fontaine were responsible for the plans and execution of this room, and their work is illustrated in a beautiful engraving in their book *Recueil de Décorations Intérieures* published in Paris in 1812. So that there should be no doubt about the matter the title below describes it as 'Cabinet made for the King of Spain'. It must have arrived from France already made and been no more than put together in Aranjuez.

The cabinet is undoubted proof of the good relations existing between Napoleon and the court of Charles IV at the time when the former wanted to win over the Spanish by flattery or intrigue before he changed his mind and preferred the more drastic method of armed force.

Nearly 4,000 feet above sea level in the middle of the Sierra de Guadarrama, surrounded by forests and pine groves, lies the royal seat of San Ildefonso, commonly called La Granja, the grange, after the farm founded there by the monks of St Jerome from Segovia. The palace and gardens of La Granja are the creation of the first Spanish Bourbon king, Philip V, who had the idea of bringing the harsh and rugged Castilian countryside a little of the refinement and *'esprit de géométrie'* prevailing in the Versailles of his grandfather, Louis XIV. Work on the future palace started in 1721 under the personal supervision of the king, using, as central nucleus, the former cloister of the monks' guest-house which received the name 'Patio de las Fuentes', the Courtyard of the Fountains.

Teodoro Ardemáns was the first architect to combine this function with that of private painter to the king. He built a simple palace with four towers of which two still remain, and a large chapel, which was

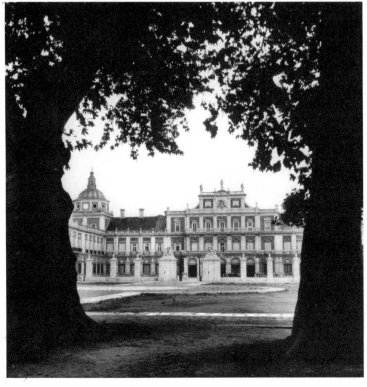

Aranjuez (above) Casita del
Labrador, c. 1800 and (left),
the Fuente de Apolo,
both by Isidro González Velázquez.

(Far left), the main façade
of the palace.

raised to the status of collegiate church in 1723. His style was the purest Madrid style of the late seventeenth century, and the church is similar to the Baroque churches in the city of the same period. The desire to embellish the palace of which her husband was so fond led Isabella Farnese, his second wife, to enlarge it, this time under the direction of Italian artists, to whom she was very attached. Between 1727 and 1737 Andrea Procaccini and Sempronio Subisati created the courtyards on the north and south sides, the latter called 'Patio de la Herradura' because it is horseshoe-shaped and opens on to the gardens. It is a delightful adaption of the central European Rococo style to the harsh granite of the Sierra. The architectural orders and all the decorative elements are on a small scale and this results in having the elevations a particular charm.

In 1736 Sachetti built the central part of the main façade overlooking the gardens, following the plans left behind by Juvara. It is a splendid composition with its pilasters and great compound piers, its lively crowning balustrade, decorated with shields, medallions, military trophies and white marble caryatids depicting the four seasons. The interior of the palace has suffered greatly from plundering and removals. The establishment of the Museo del Prado, for instance, caused the removal of 351 paintings and the sculptures from the collection of Queen Christina of Sweden. Then a serious fire in 1918 finally destroyed the rich interior of the palace and it is only being restored little by little. Recently some of the series of tapestries from this and other state-owned palaces have been hung in a part of the buildings, converted into a museum to contain them.

However worthy of interest is the palace itself, nothing in La Granja can compare with the beauty of its gardens. A great deal of tree planting was carried out, using limes, chestnuts, ash, elms, black poplars and various conifers, which merge into the pine groves of the Peñalara foothills. New drives and promenades were opened up on geometrical lines, and, in the immediate surroundings of the palace, picturesque flowerbeds were laid out, decorated with fountains, urns, pools and waterfalls. The director of the work was the gardener, Estéban Boutelou, who followed the maxims of Le Nôtre and the orderly school of French Classicism, in which the impetuosity of Baroque

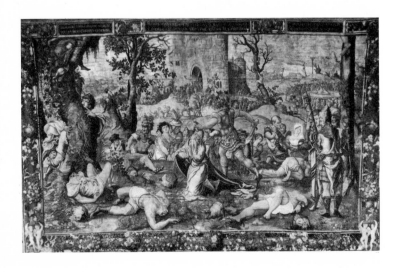

La Granja, Salón de Mármoles, with ceilings by Bartolomé Rusca, 1727-37.

◁
Madrid. Palacio de Oriente,
Flemish tapestry depicting death of St Paul 16th century.

is subordinated to the rules of perspective and the pleasing use of space. All the gardens were enlivened with statuary on allegorical and mythological themes, familiar to the reading public through a literature almost as luxuriant as the gardens themselves. The sculptors who gave solid shape to these myths were René Carlier, René Frémin, Jean Thierry, Jacques Bousseau, the brothers Dumandré and Pierre Pitué, most of them disciples of great sculptors such as Girardon,

Coysevox and Coustou. They were obsessed by the ancient world, but more by its mythology than by its classical discipline of form, and the gods and goddesses of Greek and Latin legend were dressed up anew in the Rococo fashion.

The Fuente de los Vientos (Fountain of the Winds) represents Aeolus unleashing the winds, the Fuente de la Selva (Fountain of the Woods) by Thierry shows Vertumnus soliciting the love of Pomona and divesting himself of his tattered garments, the Fuente de las Ranas (Fountain of the Frogs) illustrates the an episode from the life of the goddess Latona, and the Fuente de Diana (Fountain of Diana) by Dumandré and Pitué has a figure of the goddess bathing. The most harmonious group is the one called La Carrera de Caballos (the Horse Race) whose three main fountains represent Neptune, Apollo and Andromeda. The Andromeda group is the most effective, and captures the moment when Perseus kills the sea monster which was about to devour the daughter of Cepheus. Opposite the main façade, beyond green parterres in Baroque shapes, rises the New Cascade which is crowned by the Fountain of the Three Graces and a graceful Ionic pavillion. On the southern side, facing the horseshoe-shaped courtyard, lies the so-called Parterre de la Fama (Parterre of Fame), which is laid out on a lower level so that is can be better seen. In the centre is a fountain of the same name with a group of statues representing Pegasus and Fame. The water spurting from it can reach a height of 100 feet and can be seen from Segovia. The exclamations of pleasure from the spectators burst forth in much the same way as the water itself when the fountains of these wonderful gardens play on special occasions or at the festival of St Ildefonsus Day. They need an artificial lake rather hyperbolically known as 'The Sea' to provide enough water for all the Tritons and Nereïds, dolphins and sea-horses, sirens and shells inhabiting this enchanted world where Neptune seems to charm Philip's sceptre away from him. In the words of Jacques Delille, the French 'Virgil',

> Lieu superbe où Philippe, avec magnificence,
> Défiait son aïeul, et retraçait la France.

> A lordly site, where Philip with magnificence
> Defied his grandsire and recreated France.

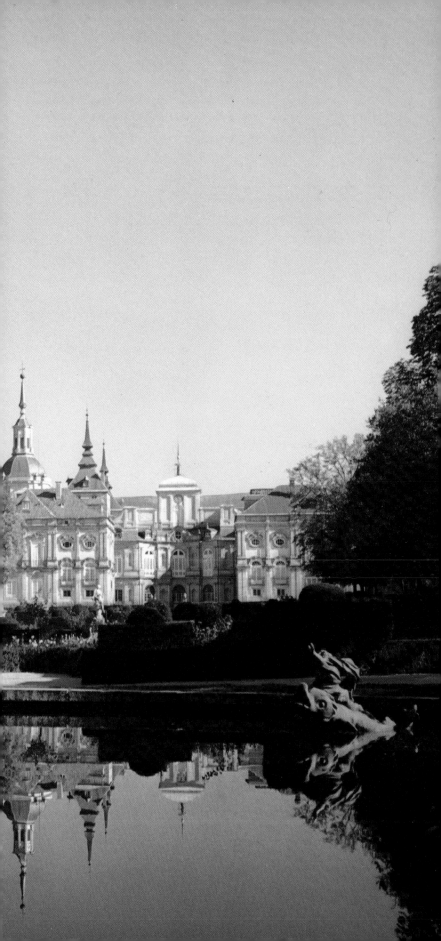

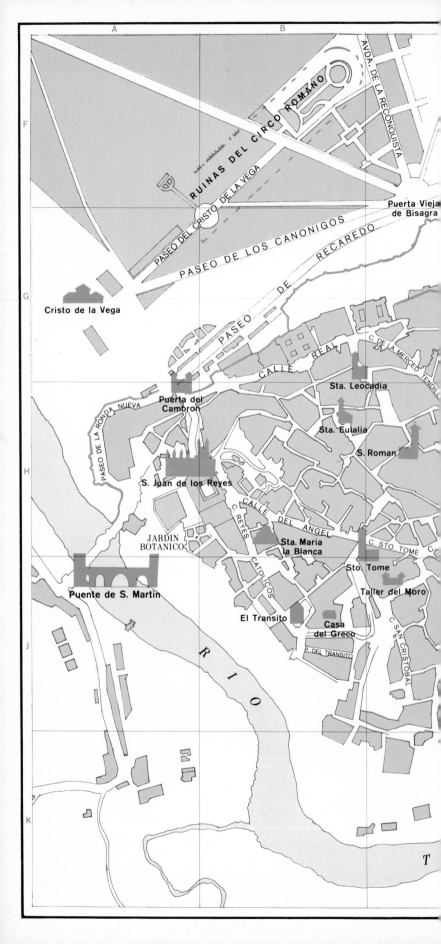

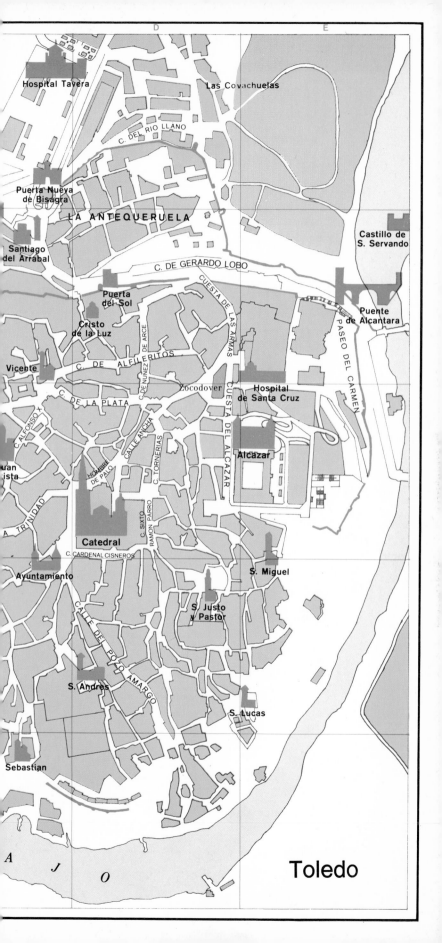

Toledo

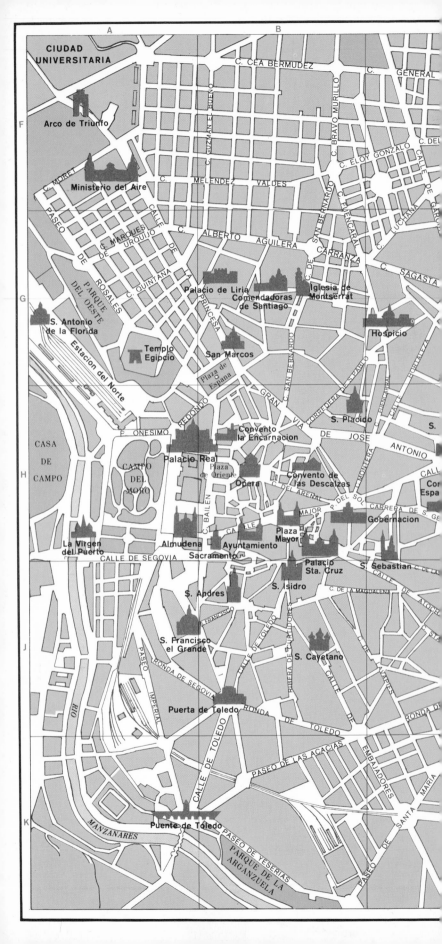

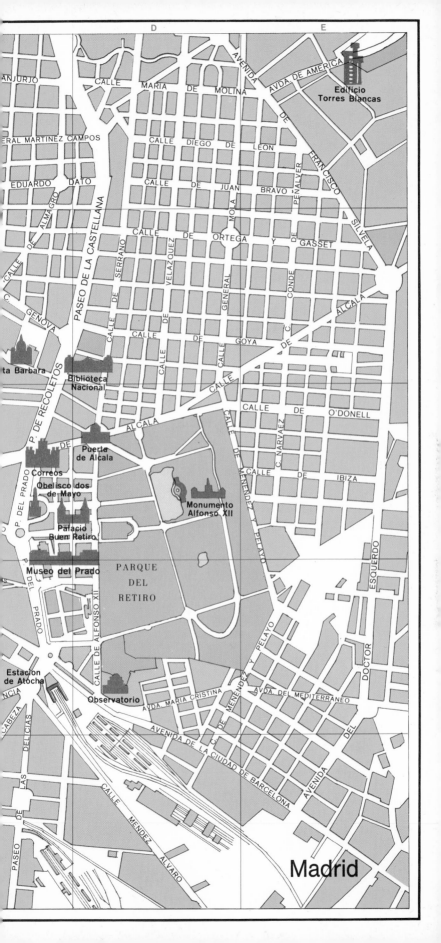

Letters in [square brackets] refer to the map, numbers in Roman to the text and in Italic to the illustrations.

Casa Museo Victorio Macho
(Victorio Macho's House and Museum)
Paseo de los Principios [BJ]. *10.00-14.00 daily.*
Museum devoted to the sculptor Victorio Macho (1887-1966), housed in the building where he lived and worked at the end of his life.

Museo Arqueologico Provincial
(Provincial Archaeological Museum)
Calle de Cervantes 19 [EH]. *10.00-14.00 and 15.00-19.00 (18.00 in winter).*
This museum, in the Hospital de Santa Cruz, displays works of art in several nave-shaped rooms grouped on two floors round the principal patio. It includes objects of classical, Moorish and medieval archaeological interest connected with Toledo and its province. Mosaics from a Vega de Toledo villa, Visigothic epigraphs, capitals, decorative friezes, Muslim ceramics, Mudéjar gates, commemorative sculptures from the Middle Ages and the Renaissance. *See* Hospital de Santa Cruz. *36, 37, 40, 47, 129, 133.*

Museo de Artes Aplicadas Toledanas
(Toledo Museum of Applied Arts)
Calle del Taller del Moro [CJ]. *10.00-14.00 and 15.00-19.00 daily.*
Interesting remains of a Mudéjar palace, belonging to the Ayala family, situated in the 'Moor's Workshop'. There are some fine examples of Toledo, Mudéjar and Renaissance ceramics, as well as woodcarvings in the style which achieved such rare perfection in Toledo. *See* Taller del Moro. *98.*

Museo y Casa del Greco
(El Greco's House and Museum)
Paseo del Transito [BJ]. *10.00-14.00 and 15.30-19.00 (18.00 in winter).*
A very accurate reconstruction of a house such as El Greco must have lived in, since as we know he occupied one of those on this site belonging to the Marquis of Villena. Thanks to the painstaking efforts of the Marquis de la Vega-Inclan, who was able, tactfully and poetically, to recreate the atmosphere of a 16th-century Toledo dwelling, the project was completed in 1910. He had a small museum built nearby, with the remains of some Toledan architecture on the site of the Marquis of Villena's palace. Besides some other old paintings it contains twenty of El Greco's pictures.
The first room includes the famous *View of Toledo,* some portraits— among them those of Diego and Antonio de Covarrubias, the sons of Alonso de Covarrubias, the great architect (q.v.). The second room shows Christ and ten apostles, replica of the series in the cathedral. In the third room are other religious pictures. The other rooms in the museum are devoted to the Elder Herrera, Espinosa, Tristán, Zurbarán, Mazo, and Carreño. There are Gothic sculptures in the Oratory. Around a curious fountain in the garden are some interesting archaeological fragments, Roman and medieval. Underground rooms with Mudéjar vaulting recall the time when the financier Samuel Levi hid his treasure there, or the later vigils of the Marquis of Villena, who as poet and alchemist sought to discover the secrets of metals. *20, 42, 46, 58, 96, 98-100, 102.*

Museos de los Concilios
(Museum of the Councils and of Visigothic Culture)
Calle de San Roman [CH].
Situated in San Roman church (q.v.), dating from Mudéjar times, it is devoted to the Visigothic period, with a special section covering the Councils of Toledo.

Museo de la Fundación Duque de Lerme
(Museum of the Duque de Lerme Foundation)
Hospital Tavera - see Historic Buildings and Churches - *10.00-14.00 and 15.00-18.00 daily.*
In the church is the tomb of Cardinal Tavera, the last work by Alonso Berruguete, who died in this hospital in 1561. The great altarpiece on the high altar was designed and sculpted by El Greco. The dispensary has been restored in accordance with 16th-century documents, and includes a fine collection of Tavera faïence bottles. The apartments contain a Titian, *Charles V at the Battle of Mühlberg,* pictures by Coello,

Moro, Bassano, Carreño, Zurbarán, and a *Holy Family* by Tintoretto. The library has the archives of the hospital from 1541, and is magnificently embellished by a Caravaggio, *Samson and Delilah,* Pedro Berruguete's portrait of Cardinal Tavera, a splendid collection of El Grecos, including the *Baptism of Christ,* his last work, and the famous *Bearded Woman* by Ribera, the portrait of Magdalena Ventura, a peasant from the Abruzzi, commissioned by the Duke of Alcala in 1631. Some superb Flemish tapestries, fine 16th and 17th-century furniture, and pieces of jewelry, all contribuite to the interest of this museum. *36, 39, 133, 134,* 134, 136, 167.

Museo de Santa Cruz
(Museum of the Holy Cross)
Calle de Cervantes, near l'Arco de la Sangre [EH]. *10.00-14.00 and 15.00-19.00 daily.*
This museum, which was completely reorganized in 1958, the four hundredth anniversary of the death of Charles V, is chiefly devoted to the emperor and his time. The chapel is hung with large tapestries from Brussels; also on show are furniture, armour, illuminated manuscripts, and some interesting pictures, besides a fine set of El Grecos which includes the wonderful *Assumption,* completed by the artist six months before his death. The sculpture is no less remarkable. *See* Hospital de Santa Cruz. *21, 32, 36, 36, 39, 40,* 46, 47, *122,* 126, 129, *130,* 133, 136, *164.*

Museo de la Santa Hermandad
(Museum of St Hermandad)
Calle de la Hermandad [DH]. *10.00-14.00 and 15.00-18.00 daily.*
This modest museum relates the history of the town, with maps, engravings, and documents. It is housed in the old Hermandad Prison, itself an interesting building dating from the time of the Catholic Kings. *See* Carcel de la Santa Hermandad in Historic Buildings and Churches.

Museo Sefardi
(Sephardic Museum)
Paseo del Tránsito [BJ]. *10.00-13.00 and 15.00-18.00 daily.*
In the Sinagoga del Tránsito (q.v.), it covers the history, the tradition and the art of the Jewish, particularly the Sephardic, community. 31, *31,* 58, 97.

Museo y Tesoro Catedralico
(Cathedral Museum and Treasury)
Toledo Cathedral [DH]. *Choir, High Altar, Capitulary, Sacristy*: *11.00-13.00 and 15.30-17.30, 18,30 or 19.00 according to season.*
The cathedral is an exceptionally fine building and museum (*see* Historic Buildings and Churches). The choir, enclosed by an elegant screen, contains magnificent carved wood choir-stalls from the 15th and 16th centuries. The one known as 'the Archbishop's' is by Berruguete. *La Virgen de la Blanca,* a marble statue over the altar, is a masterpiece of French art from the end of the 12th century. A great wealth of ornament coruscates about the red and brown marble pillars. In the Capilla Mayor the huge altarpiece on the high altar was carved in larchwood in the Flamboyant style by Diego Copin, after designs by Felipe Vigarny and Alonso Sánchez Coello. On either side, stacked one above another, are royal tombs, also by D. Copin; there are two pulpits by F. de Villalpando. Rising behind the altarpiece is the *Transparente,* a work by Narciso Tomé, an astonishing composition of Churrigueresque art (*see* Churriguera, José de) in marble and bronze, handled with a wealth of imagination that recreates the universe complete with its clouds and sunbeams. A sacramental chapel without walls, it combines architecture, sculpture and painting.

The picture gallery occupies the capitulary or chapter-house and the sacristy, where there are paintings by El Greco, Goya, Van Dyck, Bellini, Titian.

In the vestry are the three volumes of St Louis' Bible, richly illustrated by 13th-century French miniaturists; also a sumptuous collection of sacerdotal vestments and lace.

The centre-piece of the Treasury is the monstrance, which is used ceremonially. It was commissioned by Cardinal Cisneros, and executed by Enrique de Arfe in gilded silver. The massive gold cross is said to have been made from the first gold to be brought back from America by Christopher Colombus. *32, 34,* 39, *39, 40,* 46, *49,* 51, 109, 112, 113, 116-17, *142.*

Taller del Moro - *see* **Museo de Artes Aplicadas Toledanas,** and **Historic Buildings and Churches.**

Most museums are closed on New Year's Day, the Thursday and Friday of Holy Week, 1st November and Christmas Day.

Casa de Lope de Vega
(House of Lope de Vega)
Calle de Cervantes 11. [CJ]. *11.00-14.00 except Mondays; closed from 15 July to 15 September.*
A perfect reconstruction of the house and garden of Lope de Vega (1562-1635), poet and dramatist, the leading writer of his day who wrote 470 comedies. 153.

Convento de las Descalzas Reales
(Convent of the Royal Discalced Nuns)
Plaza de las Descalzas Reales [BH]. *Guided tours every morning 10.30-13.30 and Mondays to Thursdays 16.00-18.00.*
This convent was founded in 1559 by Juana of Austria, daughter of Charles V, and has been open to the public as a museum since 1960. It has retained its religious atmosphere. Throughout two centuries its royal or titled guests bestowed gifts upon it: Flemish tapestries from Rubens Sketches (*on show on Good Fridays only in the Cloister*), paintings by Titian, Zurbarán, etc. A fine statue of the foundress is by Pompeo Leoni. The church of the former convent—or its façade at least—is attributed to Juan de Toledo, the first architect of the Escorial. The monument to Doña Juana, daughter of Charles V, who founded it, is by Pompeo Leoni (1574); there is also an El Greco: *The Money-changers driven from the Temple. 155,* 156-8.

Convento de la Encarnación
(Convent of the Incarnation)
Plaza de la Encarnacion [BH]. *Guided tours 10.30-13.30 and 1600-18.00; closed in the afternoons on public holidays, Good Fridays, 27 July and 28 August .*
This convent was founded in 1611 by Philip III and his wife Margaret of Austria, and houses the Agustinas Recoletas. It was partly opened to the public as a museum in 1965. There is a fine collection of canvases of the 17th-century Madrid school, in particular by Bartolomé Román; a rich Reliquary chamber; interesting choir-stalls from the 17th century. The church of the former convent was built between 1611 and 1616 by Juan de Mora, and was

partly demolished in 1842. 159, 161-2.

Ermita de San Antonio de la Florida
Paseo de la Florida, between Parque del Oeste and the Manzanares [AG]. *10.00-13.00 and 15.30-18.00. Sundays 10.00-13.00. Summer 16.00-19.00.*
A small classically-styled chapel built by Francisco Fontana in 1798. The interior of the dome is by Goya, with the theme of the Miracles of St Anthony. It was the last great set of frescoes of the 18th century. and the first in modern painting. The painter Asciencio Julia is supposed to have helped Goya with this work. 174, 198-9, *199.*

Estudio de Zuloaga
(Zuloaga's studio)
Plaza de Gabriel Miro 7 [AJ]. *10.00-14.00 except Tuesdays; closed 1 August to 1 October.*
A miscellany of furniture, etc., paintings and sketches from the painter's later period.

Instituto Valencia de Don Juan
Calle de Fortuny 43. 12.00-14.00 and 16.00-18.00. Sundays and Public Holidays 12.00-14.00. Closed from 1 August to 15 September.
Founded by Don Guillermo Osma, who bequeathed to the State, under certain conditions and under his patronage, his palace in the neo-Arab style, his collections and his library. Significant Hispano-Moorish collection, and china remarkable for its metallic sheen.

Museo de America
Ciudad Universitaria [AF]. *10.00-13.00 daily except Mondays.*
An important collection of pre-Columbian art, including such rare pieces as the Tro-Cortesian Codex, the most famous Maya manuscript, and several steles from the Maya civilization. Spanish American art since the Spanish conquests is represented by various paintings and curios.

Museo Arqueologico Municipal
(Municipal Archaelogical Museum)
Calle de Fuencarral 78 [CG]. *At present closed for reconstruction.*
This historical museum in the old Madrid Hospice, the work of Pedro de Ribera, brings together many

objets d'art and documents that have to do with the city's history.

Museo Arqueologico Nacional
(National Archaeological Museum)
Calle de Serrano 13 [DG]. *09.30-13.30 daily.*
Situated in the Palacio de Bibliotecas y Museos, this is the chief national museum devoted to ancient and medieval archaeology, Moorish art, and other civilizations as they relate to Spain, from earliest times to the present day.
Iberian sculpture is admirably represented by the *Lady of Elche;* the classical world by Greek ceramics, Roman mosaics, Hellenistic and Hispano-Roman sculpture, together with a host of domestic objects. The votive crowns of Guarrazar, and the Visigoth king Recceswinth, are particularly interesting. The ivory cross of Don Fernando I is of key importance in Romanesque art. A great variety of techniques are displayed in the numerous collections of ceramics and porcelain. The Levantine ceramic with its metallic sheen is noteworthy, as are the modern porcelains of Alcora and Buen Retiro. The collection of medals contains over 200,000 pieces. 211, *211.*

Museo de Artes Decorativas
(Museum of the Decorative Arts)
Calle de Montalban 12 [CH]. *10.00-13.30 Mondays excepted; closed from 1 August to 8 September.*
There are sixty-two rooms devoted to industrial art, crafts and furniture from every region of Spain. The collections are ingeniously displayed and occasionally grouped to re-create characteristic interiors. It is one of the few Spanish museums to possess a collection of Oriental art.

Museo de Carruajes
(Carriage Museum)
Campo del Moro [AH]. *Winter: 10.00-1245 and 15.30-18.30. Summer: 10.00-12.45 and 16.00-18.15. Sundays and public holidays 10.00-13.30.*
An original collection of old horse-drawn carriages, Crown coaches and items of saddlery.

Museo Cerralbo
Calle Ventura Rodriguez 17 [BG]. *09.30-13.30, except Tuesdays and public holidays; closed in August.*
The town residence of the Marquis de Cerralbo. His collection, left to the state in 1926, is preserved in the environment of an aristocratic household exactly as it was in the 19th century. There are paintings by El Greco, Zurbarán, Alonso Cano, and Pereda; some interesting drawings, furniture and weapons.

Museo de Ciencias Naturales
(Natural History Museum)
Paseo de la Castellana 84 [DG]. *10.00-14.00 and 17.00-19.30; Sundays and public holidays 10.00-14.00.*
Extremely interesting exhibits in the fields of zoology, geology, palaeontology and entomology. 196-7.

Museo del Ejercito
(Army Museum)
Mendez Nuñez 1 [CH]. *10.00-14.00 except Mondays.*
The building which houses this museum is all that remains of the former Palacio del Buen Retiro (q.v.). This includes the original 'Salon de Reinos' where paintings of battles were hung, such as *The Surrender of Breda,* by Velázquez. There is a collection of sidearms, firearms and war trophies of great historical value. 168.

Museo Etnologico Antropologico
(Museum of Ethnology and Anthropology)
Paseo de Atocha 11, and Calle de Alfonso XII 68 [DJ]. *10.00-13.30; closed in August.*
This museum was founded by Dr Don Pedro Gonzáles Velasco (1815-1882), and contains a great variety of exhibits of primitive cultures, others of ethnological interest, and a number of works of art from villages in the Philippines or Guinea, once subject to the Spanish crown.

Museo de Lazaro Gadiano
Calle de Serrano 122 [DG]. *09.30-13.30 except Tuesdays and public holidays; closed in August.*
This is the newest of Madrid's museums, the legacy of the indefatigable collector Don José Lazaro. It consists of thirty rooms containing hundreds of Spanish paintings (including Goyas), Flemish primitives, Italian, French and English schools, etc. A great variety of jewels, ceramics, ivories, woodcarvings, and furniture.

Museo Municipal
Parque de la Fuente del Berro. 11.00-13.00 and 16.00-20.00 except Mondays. Sundays and public holidays 10.00-14.00.
This valuable collection includes fossils and prehistoric utensils from the Manzanares region, as well as other finds from the rest of Europe, the Sahara and the Orient.

Museo Nacional de Arte Contemporaneo
(National Museum of Contemporary Art)
Paseo de Calvo Sotelo 20 [DH]. *10.30-14.00.*
At present on the ground floor of the

National Library, this museum is awaiting a new home now being constructed in the Ciudad Universitaria. There are paintings by Picasso, Solana, María Blanchard, and young Spanish abstract painters. 211.

Museo Nacional del siglo XIX
(Nineteenth-century Museum)
Paseo de Calvo Sotelo 20 [DH]. *10.30-14.00.*
A relatively new museum, featuring Spanish paintings and a notable collection of 19th-century sculpture.

Museo Naval
Calle de Montalban 2 [DH]. *10.00-13.30 except Mondays.*
This museum is in an annexe of the Ministry of Marine, and illustrates the history and exploits of the Spanish armadas through the centuries; there are model ships, navigation charts—in particular the famous chart belonging to Juan de la Costa —and nautical instruments.

Museo del Prado
Paseo del Prado [CJ]. *Winter: 10.00-17.00. Summer: 10.00-18.00. Sundays and public holidays 10.00-14.00.*
The leading picture gallery in Spain, and one of the most famous in the world, opened its doors in 1819, during the reign of Ferdinand VII. It occupies the splendid neoclassical edifice begun by Juan de Villanueva in the time of Charles III (1760-88) as a natural history museum. It contains the finest collections from the Royal Household, many works acquired from convents and religious foundations, from bequests and donations. Unless acquainted with the Prado it is impossible to reach a full understanding of Spanish painting, particularly from the 15th century to the present day. El Greco's work is grouped in three rooms, and includes *The Resurrection* and *The Adoration of the Shepherds.* Velázquez occupies five rooms, which trace his evolution from his youthful works to his last masterpieces, in his still-lifes, his portraits (*Pope Innocent X, Members of the Royal Family*), and particularly in the just-ly-famed pictures *Las Hilanderas* (*The Spinners*) and *Las Meninas* (*Maids of Honour*), in which it seems that the art of painting could reach no higher peak than these. Goya is represented by forty or so tapestry sketches, his first royal commissions for the looms of Santa Barbara, and by his portraits of famous men, his two *Mayas,* the sombre pictures of his later years, and the engravings of *The Disasters of War,* in which he expresses his bitterness and revulsion.

Beside these three giants hang the pictures of other Spanish painters, from Berruguete, Coello, Ribalta, Ribera and Zurbarán, to Murillo, with his portraits of children, rich with charm and emotion.
The Flemish school of the 15th and 16th centuries includes key works by the Master of Flemalles, Van der Weyden (*The Deposition from the Cross*), Memling (*The Epiphany*), Brueghel the Elder, Hieronymus Bosch, known here as El Bosco, Gossaert, etc.
Grand Italian Renaissance painting is represented here by several works of Fra Angelico, Mantegna, Antonello da Messina, Raphael and Andrea del Sarto. Besides these, the Venetian school is the best represented. Titian, with the *Bacchanalia,* Veronese, Tintoretto, with *Lady uncovering her breast,* are the chief representatives, among a great number of significant paintings.
Nor is the Prado lacking in magnificent examples of 17th-century classicism and of the painting known as Baroque: Flanders, Holland, France, Germany, England; Rubens, Jordaens, Teniers, Poussin, Claude Lorrain, Van Dyck, Mengs.
The museum owns a fine collection of classical sculpture, both original and Roman-copied, and an excellent series of statues by the Leonis. 133, *142, 152,* 161, *170, 180, 182, 194, 196,* 198, *201, 203, 205, 207,* 246.

Museo del Pueblo Español
(Museum of the Spanish People)
Plaza de la Marina Espanola [BH].
This museum is housed in the palace of Godoy (formerly Grimaldi) built by Sabatini, and brings together a number of different aspects of Spanish folklore, with costume and household objects, grouped according to the regions. It is at present closed, and in course of re-arrangement. 195.

Museo de Reproducciones Artisticas
(Museum of Art Reproduction)
Museo de America building. 10.00-16.30; closed from 1 August to 2 September.
An exhaustive collection of casts of the most famous works from classical times and from the Renaissance.

Museo Romantico
Calle de San Mateo 13 [CH]. *11.00-18.00; Sundays and public holidays 10.00-14.00; closed from 1 August to 15 September.*
The Marquis de Vega-Inclan founded this museum in the small palace of the Counts of the Puebla del Maestre, and its contents are in part his gifts. Its atmosphere is interestingly permeated by the spirit of an age. It contains an evocative collection

of furniture and pictures from the middle years of the 19th century.

Museo de Sorolla
Calle de General Martinez Campos 33 [CF]. *10.00-14.00 except Mondays; closed 1 August to 15 September.*
A little museum exclusively devoted to the work of the painter Joaquin Sorolla y Bastida, in the house where he spent the last years of his life.

Museo Taurino
(Bullfighting Museum)
Plaza de Toros de las Ventas [EG]. *10.30-13.00 and 15.30-18.00.*
Pictures, engravings and models tell the complete story of the art of bullfighting.

Museo del Teatro
(Theatre Museum)
Calle de la Beneficiencia 16 [CG]. *Visits by permission only.*
Busts and silhouettes of famous actors, as well as stage sets and costumes.

Palacio Real
(Royal Palace) [AH].
Plaza de Oriente [AH]. *Summer: 10.00-12.45 and 16.00-18.00. Winter: 10.00-12.45 and 15.30-17.45. Sundays and public holidays 10.00-13.30.*
Two centuries of history pervade this palace, which is one of the finest in Europe, and a museum in itself.
The first stone was laid on 7 April 1738. Sacchetti was the architect from the very beginning although his master, Father Juvara, shortly before his death in 1736, was brought from Italy to assist with the drafting of plans for this enormous building. In 1764 Charles III inaugurated this palace, on the site of the earlier Alcázar of the Austrian monarchs.
The square building surrounds a patio, tall in proportion to its extent, and built of rich and sturdy materials: Colmenar stone and granite. Ventura Rodriguez and later Francesco Sabatini also participated in the work, and the latter re-built the staircase and added a wing.
In 1962 a set of rooms in the northwest corner were converted into a picture gallery. There are works by Juan de Flandes, part of the Catholic Queen's polyptych, a portrait of Philip of Burgundy attributed to Van der Weyden, and pictures by Bosch, Patenier, Rubens, Velázquez, etc. Notable also are Caravaggio's *Salome*, the Tiepolo ceilings and a room devoted to Goya. Furniture and sculptures, musical instruments and glod plate, all contribute to the setting. The tapestries, in one of the world's finest collections, number over 2,500. Some of these date back to Philip the Handsome and Charles V. The royal library contains more than 200,000 books and 6,000 manuscripts. *144, 151, 152, 176, 182-5, 184.*

Real Academia de Bellas Artes de San Fernando
(San Fernando Academy of Fine Art)
Calle de Alcala 13 [CH]. *10.00-13.30 and 16.00-18.30.*
This is the most important picture gallery after the Prado, and was founded upon Real Academia funds, donations by its members, and numerous bequests. It contains some very fine pictures by Zurbarán and Goya. *188.*

Real Academia de la Historia
Calle de Leon 21 [DF]. *16.00-18.30 daily.*
The Academia's original collection was of medals, the gift of Philip V. Later followed more diversified exhibits of Iberian, Visigothic and Moslem antiquities. Of particular significance is the *Disco de Teodosio*, a shield of chased silver upon which the emperor Theodosius is represented between his sons Arcadio and Honorio; also the Reliquary (1390) from Piedra monastery. *198.*

Real Armeria
(Royal Armoury)
Plaza de la Armeria [AH]. *Same hours of opening as the Palacio Real.*
The richest collections of weapons and armour in Spain, housed in an annexe to the royal palace. The most noteworthy are the exhibits from the time of Charles V and Philip II. Many of these came from the world-renowned armourers' workshops of Milan and Augsburg.

Historic Buildings and Churches

TOLEDO

Acueducto Romano
(Roman Aqueduct) [EG].
Only a few buttresses remain, on either side of the Tagus, downstream from the Alcantára bridge.

Alcázar [D-EH].
The Arabs had built a fortress on the site of a 3rd-century Roman camp. This was later extensively renovated by the Christians, especially by Alfonso VI and Alfonso X the Wise, and the first Alcázar was then built, with El Cid Campeador as its first governor. It was at this date that it acquired its quadrilateral plan, with the four square corner towers, and the machicolated east façade. When Charles V made Toledo his capital he called upon Alonso de Covarrubias to add a Plateresque gateway to the west façade (which was the work of the Catholic Monarchs), and to build the north façade (1537-1551). Between 1540 and 1554 a patio was added, and lastly the south façade, according to the plans of Juan de Herrera, in 1571, classically inspired, consisting of four main Doric sections. The impressive staircase is by Villalpando and Covarrubias. In 1710, during the war of the Spanish Succession, Toledo fell and the Alcázar was set on fire. In the reign of Charles III, Cardinal Lorenzana had it restored by Ventura and it became an almshouse. It was again burnt in 1810, this time by the French, and again restored between 1867 and 1882, to house the College of Infantry. However in 1887 it was yet again damaged by a fire, and then again rebuilt. When the nationalist rebellion broke out, the garrison joined the rebel cause. Government troops besieged the Alcázar for seventy days. The most recent restoration work is still unfinished. A terraced garden, beneath its walls, overlooks the Tagus. *10, 16, 22, 39, 46, 49, 134, 136-9, 137, 139, 142.*

Arco de la Sangre del Cristo
(Arch of the Blood of Christ) *Plaza del Zocodover* [DH].
Formerly a Moorish gateway, destroyed in 1936 and restored in modern style in 1948. Miguel de Cervantes lived in the house known as 'del Sevillano'—now demolished—where he is said to have written *La Ilustre Fregona. 58.*

Ayuntamiento
(Town Hall)
Facing the Cathedral [CJ].
This was designed by Juan de Herrera, and begun in 1575. The main building is attributed to Jorge Manuel Theotocópuli, El Greco's son. After being burnt out in 1939, it has been identically restored, including its Graeco-Roman facade bearing the arms of the town on its pediment—Herrera's work—and its two slate-roofed bell-turrets, in the Castilian Baroque style. On the first floor there is a chapter-house with azulejos decoration and old velvet hangings. *98, 139.*

Baños arabes
(Arab baths)
There are some not very extensive remains of two buildings, one in the *Badaja (Way Down) al Colegio de Infantes,* and the other in the *Calle Jón del Angel.* [BH]. *80.*

Baño de la Cava
Near San Martín bridge [AJ].
A great Mudéjar tower, with some Arab elements formerly, which served as the head of a bridge of boats, washed away by the floods of 1203. *25, 64.*

Benitas Recoletas
Calle del Barco.
Several 16th-century houses form this home of Benedictine nuns. The single nave church was built in the 17th century in a pre-Baroque style. *142.*

Bridges - *see* Puente

Calle de San Lorenzo
A picturesque street leading to the ruined church of the same name. It contains the Palacio Nunarriz and a fine Plateresque house. *9.*

Callejón de Santa Isabel
A typical Toledan street running between the calls and the church of the convent of the same name. *52.*

Callejón de Santa Ursula
A typically narrow street next to the Convento de las Ursulinas. From it the tower of the cathedral appears divided as if seen through binoculars. *25.*

Capilla de Belén
In the Santa Fe convent, Paseo del Miradero [DG].
This chapel is octagonal, and has a dome supported by Norse arches, from the 11th century. It was very probably an oratory or a private mosque forming part of one of the palaces that once stood near this spot. *80.*

Capilla de los Desamparados
On the way up to Toledo below the

Paseo del Miradero. Originally dedicated to San Leonardo, it was rebuilt around 1554 and reconsecrated in 1587. Built in Renaissance style, it is now closed, and the adjoining buildings are used as a municipal warehouse. 73.

Capilla de Santa Catalina - *see* Iglesia del Salvador

Capilla de San José
Calle Nuñez de Arce
This chapel was founded by the knight Martín Rodríguez, and consecrated in 1594. The altarpieces were painted by El Greco but the entire set has been destroyed except for two works: *San José* and the *Coronation of the Virgin*. It is private, but permission to visit can be requested. 47, 134.

Capuchinas de la Inmaculada Concepción
(Capuchin nuns of the Immaculate Conception)
Calle de las Tendillas [EB].
A fine pre-Baroque church by the master Bartolomé de Zumbigo, built between 1666 and 1673, like the convent itself, which was founded by the Cardinal Archbishop Don Pascual de Aragón (after 1677). In the church are some pictures by Francisco Rizi. 142.

Carcel de la Santa Hermandad
(St Hermandad Prison)
Calle de la Triperia
A Gothico-Mudéjar building with an interesting gateway featuring the coat-of-arms of the Catholic Monarchs. A small municipal museum has been opened there. *See* Museo de la Santa Hermandad. 102.

Carmelitas Descalzas de San José
Calle Real [BG].
Convent and church in the style of the Herreras, built in 1608. On the high altarpiece there is a painting signed by Antonio Pereda in 1640. *51, 52.*

Casa del Conde Esteban
(Count Esteban's House)
Plaza del Consistorio 5
Interesting remains of a Mudéjar patio, with decorated pilasters, wrought beams and supports. 98.

Casa del Greco - *see* Museo y Casa del Greco.

Casa de Mesa
(Mesa House)
Calle Esteban Illan [CH].
Here was the dwelling of Estebán Illán, which remains the inalienable property of that powerful family. It was built about 1400, and has retained from the period of its splendour a magnificent Mudéjar drawing-room with a superb marquetry ceiling and handsome gilded stucco. It is now the seat of the Toledo Academy of Letters, Arts & Sciences. 98.

Casa de los Templarios
(Templars' House)
Plazuela del Seco.
Amidst humble buildings stands this Moorish arch decorated with finely worked stucco. From its style, this noble remnant must date from the years immediately preceding the Reconquest. *51, 81.*

Castillo Galiana
1 km. northeast of the city, Huerta del Rey.
This is a cross between a palace and a country house, originally dating from the 11th century but much altered after that, and ornamented in the 14th century with Mudéjar stucco. It is private property, but may be seen on request. 12, 82.

Castillo de San Servando
A Moslem castle commanding and protecting the Alcántara bridge. It was repaired by Alfonso VI and almost entirely rebuilt in the time of Archbishop Tenorio in the 14th century. 68, 73, 74.

Cathedral
In the centre of the town [DH].
St Ferdinand and Archbishop Don Rodrigo Jiménez de Rada laid the foundation stone in 1227, after the demolition of the old church which had been founded in the 11th century under the reigning Visigoth king, and had been turned into a mosque upon the invasion of the Moors. Construction of the cathedral was completed only in 1493; the work was supervised first by Martín, and later by Petrus Petri, called Pedro Peréz, by Spanish authors who remained in charge for almost fifty years. It is a superb example of Gothic architecture, reflecting the evolution of styles in the period during which the work-was carried out. It stands 113 metres long and 56 wide, has five naves, one transept and a double apse with radiating chapels. These chapels, the screens, the gateways, as well as the paintings, sculptures and plate, are the very essence of the art of the centuries that have gone by since the building of the cathedral. The *Transparente* is the most spectacular example of Baroque (*see* Museo y Tesoro Catedralico) and the *Puerta Leana* of neoclassicism. The cloister and the slender tower which overlooks the houses of the town both date from the 14th century. *9, 10, 14, 16, 25,* 30, *32, 34, 39, 39, 40, 46, 46,* 49, *49,* 51, *55,* 86, *93,* 102-17, *104, 106, 108, 113,* 128, 142 - *see* Museums.

Las Cigarrales
This is the name given to the gardens planted with olive trees that line the left bank of the Tagus to the south of the town, and from which there is a magnificent view of Toledo, especially at sunset. *13, 46.*

Circo Romano
(Roman Circus)
In the Vega [BF].
It lies half-buried, 422.5 metres by 100.5, near the Cristo de la Vega, beside which one can see the arch of a side entrance and a vaulted gallery which led to the vomitories.

Colegio de Doncellas Nobles
(College for Young Ladies)
Plaza del Cardinal Siliceo [BH].
A well-proportioned classical building, in which lies the body of Cardinal Siliceo in a modern (19th-century) tomb. *39, 134.*

Colegio de Infantes
(Children's College)
Plaza de la Bellota.
A Renaissance building with a handsome gateway by Francisco de Villalpando (middle 16th century). It was founded by Cardinal Siliceo to educate the children of the cathedral choir. *39, 80, 134.*

La Concepción Francisca
Behind the Santa Cruz hospital [EG].
Founded by Dona Beatriz de Silva, a lady of Portugal. The apse and tower are Mudéjar from the 13th century. Its chief interest lies in the San Jerónimo chapel built in 1422, whose Moorish cupola is ornamented with coloured metallic-looking glazed tiles from the Levant.

Convents - *see* under name.

Corral de Don Diego
Calle de la Magdalena
The remains of an old Mudéjar palace belonging to the Trastamara family. There is one room in the Moslem 'Kuba' form, with a well-preserved wooden octagonal ceiling. *98.*

Cristo de la Luz
Cuesta del Cristo de la Luz [DG].
This is the most important Islamic monument in Toledo. It was formerly the Bab-el-Mardón mosque, near the gate of the same name, and the mosque itself may well have been a conversion of an earlier Visigothic temple. The façade bears the date of construction 999. In the 12th century it was transformed into a church, and a transept added; also a Mudéjar apse with frescoes. The design of the mosque is square divided into nine sections by four columns with Visigothic capitals. Each of these sections is roofed by a tiny curved cupola, similar to those on the mosque at Cordoba. It is a

monument of key importance, for this brick structure is the starting-point for all the Mudéjar art in Toledo. *62, 74, 76-7, 80.*

Cristo de la Vega
Vega del Tajo (Valley of the Tagus) [AG].
Former Basilica of Santa Leocadia, erected in her honour and for her burial-place in the 6th century. Of the later Mudéjar church there remains only the apse, inlaid with stones carrying Islamic inscriptions, originally from an Arab cemetery on the same site. Above the gateway is a statue of Santa Leocadia by Berruguete, who has copied an ancient statue of one of the muses. *88, 93.*

Cuesta de San Justo
Typical Toledan street containing the church of the same name. *60.*

Cueva de Hercules
Calle de San Ginés 2 [DH].
A former cistern or Roman reservoir. *14, 21.*

Fortifications and Walls
The systems of fortifications of Toledo is complex and interesting. It summarizes the history of the town. There still remain some Visigothic sections which have made use of Roman elements; there are parts that date from the Moslem period, and numerous Christian reconstructions. Basically the system is composed of two enceintes, the chief of which encloses the districts of Santiago and Antequeruela. *22, 22, 28, 33, 58, 62-5, 73-4.*

Las Gaitanas
Plaza de San Vicente [CG].
Houses Augustine nuns, known as Gaitanas because their nunnery was founded in 1459 by Doña Guiomar Meneses, wife of Lope Gaitan. The church dates from 1630, and has a single nave, with a large apse covered by a vaulted roof in the form of a sea-shell. The canvas of the altar is attributed to Rizi.

Gate - *see* **Puerta.**

Grotto - *see* **Cueva.**

Hospital de Santa Cruz
Calle de Cervantes. [EH].
A splendid hospital building founded by Cardinal Mendoza and begun after his death in 1504. The first architect was Enrique Egas, who was later assisted, for the portals and the principal patio, by Alonso de Covarrubias. The magnificent façade is in the Plateresque style; in the tympanum of the arch stands Cardinal Mendoza adoring the Cross, between SS. Peter, Helen and Paul; on the pediment are two angels carrying the cardinal's coat-of-arms.

The great wards of the infirmary form a gigantic cross two storeys high, with fine panelled Mudéjar ceilings. In this building are the Museo de Santa Cruz and the Museo Arqueologico Provincial. *See* list of Museums. 21, *32,* 36, 39, *122,* 126, *126,* 129, 136, *164.*

Hospital de San Juan Bautista - *see* **Hospital Tavera.**

Hospital Tavera
Near the Merchan Gardens [CF].
This hospital, also known as the Hospital de Afuera because it is situated outside the walls to the north of the town, was founded by Cardinal Tavera. It is also known as the Hospital de San Juan Bautista after the saint to whom it is dedicated. It is an imposing quadrangular construction built between 1541 and 1599 by Bustamente and Alonso de Covarrubias. The latter's patios, and the severe-looking church of Gonzáles de Lara begun in 1562 and finished in 1624, are magnificent. Cardinal Tavera's tomb is in this church, and is a notable work by Alonso de Berruguete. The high altarpiece was to have been by El Greco, but it was never finished, and none of his work remains except the *Baptism of Christ.* The façade was reworked in the 18th century. The duchess of Lerma had some very fine rooms installed there, and hung with important works of art. *See* Museo de la Fundación Duque de Lerme. *36,* 39, *133,* 134, *134,* 136, 167.

Iglesia del Salvador
(Church of the Saviour)
Calle de la Trinitad and Plaza del Salvador [CJ].
Visigothic columns and capitals, and an arcade of eight Moorish arches, have survived from the former mosque which must have stood here until 1159, before its conversion to a church. Adjacent, the chapel of Santa Catalina, has been built, dating from the end of the 15th century, and founded by Don Fernando Alvarez de Toledo, secretary to the Catholic Monarchs. Graduation ceremonies for university doctorates took place here. There is a magnificent 15th-century altarpiece, of the school of Pedro de Berruguete. In a small Plateresque chapel nearby, Juan Correa del Vivar's *Calvary* is worth seeing. A plaque on the face of the church commemorates the baptism of the poet Zorrilla. *14,* 21, 80.

Illescas
33 km. (21 miles) north-east of Toledo.
El Greco's son built the hospital here, in whose chapel, the Sanctuary of Our Lady of Charity, there are five of his father's pictures. The best-known is *St Ildefonsus writing at the Virgin's Dictation.* The others are *Charity, the Nativity, the Annunciation* and *The Coronation of the Virgin.* The town was important in the 16th century, and still has a Mudéjar gate, a vestige of the old enceinte, a church with Mudéjar tower, old houses of the aristocracy. In a posada in the Calle Mayor, Charles V introduced his sister Eleanor to Francis I. 12, 20, *88,* 93.

La Magdalena
Parish church founded around 1100 and completely transformed by successive reconstructions. Destroyed in 1936, it was rebuilt entirely, no attempt being made to reproduce the original. The only remaining features on the exterior are the simple Renaissance doorway and the Mudéjar tower, which is a typically Toledan structure. 92.

Mesquita de las Tornerías
(Mosque of las Tornerías)
Calle de las Tornerías [BJ].
This simplified version of the Cristo de la Luz was probably built after 1159, and is thus the only known mosque built under Christian rule. 80.

El Nuncio (Hospital de Dementes)
Calle Real [BG].
Mental asylum founded by Cardinal Lorenzana. The present neoclassical building is by Ignacio Haan (1790-1793). 51, 65, 142.

Palacio Arzobispal
(Archbishop's Palace)
Plaza de la Catedral [CH].
The building features a number of different periods, and still has Mudéjar remains in its façade. The main doorway was built in the time of Cardinal Tavera (1534-1545) when extensive reconstruction became necesary. The face giving on to the Calle del Arco del Palacio was restored by Ventura Rodriguez in the time of Cardinal Lorenzana, about 1775.

Palacio de los Canonigos Obreros
(Palace of the Working Canons of the Cathedral)
Calle de Locum [BG].
This is the only Baroque palace in Toledo, and is now an old people's home. 142.

Palacio de los Condes de Cedillo
(Palace of the Counts of Cedillo)
Plaza del Seminario, near San Andrés [DJ].
The old palace of the Cedillos formerly housed the University of Santa Catarina; it is now the home of the Little Seminary. The fine Italianate

patio with columns of white marble is worth seeing. 102.

Palacio de Fuensalida [CJ].
This imposing Mudéjar palace was built by order of Don Lopez de Ayala, the first Count of Fuensalida, in the middle of the 15th century. Within its walls died the Empress Isabella, wife of Charles V. 98, *100,* 102, *102.*

Palacio del Rey Don Pedro
Plaza de Santa Isabel [CJ].
This is the name given to a Mudéjar-style building with a façade protected by an elegant overhanging roof, and a doorway bearing the coat-of-arms of the Ayala family. 102.

Plaza del Zocodover [DH].
In Arab times this was the place of the cattle-market or souk (zoco). The Arco del Sangre (q.v.) survives although much defaced, and used to be the gate in one wall of the town. Philip II tried to bring some formality to the shape of this plaza; but the plan was abandoned in mid-course The north and east sides have preserved their former aspect, with arcades, large sections of which must have been reconstructed after the Civil War. Celebrated in Spanish literature and theatre, it is today the animated centre of the town. *33, 54,* 58, 126.

Puente de Alcántara
(Alcántara bridge) [EG].
At the eastern end of the Tagus gorge a bridge was built by the Romans, and destroyed in 854. It was restored by the Arabs in 866, and again by Alfonso the Wise in 1258, and finally at the beginning of the 15th century. At the eastern end is a Baroque portico dating from 1721; at the western end a Mudéjar tower that saw service as a bridge head (1484) is emblazoned with the coat-of-arms and shield of the Catholic Monarchs. This is the best place to appreciate the complexity and beauty of the town, framed by the Castilian countryside, with the deep cleft of the Tagus between its rocky sides. 68, *68,* 73, *73,* 74.

Puente de San Martín
(St Martin's bridge) [AJ].
This bridge, at the western end of the Tagus gorge, dates from the first years of the 13th century. It was extensively restored in the 14th century by Archbishop Don Pedro Tenorio, and is a magnificent example of a medieval fortified bridge with its two defensive bridgeheads. *10,* 11, 25, 64, *68,* 74.

Puerta de Alcántara [EG].
(Alcántara Gate)
This Arab gate, situated at the approach to the Alcántara bridge, has been reconstructed and restored many times since the beginning of the Christian era. 22, 58, 62, *62,* 74.

Puerta del Cambrón [AH].
(Cambrón Gate)
Formerly the Bib-al-Makara, built by King Wamba in the 8th century, rebuilt in the 11th, this gate is part of the north-west wall. It was again rebuilt by Philip II in 1576, this time in Graeco-Roman style. 64, *65.*

Puerta de Doce Cantos
A much delapidated gateway in the town wall on the eastern side of Toledo. There are fragmentary remains of a possibly Moorish construction. 22, 62, 64.

Puerta Nueva de Bisagra
(New Bisagra Gate) [CF].
This gate leads out to the north of the town, and consists of two blocks of buildings with a vast courtyard in between. It was enlarged and rebuilt in 1550 by Alonso de Covarrubias. On the town side stand two towers with pyramidal roofs, displaying the coat-of-arms of Charles V. There are two towers also at the external end, round, crenellated and enormous; these also bear the Imperial crests. 12, *13,* 39, 64, 73, 88, 137.

Puerta del Sol
(Gate of the Sun)
Calle de Carretas [DG].
This is one of the best examples of Toledo military art. In the north, in the 'wall of Azor', it has been built into a former bastion. It was completed during the 14th century in the Mudéjar period by the Knights of St John of Jerusalem. Over the smaller of the two entrance arches is the scutcheon—triangular—of Toledo Cathedral (13th-century); over the larger there is a small classical marble head, and the figures of two apostles, originally from a Christian sarcophagus (3rd and 4th centuries). 62, 73.

Puerta de Valmardón
(Valmardón Gate)
Cristo de la Luz [DG].
This was formerly the Arab gate of Bab-el-Mardón. 27, 62.

Puerta Vieja de Bisagra
(Old Bisagra Gate) [CG].
The main part of its structure is of Moslem origin, with obvious features of the Caliphate period. It was through this gate that Alfonso VI entered Toledo as a conqueror in 1085. Some alterations were later carried out in Mudéjar style. 12, 62, 65, 77, *77.*

San Andrés
Plaza de San Andrés [DJ].
A Mudéjar church with triple naves,

and interesting Arab remnants and Mozárabic domes from the 14th demtury. The original chevet was demolished to make room for another in late Gothic style, at the expense of Francisco de Roja in 1500. The fine altarpieces are by Juan de Borgoña with the assistance of Antonio de Comontes. 96.

San Antonio
Calle de San Tomé [CH].
This Franciscan convent has a single-naved church built in the 16th century, where there is a handsome Plateresque altarpiece dedicated to San Antonio.

San Bartolomé
Calle de San Bartolomé [CJ].
A Mudéjar church with an interesting old bell-tower and beautiful apses with blind arcades of brick. *54, 93.*

Santa Clara la Real
Plaza de Santa Clara.
The Franciscan nuns of Santa Clara live here. The church has fine coffered and panelled ceilings of Mudéjar origin. The altarpiece, well-preserved, is the work of Luis Tristán, a pupil and follower of El Grtco, and dates from 1623.

San Clemente
Calle de San Clemente [BH].
This is a royal foundation. The church, although renovated in 1795, preserves the interesting Plateresque gateway by Alonso de Covarrubias, executed 1527-34. 129.

San Domingo el Antiguo
Plaza de San Domingo [BH].
The church of this convent founded by Doña María da Silva, a Portuguese lady in the Empress Isabella's retinue, was designed by Nicolás de Vergara and built from 1576 onwards. Its altarpiece was the first to be painted in Spain by El Greco, and three of his original canvases remain. The others have been dispersed and are in various great foreign art galleries. 42, 47, 60, 134.

San Domingo el Real
Plaza de San Domingo el Real [CG].
This convent is linked with the history of Peter, the king noted for a series of malicious murders, and known as Pedro the Cruel, and his bastard sons. Within its precinct are some notable works of art and fine examples of Toledo crafsmanship. The façade of the church is protected by an original portico with Doric columns, an example of Serlio's influence on the imperial city. *51, 52, 55.*

Santa Eulalia
Traversia de Santa Eulalia [BH].
The three naves of this Mudéjar church are separated by arches that rest on columns and pillars. It dates from the 13th century. 60, 82, 86.

Santa Fe
Calle de Santa Fe [DG].
Today the convent of the Ursulines, this once belonged to the Comendadoras de Santiago. The fine gateway with carved beams is 16th-century. The church has a rich Churrigueresque (*see* Churriguera, José de) altarpiece over the high altar. The tomb of the Infante Fernando Peréz, and the apse which can be viewed from outside, are both in the Mudéjar style. 81, 93, 96.

Santiago del Arrabal
Calle Real del Arrabal [CG].
The Gothic influence is evident in this Mudéjar church, and the grandeur of its proportions makes it very tall. It must date from the end of the 13th or beginning of the 14th century. The pretty tower is older, and very simply styled. *87, 88.*

San Ildefonso - *see* San Juan Bautista

Santa Isabel de los Reyes
Calle de Santa Isabel [CJ].
This is one of the most interesting convents in Toledo, and was founded by Doña María of Toledo, built round the Mudéjar houses of the lords of Casarrubios and Arroyo Molino, and of Doña Inez de Ayala. The interior is the most remarkable, but visitors are not allowed, except to the church, the Mudéjar apse and the external porticoes. *52, 93, 98.*

San Juan Bautista
Plaza del Padre Mariana [CH].
This parish church was once the chapel of the great house of the Society of Jesus at Toledo. It is also known as the church of San Ildefonso, as it is supposed that the saint's dwelling was on this site. It is the work of Francisco Bautista, a lay brother of the Order. It is reminiscent of Vignola's style, with a Baroque façade and a great column, and dates from the middle of the 17th century. 46, 51, 140, 141, *141.*

San Juan de la Penitencia
A Franciscan convent founded by Cardinal Cisneros in 1514, in the Casas de los Pantoja. It was completely destroyed during the civil war and all that remains are a few fragments of plasterwork and a caissoned ceiling in one of the rooms. 39.

San Juan de los Reyes
Plaza San Juan de los Reyes [AH].
This church formed part of a convent

founded by the Catholic Monarchs to commemorate the victory of Toro over the king of Portugal in 1476. It had been intended to be their burial-place; however they are in fact buried in the royal chapel at Granada. It is Jean Guas' most important work, and the most typical of Isabelino Gothic—so named after Isabella the Catholic. The convent church, with single nave, transept and chevet, is rich in royal emblems. The north-west façade was begun in 1553 by Covarrubias, and finished in 1610—a mediocre Gothic imitation. Around the outside of the apse can be seeen the chains of Christian captives, donated by King Ferdinand after their deliverance at Malaga and Almeria. *10, 33, 68, 88, 92, 116, 119, 120, 120, 124-5, 125.*

San Justo y Pastor
Plaza de San Justo [DJ].
The interesting chapel of Corpus Christi survives in this much-altered and defaced Mudéjar temple. It is in the Mudéjar style, with fine stuccoes, glazed tiles and an Artesonado ceiling. There is also the chapel begun by Jean Guas, the architect of San Juan de los Reyes, who wished to be buried there. From the outside can be seen a fine Mudéjar apse and a Baroque bell-tower. *60, 96-7, 124, 142.*

Santa Leocadia
Plaza de Santa Leocadia [BH].
An early Mudéjar church of which only the bell-tower, the aisle apses, and a fairly large part of the façade remain. *92, 93.*

San Lorenzo
Calle de San Lorenzo 6 [DJ].
Only the tower of this ruined parish church remains standing, in which it is difficult to identify a Moslem structure. *28, 80.*

San Lucas
Plaza de San Lucas [DJ].
A Mudéjar church built in the form of a basilica, with arches supported by masonry pillars. It dates from the beginning of the 13th century. *60, 82, 86.*

San Marcos
In the Calle de la Trinidad, the only surviving part of the ancient Convento de la Trinidad. The church dates from the seventeenth century and is severely classical in style. A Mozárab congregation still meets in one of its chapels. *30, 60.*

Santa María la Blanca
Calle Reyes Catolicos [BH].
Toledo's oldest synagogue, and one of the town's most original monuments, dates back to about 1180. It was rebuilt during the 13th century, and turned into a church in 1405.

It is divided into five naves, separated by horseshoe-shaped Moorish arches, supported by octagonal pillars decorated with plaster capitals in the Andalusian style. The ceiling is of larch, and the brick-paved floor is patterned with glazed tiles, some of them quite old. Its elegant decoration is a distillation of the essence of Almohadic art. *56, 60, 86, 97.*

Santa María de Melque
35 km. (22 miles) east of Toledo, in the Town Hall (Ayuntamiento) of Puebla San Martín de Montalbán.
A Mozárabic church built between 862 and 930; the only Mozárabic church that has survived in the province of Toledo. *82.*

San Miguel el Alto
Calle de San Miguel [EJ].
Only the elegant tower remains from this Mudéjar church situated at the highest point in the town. *81, 81, 92.*

San Pablo
Calle de San Pablo, at the end of the Calle del Barco [DJ].
Founded in 1400. Its conventual atmosphere is typical of Toledo. The 16th-century church still has Gothic vaulting, and contains the funeral monument of Don Fernando Guevara.

San Pedro Mártir, Church
Originally the chief Dominican monastery in Toledo, today used as an orphanage. Of the original Mudéjar structure only a tower remains, almost hidden by later additions. The three-storeyed cloister is a splendid Renaissance structure, attributed to Covarrubias. The church is severely classical with much ironwork. It contains the tomb of the famous soldier and poet Garcilaso de la Vega, also other tombs and numerous works of art, some from religious buildings which have now disappeared. *84, 92, 136.*

San Román
Calle de San Román [BH].
This is the most beautiful and the most complete Mudéjar church in Toledo. It has three naves, separated by great Moorish arches supported by composite pillars. The paintings which decorate it have been to a great extent preserved, and are particularly important. The present building must date from 1221. It has one of the finest Mudéjar towers in Toledo. The choir was built in the 16th century by Alonso de Covarrubias. *58, 78, 84, 86-8, 140.*
See Museo de Los Concilios.

San Servando
Convent founded by Alfonso VI near where the Castillo de San

Servando now is. It had disappeared completely. 74.

San Sebastian
Ronda de las Carreras [CK].
One of the oldest Mudéjar churches, built on the site of a mosque. It is a small triple-nave basilica with Moorish arcades. It was last altered in the 13th century. 60, 64, 82, 86.

Santo Tomé
Calle de Santo Tomé [BJ].
Of the early Mudéjar church only the belltower remains, one of the finest in Toledo. Above the tomb of Count Orgaz, low on the right aisle, is an admirably-placed picture by El Greco, *Burial of Gonzalo Ruiz, Count of Orgaz, with the Appearance of St Augustine and St Stephen,* recording the miracle which is supposed to have occurred in this church. Scholars and notable citizens of contemporary Toledo are recognizable in the picture, among them the two sons of Alonso de Covarrubias, and perhaps El Greco himself. *42, 45, 46, 47, 88.*

Santa Ursula
Calle de la Ciudad.
A single-nave Mudéjar church with a handsome apse, built in 1360. In the 16th century a second nave was added, containing Berruguete's altarpiece which is now in the Santa Cruz museum.

San Vicente
Plaza de San Vicente [CG].
A single-nave Mudéjar church, recently restored. 88, 130.

Sinagoga del Tránsito
Paseo del Tránsito [BJ].
This synagogue was founded and commissioned by the financier Samuel Levi, when as Treasurer he enjoyed the favour of Pedro the Cruel. After the expulsion of the Jews in 1492 the Catholic Monarchs granted it to the Knights of Alcántara who turned it into a church. It consists of a handsome rectangular room with a panelled larchwood ceiling magnificently inlaid with ivory and decorated with the best of Toledo Mudéjar stuccoes. The building now houses the Museo Sefardi. *See* list of Museums. 31, *31, 58, 97.*

Taller del Moro
(The Moor's Workshop)
Calle del Taller del Moro [CJ].
The remains of a former Mudéjar palace which belonged to the Ayala family, built at the end of the 14th century. It was later converted into a workshop where marble was cut and prepared for the cathedral—whence its name. Nowadays it is the home of the Toledo Museum of Applied Arts. *See* Museo de Artes Aplicadas Toledanas. 97-8, *99, 100.*

Teatro Rojas
Built in the second half of the 14th century and of no artistic interest. 58.

Universidad Nueva
(New University)
Calle Cardinal Lorenzana [CG].
A neoclassical building by Ignacio Haan, begun in 1795. It is one of the most beautiful examples of the style in all Spain, and is today occupied by the Institute of Secondary Education.

Walls - *see* **Fortifications and walls.**

MADRID

Aduana - *see* **Ministerio de Hacienda**

Alcalá de Henares
31 km. (19 miles) east of Madrid.
The town has been here since before the Roman occupation. The Arabs built a fortress here in the 8th century to defend the Henares. Cardinal Cisneros founded a university here at the end of the 15th century, that rivalled Salamanca, and established the famous polyglot Bible in six volumes, the *Biblia Poliglotta Complutensis.* It is also the birthplace of Cervantes (1547).

Alcázar
The old Alcázar or palace of the kings of Spain disappeared in a terrible fire in the year 1734. The new palace of the Bourbons was built in its place. The Alcázar was originally an old Moorish fortress, which had been constantly improved and embellished by successive kings. Philip II and Philip III in particular undertook major works. 151, 152, 161.

Alfonso XII Monument
Parque del Retiro [DH].
This was built near the lake to commemorate Alfonso's restoration and the peace which followed the Carlist wars; designed by José Grases Riera; executed by Benlliure, José Blay, Mateo Irruria and others. 214.

Almudena
Calle de Bailen [AH].
Cathedral in course of construction,

facing the Palacio Real on the Plaza de la Armerí. Francisco de Cubas began it in 1883, in a neo-Gothic style. In 1950, construction being almost at a standstill, the initial designs were modified to bring them more into harmony with the Palacio Real. Work is a long way from completion. *146, 148, 210.*

Aranjuez
47 km. (30 miles) south of Madrid.
At the end of the 14th century the Grand Master of the Order of Santiago had a palace built here, where Isabella the Catholic liked to stay, and which was enlarged by Charles V. Philip II embellished it and added the gardens, which are open to visitors from 10.00 to sunset. The Casita del Labrador (*10.00-13.00 and 15.00-17.00, 18.00 or 19.00 according to season*) is the Trianon of the Spanish Bourbons. The Palacio Real, which is open to the public at the same times, was built for Philip II in 1561 by Juan Bautista de Toledo, and Herrera. Philip V had the great staircase added, and Charles III the two brick and stone wings by Colmenar. The apartments are hung with many works of art. *140, 160, 186, 232, 240, 242, 243, 243, 245.*

Ayuntamiento
(Town Hall)
Plaza de la Villa [BH].
This building, the meeting-place of the city council, was begun in 1644 to the plans of Juan Gómez de Mora, continued by José de Villareal and then by Teodoro Ardemans, who built the towers about 1670. Juan de Villanueva opened up a colonnade in the frontage of the Calle Mayor to facilitate processions and pageants. *198.*

Balsain
Originally a palace and royal residence on the northern slope of the Sierra de Guadarrama a short distance from the Real Sitio de San Ildefonso, better known as La Granja. Philip II was particularly fond of this palace, where the architects Luis and Gaspar de Vega worked. Abandoned after the building of La Granja, it now consists only of a few sadly dilapidated ruins. *160, 240.*

Banco de España
Plaza de la Cibele [CH].
A magnificent neo-Renaissance building designed by the architect Eduardo de Adaro, and completed in 1891. *210, 215.*

Bernardas Recoletas del Sacramento
Calle del Sacramento [BH].
The convent was founded in 1616, and the church appears to have been in construction from 1671 to

1744. The chief architect is said to have been Andrés Estebán. There is a singular façade, with undertones of some of Francisco de Mora's work, and the interior, with its fresco-decorated dome, its classical and Baroque altarpieces, is one of the most harmonious and the best proportioned examples of Madrid Baroque. *174.*

Bolsa de Comercio
(Commercial Exchange)
Plaza de la Lealtad [CH].
Built between 1866 and 1893 by Enrique Repulles y Vargas; neoclassical in style. *215.*

Caballero de Gracia
Calle del Caballero de Gracia.
A unique church built by Juan de Villanueva in 1795 in the form of a basilica, imitating the temples of the early Christians. *198.*

Calatravas
Calle de Alcalá [CH].
It once belonged to the nuns of the Order of Calatrava, and now that the convent is no longer in existence, it has become a parish church. It must have been built about 1686, and its bold outlines make it the prototype of Madrid Baroque. The altarpiece is 18th-century, with sculptures by Pablo González Velázquez. The exterior façade, surmounted by an elegant dome in purest Madrid style, has been re-decorated by Juan de Madraso in neoclassical style. *172.*

Capilla del Cristo de los Dolores
Situated near San Francisco el Grande [AJ].
This chapel belongs to the Venerable Orden, Tercera Franciscana (Third Venerable Order of Franciscans). Its architect was the Jesuit lay Brother Bautista, Built between 1662 and 1665 by the masons Marcos and Mateo López. *170.*

Capilla del Obispo
(The Bishop's Chapel)
Plaza de la Paya.
Founded by Don Francisco de Vargas and completed in 1535 by his son, the bishop of Plasencia, Don Gutierrez de Vargas y Carvajal who lies buried here with his parents. A magnificent altarpiece by Giralte and Villoldo. The alabaster tombs are thought also to be by Giralte. *153, 154-5, 157.*

Capilla de San Isidro en San Andrés
Plaza de los Carros [BJ].
This was attached to the San Andrés church, where Isidro had been a member of the congregation, and where he was buried. The San Andrés church has now disappeared, and the big chapel, that had been built after San Isidro's canonization,

has become the parish church in its own right. The first designs were by Juan Gómez de More and Pedro Pedroso, but these were set aside in favour of those drawn by Pedro de la Torre. The foundation stone was laid in 1642, and the main part of the work carried out between 1657 and 1659. The interior is lavishly decorated; there are stuccoes by Charles Blondel and Francisco de la Vina. *168, 170, 172.*

Carcel de Corte
(Court Prison)
Plaza de Santa Cruz [BH]
This monumental building was designed to provide offices for the Alcaldes of the royal household and the court, with a prison for persons of noble rank as an annexe. It is now given over to the Ministry of Foreign Affairs, and is sometimes known as the Palace of Santa Cruz by virtue of its location. This finest building in the capital of the Austrian Monarchs was in construction from 1629-34, and designed either by Alonso Carbonell or by Juan Gómez de Mora. Another name is also mentioned in this context; that of G. Battista Crescenzi, but it seems more probable that he was the superintendent of works. *164, 165, 167.*

Casa del Campo
A woodland reserve to the west of Madrid, facing the Palacio Real across the River Manzanares. An extension of the Campo del Moro, it was the property of the Crown. At the entrance is a rustic house or small palace and a walled garden, which in the time of the Archdukes of Austria contained the equestrian statue of Philip III now standing in the Plaza Mayor. During the second Republic it was handed over to the municipal authorities, who opened it as a public park. *50.*

Casa de Cisneros
Plaza de la Villa [BH].
Built in the 16th century by Benito Jimenez de Cisneros, the nephew of the cardinal. The older part gives on to the Calle del Sacramento, and boasts a Plateresque doorway and gallery in the Toledo style. The offices of the Alcalde of Madrid are here. *153.*

Casa de Lasso de Castilla
Plaza de la Paja
From one of these houses Cisneros harangued the Castilian nobility during a time of insurrection. The present buildings include a Renaissance gallery reminiscent of Toledo. There has been much restoration. *153-4.*

Casa de Lujan, or Lujanes
Plaza de la Villa [BH].
A fortified house with a tower, once the property of the Lujan family. Recently restored, with a late Gothic doorway having a mixtilinear arch ending in a straight line. Another less important door with a Moorish arch. According to tradition Francis I was held prisoner in this tower after his defeat at Pavia and before being transferred to the Alcázar. *152, 153.*

Casa de Panadería
Plaza Mayor [BH].
This huge building was begun in 1590. The ground floor had originally been intended as a bakery, and after a fire in 1672 was rebuilt by José Jiménez Donoso. Above the portico, which is all that remains of the original building, rise three storeys decorated in the Churrigueresque manner, and framed between two towers with pyramidal roofs. *148, 162.*

Ciudad Universitaria
(University Halls and Buildings)
La Moncloa [AF]
Founded by statute on 17 May 1927, under the patronage of Alfonso XIII, it occupies the site of the old Moncloa Gardens. Its chief architect, Don Modesto Lopez Otero, sought to give the buildings a certain unity, and although this has been broken of late, the urbanist lines remain. Some good example sof modern architecture. *212-14, 220.*

Comendadoras de Santiago
Plaza de las Comendadoras [BG].
A convent church, built from 1668 to 1693. Its plan is interesting, in the form of a Greek cross, with an exedra at the end of each arm. There is a large dome. Almost the whole of the high altar is taken up with a composition by Luca Giordano (1695). The sacristy (1745-1754), designed by Francisco Moradillo, influenced by Juvara and Sacchetti, is of interest. *172.*

Congreso de los Diputados
Carrera de San Jerónimo [CH].
This building was the seat of the Spanish Democratic Parliament during the constitutional period (Camara Popular - the People's Chamber). It is now the home of the Cortes Españolas. It was built by Narciso Pascual y Colomer between 1843 and 1850, in a classical style, fine pediment and corinthian columns. *209.*

Court Prison - *see* Carcel de Corte

Cuartel del Conde Duque
Calle del Conde Duque [BG].
There is a clearly-dated work by Pedro de Ribera on the spectacular military-style doorway (1720). The sturdy building, whose original towers have been removed, is to be

restored and devoted to cultural uses. 175.

Descalzas Reales
Church belonging to the former convent - *see* **Museums.**

Encarnación
As above.

Ermita de San Antonio de la Florida
- *see* **Museums**

Ermita de la Virgen del Puerto
Paseo de la Virgen del Puerto, near the Manzanares [AH].
This was founded by the Marquis del Vadillo, Corregidor of Madrid. It was consecrated in 1718, and is one of the first and most original works by Pedro de Ribera. 172, 174.

Escolapios de San Anton
Calle de Hortaleza [CG].
This church was originally built by Pedro de Ribera, but only the outline of its first design remains, as it was transformed at the time of Charles IV, in the neoclassical fashion, when it was handed over to the Escolapios. It contains what is perhaps Goya's most inspired religious painting, *the Last Communion of San José de Calasanz.*

El Escorial
49 km. (31 miles) from Madrid. Conducted Tours: 10.00-13.00 (12.30 for the Princes Pavilion) and 15.00-19.00 (18.00 from 16 September to 1st April. Closed on 1 January, the morning of 28 February, the afternoons of Good Friday and 10 August, all day on 18 July and 25 December.
Work was carried on first by Juan de Herrera and later by Juan de Toledo, between 1563 and 1584 to fulfil a wish of Philip II, to build a monastery that would also be a royal palace, dedicated to the glory of St Lawrence in gratitude for the victory accorded to the king at the battle of St Quentin. The plan of the monastery, in the form of a gridiron, recalls the instrument by which the saint was martyred. The exterior is severe; the interior a well-stocked museum.
Court of Kings: Main court of the monaster with the majestic façade of the church.
Basilica: The plan, in the form of a Greek cross, recalls some of Bramante's designs for St Peter's in Rome. The vaulting of the naves, painted by Luca Giordano, is carried on enormous columns. On either side of the high altar are the mausolea of Charles V and Philip II. Below the sanctuary, the Pantheon of Kings houses the tombs of Spanish sovereigns and their families.
Chapter-Houses: Set about the Court of the Evangelists, they contain a fine collection of pictures and sacerdotal vestments.
Library: Precious books with magnificent bindings.
Royal Apartments: Those that date from the time of the Austrian Monarchs are very sombre, while the Bourbons preferred a very rich decoration. There are beautiful Flemish and Spanish tapestries, some of which are from sketches by Goya.
New Museums: Picture Gallery: Bosch, Veronese, Titian, Tintoretto, Ribera, Velázquez, and El Greco's picture painted for the monastery, *The Martyrdom of St Maurice and the Theban Legion.*
Historical Museum of the building of the Escorial: plans, drawings and iconographies belonging to those who took part in the venture; tools and machines used in the construction.
Casita del Principe (Prince's Pavilion): In the del Principe gardens. A pretty T-shaped pavilion built by Charles III for his son, later to be Charles IV. The interior is decorated in extremely good taste, there are ceilings painted in Pompeian style, Spanish, Italian and French pictures, and rich furniture. 42, 49, 113, 158, 160, 167, 196, 220-24, *223, 224, 226, 227, 233-35, 234, 236, 238, 240, 240.*

Escuelas Aguirre
(Aguirre Schools)
Calle de Alcalá [CH].
Founded by the legacy of the philanthropist Lucas de Aguirre, who died in 1873. The building is typical of the neo-Mudéjar style which became prevalent in Madrid through the influence of the distinguished architect Emilio Rodríguez-Ayuso. 211.

Fuente de la Cibeles
Situated on the Paseo del Prado, in the Plaza de la Cibeles. Designed by the architect Ventura Rodríguez. Francisco Gutiérrez modelled the figure of the goddes and Robert Michel the lions drawing her chariot. *176, 192.*

Fuente de Neptuno
On the Paseo del Prado, in the Plaza de Cánovas. Designed by the architect Ventura Rodríguez; the sculpture is by Juan Pascal de Mena. 192, *248.*

General Hospital
Calle de Santa Isabel [CJ].
Only a very small part of Francisco Sabatini's original plans for this project was ever realized—had it been completed it would have been most impressive. 194.

Góngoras
Calle de Góngoras.
Philip IV entrusted the construction of this convent of the Mercedarias

Descalzas (Discalced Nuns of Mercy), to Don Juan Felipe Jiménez Góngara. The church was completed in 1689, and is a good example of Madrid Baroque, particularly on account of its dome, which is well worth seeing. 172.

La Granja
77 km. (48 miles) from Madrid. Visits to the Palace: 10.00-13.00 and 14.00-18.00 or 19.00. Visits to the gardens: 09.00-14.00, Thursdays, Saturdays and Sundays. Fountains: Display at 17.30 every Thursday, Saturday and Sunday from Easter onwards; also 30 May, 5 and 25 July, 25 August; on these days the gardens are opened at 14.00.
The creation of Philip V, and somewhat reminiscent of Versailles. An imposing and severe palace, rectangular in form, with four parallel wings, based on designs by Teodoro Ardemans in 1721-23. The face that overlooks the gardens was designed by Juvara and executed by Sacchetti in 1739. The apartments are richly hung with Flemish tapestries imported from Brussels by Charles V, and with Spanish tapestries based on sketches by Goya. The gardens are the work of the Frenchmen René Carlier and Etienne Boutelou. There are twenty-six monumental fountains comparable with those at Versailles, sculptured by Frémin, Thierry, Dumandré and Pitué. 186, 240, 243, 246, 247-8, 247, 248.

Hospicio de San Fernando
Calle de Fuencarral [CG].
Philip V personally assumed the patronage of the Madrid Hospice, and commissioned a new building for it. Pedro de Ribera completed it in 1729. It is undoubtedly the finest example of 18th-century Madrid Baroque, preceding the academic style that was soon to dominate the scene. Today, the building houses the Museo Arqueologico Municipal (q.v.) and the municipal Library. 176, *176*.

Mercedarias de Don Juan de Alarcón
Calle de la Puebla.
The chief convent of the Mercedarias Descalzas. Its architecture is extremely severe, and akin to Herrera's style. It was founded by Dona María de Miranda, and her executor Don Juan de Alarcón. The church was finished in 1656.

Ministerio del Aire
Plaza de la Moncloa [AF].
A monumental construction which on a gigantic scale shows the influence of Madrid architecture at the time of the Austrian Monarchs. The architect, Luis Gutiérrez Soto, designed it at the end of the civil war

as a positive affirmation of the new regime, afterwards matched by a plaza in the same style. The whole was completed about 1965. 217.

Ministerio de Hacienda
Calle de Alcalá [CH]
Charles III commissioned Sabatini to build this noble edifice for the Casa Real de la Aduana (the Royal Custom-house). It was completed in 1769. Above the central door are two statues of *Fama* by Robert Michel. It is now the Finance Ministry. 176, 194.

Monte del Pardo
A forest of evergreen oaks to the north of Madrid, on both banks of the River Manzanares, to which the royal residence of El Pardo owes its origin. From the Middle Ages onwards, this area was a favourite hunting ground of the kings of Spain. The bear which figures on the Madrid coat of arms must have been one of the species found in this forest. 50.

Monserrat
Calle de San Bernardo [BG].
Built about 1720, but incomplete in that transept, dome and chevet have never been added. It belongs to the Benedictine monastery of Monserrat. Its unusual steeple, topped by a bulbous Rococo spire, is striking. 173, *173*.

Nuevos Ministerios
At the end of the Paseo de la Castellana [DF].
A ministerial office building for which plans were drawn during the Second Republic (1931-36) by Secundino Zuazo, who was seeking to reconcile architectural rationalism with representational art in the manner achieved by the Escorial. Zuazo undertook the extension of the Castellana, opening up one of the most modern highways in Madrid. 216.

Obelisco del Dos de Mayo
Plaza de la Lealtad, near the Paseo del Prado [CH].
Built between 1822 and 1840 by Isidro Velázquez, in neoclassical style with hints of Egyptian influence, to commemorate the bravery of two artillery officers who on 2 May 1808 held General Lefranc's French troops in check during the War of Independence. 200.

Observatorio Astronomico
Parque del Retiro, Alfonso XII entrance [DJ].
This still fulfils the original purpose for which it was designed about 1790 by Juan de Villanueva. 198.

Palacio de Bibliotecas y Museos
Paseo de Recoletos [CG, CH].
This palace, one of the finest buildings in Madrid, was begun by Fran-

cisco Jareño in 1886 and finished by Ruiz de Salces in 1892. It houses the Biblioteca Nacional, Museo Arqueologico Nacional, Museo Nacional de Arte Contemporaneo and Museo de Artes Decorativas. *See* Museums. 208, 211, 213.

Palacio del Buen Retiro
Calle Mendez Nunez [DJ].
Very little remains of this palace except a building housing the Museo del Ejercito and the Cason del Buen Retiro, which was once a ballroom, and has a ceiling decorated by Luca Giordano. It is nowadays used for art exhibitions. 160, 168, 169, 198.

Palacio de Comunicaciones
Plaza de la Cibeles [CH].
The General Post Office, built between 1904 and 1918 by Antonio Palacios, is in a very free and individual style, which by mixing Spanish Plateresque features with a manner closer to modern art and to the Austrian 'secession', lends an unmistakeable aspect to one of the most elegant plazas in Madrid. 215. *217.*

Palacio Grimaldi
Calle de Bailen [AH].
Built by Sabatini for the Marquis of Grimaldi, it later became the home of Godoy for a time; then the offices of the Ministry of State, and the Ministry of Marine; it is now the Museo del Pueblo Español. 195.

Palacio de Liria
The palace of the Dukes of Liria, in the Calle de la Princesa, was begun in the year 1773 by the architect Gilabert. Work had hardly started, however, when it was redesigned by Don Ventura Rodríguez, who was responsible for most of its eventual architecture, inspired by the Palacio Real and that of La Granja. When the Duchess of Alba Cayetana died without issue, the houses of Alba and Liria-Berwick merged and the Palacio de Liria became the residence of the Dukes of Alba. It houses the best private collection of works of art in Madrid. *184,* 188.

Palacio del Marques de Salamanca
Paseo de Recoletas [CH].
This is in neo-Renaissance style, built by Narciso Pascual y Colomer about 1855 . It is now the Banco Hipotecario de España. 209.

Palacio de la Torrecilla
In the Calle de Alcála, next to the Ministerio de Hacienda. Today only the façade remains, incorporated into a modern building which belongs to the ministry. Attributed to Pedro de Ribera. 176.

Palacio de Miraflores
Carrera de San Jerónimo.
Attributed to Pedro de Ribera. There

is a central portal of granite which embraces the doorway and the main balcony in a way typical of Spanish Baroque. 176.

Palacio de Perales
Calle de la Magdalena [BJ].
One of the most beautiful or the doorwas to 18th-century palaces of Madrid is this by Pedro de Ribera, with door and balcony integrated, incrusted with great jutting mouldings, and lavishly decorated. 176.

Palacio Real - *see* Museums

Palacio de Ugena
Calle de las Huertas [CJ].
It once belonged to the Marquis of Ugena, a member of the Goyeneche family who were the patron sof Churriguera and de Ribera and who did so much to encourage Madrid Baroque art. This palace is a characteristic expression of the Ribera's art, though it has been extensively altered in the 19th century. 176.

El Pardo
Royal and governmental residence and palace twelve kilometres (7½ miles) north of Madrid in the middle of the Monte del Pardo. The present palace was started by Charles V after the demolition of another building dating from the time of Henry III of Castile. It was finished by the architect Luis de Vega in 1558. Philip II enlarged and improved it. Under Charles III, Francisco Sabatini enlarged it again to twice the size. Contains numerous works of art and a remarkable collection of tapestries. Now used as a residence by Generalisimo Franco, the Spanish Head of State. 160, 240.

Parque del Buen Retiro [DJ].
This magnificent park lies in the centre of Madrid and has been here since the 15th century. Philip II held nautical pageants on its lake. It used to be attached to a palace to which royalty would retire during Holy Week and in period sof mourning. After alterations during the 17th century the palace was abandoned, and subsequently suffered several fires during the 18th century. It was almost totally destroyed during the French occupation in 1808. The park provided a place of entertainment for the court of Philip IV, and at that time contained many monuments, retreats and other buildings which have since largely disappeared, or been replaced by others during the 19th century. The latest changes have ruined the 16th-century character of the landscapes, and have introduced modern gardens of indifferent taste. 214, *215.*

Paseo del Prado [CH, CJ].
That which goes by the name of 'El Salon del Prado' represented one of the soundest urban reforms carried out by Charles III. Work began in 1775 under the joint direction of the military engineer José Hermosilla, and the architect Ventura Rodríguez who designed the wonderful fountains of Cybele, Neptune and Apollo or *Las Quatro Estaciones* (Four Season), executed by the sculptors Francisco Gutiérrez, Robert Michel, Juan Pascual de la Mena, Giraldo Bergaz and Manuel Alvarez. 188, *190,* 191, 192, 196, 197, 200.

Plaza de la Independencia
A large circus where the Calle de Alcalá, the Calle de Serrano and the Calle de Alfonso XII meet. In the middle is the Puerta de Alcalá, built by Francisco Sabatini. 215.

Plaza Mayor [BH].
Planned by Juan Gómez de Mora and built from 1617 to 1619 on the site of the Plaza del Arrabal. Following a terrible fire, Juan de Villanueva began its restoration in 1791, but the work was not finished until 1853. It is the best piece of town planning caried out in Madrid by the Austrians, a place where for two centuries and more the significant events of the capital have unfolded, as well as jousts and tourneys, fairs, races, etc. 36, 153, 160, 161, 162, *162,* 164, *164,* 165, 175, 198.

Plaza de Oriente [BH].
This is situated opposite the east face of the Palacio Real. It was opened up as a consequence of the demolitions ordered by Joseph Bonaparte. The plans of Isidro González Velázquez, in the reign of Ferdinand VII, to give it a regular shape, were abandoned in favour of a more modest solution put into effect in 1841. In the centre stands an equestrian statue of Philip IV by Pietro Tacca, on a pedestal with monumental fountains designed by the architect Juan José Sánchez Pescador in the reign of Isabella II. *146, 167, 169, 183,* 200.

Plaza de la Villa
One of the most interesting squares in old Madrid. In the Middle Ages it was for a long time the centre of the town. It was then known as the Plaza del Salvador, since it was the site of the parish church of El Salvador—now disappeared—in the portico of which the members of the town council held their meetings. Later the town hall was built there, whence the current name of Plaza de la Villa. Outstanding among the monuments around it are the Torre de los Lujanes, the Casa de Cisneros and the Ayuntamiento itself. In the middle of the square is the statue of Philip II's admiral Don Alvaro de Bazan, by Marciano Beulliure. 153, 168.

Puente de Segovia
The oldest bridge in Madrid, built during the reign of Philip II, who wished to make an important entrance to Madrid via the Calle de Segovia. The architect was Juan de Herrera. 160.

Puente de Toledo
Work was completed in 1732 based on Pedro de Ribera's designs in 1719, and a part of the former structure was preserved. All the decorative detail is by Pedro de Ribera's skilful hand, particularly the unusual miniature shrines that house the statues of San Isidro and Santa María de la Sabeza by Juan Ron. 174, *175.*

Puerta de Alcalá
Plaza de la Independencia [DH].
Charles III entered the town that was to become his capital through an earlier gate on this site. To celebrate the event he had a new gate built in the form of a triumphal arch, splendid and solemn, a masterpiece by Sabatini, completed in 1778. 192-4, 242.

Puerta de Guadalajara
The old eastern gateway to the walls of Madrid, which disappeared towards the end of the 17th century, when the town spread towards the east. It was situated in the Calle Mayor, between the Plaza Mayor and the Plaza de la Villa. 162.

Puerta de San Vicente
A former gateway by the River Manzanares, near where the Estación del Norte is today. Built by Francisco Sabatini in the reign of Charles III, it came down towards the end of the 19th century. 198.

Puerta del Sol [BH].
This is the historic heart of Madrid. Its name derives from a gate in the old enceinte and a picture of the sun painted over the doorway of a chapel now disappeared. Between 1857 and 1862 it was altered and improved. It is overlooked by the Correo (the old General Post Office) built at the end of the 18th century by the Frenchman, Jacques Marquet. For a long time this building was the office of the Ministerio de la Governación (Ministry of the Interio), the centre of political life and the busiest place in Madrid during the 19th and early 20th centuries. 153, 175, 188, 202, 205, 212, *215.*

Puerta de Toledo
Calle de Toledo [BJ].
This was built from 1813 to 1826 by Antonio López Aguado, a pupil of Villanueva. It commemorates Ferdinand VII's return to Madrid. 200.

Riofrio

21 km. (13 miles) from La Granja;
88 km. (55 miles) from Madrid.
Virgilio Rabaglio built this palace
in 1732 for Isabella Farnese, the
widow of Philip V. It is a copy of
the Palacio Real in Madrid. 242.

Salesas Reales

(Nuns of the Order of the Visitation)
Calle de Barbara de Braganza [CH].
This convent was founded in 1758
by Doña Barbara de Braganza, the
wife of Ferdinand VI, as a retreat
for her widowhood. It was con-
structed during the period from 1750-
58 by François Carlier, the son of
René Carlier, the landscape gardener
who was responsible for the gardens
of La Granja. The church, now the
parish church of Santa Barbara, con-
tains a fine monument to Ferdi-
nand VI by Sabatini. The convent
has become the Law Courts. 186,
188, *190*.

San Andres

Former parish church of Madrid,
now disappeared. The late Gothic
Capilla del Obispo was built next
to it, and later in the 17th century
the Capilla de San Isidro. Today
part of the latter is used as a parish
church; it was destroyed during the
war and has not been entirely re-
built. 153, 155, 170.

San Antonio de la Florida - *see* Mu-
seums, Ermita de San Antonio de la
Florida

San Antonio de los Portugueses

Corredere baja de San Pablo [BH].
This church is elliptical in shape,
with a dome, the work of the Jesuit
Pedro Sánchez (1624-26). It is all
covered with frescoes, the dome by
Carreno and Rizi, the walls by Luca
Giordano. 170.

Santa Barbara - *see* Salesas Reales

San Cayetano

Calle de Embajadores [BJ].
The church of the Theatines, begun
about 1700, and very probably the
work of José de Churriguera. How-
ever the Italianate features of its
design suggest that it may have been
brought from Italy by the Theatines.
In 1722 and 1737 Ribera drew plans
to extend and improve the church.
It was almost completely destroyed
during the Civil War in 1936, and
has been clumsily restored. 173.

San Fermín de los Navarros

In the Paseo del Cisno. Built in
neo-Mudéjar style by the architect
Carlos Velasco in 1891. 212.

San Francisco el Grande

Plaza de San Francisco [AJ].
Ventura Rodriguez prepared plansto
replace the Gothic church of the
old Franciscan convent which was

pulled down in 1760. The designs
of Brother Francisco de las Cabezas
were preferred, however. After a
number of mistakes he was replaced
by Sabatini *c.* 1780. The façade is
entirely his work. Goya's *St Ber-*
nardino of Siena Preaching is in one
of the chapels. 170, *193*, 195.

Santa Isabel

An Augustine convent, in the street
of the same name. The church was
built between 1639 and 1665 by an
unknown architect. The interior
contains a number of magnificent
paintings, including the large Virgin
by Ribera over the high altar. 172.

San Isidro

Calle de Toledo [BG].
The Imperial College of the Society
of Jesus, founded by a bequest of
the Empress María, sister of Phi-
lip II, was converted, after the ex-
pulsion of the Jesuits, into a govern-
ment teaching establishment. Its
church became a parish church, but
was later elevated to a cathedral. It
is grandiose in conception, and was
begun according to the designs of
the Jesuit Pedro Sánchez, who di-
rected the work until his death in
1663. He was followed by the lay
brother Francisco Bautista. It fol-
lows the lines of Il Gesú in Rome,
which was built by Vignola; however
it has features quite specific to Ma-
drid Baroque. The façade, with its
high Corinthian columns, is parti-
cularly worth noting. 140, 169, 210.

San Jerónimo el Real

Calle de Alarcón, near the Prado
Museum [CJ].
The important convent of the Order
of St Jerome, founded by Don Bel-
tran in the reign of Henry IV, was
transferred to this site by the Ca-
tholic Monarchs in 1503. Its church
was built between 1464 and 1505,
in late Gothic with Mudéjar features.
It was extensively restored in the
19th century in stylized Gothic. *150*,
154, 160, *167*, 169.

San José

Calle de Alcalá [CH].
The former Convento de las Car-
melitas Descalzas, called San Her-
menegildo, it is now converted into
a parish church. It is the most
beautiful example of the pure Madrid
Rococo style. In common with the
remarkable Chapel of Santa Teresa,
it was most probably completed in
1742. 174.

SS. Justo y Pastor

Calle del Sacramento [BH].
Santiago-Jacopo Bonavía's master-
piece, built from 1739 to 1743 at
the expense of Cardinal Infante Don
Louis of Bourbon and Farnese, Arch-
bishop of Toledo. On the convex

façade there are sculptures by Carisana and Robert Michel. The interior has frescoes by Bartolomé Rusca and the brothers González Velázquez. 186, *186.*

San Marcos
Calle de San Leonardo [BG].
Built from 1749 to 1753 on plans by Ventura Rodríguez, who followed the influence of his Italian masters gracefully and skilfully, to achieve a plan of intersecting ellipses reminiscent of Borromini. 186, *189.*

San Martín
Calle del Desengano [BH].
This was formerly the church of the Convent of Portocoeli. It was begun in 1725, and in the fullness of the 18th century it follows the pure tradition of Spanish Baroque. 174.

San Nicolas
Old parish church of medieval Madrid, in the Calle de San Nicolas. Built simply in the Mudéjar style, it has a 15th-century Gothic apse. The tower is highly interesting, its lower part retaining features of the Toledan Mudejar style of the thirteenth and fourteenth centuries. 149.

San Pedro
Old parish church of medieval Madrid, in the Costanilla de San Pedro near the Calle de Segovia. The church is of little interest since it was rebuilt in the 17th century, but the graceful, unadorned brick tower, possibly dating from the 14th century, is the best Mudéjar tower in Madrid.

San Plácido
Calle de San Roque [BH].
It was founded in 1623 by Doña Teresa Valle de la Cerda and Don Jerónimo de Villanueva. The church was begun in 1641 by Brother Lorenzo de San Nicolas. The Benedictines collected a great many works of art here; altar paintings by Claudio Coello and Francisco Rizi, sculptures by Pereira and Gregorio Hernandez, and the famous Velázquez *Christ,* which is now in the Prado. 170, *170.*

Teatro Real or **Teatro de la Opera**
Plaza de Oriente Isabella II.
This theatre was built by Antonio López Aguado about 1830, and underwent considerable modification throughout the 19th century. It has been famous in the history of *bel canto.* It was closed from 1925 to 1960 when it re-opened as a concert hall. 200.

Torres Blancas
(White Towers)
Avenida de America [EF].
A significant example of the brutal expressionism of reinforced concrete, built from 1964 to 1970 by the architect Francisco Sainz de Oiza, with the collaboration of the engineer Carlos Fernandez Casado. 217, *220.*

Town Hall - *see* **Ayuntamiento**
University - *see* **Ciudad Universitaria**

Painters, Sculptors and Architects

Adaro, Eduardo de. Madrid, 1848-1906. Architect. Banco de España. 211.

Aguado - *see* **López Aguado**

Aguirre, Ginés. Active in the 18th century. Spanish painter. Works in the Encarnación church. 161.

Almonacid, Sebastian de. Active between 1494 and 1527. Spanish sculptor. Works in Toledo cathedral: tombs, altarpiece. 109.

Alvárez, Manuel. Salamanca, 1727-Madrid, 1797. Sculptor. Works in the Museo del Prado and Encarnación church. 161, 192.

Ardemáns, Teodoro. Madrid, 1644-1724. Architect. Works in Toledo Cathedral; at the Ayuntamiento and the Palacio Real in Madrid; at Aranjuez and La Granja. Author of a treatise on Construction.

Arfe, Enrique. Cologne *c.* 1470-1545. Goldsmith. With his sons, many monstrances (ornate, transparent display vessel) in Spanish cathedrals. (Enrique himself) Huge monstrance in Toledo cathedral. 116.

Bassano. Da Ponte family of painters active in the 16th century. Works in the cathedral and the Tavera hospital at Toledo; and in Prado. 116.

Bautista, Francisco. 1594-1679. Jesuit, architect. San Juan Bautista at Toledo; Los Dolores de la V.O.T. chapel and San Isidro in Madrid. 141, *141, 168,* 169, 170.

Bayeu y Subias, Francisco. Saragossa, 1734-Madrid, 1795. Painter, pupil of Mengs, brother-in-law of Goya whom he helped in his youth. Tapestry sketches; vaults and ceilings; portraits. Works in the Prado. *185, 235, 242.*

Becerra, Gaspar. Baéza, 1520-Madrid, 1570. Sculptor and painter trained in Italy; in the service of Philip II. Paintings: in the former Alcázar and in the Prado, sculptures: Descalzas Reales, all Madrid. *157.*

Benlliure, Mariano. Grao, Valencia, 1862-Madrid, 1947. Sculptor. Equestrian statue of Alfonso XII in the Buen Retiro park, and numerous other statues in Madrid. *215.*

Bergamasco, Giambattista Castello, (known as **El Bergamasco**). Gandino (Bergamo), 1509-Madrid, 1569. Painter and architect. Design of the main staircase of the Escorial attributed to him; decoration of the Alcázar at Madrid. *234.*

Bergaz, Giraldo. Active in the second half of the 18th century. Spanish sculptor. Collaborated in many minor works such as Artichoke fountain in the Buen Retiro park. *192.*

Berruguete, Alonso de. Paredes de Nava, Palencia, *c.* 1488-Toledo, 1561. Sculptor, son of Pedro. Trained in Italy, where he assimilated the art of Ghiberti and Michelangelo. Private sculptor to Charles V. Toledo: half the cathedral choir-stalls; works in Santa Cruz museum, at the Cristo de la Vega, and the Tavera hospital. Madrid: the Prado. *39, 39, 112, 133, 134, 155.*

Berruguete, Pedro de. Paredes de Nava (?)-1503. Spanish painter. Works in the Tavera hospital, Toledo. *36, 39.*

Biguerny, Felice - *see* **Vigarny.**

Blanchard, Maria. Santander, 1881-Paris, 1932. Works in the Museo Nacional de Arte Contemporaneo in Madrid.

Blondel, Charles. Flemish, active in Madrid in 1671. Decorator and stuccoist. Decorated the chapel of San Isidro en San Andrés, Madrid. *172.*

Bonavía, Santiago-Jacopo. d. Madrid 1760. Italian painter and architect. Arrived in Spain *c.* 1731. Madrid: Buen Retiro theatre (now disappeared), SS. Justo y Pastor. Aranjuez: reconstruction of the royal palace, from 1744; town planning for the new town proposed to house a population of 20,000 (1750); churches of Alpajes and San Antonio. *186, 242.*

Borgoña, Juan de. Burgundy (?)-Toledo, *c.* 1553. French painter. Must have trained in Italy. Works in

Toledo cathedral: cloister, chapter-house, Mozárabic chapel, and altar-pieces in San Andres church. *32, 96, 113, 116.*

Bosch, Hieronymus (known as **El Bosco**). 's Hertogenbosch, *c.* 1450-60-1516. Painter. Works in the Prado and the Escorial. *185, 186, 207, 235.*

Bousseau, Jacques (known in Spain as **Jacopo Buso**). Poitou (?)-Balsain, 1740. French sculptor, pupil of Guillaume Coustou, brought to Spain by Philip V. Works in the Prado and at La Granja. *247.*

Boutelou, Etienne. French landscape architect, pupil of Le Nôtre. After Rene Carlier's death, worked at La Granja (1722). Had two sons, Esteban and Claudio, famous Spanish botanists. *246.*

Brueghel, Pieter (called the Elder). Breda, Holland or Bree, Belgian Campine, *c.* 1525-69. Painter. Works in the Prado and in the Descalzas Reales, Madrid. *157.*

Bustamante, Bartolomé. 16th-century. Spanish architect. A collaborator of Alonso de Covarrubias at the Tavera hospital, Toledo. *133.*

Cabezas, Brother Francisco de las. Enguera, 1709-Valencia, 1773. Architect of Francisco el Grande, Madrid, for the Franciscan order to which he belonged. *193, 195.*

Cambiaso, Luca, known as **Luqueto.** Genoa, 1527-El Escorial, 1586. Came to Spain in 1583 with his son Orazio and Lazzaro Tavarone. Works in the Escorial. *233, 234, 238.*

Cano, Alonso. 1601-67. Sculptor, painter and architect. From 1637 in Madrid as painter to Count-Duke Olivares and employed by Philip IV to restore paintings in the royal collection. His *The Virgin with the Effulgence* (*c.* 1630-40) in the Prado.

Caravaggio, Michelangelo Merisi. Bergamo, 1573-Porto Ercole, 1610. Italian painter. Works in Toledo cathedral and the Tavera hospital; in the Prado and Palacio Real in Madrid. *116, 185.*

Carbonell, Alonso, died 1660. Spanish architect. The first supervisor of works for the Alcázar in Madrid in 1627. In 1633, superintendent of works for the Buen Retiro. Participated in the design of the Royal Pantheon in the Escorial. The larger part of the Carcel de Corte is attributed to him. In 1648, with the death of Juan Gomez de Mora, he became superintendent of all royal palaces. *164, 167.*

Carlier, François. d. Bayonne, 1760. French Architect, son of René Car-

lier. Designed the church of the Salesas Reales, Madrid (1750-58). 186, *190*.

Carlier René. d. 1722. French landscape architect and sculptor. Gardens and park at La Granja. 186, 247.

Carnicero, Isidro. Valladolid, 1736-Madrid, 1804. Sculptor. The window stuccoes of the Encarnación church in Madrid. 161.

Carreño de Miranda, Juan. Avila, 1614-Madrid, 1685. Painter. From 1671 court painter to Charles II. Works in Toledo cathedral and the Tavera hospital; the dome of San Antonio de los Portugueses in Madrid. 157, 170.

Castello, Fabrice. El Escorial, 1617. Italian painter, son of El Bergamasco (q.v.) with whom he came to Spain in 1567. With his brother, Nicolas Granello, Lazzaro Tavarone, Orazio Cambiaso, he painted the frescoes in the Gallery of Battles in the Escorial. 233.

Castello, Giambattista - *see* **Bergamesco.**

Castillo, José del. Madrid, 1737-93. Painter. Studied in Rome with Corrado Giaquinto who he accompanied to Spain when the master was summoned by Ferdinand VI in 1753. Later while in the service of Charles III he painted a number of designs for the royal tapestry-makers. Works in Madrid at the Palacio Real, San Fernando Academy, Encarnación and San Francisco churches. 161, 235.

Castro, Carlos María de. Engineer. Designer of plans for the enlargement of Madrid, approved by the government in 1859. 208-9.

Castro, Felipe. Noya, 1711-Madrid, 1775. A sculptor who studied in Italy, was granted a pension by Philip V, and summoned to Madrid by Ferdinand VI. Works in Palacio Real and two Madrid churches, San Marcos and La Encarnación. 161.

Cellini, Benvenuto. Florence, 1500-71. Italian sculptor and goldsmith. The *Christ* in the retro-choir of the basilica in the Escorial; a gift of Francisco de Medici. 233.

Churriguera, José de. Madrid, 1665-1723; **Joaquín**, 1674-1724; **Alberto,** 1676-1740. Architects and decorators. The term 'Churrigueresque' has been applied—wrongly in the opinion of some authors—to the Spanish Baroque style, characterized by its exuberance. 173, 188.

Cignaroli, Giambettino. Salo, Verona, 1706-72. Italian painter. Studied Veronese and Correggio, and was sought after by every prince in Europe. Altar-painting in the Salesas Reales, Madrid. 186.

Cincinnati, Romulo. Florence, 1502-Madrid, 1600. Italian painter. Came to the Escorial in 1567. A few scenes on the choir walls, and several altarpaintings. 233.

Coello, Claudio. Madrid, 1642-93. Painter. Frescoes in the vestry of Toledo cathedral, and works in the Tavera hospital; in Madrid, frescoes of La Panadería, picture in the Prado, and at San Placido; the Escorial. 162, 170, *170, 233, 236*.

Comontes, Antonio de. Painter, active in Toledo *c.* 1519. Assisted Juan de Borgoña on the altarpieces of San Andrés. 96.

Copin, Diego. Dutch born, d. Toledo, *c.* 1541. Active about 1500 in Toledo cathedral. Sculptor. Big altarpiece and statues of monarchs in the Capilla Mayor. 109.

Correa del Vivar, Diego. Born in Castile *c.* 1550, and active in the second half of the 16th century. Spanish painter. Works in the Santa Cruz hospital and El Salvador church in Toledo, the Prado in Madrid, and the Escorial.

Cotera, Pedro de la. Spanish architect. Assisted Gil de Hontañón with the façade of the university of Alcalá at Henares, 1541-53. 146.

Coustou, Guillaume. Lyon, 1677-Paris, 1746. French sculptor. Trained the artists who worked at La Granja: Frémin, Thierry, Bousseau, and the brothers Dumandré. 247.

Covarrubias, Alonso de. Torrijos, Toledo, 1448-Toledo 1570. Architect, and key figure in the Toledo Renaissance. Participated in the most important artistic achievements of the town: tombs in San Andrés, Santa Cruz hospital (doorway, patio and staircase), doorway of San Clemente, Capilla Mayor de San Román, Reyes Nuevos chapel in the cathedral, San Juan de los Reyes, the Tavera hospital, the Alcázar, Puerta Nueva de Bisagra, etc. Succeeded Enrique Egas in 1534 as master of works in the cathedral. *10, 13, 32, 39, 73, 88, 102, 122, 126,* 129, 133, *134,* 136, 137, *137, 139,* 140, 144, *164.*

Crescenzi, Giovanni Battista. Rome, 1577-Madrid, 1660. Italian architect, painter and decorator. In 1617 Philip III called upon him to carry out the chiefly decorative works on the Pantheon in the Escorial. Philip IV made him Marquis de la Torre and Knight of Santiago, and in 1630 appointed him Superintendent of Royal Works. The Carcel de Corte in Madrid is his. *164,* 167.

Cubas, Francisco de. Madrid, 1826-99. Architect. Many palaces and convents in Madrid during the reign of Isabella II and the Alfonsine Restoration; a very ambitious design for La Almudena cathedral, in neo-Gothic style. 210.

David, Gerard. Oudewater, Holland, c. 1450/60-Bruges, 1523. Painter. Works in Toledo cathedral and in the Prado. 235.

Donoso - see **Jiménez Donoso.**

Dumandré (or **Demandré**), **Antoine.** Born in Lorraine at the beginning of the 18th century. French sculptor, pupil of Coustou. Worked on the gardens at La Granja. Principal work: Apollo and Daphne. 24.

Dumandré (or **Demandré**), **Hubert.** Lorraine, 1701-Madrid 1781. French sculptor, brother of Antoine. Member of the San Fernando Academy, where he was in charge of the sculpture section. At La Granja: Fountains of Diana and Latona Bathing. 247, 248.

Egas, Enrique. d. Toledo, 1534. Architect, pupil of Jean Guas, whom he succeeded as director of such works as the Convent of San Juan de los Reyes. Master of Works at Toledo from 1496: responsible for the Capilla Mayor and the Mozárabic chapel in the cathedral, the hospital of Santa Cruz (begun 1560) . 11, 32, 36, 96, 125, 126, 128.

Fernández (or **Hernandez**), **Gregório.** Galicia, 1576-Valladolid, 1636. Sculptor. Works in Madrid at the convents of San Placido and the Encarnación. 170.

Flandes, Juan de. d. Palencia, 1519. Flemish painter. Entered the service of Isabella the Catholic in 1496, and prepared an oratory for her decorated with small pictures, of which some can still be seen at the Palacio Real, Madrid. 185.

Flipart, Charles Joseph. Paris, 1721-Madrid, 1797. French painter and engraver. Studied in Italy, particularly at Venice, with Tiepolo and Amiconi. Summoned by Ferdinand VI from Rome to be his court painter and engraver. A work in Santa Barbara, Madrid. 186.

Fontaine, Pierre François Léonard. Pontoise, 1762-Paris, 1853. Architect. Designed the decoration for the Platine cabinet of the Casa del Labrador at Aranjuez. 243.

Fontana, Domenico. (Ticino, 1543-Naples, 1607). Italian architect. Worked in the Rome of Sextus Quintus. 194.

Fontana, Francisco. Architect. Author of plans for the Ermita de San Antonio in Madrid. 198.

Frémin, René. Paris 1672-1744. French sculptor. Worked for many years in Madrid. Philip V appointed him chief sculptor. Busts of kings, and took part in design of fountains at La Granja. 247.

Gasparini, Matteo. 1744. Italian painter and stuccoist. Charles III called him from Naples to decorate the apartments known as the 'Cuarto del Rey', Palacio Real, Madrid. 185.

Giaquinto, Conrado or Corrado. Molfetta, 1703-Naples, 1765. Painter, appointed private painter to Ferdinand VI. Works in Palacio Real, Madrid, at Santa Barbara and in the royal residences. 184, 186.

Gil de Hontañon, Rodrigo. d. Segovia, 1577. Spanish architect, one of the most productive of the Plateresque period. Façade of the university of Alcalá de Henares (1541-53). 143, 146.

Giordano, Luca. Naples, 1632-1705. Painter. Came to Spain in the reign of Charles II. Sacristy vaulting in Toledo cathedral; in Madrid, vaulting of the Cason del Buen Retiro, walls of San Antonio de los Portugueses, altar painting at Comendadores de Santiago; at the Escorial, vaulting of the monastery staircase. 49, 168, 170, 172, 234, 238.

Giralte, Francisco. Palencia, ?-Madrid, 1576. Sculptor. Worked with Berruguete on the Toledo cathedral choir-stalls; altarpiece and tombs in San Andrés church, Madrid. 155, 156, 157.

Gómez de Mora, Juan. Madrid, c. 1580-1648. Architect, follower of the style of Herrera. In Madrid: convent of the Encarnación, Plaza Mayor, Ayuntamiento, San Isidro chapel. 159, 161, 162, 162, 167, 168, 170.

González de Lara, Hernán. Active in second half of 16th century. Worked with Covarrubias in Toledo on the Alcázar and the Tavera hospital, for which he designed the church. 133, 137.

González Velázquez. A distinguished family of artists active during the 18th century. Luis, painter of frescoes; works in Madrid: San Marcos, Encarnación, Sacramento, Salesas Reales, the Queen's Antechamber at the Royal Palace. Alejandro, painter and architect, collaborated with his brother Luis, and worked as architect on the new plans for the town of Aranjuez, with Bonavía. Besides this he painted the altarpiece of the Alpajes church. Antonio was the most important of the three. At Madrid: works in the Encarnación, the Descalzas Reales, Salesas Reales,

and the Palacio Real. The three collaborated at SS. Justo y Pastor. Antonio had several sons, including Isidro, designer of the *Dos de Mayo* obelisk in Madrid. 186, *189*, 200, 242, *245*.

Goya y Lucientes, Francisco. Fuendetodos, Saragossa, 1746-Bordeaux, 1828. Painter. Started at the Royal Tapestry Factory in Santa Barbara in 1775, where he made fifty-four designs, of which forty are in the Prado, together with a vast number of other very varied works: portraits, religious paintings, battle-scenes, scenes of everyday life, drawings, 'black paintings'. Works in the Palacio Real, the San Fernando Academy, Lazaro Galdiano museum, San Fernando el Grande, Escolapios de San Anton, and particularly the frescoes of San Antonio de la Florida (*see* Museums). Works at the Escorial and in Toledo cathedral. 116, 133, 174, *181*, *182*, 185, 188, 195, 198-9, *199*, *201*, *203*, *205*, 213, 215, 235.

Granello, Nicolas. d. Escorial, 1593. Italian painter. Came to Spain with his father Giambattista Castello, known as El Bergamasco, in 1567. At the Escorial, decoration of the chapter-houses, the ante-sacristy, the library and the Gallery of Battles. 227, 233, 234.

Grases Riera, José. Barcelona, 1850-Madrid, 1919. Architect. Monument to Alfonso XII overlooking the lake of the Retiro, Madrid. 214.

Greco, El. (Domenico Theotocópuli). Candia, Crete, 1541-Toledo, 1614. Painter. Trained in Venice with Titian, Tintoretto and the Bassanos; lived in Toledo from about 1577. In Toledo: the altarpiece of Santo Domingo el Antiguo, works in the cathedral, Santo Tomé, San José, Casa del Greco, Santa Cruz and Tavera hospitals, Illescas. In Madrid: at the Descalzas Reales, and the Ceralbo museum. El Greco was also an architect and sculptor, who himself manufactured the altarpieces he painted, and who executed the relief on San Ildefonso's chasuble in Toledo cathedral sacristy, and the *Risen Christ* in the Tavera hospital. 12, 20, *20*, *36*, 37, 40, *40*, 42, *45*, 46, 49, *49*, 51, 55, 92, 97, 98, 99, 100, 102, 112, 116, 129, *130*, 133, 134, 185, 222, 235.

Greco, Jorge Manuel Theotocópuli. Toledo, 1578-1631. Architect, son of Domenico. Worked in the Herrera tradition, as defined by the Escorial. Took part in the construction of the Ayuntamiento and the 'del Ochavo' chapel in Toledo cathedral. He paint-ed copies of some of his father's pictures. *108*, 139, 140.

Gricci, Giuseppe (died Madrid, 1770). Sculptor of the Neapolitan school. Worked in the Capodimonte porcelain works. Came to Spain in 1759 with his brother Stefano and with him created his masterpiece, the porcelain room in the Palacio Real at Aranjuez.

Guas, Juan. Saint-Pol de Leon, 1430-Toledo, *c.* 1496. French architect. At Toledo: the Gate of Lions at the cathedral, Convent of San Juan de los Reyes, where all the Gothic elements he had learnt from Hannequin of Brussels became merged with other features, Mudéjar in origin. From 1491 he was Master of Works in the cathedral. 10, 65, *88*, 92, *116*, *119*, *120*, 124, 125, *125*, 136.

Guercino, El (Giovanni Francesco Barbieri). Cento, 1591-Bologna, 1666. Italian painter, pupil of Carracci. Work in Toledo cathedral. 116.

Guidi, Domenico. 1625-1701. Italian sculptor, nephew and pupil of Finelli. Bronze crucifix on the Pantheon altar in the Escorial. 233.

Gumiel, Pedro. Active in the 16th century. Native, citizen and magistrate of Alcalá de Henares: Iglesia Magistral. Laid the first stone of the university college of San Ildefonso in 1498. At Toledo: assisted with the cathedral chapter-house. 129, 146.

Gutiérrez, Francisco. San Vicente de Arevalo, Avila, 1727-Madrid, 1782. Sculptor, trained by Carmona, and granted a pension to complete his apprenticeship in Rome. Became Court sculptor to Charles III. In Madrid: tomb of Ferdinand VI in the Salesas Reales, statue of Cybele for the Prado fountain, the Alcalá gate, a large part of the high altar of San Antonio de los Portugueses, a number of stuccoes at the church of the Encarnación and at the Royal Palace. 161, *176*, 188, 192.

Gutiérrez Soto, Luis. b. Madrid, 1900. Architect. Designed building for the Air Ministry. 217.

Haan, Ignacio. 1810. Architect, pupil of Sabatini. At Toledo: 'Puerta Llana' at the cathedral, El Nuncio (1790-94), and the Old University (1795-99). 51, 142.

Hannequin (Egas) of Brussels. d. Toledo, 1471. Architect and sculptor. Introduced the Flamboyant style into the Toledo region. In 1448 was Master of Works in the cathedral, where he completed the bell-tower and planned the Gate of Lions. Juan Guas brought some of his work to completion. 117, 124.

Hermosilla, José. d. 1775. Spanish architect. In Madrid: the 'Salon del Prado' (1768) and the General Hospital, after Sabatini's plans. 191.

Herrera Barnuevo, Sebastian. Madrid, 1619-71. Architect, in the king's service. Worked at the chapel of San Isidro en San Andrés, Madrid, and at Aranjuez. 169.

Herrera el Mozo, Francisco (the Younger). Sevilla, 1612-85. Painter and architect, son of Francisco Herrera the Elder. Trained in Rome. The church of the Comendadores de Santiago in Madrid is attributed to him. 169, 172.

Herrera, Juan de. Mobellan, Santander, 1530-Madrid, 1597. Architect in the service of Philip II from 1563, first as assistant to Juan Bautista of Toledo. Works: The Escorial. At Toledo: Ayuntamiento, South façade of the Alcázar. At Madrid, the preliminary planning of the Plaza Mayor. At Aranjuez, design of the Palacio Real. 116, 133, 138, 139, 140, 162, 221, 222, 223, *233*, 234, 235, 242.

Jareño, Francisco. Albacete, 1818-Madrid, 1892. Architect. Palacio de Bibliotecas y Museos completed by Ruiz de Salces. 211, *213*.

Jiménez Donoso, José. 1690. Spanish painter and architect who studied in Rome. Master of Works at Toledo cathedral in 1685. In Madrid: façade of la Panaderia, doorway of the defunct church of San Luis, now transferred to the church of the Carmen. 157, 162, 169, 170.

Juan de Borgoña - *see* **Borgoña**

Juan de Flandes - *see* **Flandes**

Juliá, Ascensio (Valencia, before 1771-Madrid, 1816). Genre painter. Friend and contemporary of Goya.

Juvara, Filippo. Messina, 1678-Madrid, 1736. Architect. Trained in Rome. Arrived in Spain in 1733 to lay down in the first plans for the Palacio Real in Madrid—later altered by Sacchetti. Also designed the garden front of the palace of La Granja. 172, 182, 186, 246.

Leoni, Leone. Menaggio, *c.* 1509-Milan, 1590. Sculptor, metal-caster, and medallist. Italian who worked in Ital for Charles V and Philip II. At the Escorial, the sculpture on the great altarpiece of the church, in marble and bronze. At the Prado, statues of Charles V's family. 233.

Leoni, Pompeo. Pavia *c.* 1533-Madrid, 1603. Sculptor, son of Leone, by whom he was trained. Came to Madrid accompanying the works that his father had executed in Milan for Philip II. In Madrid, a marble statue of Juana of Austria in the Descalzas Reales; at the Escorial, the tombs of Charles V and his family and of Philip II and his family. 158, 233, *238*.

López Aguado, Antonio. Madrid, 1764-1831. Architect. Among other works in Madrid: the Toledo gate, and the Royal Theatre, begun in 1818, and now totally rebuilt. 200.

López Otero, Modesto. Valladolid, 1885-Madrid, 1962. Architect. Planner and designer of the Ciudad Universitaria in Madrid. 214.

López y Portaña, Vicente. Valencia, 1772-Madrid, 1850. Painter, pupil of Maella, and private painter to Charles IV. Frescoes and portraits in the Palacio Real, Madrid. 185.

Lorenzo de San Nicolas, Brother. Madrid, 1595-1679. Architect. At Madrid: San Placido. Author of the treatise *Arte y Uso de Arquitectura* 1633-63, which had a profound influence in its time. 170, *170*.

Lorrain (Claude Gellée, known as Claude). Chamagne, Mirecourt, 1600-82. French painter who spent much of his life in Rome. Works in the Prado.

Macho, Victorio. (Palencia, 1887-Toledo, 1966). Contemporary Spanish sculptor. Author of numerous works in Spain and author of numerous works in Spain and America. In Madrid, the statues of Dr Ramón y Cajal and the novelist Pérez Galdós in the Retiro gardens.

Maella, Mariano Salvador. Valencia, 1739-Madrid, 1819. Painter who received his training in Rome. Court painter in 1774. Decorated the Palacio Real in Madrid under the direction of Mengs; works in Francisco el Grande, Madrid; Toledo cathedral; Aranjuez; the Escorial; the Prado. 242.

Marquet, Jacques. French architect who worked in Madrid during the reigns of Ferdinand VI and Charles III. The Correo, the former Post Office at the Puerta del Sol, is his work. 188, 202.

Martín. Active in Toledo in the 13th century. Architect. One of the first to design plans for the cathedral with Petrus Petri. *16*, *104*, 106, *106*, *108*.

Mateo. Madrid Architect. Took part in construction of Capilla de los Dolores del V.O.T., Madrid.

Mazo, Juan Bautista Martínez del. Province of Cuenca *c.* 1612-Madrid, 1667. Painter, pupil and son-in-law of Velázquez. Works in El Greco's house at Toledo, and the Prado. 102.

Memling, Hans. 1433-94. Flemish painter who spent his whole work-

ing life in Bruges. Works in the Prado.

Mena, Juan Pascual de. Villaseca de la Sagra, 1707-84. Sculptor. Collaborated with Ventura Rodriguez on the decoration of the church of the Encarnación, and the fountain of Neptune, both in Madrid. 161, 192, *248*.

Mena y Medrano, Pedro de. Granada, 1628-Malaga, 1679. Sculptor, pupil of Alonso Cano. Works in Descalzas Reales, Madrid. 158.

Mengs, Anton Raphael. Usti nad Labem, 1728-Rome 1799. Painter and writer on art from Bohemia. Protagonist of neoclassicism. Worked in Spain in the service of the Bourbons from 1761 to 1769 and from 1774 to 1776. Works in Toledo cathedral and Palacio Real, Madrid. 116, 184-5, 242.

Metelli, Agostino. Bolognese painter, 17th century. On one of his journeys to Italy Velázquez engaged him for fresco work; later he worked at the court of Philip IV. At Madrid: part of the staircase frescoes of the Descalzas Reales. 156.

Michel, Robert. Le Puy, 1721-Madrid, 1786. Came to Spain c. 1740. French sculptor. The pediment of the Aduana, fountain of Cybele, work in Palacio Real in Madrid and SS. Justo y Pastor. *176*, 192.

Monegro, Juan Bautista. c. 1545-50. Toledo, 1621. Spanish sculptor. Toledo: works in Santa Leocadia (Puerta del Cambrón), San Julian (Puerta de Bisagra), San Domingo el Real, Santa Clara, Concepción Francisca; Escorial: a statue of San Lorenzo on the main façade, the kings of Judah on the façade of the church and the Evangelists in the Court of the Evangelists; Alcalá de Henares. church. 140, *240*.

Mora, Francisco de. Cuenca, c. 1560-Madrid, 1610. Architect, trained at the Escorial. In Madrid, the palacio de los Consejos. 162, 235.

Moradillo, Francisco 18th-century Spanish architect. In Madrid: the sacristy of the Comendadores de Santiago, the Hospice in collaboration with Ribera, la Caserna del Conde Duque, San Cateyano; he also worked with Carlier to finish the church of Salesas Reales. 172, 173.

Morales, Luís de. Badajos, c. 1500-1586. Painter. Commonly known as El Divino, because of the exquisite quality and the profound sense of religious feeling in his pictures. Works in Toledo cathedral and Santa Cruz museum; at the Prado and the San Fernando Academy. 116.

Moro, (Anthonis Mor van Dashorst), known as Antonio. Utrecht c. 1519-76. Court portraitist, influenced by the Venetian school. 133.

Mura, Francesco. Naples, 1696-1782. Italian painter, pupil of Solimena. Worked chiefly at Naples and Turin. Madrid in Santa Barbara. 186.

Murillo, Bartolomé Esteban (Seville, 1618-82). The most important painter of the Seville school and one of the great masters of Spanish painting. The collection in the Prado is comprehensive, but for a fuller knowledge of the painter's work, that in the Museo de Bellas Artes in Seville should also be seen.

Navarrete, Juan Fernández. Logroño, 1526-Toledo, 1579. Painter, known by the sobriquet 'El Mudo' (The Dumb One). He was in the service of Philip II. There are works at the Escorial and the Prado. 233.

Olivieri, Giovanni. Italy, 1701-Madrid, 1762. Italian sculptor, active in Spain. In the service of Philip V, and one of those who created the San Fernando Academy in the reign of Philip VI. Works in Palacio Real, the San Fernando Academy, the Salesas Reales, and in the Alpajes church at Aranjuez. 186.

Olmo, José del (d. 1702). Architect. Appointed master of royal works in 1677. Considered to be the author of the Sagrada Forma altar in the Sacristy of the Monasterio del Escorial, though Palomino attributes it to Francisco Rizi. 236.

Ordóñez, Bartolomé. Burgos, c. 1480-Carrara, 1520. Spanish sculptor, who worked with his compatriot Diego de Siloe at Naples in 1517; then two years later at Carrara. Among other works is the tomb of Cardinal Cisneros, in the San Ildefonso chapel of the university of Alcalá de Henares. 144.

Orrente, Pedro de Murcia, c. 1588-Valencia, 1645. Painter in a style similar to the Bassanos. Works in Toledo cathedral and the Prado. 116.

Otero - *see* López Otero

Paciotto, Francesco. Urbino, 1521-91. Architect and military engineer. He was in charge of fortifications in the service of the Dukes of Parma and Savoy, and of the Duchy of Milan. Brought to Spain by Philip II to inspect his fortresses. 221.

Palacios, Antonio. 1876-1945. Spanish Architect. Madrid: Palace of Communications. Plaza de la Cibeles, Circle of Fine Arts. 215-16, *217*.

Palomino y Velasco, Ascislo Antonio. Bujalanca, Cordova, 1653-Ma-

drid, 1726. Painter and author of the book *Museo Pictórico y Escala Optica*. 170.

Pantoja de la Cruz, Juan. Valladolid, 1553-Madrid, 1608. A pupil of Sánchez Coello and court painter to Philip II. Works in Toledo cathedral. 116, 133, 157.

Paret y Alcázar, Luis. Madrid, 1746-99. Spanish litterateur and painter. Works in Escorial. 185.

Pascual y Colomer, Narciso. Madrid, 1808-70. Architect. Designed the Congreso de Diputados, now Palacio de los Cortes, and the palace of the Marquis of Salamanca. 200, 210.

Pedroso, Pedro. Spanish architect. Plans for the San Isidro chapel in San Andrés, Madrid. 170.

Pellegrini - *see* **Tibaldi, Pellegrino.**

Percier, Charles. Paris, 1764-1838. Architect. Drew up the plans, in collaboration with Fontaine, for the Platine cabinet in the Casa del Labrador at Aranjuez. 243.

Pereda, Antonio de. Valladolid *c.* 1608-Madrid, 1669. Painter. At Toledo, works in the Carmelitas Descalzas; at Madrid: Prado, Cerralbo Museum, San Fernando Academy.

Pereira, Manuel. 1614-67. Portuguese sculptor who settled in Madrid in 1646. Worked for the court convents. Works in San Placido. 170, *170.*

Pérez Villamil, Genaro. El Ferrol, 1807-Madrid, 1854. Painter. Works in Museo Nacional de Arte Contemporaneo and Museo Romantico, Madrid. *55, 108, 125.*

Peruzzi, Baldassare. Sienna, 1481-Rome, 1536. Painter and architect. Works in Prado.

Petit, Jean. *c.* 1500. French sculptor, designed sketches for the altarpiece of Toledo cathedral. 109.

Petri, Petrus (also called Pedro Pérez). d. 1291. Architect and Master of Works of Toledo cathedral, where he is buried. Upper parts of the Chevet, Mudéjar triforia of the interior arcades of the apsidal nave and of the Capilla Mayor. *93, 104,* 106, *106, 108.*

Picasso, Pablo (Pablo Ruiz Blasco). b. Malaga, 1881. Painter and sculptor. Works in the Museo Nacional de Arte Contemporaneo, Madrid.

Pitué, Pierre. 18th-century French sculptor. Called to Spain *c.* 1740, and worked at La Granja. *247, 248.*

Poussin, Nicolas. Les Andelys, 1594-1665. Spent most of his life in Rome. Works in the Prado.

Primo, Antonio. Andujar, 1735-Madrid, 1798. Sculptor. Pupil of Ro-

bert Michel at the San Fernando Academy; completed his training in Rome. In Madrid: the reliefs on the tribunes of the Encarnación church, and the sculpture on the façade of the old Post Office, Puerta del Sol. 161.

Procaccini, Andrea. Rome, 1671-La Granja, 1734. Painter, engraver and architect, a disciple of Carlo Maratta. Worked at Rome; in 1720 summoned by Philip V to be his personal painter. As an architect he revised the work-plans of La Granja, earlier in Juvara's charge. 246.

Ramos, Francisco. Madrid, 1744-1817. Spanish painter, with works in Encarnación church, Madrid. 161.

Raphael (Raffaello Sanzio). 1483-1520. Italian painter. *Portrait of a Cardinal* (*c.* 1510) and *The Madonna of the Fish* (*c.* 1513) in the Prado.

Reni, Guido. Calvezzato, 1575-1642. Italian painter with works in Toledo cathedral. 116.

Repulles y Vargas, Enrique. Avila, 1845-Madrid, 1922. Architect. Designer of the Bolsa (1885). 215.

Ribalta, Francisco. 1565-1628. Painter. Several paintings in the Prado, most notably the *Vision of St. Francis* (*c.* 1620).

Ribera, José (Jusepe) de. Játiva, Valencia, *c.* 1588-Naples, 1652. Painter. At Toledo: works in the Tavera hospital and the Santa Cruz museum; at Madrid: in the Prado; in the Escorial.

Ribera, Pedro de. Madrid, 1683-1742. Architect, and follower of Churriguera's style. In Madrid: Ermita de la Virgen del Puerto, church of Monserrat, Conde Duque barracks, Toledo bridge, Hospice, San Cayetano, Miraflores palace, palaces of Ugena and Perales, and the Fountain of Fame. 133, 134, *173, 173,* 174, *175, 175,* 176, 186, *248.*

Rizi, Francisco (Ricci). Madrid, 1608-the Escorial, 1685. Painter, in the king's service in 1656. At Toledo: frescoes in the chapel of the Virgen del Sagrario and of the Ochavo in the cathedral, pictures in the cathedral sacristy, the convent of the Immaculate Conception, las Gaitanas; at Madrid: convent of San Placido, dome of San Antonio de los Portugueses; in the Prado, the Capuchin church. 116, 157, 170, *170.*

Rodrigo, Alemán. A sculptor of German origin, active in Toledo from 1489 to 1503. Lower stalls of the cathedral; the themes represented on the stall-backs relate to the conquest of Granada by the Catholic Monarchs.

Rodríguez Ayuso, Emilio. Madrid, 1845-91. Architect. Escualas Aguirre and former arenas of this neo-Mudéjar style (now demolished), which he often made use of in his many buildings in Madrid. 211-12.

Rodríguez, Ventura. Ciempozuelos, Madrid, 1717-Madrid, 1785. Architect, trained by the Italians who were working on various royal undertakings. At Toledo: façade of the Archbishop's palace, and construction at the Alcázar. At Madrid: collaborated with Juvara and Sacchetti on the Palacio Real, in his own right designed San Marcos church and the fountains of Apollo, Neptune and Cybele, with José de Hermosilla, plans for the Salon of the Prado. 142, 161, *176*, 182, 183, *184*, 186, 188, *189*, 190, 191, 192, 193, 195, 198.

Román, Bartolomé. A Madrid painter of the 17th century. Works in the monastery of the Encarnación.

Ron, Juan Antonio. 18th-century. Spanish sculptor who collaborated with the architect Pedro de Ribera. In Madrid: San Isidro Salvador and Santa María de la Cabaza on the Toledo bridge.

Rubens, Peter Paul. Siegen, Westphalia, 1577-Antwerp, 1640. Visited Spain twice, first in 1603, then from 1628 to 1629. Did much work for Philip II and made the designs for tapestries ordered by Isabella Clara Eugenia for the Descalzas Reales in Madrid. Other works in the Prado and the Palacio Real. 158, 185, *205*.

Rusca, Bartolomeo (near Lugano, 1680-Bilan, 1745). Painter. From 1717, painter to the Court of Madrid. Painted the ceiling of the Sala de Mármoles in the palace of La Granja. 247.

Ruiz de Salcez, Antonio. Madrid, 1899. Architect. Completed the Palacio de Bibliotecas y Museos. 211, *213*.

Sabatini, Francesco. Palermo, 1722-Madrid, 1793. Italian architect, son-in-law of the Neapolitan architect Luigi Vanvitelli. Came to Spain in the service of Charles III, who entrusted him with important military affairs and loaded him with honours and grants. In Madrid: the Aduana, the General Hospital, Puerta de Alcála, Grimaldi palace, San Francisco el Grande, and Santa Barbara; at Aranjuez, the convent and church of San Pascual; at El Pardo: enlargement and completion of the palace. 51, 142, 184, 186, 188, 193-5, *193*, 198, *215*, 240, 242, *243*.

Sacchetti, Giovanni Battista. Turin, 1700-Madrid, 1764. Architect and painter, pupil of Juvara, whose plans for the Palacio Real in Madrid he transformed. Although he began the work of building the palace, he was succeeded by Sabatini in 1760, twenty-six years after his arrival in Madrid in 1736. *144*, 172, 182, 183, 186, 246.

Sainz de Oisa, Francisco. Contemporary Spanish architect, designer of the 'Torres Blancas'. 217, *220*.

Salamanca, Marquis of. Málaga, 1811-Madrid, 1883. Financier and political figure, a promoter of construction works and other undertakings such as the financing of railways, and the expansion of Madrid, where a large district bears his name. 200, 209.

Sánchez, Pedro. 1568-1633. Architect. In Madrid: San Antonio de los Portugueses, with Francisco Bautista, designs for the present church of San Isidro for the Society of Jesus, to which both of them belonged. *152*, 170, *170*.

Sánchez Coello, Alonso. Benifato, Valencia, 1531-Madrid, 1588. Court painter to Philip II. Works in the Descalzas Reales and at the Escorial. 157, 233.

Sánchez Pescador, Juan José. Spanish architect who worked in Madrid in the reign of Isabella II. Works include the pedestal of the equestrian statue of Philip IV in the Plaza de Oriente. 169.

Sansovino, Andrea Contucci. Montepulciano, 1460-1529. Italian sculptor, who lived in Spain and was active in Toledo and Seville. At Toledo: Cardinal Mendoza's tomb in the cathedral. 109, 126.

Seghers, Daniel. Antwerp, 1590-1661. Works in Toledo cathedral. 116.

Serrano, Pablo (born in Teruel, 1910). Contemporary sculptor. Distinguished member of the Spanish avant-garde. Monument to Dr Gregorio Marañón in the Ciudad Universitaria in Madrid. 220.

Serlio, Sebastian. Bologna 1475-Fontainebleau 1564. Italian architect and architectural theorist. In 1537 and 1540 published in Venice the fourth and third books of a comprehensive treatise on architecture. Appointed court painter and architect to Francis I in 1541. Other volumes were published later and in 1611 the whole translated into English entitled *The Entire Works of Architecture and Perspective*. 73, 132, 138, 157, 222.

Siloe, Diego. (Burgos, *c.* 1495-Granada, 1563). Sculptor and architect. One of the masters of the

Spanish Renaissance. His major work is the cathedral in Granada.

Sorolla y Bastida, Joaquín. (Valencia, 1863-Cercedilla, 1923). Master of Post-Impressionist Illuminist painting.

Subisati, Sempronio. Italian architect who worked at La Granja. Designed the Patio de la Herradura and the tomb of Philip V and his wife Isabella Farnese. 246.

Tacca, Pietro. Carrara. 1557-Florence, 1640. Sculptor. Equestrian statue of Philip IV, Plaza de Oriente, Madrid. *167, 168, 233.*

Texeira, Pedro. 16th-century Portuguese geographer. Maker of a map of Madrid which is of great historical interest, drawn to a scale of 1:1,850. He was in the service of Philip II. *150, 160, 168.*

Theotocópuli, Domenico - *see* **Greco.**

Theotocópuli, Jorge M. - *see* **Greco**

Thierry, Jean. Lyon, 1669-1739. French sculptor, pupil of Coysevox, who worked at La Granja. *247.*

Tibaldi, Pellegrino. 1527-96. Italian painter, sculptor and architect. Worked as an architect in Milan before coming to Spain in 1588. Stayed in the Escorial until 1596, then returned to Milan where he died. In the Escorial: frescoes in the convent cloister, vaulting of the 'Camarin', pictures for the high altar which replaced those of Zuccaro, and the library, his masterpiece. *227, 234.*

Tiepolo, Domenico. Venice, 1727-1804. Painter. Son of Giambattista with whom he came to Madrid in 1762. With his father, the frescoes of the Palacio Real in Madrid; in his own right, the vaulting of the antechamber. *185.*

Tiepolo, Giambattista. Venice, 1696-Madrid, 1770. Painter. Called upon by Charles III to paint the ceilings of the Palacio Real in Madrid. His sons Domenico and Lorenzo accompanied him, and helped in the work. Painted pictures for the convent of San Pascual. *184, 242.*

Tiepolo, Lorenzo. Venice, 1736-Madrid 1776. Painter, son of Giambattista. Collaborated with his father on the frescoes of the Palacio Real in Madrid. *185.*

Tintoretto (Jacopo Robusti). Venice, 1518-1594. Painter. Works in the Tavera hospital, Toledo, in the Prado, and in the Escorial. *235.*

Titian (Tiziano Vecellio). Cadore, 1487-Venice, 1576. Painter. Received numerous commissions from Charles V and Philip II. The Prado has a magnificent collection of his works. Among these are the *Wor-*

ship of Venus and the *Bacchanal* painted for Alfonso d'Este between 1518 and 1523, the portrait of Charles V (1533), *Charles V at the Battle of Mühlberg* (1548) and *La Gloria* (1554), again of the Emperor. Also here are the *Danaë* and *Venus and Adonis* painted for Philip II in 1554. There are other works in Toledo at the Tavera hospital and the cathedral; also at the Escorial. *235.*

Toledo, Juan Bautista de. Spanish architect d. Madrid 1567, who lived at Naples until Philip II called upon him to take charge of the work of building the Escorial. Works in Madrid include façade of the church of the Descalzas Reales; also at Aranuez. He is said to have worked with Michelangelo on St Peters', Rome. *137, 139, 156, 221, 222, 233, 242.*

Tomé, Narciso. *c.* 1690-1742. Spanish architect and decorator. In 1721 appointed Master of Works in Toledo cathedral. With others, produced the *Transparente*, a particularly significant work in relation to Spanish Baroque. *113, 116, 142.*

Torre, Pedro de la. 17th-century. Spanish architect. In 1632, it is recorded, he visited the chapel of the Ochavo in Toledo cathedral, accompanied by Brother Francisco Bautista. In Madrid, he drew up the plans for the Capilla San Isidro en San Andrés, *c.* 1640. *170.*

Tristán, Luis. Toledo, 1586-1624. Painter, and follower of El Greco's style. Works in Toledo cathedral, Casa del Greco, Santa Clara la Real (altarpiece); also in the Prado and the Escorial. *102, 116, 133.*

Turriano, Gianello. Cremona, 1501-Toledo, 1575. Italian architect in the service of Charles V. *49.*

Urbino, Francisco de. d. Escorial, 1582. Italian painter, who came to Spain as assistant to Castello. At the Escorial: frescoes in the vestibule of the chapter-houses, and a ceiling (with Granello). *234.*

Vega, Gaspar de la. Spanish architect in the 16th century. One of an important family of architects in the service of Charles V and Philip II. At Toledo he worked on the Alcázar with Covarrubias and Villalpando, also on the Tavera hospital. *137.*

Vega, Luís de. d. 1562. Spanish architect. Works on royal residences included Madrid, Balsain, Aranjuez, and particularly the palace at El Pardo, rebuilt from 1549 to 1558. *240.*

Velasco, Carlos. (d. Madrid, *c.* 1888). Architect. Built in the so-called neo-Mudéjar style, of which the church of San Fermín de los

Navarros in Madrid is a good example. Designed Madrid town hall. 214.

Velázquez, Diego Rodríguez de Silvany. Seville, 1599-Madrid, 1660. Painter. There is a magnificent collection in the Prado representative of his career, from his youth (the Seville period, then the Madrid, before his first visit to Italy); via the great equestrian portraits of his mature years; *the Surrender of Breda, Las Meninas,* which occupy a special room; up to his late period, with *Las Hilanderos (The Spinners).* Other works in the Palacio Real, the Museo del Ejercito, Madrid; the Escorial. 116, 160, *161,* 170, 185, 198, *205,* 235.

Velázquez, Gonzáles - *see* **González.**

Vergara, Nicolas de. Sculptor in bronze, 16th century. Pulpits in the Toledo cathedral choir, and a grille surrounding the tomb of Cardinal Cisneros at Alcalá de Henares. 133, 134, 140.

Veronese, Paul. Verona, *c.* 1528-Venice, 1588. Painter, one of the most important figures in the Venetian Renaissance. In the Prado and the Escorial is a significant collection which was once belonged to the Austrian Monarchs. 235.

Vigarny, Felipe (or Biguerny); Langres, 1498-Toledo, 1543. French sculptor. Half the choir-stalls in Toledo cathedral, and the altarpiece of the Reyes Nuevos chapel, also in the cathedral. *34, 39,* 109, 112.

Villacastin, Brother Antonio. Villacastin, Segovia, *c.* 1512-Escorial 1603. His zeal and industry characterized his direction of the monastery's works. 221.

Villalpando, Francisco Corral de. d. Toledo, 1561. Metalworker and are architect. In Toledo: the enormous grilles of the Capilla Mayor (1548), bronze pulpits in the cathedral, doorway of the Colegio de Infantes. In Madrid: doors hung in the main doorway of the Obispo chapel. Played an important part in the rebuilding of the Alcázar at Toledo, the great patio and the imperial staircase (1556). In 1552 he published in Toledo the translation of Volumes III and IV of Serlio's book on architecture. 39, 109, 134, 138, 156, 157, 223.

Villanueva, Juan de. Madrid, 1739-1811. Son of the sculptor Juan. Studied at the San Fernando Academy and then in Italy (1758). At the Escorial, the house of the French Consul, his first achievement (1768), Amba's house and the Prince's House. At El Pardo, another Prince's House, which heralded his masterpiece, the Prado museum. Also in Madrid: the astronomic observatory, church of the Caballero de Gracia, colonnade of the Ayuntamiento, gates of the Botanical Gardens. Other works also at Aranjuez and the Escorial. *162,* 164, *164,* 168, *194,* 195, 198, 200, 208, *235,* 240.

Villareal, José de. Spanish architect, in 1645 assistant to the chief architect of the Alcázar in Madrid. In 1654 he was supervising the works, and by 1660 Master of Works. Worked also at the Casa Consistorial and at San Isidro en San Andrés, Madrid. With Velázquez, accompanied Philip IV to Irun for the negotiations for the Treaty of the Pyrenees. (1659). 168.

Villoldo, Juan de. Spanish painter who lived in Toledo in the middle of the 15th century. Responsible for the great altarpiece in the chapel of the Obispo, Madrid. 155, *157.*

Viña, Francisco de la. Decorator and stuccoist, who worked in Madrid 1671 and decorated the interiors of the Capilla de San Isidro en San Andrés. 172.

Watteau, Jean-Antoine. Valencien-1684 - Nogent-sur-Marne, 1721. Painter. Works in the Prado and the Palacio Real in Madrid. 185.

Weyden, Rogier van der. Tournai, *c.* 1400-64. Painter. Works in the Prado and the Escorial. 185, 235.

Zuazo Ugalde, Secundino. Bilbao, 1887-Madrid, 1970. Planning for new ministerial buildings, and extension of the Castellana. .216.

Zuccaro, Federico. 1543-1609. Italian painter. Began by working with his brother Taddeo. At the Escorial, works of note in the cloister, and part of the high altarpiece. 233.

Zuolaga y Zabalete, Ignacio. Eibar, 1870-1945. Painter of popular Spanish types, portraitist.

Zumbigo, Bartolomé de. d. 1682. Spanish architect. In Madrid, he was assistant to the chief architect of the Palacio Real; at the Escorial, he worked on the royal Pantheon under the orders of Carbonell. At Toledo he was Master of Works for the cathedral in 1671, lined the Ochavo chapel with marble facings, also church of the Immaculate Conception. 142.

Zurbarán, Francisco. Fuente de Cantos, Badajoz, 1598-1664. Painter. At Toledo: works in El Greco's house, the cathedral, the Tavera hospital; at Madrid: in the Prado, the San Fernando Academy, at the Cerrebaldo museum, at the Descalzas Reales. 102, 116, 188.

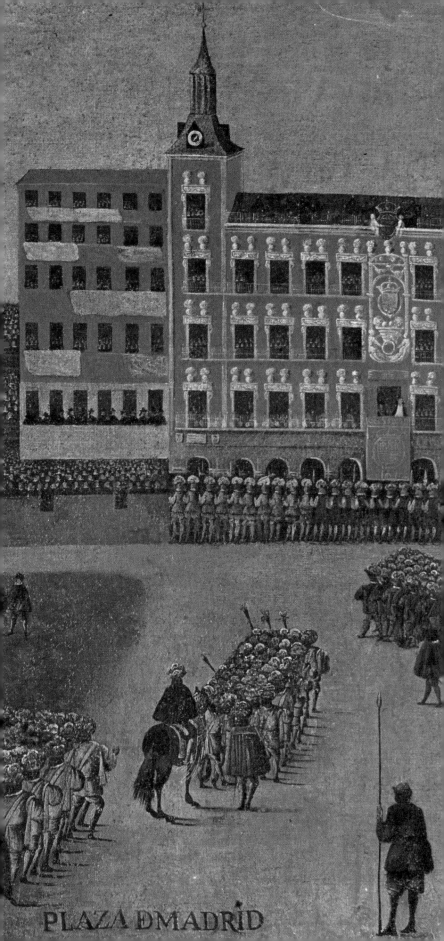

PLAZA ĐMADRID